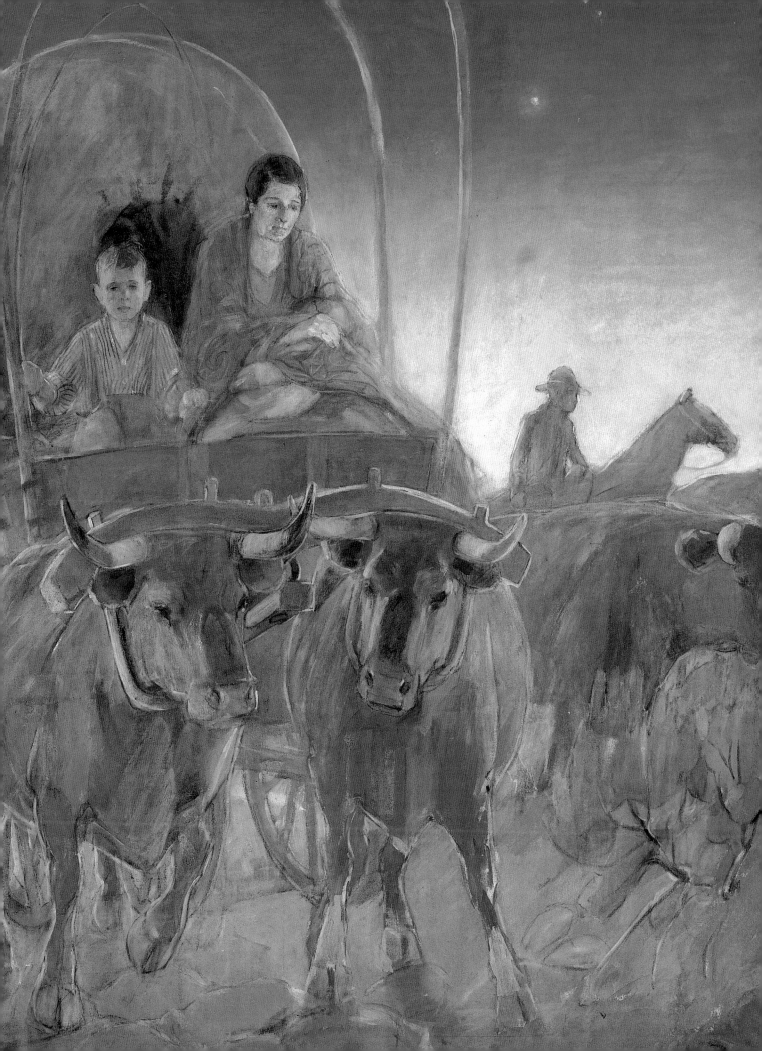

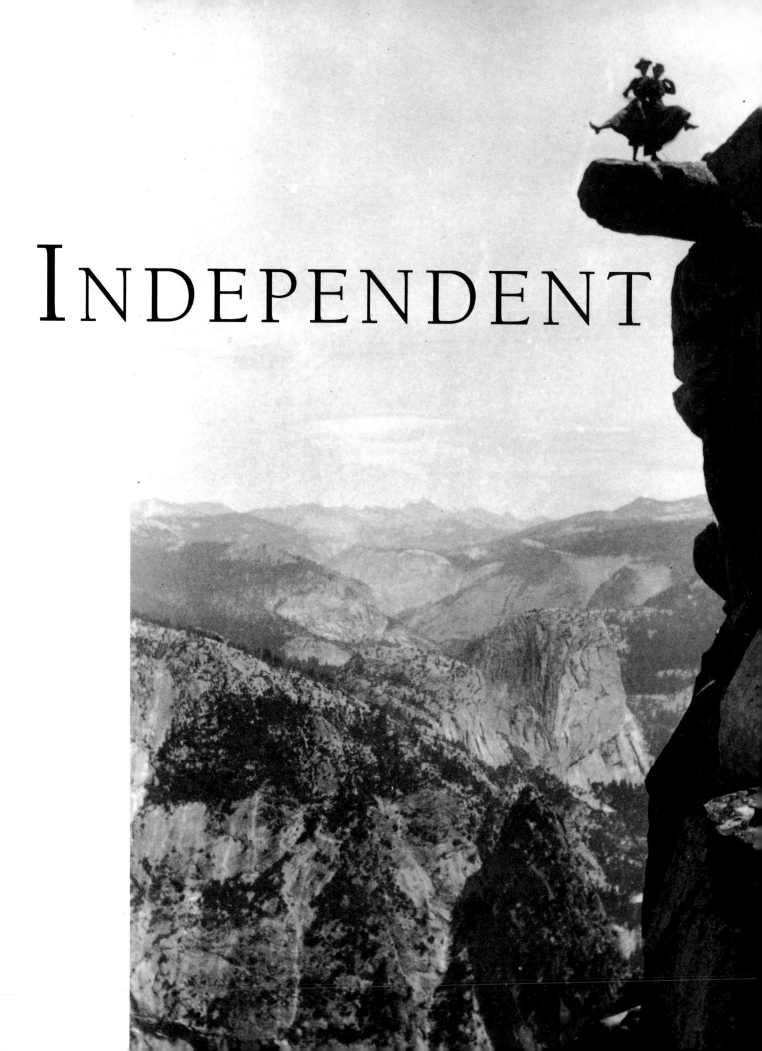

INDEPENDENT

Women Painters Spirits of the American West, 1890-1945

Patricia Trenton, *Editor*

with essays by
Sandra D'Emilio

Erika Doss

Ilene Susan Fort

Vicki Halper

Joni L. Kinsey

Susan Landauer

Sarah J. Moore

Becky Duval Reese

Virginia Scharff

Patricia Trenton

Sharyn Udall

Autry Museum of Western Heritage
in association with the
University of California Press
Berkeley • Los Angeles • London

This book is published in association with the University of California Press, Berkeley and Los Angeles, and on the occasion of an exhibition of the same title organized by the Autry Museum of Western Heritage, Los Angeles, California.

Editor: Jeanne D'Andrea
Designer: Dana Levy, Perpetua Press, Los Angeles
Copyeditor and proofreader: William Heckman
Production coordinator: Fran Mitchell
Indexer: Susan DeRenne Coerr
Photo editor: Lawrence Reynolds

PHOTOGRAPHY CREDITS: Plates 3, 10, 19, 25, and 28, M. Lee Fatherree; plate 47, Christopher Bliss Photography; plate 87, Douglas M. Parker Studio; plate 103, Susan Dirk; plate 105, Howard Giske; plates 109, 112, 117, 118, and 125, Paul Macapia; plate 113, David Anderson; plate 133, Gene Balzer Photography; plate 156, Damian Andrus; plate 164, James O. Milmoe; plate 168, Gary Samson; plates 170 and 171, Blair Clark; plate 177, Justin van Soest; plate 187, A. Mewbourn; plate 199, Michael Tropea; plate 206, Andy Hanson; plate 245, Robert Reck Photography

Printed in Hong Kong

Library of Congress Cataloging-in-Publication Data

Independent Spirits : women painters of the American West, 1890–1945 / Patricia Trenton, editor; with essays by Sandra D'Emilio . . . et al.
 p. cm.
 Catalog of an exhibition of the same name organized by the Autry Museum of Western Heritage.
 Includes bibliographical references and index.
 ISBN 0-520-20202-3 (acid-free paper) — ISBN 0-520-20203-1 (pbk. : acid-free paper)
 1. Painting, American—Exhibitions. 2. Painting, Modern—19th century—West (U.S.) —Exhibitions. 3. Painting, Modern—20th century—West (U.S.) —Exhibitions. 4. Women painters—West (U.S.) —Exhibitions. 5. West (U.S.) in art—Exhibitions. I. Trenton, Patricia. II. D'Emilio, Sandra. III. Autry Museum of Western Heritage.
ND225. I53 1995
759. 18′082—dc20 95-17367

9 8 7 6 5 4 3 2

FRONTISPIECE: Detail of plate 216, Minerva Teichert, *1847 Covered Wagon Pioneers, Madonna at Dawn*

TITLE PAGE: George Fiske, *Kitty Tatch and Friend on Overhanging Rock, Glacier Point, Yosemite, California,* c. 1890s. Albumin Cabinet Mount #287, Yosemite National Park Collections, Yosemite National Park Research Library, negative no. YM-18,194.

Contents

Contributors

SANDRA D'EMILIO
Curator of Art, 1900–1945, Museum of Fine Arts, Museum of New Mexico, Santa Fe

ERIKA DOSS
Associate Professor of Art History, Department of Fine Arts, University of Colorado, Boulder

ILENE SUSAN FORT
Curator, American Art, Los Angeles County Museum of Art

VICKI HALPER
Associate Curator of Modern Art, Seattle Art Museum, Washington

JONI L. KINSEY
Assistant Professor of Art History, University of Iowa, Iowa City

SUSAN LANDAUER
Independent curator and writer, Oakland, California

SARAH J. MOORE
Assistant Professor of Art History, University of Arizona, Tucson

BECKY DUVAL REESE
Director, El Paso Museum of Art, Texas

VIRGINIA SCHARFF
Associate Professor of History, University of New Mexico, Albuquerque

PATRICIA TRENTON
Art Director, Los Angeles Athletic Club Collection, LAACO Ltd.
Guest Curator, Autry Museum of Western Heritage, Los Angeles

SHARYN UDALL
Art historian and independent curator, Santa Fe, New Mexico

Foreword

THERE IS ALWAYS A SENSE of excitement at the Autry Museum of Western Heritage, and we plan it that way. There is so much to know about the history and people of the West and there are so many ways to share the area's art and history. Through exhibitions, publications, films, and performances we intend for visitors to come away with a sense that the Western story is one much greater than just cowboys and Indians. It is, in fact, a primary objective of the museum to expand awareness of the West in the examination of issues related to gender, ethnicity, culture, occupation, politics, economics, the environment, and other aspects of life, and to do so within broad temporal and disciplinary boundaries.

When Dr. Patricia Trenton proposed *Independent Spirits* as an exhibition and book project, we were immediately receptive. The proposed combination of scholars and content matched our own interests. Topics related to understanding the roles of women in the history and development of the West have been shared with our visitors through other exhibitions. The story of women artists clearly would add to our continued effort while providing a corrective for the lack of attention they have received in earlier literature. Dr. Trenton has been a longtime supporter of the museum and it was obvious from her previous endeavors that the quality of the work would be

exemplary. Needless to say, Pat has been the driving force in the completion of this project, giving it the vision and elements of quality essential to its content. We owe Pat and her team of art and social historians a special vote of thanks. These participants happen to be women, but more important, they are scholars of vision and ability. Our own team from design, collections management, curatorial, conservation, development, education, publications, facilities, and security brought many pieces together to help produce this project. Along with the scholarship brought to bear by the academic side, they are the often heroic corps which forms the backbone of all our efforts.

Independent Spirits has been made possible because of the ongoing support of our friends at Wells Fargo Bank. In particular, Lois Rice has been a key supporter in the production of many of the museum's exhibits and programs. Like the founding organizers of the Autry Museum of Western Heritage, she proves that gender is not the basis of intelligence or ability.

JOANNE D. HALE
Chief Executive Officer and Director

JAMES H. NOTTAGE
Chief Curator

Independent Spirits: Women Painters of the American West, 1890–1945 has
been made possible through the generosity of:

Wells Fargo Bank
ARCO Foundation
Joan Irvine Smith and Athalie R. Clarke Foundation
Mattel

The Publisher gratefully acknowledges
the generous contribution provided by
the Director's Circle of the
Associates of the University of California Press,
whose members are:

June and Earl Cheit

Edmund J. Corvelli, Jr.—New England Book Components

Lloyd Cotsen

Susan and August Frugé

Harriett and Richard Gold

Florence and Leo Helzel

Ruth and David Mellinkoff

Thormund A. Miller

Mr. and Mrs. Richard C. Otter

Joan Palevsky

Lisa See and Richard Kendall

Judith Lee Stronach and Ray Lifchez

Preface and Acknowledgments

SEVERAL YEARS AGO, as I was doing research on a number of paintings in a private collection, I noticed that some of the painters signed their canvases with an initial for the given name. Further investigation revealed that these paintings were by women artists. I soon discovered that women artists frequently used initials, or altered first names, to conceal their gender in order to circumvent latent (and not-so-latent) discrimination. Since my scholarly interests were in Western painting, I became intrigued with the idea of singling out women artists of the American West from 1890 to 1945. During this period of robust and spectacular development of our country's so-called last frontier, almost every aspect of our society underwent significant deviations from earlier practices and accepted norms—government, industry, finance, and inevitably the arts. In this dynamic transition life patterns were greatly altered as well. My decision to proceed with the project was further validated when research revealed that women artists of the West, with the exception of Georgia O'Keeffe and a few others, had received minimal attention, yet their Eastern sisters have recently enjoyed well-deserved recognition in exhibitions, literature, and the media. With this new understanding, I approached the Autry Museum of Western Heritage and its talented, forward-thinking director, Joanne Hale, about sponsoring what was then taking form as a specific book/catalogue and exhibition proposal for four venues.

As the first comprehensive scholarly study of its kind, *Independent Spirits* should make a strong contribution to the literature of women's studies, American art history, and the cultural history of the West. Thus far the topic has been treated only fragmentarily in books and exhibition catalogues that are either monographic or limited to a single state.[1] Yet, one does not have to look very far to discover that Western women have been formidable cultural innovators and agitators for the rights of both artists and women. Many of these artists achieved national and sometimes international recognition in their lifetimes, only to slip into art-historical obscurity.

The primary purpose of this present book, however, is not just to retrieve lost talent but to explore the shifting mechanisms of privilege and exclusion, as women evolved from amateurs to professionals, from the Victorian ideology of "separate spheres" to a more integrated participation in the arts.[2] While each of the contributors brings an individual approach to this study, all are concerned with examining the range of forces—economic, social, and political—that have shaped the painting of women artists in the trans-Mississippi West, or specifically the area west of the ninety-eighth meridian to the Pacific Coast.[3] Although most of the essayists take cognizance of critical feminist discourse, the book will not be heavily weighted with theory, feminist or otherwise. Our intent is to provide an informative, penetrating, readable survey, concurring with the preeminent art historian Robert Herbert that too much reliance on theory can obscure rather than illuminate works of art.[4]

An introduction by Virginia Scharff examines the exhibition's theme, breadth, and scope. "Irony," she writes, "drives every good story about

women's lives in the West. The best stories run like the braided streams of the region's great river systems, liberally strewn with ironies and ambiguities." From the time of the earliest prehistoric settlements, women have participated actively in the life of the West; but not until the late nineteenth century did women within the mainstream Anglo culture begin to enjoy access to the region's openness and opportunities. In contrast to the East, the West was unhampered by tradition and social hierarchy. Western women thus had more freedom than their Eastern counterparts in almost every sphere of creative endeavor, and they pushed the boundaries of femininity sooner and farther. In most Western states women had voting privileges before 1915, five years before the passage of the Nineteenth Amendment. By 1930 the West had sent the first women to the United States Congress and had elected two woman governors (Wyoming and Texas) and a woman mayor of a large city (Seattle), while Eastern women still exercised influence from behind the scenes, or as volunteers.

The West is not monolithic. Its climate, geography, sociopolitical character, and art vary from region to region. To reflect this diversity, *Independent Spirits* treats five distinct geographic and cultural areas, or regions, of the West. The first, California, is represented by three essays, one on Northern California and two on Southern California. The exponential growth that resulted in larger numbers of women painters in Southern California necessitated addressing traditionalists and modernists separately. In her essay on Northern California, Susan Landauer points out that women were early leaders and founders of most art establishments, which helped to prevent the "ghettoization" of women artists noted elsewhere by feminist art historians. While women encountered gender-related discrimination in this region, some were highly successful nonetheless. Grace Carpenter Hudson, a traditionalist painter, became so prosperous that her husband left a successful medical practice, sparking a rumor that he, not his wife, was the painter. Landauer also discusses the large modernist cadre in the region and its relationship to feminism. Her provocative closing comment reveals a troubling side effect of Abstract Expressionism: "The notion that muscle, alcohol, and American art went together disenfranchised women artists more than ever before."

Art establishments in Southern California developed several decades after those in Northern California. In 1874 San Franciscans founded the first art academy in the state, the California School of Design, while institutional art training was not available to Angelenos until the Otis Art Institute opened in 1918. In Los Angeles support for art developed slowly against a background of frenetic growth, stimulated by low-priced railroad fares, unparalleled optimism, boosterism, and—for Midwesterners and Easterners—the lure of a magnificent climate. Surprisingly, traditionalists and conservatives were able to flourish in this cauldron of activity. Patricia Trenton in "'Islands on the Land': Women Traditionalists of Southern California" offers a scenario that examines the dynamics of artists married to artists—working, eating, and sleeping side by side and, in some instances, openly competing with each other. The essay provides new insight into the personal and professional lives of these early artist teams.

In a sense, the story of Southern California magnifies the story of the West at large: the very lack of entrenched academies seems to have nurtured unconventionality. In her essay, Ilene Fort describes Southern California modernist painters as highly independent, freethinking, outspoken, affluent, well educated, and free from intellectual or financial dependence on men. While the majority of these painters did marry, few had traditional marriages. The lack of conformity during this period was heightened by the growth of cults and religions, both orthodox and esoteric. When regionalism and the federal art aesthetics encouraged a return to a more conservative type of art, the modernist movement lost momentum for a time.

The second region, the Northwest—Oregon and Washington—known for its natural resources and the physical beauty of its misty coastlines and pine-covered mountain ranges, was virtually isolated from both the Eastern and Western cultural centers. The Northwest was initially settled by a population with commercial interests in its bountiful resources. Women outnumbered men as artists, although little remains of the work they did before 1930. Of the eleven painters in the Northwest discussed by essayist Vicki Halper, the best known was the controversial Margaret Tomkins. Not identified with any women painters' group, Tomkins found her female colleagues self-pitying, lacking in the clarity, balance, and energy to be artists, mothers, and wives.

In the Southwest—Arizona, New Mexico, and Texas—as in the Northwest and California, most women painters received advanced formal training, often in the East and the Midwest, and were relatively privileged and white. In "No Woman's Land: Arizona Adventurers," Sarah Moore affirms that the state's reputation as "all cactus, rattlesnakes, and bad men" was not entirely a fiction, that the aridity of the landscape was matched in large part by Arizona's cultural

sparseness. Given these harsh realities, women artists who came to Arizona understandably brought with them a spirit of independence and adventure that challenged the state's unyielding expanse. For many there was motivation enough in the quality of life and the freedom from social restraints as well as the clarity of light, the open vistas, and the indigenous inhabitants.

In New Mexico, a number of Pueblo women managed to overcome severe cultural obstacles to become professional artists. Essayists Sandra D'Emilio and Sharyn Udall write about the influence of the mercurial Mabel Dodge Luhan, a symbol of the self-determining, sexually emancipated New Woman, expansive in her ideas about art, society, and politics. Georgia O'Keeffe, invited to New Mexico by Luhan, found a therapeutic place, for both her art and her physical being. Other artists, tired of hackneyed European subject matter, found in New Mexico a subject unique to America—the Native American.

In "Lone Star Spirits" Susan Landauer and Becky Duval Reese remark that although both men and women were engaged in the growth of the state's arts, most historians acknowledge a striking division of labor along gender lines as Texas developed. While men were preoccupied with building the state's dynamic base, women took the lead in promoting cultural causes and raising the aesthetic consciousness of Texans. In cities throughout the state, the Texas Federation of Women's Clubs encouraged art appreciation as early as 1897 by showing the work of members and bringing art exhibitions to their communities. As "civilizers" and crusaders for cultural enlightenment these women painters exerted considerable influence on the art of Texas and made significant contributions to the state's artistic heritage.

Essayist Erika Doss in "I must paint" states that nineteenth-century male artists created pictures of the Rocky Mountain region that came to be broadly mythologized as icons of the true West. At issue are the roles and experiences of pioneer women, which do not jibe with the how-the-West-was-won approach adopted by most male Western artists when they imagined and mythologized the American frontier. Historian Patricia Nelson Limerick cautions: "Exclude women from Western history, and unreality sets in. Restore them, and the western drama gains a fully human cast of characters—males and females whose urges, needs, failings, and conflicts we can recognize and even share." The diversity of women artists and their paintings calls into question the veracity of our picture of an overwhelmingly masculine American West.

By 1890 the Great Plains encompassed the states of North and South Dakota, Nebraska, Kansas, and the territory that would become Oklahoma. Only Nebraska and Kansas had been states for more than a year and it would take Oklahoma seventeen more years to achieve statehood. Joni Kinsey in "Cultivating the Grasslands: Women Painters in the Great Plains" points out that except for cursory biographies and modest regional studies exceptionally little has been published on the female contribution to the visual arts in this part of the United States. In her essay we discover that despite the great distance from cultural centers, women painters of the Great Plains left a substantial legacy in their work as well as in the institutions and programs they initiated.

While Western historians grapple with a "new" historiography of the American West[5]—rethinking and broadening its scope in terms of race, class, and gender—the production of art by Western women has been virtually ignored. Attention and focus have been directed only toward nineteenth-century art created by men and toward the stereotypical imagery of the Old West conveyed by their work. Shaped by socioeconomic, historical, and environmental forces, the painting produced by Western women represents a broad spectrum of American art in its diversity and scope. If the intent of the "new" Western historian is to integrate Western history into American history, our goal here is to reintroduce art by Western women into the mainstream of American art. No longer will myth stand for reality. *Independent Spirits: Women Painters of the American West, 1890–1945* to some degree will have corrected perceptions about how women have contributed to the dynamics of the West.[6]

I have been most fortunate in attracting a distinguished group of scholars to present essays on women artists of the American West from 1890 to 1945. The challenge was unique and new ground has been broken through their distinctive, individual viewpoints. Insightful, provocative, at times controversial, the subject matter presents a new perspective on these painters and their contribution to the larger culture. We are indebted to each of the writers for her scholarship and, equally important, for her perseverance in personalizing the lives and careers of these women painters.

I wish to acknowledge with special thanks the efforts and able assistance of our research associates, who gave freely of their time: Samuel Blain, Jr., Roberta Gittens, Billie C. Gutgsell, Catherine Johnson, Stephanie Strass, and Ann Wagner.

To Jeanne D'Andrea, editor of the project,

we are indebted for the editorial development of the manuscript and for its fine-tuning. Her contribution has been extraordinary, coordinating ten essays and meeting a demanding deadline. Dana Levy of Perpetua Press has made a significant contribution in the design of the book. William Heckman's conscientious work, careful copyediting and proofreading, has been invaluable. Lawrence Reynolds, an independent photographer, has set high standards in quality control for the transparencies and photographs. And we thank Deborah Epstein Solon, who contributed endless hours in biographical research.

In addition, I am grateful to the following individuals for their invaluable contributions to this volume: Peter and Elaine Adams, Jerome Adamson, Joseph Ambrose, Jr. and Michael Feddersen, Carma Rose DeJong Anderson, Professor Barbara Babcock, Elizabeth Barrett, Glenn Bassett, Paul Benisek, Janet Blake, William, Kay, and Kitty Botke, Len and Jo Braarud, Michael Brown, Gerald Buck, Bill and Mary Cheek, Rena Coen, A. C. Cook, Stanley L. Cuba, Bruce Currie, Laurie Eastwood, Eugenie Everett, Whitney Ganz, John Garzoli, Professor William H. Gerdts, Salomon Grimberg, Donald J. Hagerty, Evelyn Payne Hatcher, Al Hays, Miles Herter, Mark Hoffman, David Hoy, Lucy Jane Jackson, William Karges, Stanley Karnow, Michael Kelley, Phil and Marion Kovinick, Pam Ludwig, Professor Emeritus Frederick Luebke, Janelle Lupin, DeWitt McCall III, Susan Hallsten McGarry, Emilie McMinn, David Martin, John J. Morrison, Tobey C. Moss, Nancy Moure, Linda Parsons, Chris Petteys, Ray Redfern, Ginger Renner, Robert Richmond, Ph.D., M. Roberts, Elizabeth Schlosser, Jason Schoen, Ro Sipek, Sister M. Philomena, George Stern, Terry and Paula Trotter, Ron Tyler, Ph.D., Kevin Vogel, H. F. and Ruth Westphal, Evans R. Woodhouse, Ursula Moore Works, Barton Wright, Kirby Van Mater, Marcel Vinh, Richard York, and Katharine Zettas.

Many institutions and their able staffs unstintingly provided materials and research in a timely manner: Victor Bausch, Reference Librarian, Monterey Public Library; Barbara Bishop, Center Manager, Archives of American Art, Huntington Library; Jeff Briley, Curator, Oklahoma Historical Society; Larry E. Burgess, Library Director, A. K. Smiley Public Library; Larry Campbell, Registrar/Archivist, Art Students League; J. D. Cleaver, Curator of Collections, Oregon Historical Society; Bolton Colburn, Curator of Collections, and Susan Anderson, former Curator of Exhibitions, Laguna Art Museum; Steven Comba, Registrar, Montgomery Gallery, Pomona College; Georgianna Contiguglia, Curator of Decorative and Fine Arts, Colorado Historical Society; Betty Copeland, Chairman, Department of Visual Arts, Texas Woman's University; Virgie D. Day, Associate Director, Linda Jones Gibbs, Senior Curator, and Julia Lippert, Registrar, Museum of Art, Brigham Young University; Elizabeth Dear, Curator, C. M. Russell Museum; Brian Dippie, Professor of History, University of Victoria; George Ellis, Director, Honolulu Academy of Arts; Krista Elrick, Curator, and Larry Yanez, Assistant Curator, Arizona Commission of the Arts; Lawrence Fong, Research and Collections, Museum of Art, University of Oregon; Michael Grauer, Curator, Panhandle-Plains Historical Museum; Sandy Harthorn, Curator of Exhibitions, Boise Art Museum; Kim Grover-Haskin, Special Collections Library Assistant, Texas Woman's University; Harvey Jones, Senior Curator of Art, and Arthur Monroe, Registrar, Oakland Museum; Bruce Kamerling, Curator of Collections, and Barbara Pope, Registrar, San Diego Historical Society; Dennis Kerns, Director, Gallery of Visual Arts, School of the Fine Arts, University of Montana; Armand Labbé, Curator of Collections, Bowers Museum of Cultural Art; Glen Leonard, Director, and Robert Davis, Curator of Art, Museum of Church History and Art, Church of Jesus Christ of Latter-day Saints; Dominique Lobstein, Documentaliste au Musée d'Orsay; Richard Lynch, Registrar and Archivist, School of the Art Institute of Chicago; Anne M. Marvin, Curator of Art, Kansas Museum of History; Ann Morand, Curator of Paintings, Gilcrease Museum; Mary Murray, Registrar, Monterey Peninsula Museum of Art; Susan Perry, Senior Librarian Assistant, Ryerson Library, The Art Institute of Chicago; Martin Petersen, Curator of American Art, San Diego Museum of Art; Michael Redmon, Librarian, Santa Barbara Historical Museum; Kathy S. Reynolds, Registrar, Colorado Springs Fine Arts Center; Steven W. Rosen, Director, Nora Eccles Harrison Museum of Art, Utah State University; Pierre Rosenberg, Conservateur Général du Patrimoine, Chargé du département des Peintures, Louvre; Sherrill Sandberg, Visual Arts Coordinator, Utah Arts Council; Marc Simpson, former Ednah Root Curator of American Painting, The Fine Arts Museums of San Francisco, M. H. de Young Memorial Museum; Will South, Research Curator, Utah Museum of Fine Arts, University of Utah; Rick Stewart, Curator of Western History, Amon Carter Museum; Vern Swanson, Director, Springville Museum of Art; Edwin Wade, Deputy Director, and Carol Burke, Rights and Reproductions, Museum of Northern Arizona, Flagstaff; Jennifer Watts, Associate

Curator, Historical Photograph Collections, and Jill Cogen, Reference Librarian, Huntington Library; Michael Zakian, Assistant Art Curator, Palm Springs Desert Museum; Sibylle Zemitis, Librarian, State Library, California Section.

The Autry Museum of Western Heritage, its board of directors, and the author are pleased that the University of California Press is co-publishing this book. This prestigious press is known worldwide as one of the outstanding scholarly publishers. We further acknowledge the role of staff members Deborah Kirshman, Fine Arts Editor, Marilyn Schwartz, Managing Editor, and Anthony C. Crouch, Director, Design and Production, for their faith in the project and their expertise in producing the publication.

The magnitude of this book, in conjunction with a four-venue exhibition and the selection of 140 paintings, was made possible only by the efforts of the Autry Museum of Western Heritage and its dedicated staff. Joanne D. Hale, Chief Executive Officer and Director, was always available for discussion and counsel whenever required. Mary Ellen and James Nottage, in their respective positions as Director of Collections and Exhibitions Services and Chief Curator, were dedicated, cooperative, and patient beyond the call of duty in resolving the myriad details of the project. Special gratitude also is acknowledged to Kevin Mulroy, Director of Research, and his fine staff, and John Langellier, Director of Publications and Productions, for their problem-solving skills. It has been most rewarding personally to have been associated with the museum and its professional staff.

Finally, my gratitude to the lenders who made this exhibition possible with their willingness to share their art. To Norman Trenton, a remarkable individual, whose untiring patience, support, and devotion helped bring this project to its fulfillment, I dedicate this book.

PATRICIA TRENTON, Ph.D.
Editor

4. Women's life-drawing class, California School of Design, San Francisco, c. early 1890s

Independent Spirits

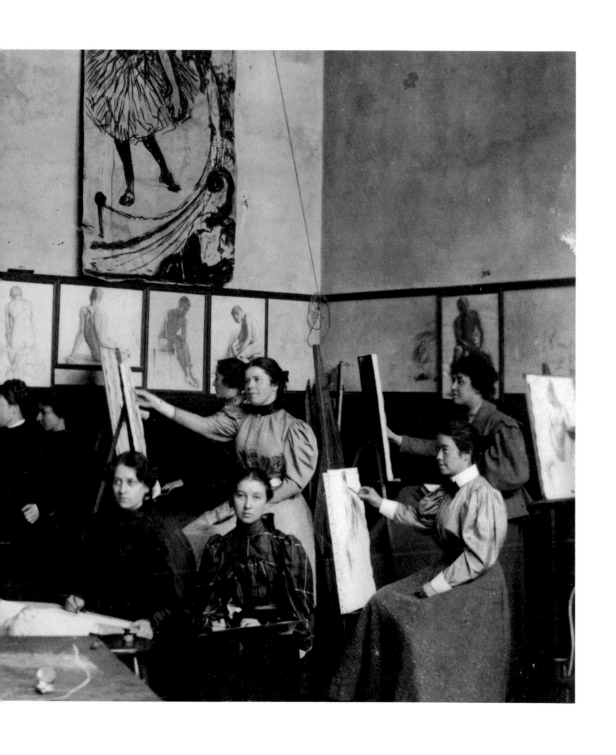

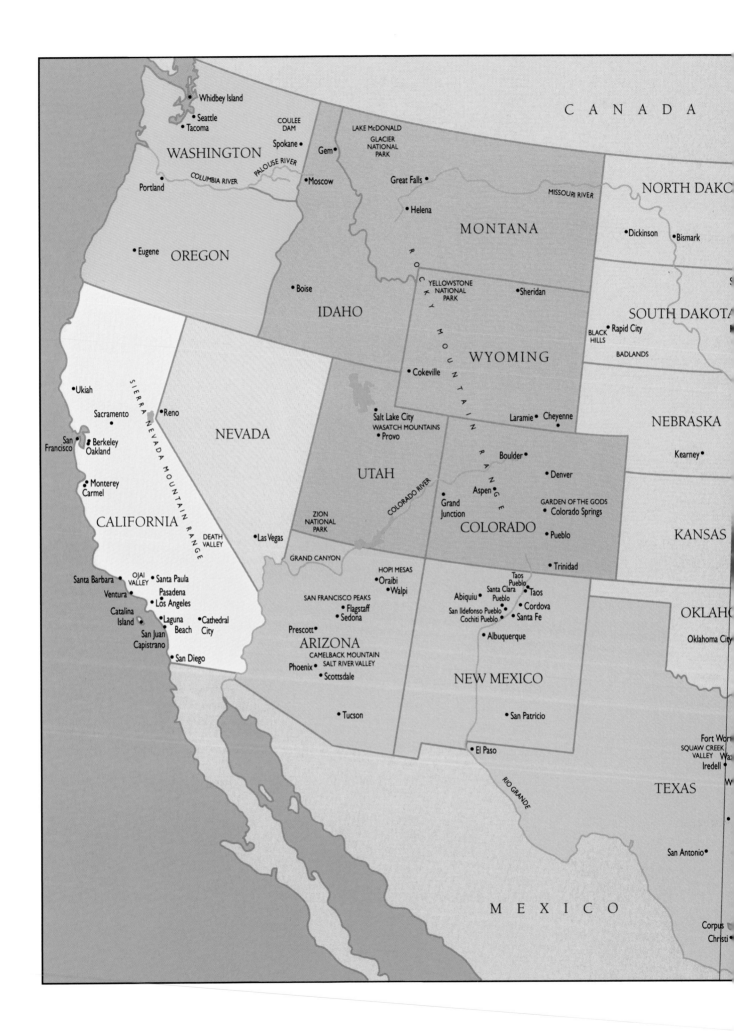

Introduction
WOMEN ENVISION THE WEST, 1890–1945

Virginia Scharff

IRONY DRIVES EVERY GOOD STORY about women's lives in the West. The best stories run like the braided streams of the region's great river systems, liberally strewn with ironies and ambiguities. And like the rapids and twists in those streams, the turbulences of irony arise not only from large, structural phenomena (like the geologic formations through which waters flow) but also from the accidents of time and place. Here, lightning strikes a tree that falls into the river's path, diverting flow. There, beavers erect dams, spawning pools and ponds. Further along still, humans seek power and pleasure, building far bigger, more ambitious constructions that turn a craggy canyon and a cantankerous river into a hydroelectric leviathan and a lake basin full of houseboats and marinas. Women's lives, and their creations, take shape through analogous contingent processes, with ironic but sometimes creative consequences. No one can predict at the outset where the lifestream will lead, but those moments of fissure, rupture, diversion, and frustration require choice and can even become springboards to opportunity.[1]

To approach the multiple openings and closings of women's history in the American West, think, first, of woman's place in the epic of Western expansion, a tale most grandly interpreted by the historian Frederick Jackson Turner at the 1893 Columbian Exposition in Chicago. In a speech now so famous that hardly anyone reads it anymore, Turner used the federal census of 1890 to argue that the "frontier" had closed and an epoch of American exploration had come, alas, to an end. Turner's address was an allegory of a

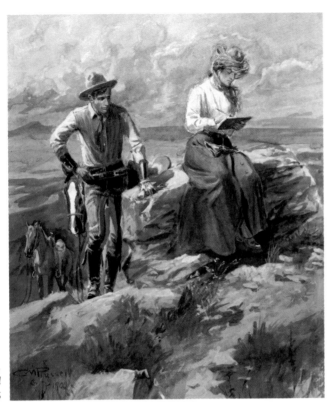

1. Charles M. Russell, *Cowboy and Lady Artist,* 1906

to vast landscapes and radical murals, to highly cerebral Surrealist and abstract pieces.[3]

And yet, ironically, in the canon of Western art, these scores of accomplished women painters have escaped public and historical notice. With the conspicuous exception of Georgia O'Keeffe, Western women artists have stood in the long, deep shadows of George Catlin and Albert Bierstadt, Frederic Remington and Charles Russell. At this point in our discussion of the historical invisibility of the art women created in the West, it would be convenient to point the finger at these towering male figures and to blame them for the obscuring and ignoring of women's accomplishments. It wouldn't be quite fair, however. Where life's ironies abound, narratives never run smooth, but flow tumultuous and fanciful.

Charlie Russell himself made a visual record of the fascinating presence of the woman artist in the masculine West, in a 1906 watercolor titled *Cowboy and Lady Artist* (plate 1). Russell shows us a woman modeled on his writer-artist friend Bertha M. Bower, dressed for outdoor adventure, somewhere up in the basin and range country of limitless Montana, sitting on a rock, absorbed in sketching.[4] Two horses are staked in the background. Below and slightly behind her, a cowboy, with whom she may have ridden to this high, lonesome spot, tries to sneak a glimpse of what she's drawing. But the artist, absorbed in her work, appears absolutely oblivious to his presence. This time it is the mythic male figure in Western art who passes unnoticed.

What must women have in order to create art?[5] They need food and shelter. They must have tools and materials and training. They require some time to themselves and some human support. They have to have a source of inspiration, something worth making art about. And, not insignificantly, their right to express themselves must be recognized by somebody who matters. Women have never been able to count on any of these things and have only achieved them through immense conscious, sometimes collective effort. They must also be able to turn disruptive life changes into chances.

The first half of the twentieth century witnessed a remarkable outburst of such effort, bringing American women the right to vote and hold office, the access to education that would open new economic and creative opportunities, and the social latitude to claim the right to pleasure and dignity on their own behalf. Women's access to artistic training, to the time and means to make art, and to the possibility of artistic recognition was assuredly part of this greater enlargement of women's possibilities. Most women remained

golden age, a story of bygone greatness intended to inspire new campaigns to conquer and civilize in places beyond the confines of North America.[2] But for some Americans, the era of exploring the continental West was just beginning. If the door to "free" land for those moving westward under the Stars and Stripes slammed shut in 1890, the portal to political rights for American women was just creaking open. That year, Wyoming entered the Union as the first state to grant women full suffrage. And there at the Chicago exposition in 1893, while Turner lamented the passing of American opportunity, the pavilion representing the state of California featured an art gallery in which more than half of the exhibitors were women.

We know that women artists have worked in what would come to be called the American West as long as humans have inhabited the terrain between the ninety-eighth meridian and the Pacific Ocean. Navajo women wove. Pueblo women made pottery. Pomo women shaped baskets. Between 1890 and 1945 women artists of all kinds worked in the West in great numbers, creating objects so abundant and diverse as to defy facile generalization. They traveled to Eastern cities and to Europe to seek training, taught in and founded Western art schools, and exhibited in prestigious venues throughout Europe and the United States. They made paintings ranging from the most conservative representations of domestic themes,

VIRGINIA SCHARFF

committed to wifehood and mothering. Still, the possible combinations of what women *should* do, and what they *might* do, proliferated.

In the years between 1890 and 1945, many women artists working in the American West found access to the vital elements of creativity to an unprecedented degree. Some had been born in the region, and some moved into the West looking for space in which to pursue their calling. Some were involved in the great women's political movements of the day—suffrage and social welfare—while others were more interested in emancipating themselves from the constraints of conventional femininity. Many struggled to reconcile the claims of womanhood and art, of responsibility to others and commitment to a demanding, at times consuming, personal calling.

Their work is a testament to a *time* in American women's history when men's power to constrain women's actions was contested in the grandest, and most mundane, ways. But Western women artists have also left us a highly self-conscious visual, plastic, and literary record of their personal visions in a *place* like no other on earth. The West, of course, is not a monolith, any more than all women are alike. It rains all the time in Seattle and hardly ever in Albuquerque. The gentle breezes of Santa Barbara are no kin to the pounding gales of the Laramie plains. The ranch woman who lives far down a lonely road from her nearest neighbor may have little in common with the town dweller who makes her life within a dense circle of buildings and people.

Although women have lived in and surveyed Western landscapes for tens of thousands of years, the first half of the twentieth century was a time when women as a group enjoyed extraordinary access both to strange, big, wild places and to familiar communities. To speak of the West is, of course, to make an implicit comparison with the East, both terms rooted in the history of the United States, particularly in the nineteenth century. To those accustomed to thinking in such comparisons, East meant tame, familiar, domesticated, ordered; West meant whatever continued to resist ordering. Even Western towns, which we now understand were at the heart of the process of American conquest, had a reputation for barbarity not generally associated with urban life, however violence-riddled. There had been towns in the West before the West was "American," and mid-nineteenth-century immigrants from the East found the social life of long-established towns like Santa Fe unsettling. There, women like the cigar-smoking, fandango-dancing gambling house owner Gertrudis Barceló, better known as Doña Tules, defied Victorian visions of what women

ought to be like, and made plenty of money into the bargain.[6] Could such a place, where the sunsets were fiercely beautiful and the women not at all what middle-class European Americans had come to expect, ever be completely domesticated? Would the reckless spirit of the place simply carry one away? Or might such a place be, on its own terms, a community that would reconstruct the newcomer in some unforeseeable way?

As the various inhabitants of the West—Native American, Hispanic, later European American and African American and Asian American—strove to make sense of one another and the transformations in their lives that contact among them brought, the West changed. It changed particularly rapidly as the nineteenth century gave way to the twentieth. European Americans grappled again and again with the dilemma of loving what they imagined to be the wildness of the West, even as they sought to order and sometimes obliterate it. Native Americans and Hispanics coped with the consequences of conquest in every way known to human ingenuity. Asian Americans persisted in claiming a West for themselves, despite government policies that ranged from absolute exclusion to internment in relocation camps. African Americans worked their way westward in hopes that the West lay beyond the borders of Jim Crow country.

Despite their different inheritances, motives, and opportunities, early twentieth-century Westerners shared some common ground. By 1900 the United States government had defeated the last organized armed resistance to its authority, from the Atlantic to the Pacific and from the forty-ninth parallel to the Rio Grande. The often visible hand of the government transformed Western space, etching a grid of roads into land surfaces, erecting dams to discipline rivers and border fences to dominate people, spending its money to subsidize factories and shipyards and finally cities themselves. The power of corporate capital made its presence felt, too, recruiting and deploying the civilian platoons that built the railroads, dug the ditches, served the dinners, and staffed the banks. This revolutionary infusion of authority and energy galvanized movements of women as well as men into and within the West, enabling and challenging these diverse people in myriad ways.

Western women pushed the boundaries of femininity as nowhere else and never before. While American women as a whole did not win the right to vote until 1920, with the passage of the Nineteenth Amendment to the Constitution, women in most Western states had the vote before 1915.[7] By 1930 the West had sent the first

woman to the United States Congress (Jeanette Rankin of Montana), had elected the first women governors (Nellie Tayloe Ross of Wyoming and Miriam Ferguson of Texas), and had chosen the first woman mayor of a large American city (Bertha Knight Landes of Seattle). While Eastern women tended to gravitate toward voluntary and behind-the-scenes positions of influence, building support networks for their endeavors in a very crowded and competitive political environment, a surprising number of Western women found that they had the room to seek direct control over the levers of power. Many such women achieved their offices by seizing opportunities that must have appeared, at first, as sudden tragedies. In 1924, at the age of forty-seven, the recently widowed Nellie Tayloe Ross found herself running to succeed her late husband as governor of Wyoming. Nellie Ross had never before involved herself in public life, not even to the extent of supporting woman suffrage, a cause long popular in the self-proclaimed "Equality State." She agreed to become a candidate for office, she said, out of wifely devotion to a husband's unfinished work. Yet she ran for reelection in 1926; when she was defeated, she declined to return to private life. Instead, she moved to Washington, D.C., and spent the next three decades of her life in public service, retiring, finally, as director of the United States Mint under President Eisenhower.[8]

Nellie Ross always insisted that she never intended to become a politician, and of course not all Western women believed that formal politics held the key to personal emancipation. Some put their faith in the pursuit of fame or pleasure, heading to Hollywood to give a nationally visible face to the flapper of the twenties, the gun moll of the thirties, the career woman of the forties. During the 1920s and 1930s literally hundreds of women worked as Hollywood screenwriters, with all the heady fun and heartache attendant to that job.[9] Women who followed less glamorous paths searched for economic independence, finding excitement and pride, however temporarily, working in one-room schoolhouses in small prairie towns, in offices in growing Western cities, on sometimes remote homesteads, in the wartime shipyards of Seattle, Washington, and Richmond, California.[10]

Formal education loomed particularly large as an avenue of opportunity for women in the American West in this period. For those who possessed geographic mobility and a college degree, the West was a region of careers open to talent. By 1890 fledgling state universities hungry for faculty offered Eastern- and Midwestern-educated women professional opportunities unavailable to them in places where college-trained men were more abundant, a phenomenon echoed in the region's art schools. At the University of Wyoming, for example, the first three heads of the history department were women. By 1920 women faculty at that institution were so numerous that they formed an organization called The Professors Club, reasoning that "if the men professors want a club, they can call it the Men Professors' Club."[11] All over the West, women who possessed college degrees in art also taught in and even founded art academies.

And yet, for most women in the West, the exigencies of femaleness marked the difference between their lives and those of men who shared their class and racial experiences. Daughterhood, wifehood, motherhood, and widowhood carried their meanings and burdens both generic and special, and women of all kinds have articulated their stories with simplicity and eloquence. Motherhood has, of course, commanded the most visual and literary attention. Grace Carpenter Hudson painted rosy pictures of Pomo Indian children and their doting mothers.[12] Polingaysi Quoyawayma recalled the anguish of Hopi mothers as their children were wrenched from them and herded onto trains bound for remote boarding schools.[13] Dorothea Lange photographed the gaunt faces of hungry mothers and children in migrant-labor camps squatting in the brimming green fields of depression California. European American Arizona mothers recalled the time before air conditioning, when they wrapped babies in wet sheets and set them outside in the shade to ward off the killing heat of the Arizona summer.[14] Japanese American mothers at Topaz and Manzanar bathed their infants in lime-stained washtubs in grim barracks laundry rooms.[15]

Family ties both empowered and constrained women painters. Some married their painting teachers or colleagues or students, and regardless of the merits or originalities of their own work, whatever, indeed, their influences on their partners' styles, forever after they were assumed to have painted "in the manner of" their husbands. When Marion Kavanaugh married Elmer Wachtel, she stopped painting in oils and took up watercolors. Since Kavanaugh and Wachtel were happy artist companions who often painted the same scenes, it made sense to work in different media, and Kavanaugh was assuredly a fine watercolorist. Whether or not marriage sidetracked Marion Wachtel's painting career, she was never derailed, and she returned to oil painting after Elmer's death. Some women refrained from painting at all while they were married, putting caring for their husbands and children ahead of art. But for some the burden of

VIRGINIA SCHARFF

widowhood was also a release. The Texas painter Clara Williamson took up the profession as a new widow, at sixty-eight years of age. After that time, she exhibited more than 150 paintings.[16]

Certainly, women artists have struggled again and again with the family claim, sometimes concluding that art and family were utterly incompatible, sometimes relying on family to make art. Georgia O'Keeffe left Alfred Stieglitz in Lake George and sought solitude in New Mexico. Many others did their best to "have it all." And for some, painting would become a treasured family tradition. Tonita Peña, sometimes called "the mother of Pueblo art," first wed at the age of fourteen and bore eight children in the course of three marriages. She taught her son, Joe Herrera, the fundamentals of painting, and also influenced Santa Clara painter Pablita Velarde, herself the mother of the late painter Helen Hardin.[17]

Sometimes women wanted escape from the bonds of society; at other times, they sought out family, community, even sisterhood. For aspiring women artists in the first half of the twentieth century, Western locales offered the possibility of social support balanced by freedom of movement. In Taos and Santa Fe and Carmel and Monterey, women found that rare combination of sympathy and privacy necessary to make powerful art. The mercurial Mabel Dodge Luhan, sometimes an impossible friend, nonetheless created by force of will a Taos arts community from which women as various as Mary Austin, Willa Cather, Dorothy Brett, and Georgia O'Keeffe emerged ready to seek their own Western visions.[18] Mabel's erstwhile pal and fellow art patron, California-born Gertrude Stein, may have insisted that there was "no there, there" when she thought about her native Oakland in particular, and the West in general. But the adventuresome Stein's own favorite song, she said, was "On the Trail of the Lonesome Pine."[19]

While daughterhood, sisterhood, motherhood, and membership in community affect all women's lives, even the common experiences of the female life cycle must be understood in light of hierarchies of race and ethnicity. Where the government-subsidized railroad made it possible for Dorothy Brett or Georgia O'Keeffe to enter the West first as tourists, then as cosmopolitan residents, that same railroad brought a cash economy to the Pueblo of New Mexico, impelling women like San Ildefonso's Maria Martinez to sell pottery to tourists.[20] Native American women like Pablita Velarde and Taos painter Pop Chalee found themselves always contending with established ideas about what kind of art people of their heritage ought to make. California artist Miné Okubo, later known for her abstract paint-

ings, produced painfully hard-edged representations of community life in the Utah internment camp where she spent much of World War II.[21] Women who coped with racial oppression demonstrate once again how creative spirit can turn hardship into a chance to say something important.

Geographical location too had its price. The history of women in the American West has generally been treated as marginal to the main narrative of American women's history, an elision repeated in art history.[22] If women artists have been invisible in the Western canon, their regional affiliation has sometimes made them provincials in the eyes of the New York–based art world. Many of the women whose works grace this book studied in New York and Chicago and Paris, but once they crossed the ninety-eighth meridian, they seemed to disappear.

Thus we come back again to the fact that the West was and is a *place*, sometimes unutterably remote, where women are not only women, and not only identified by race or ethnicity. They are also denizens of some of the most magnificent country on earth. In virtually all cultures, femininity has carried with it the injunction to spatial constraint. Women are not supposed to take up much room, or to go very far from home, or to stay away for long. They are not supposed to be by themselves. They are supposed to hear and obey, to come back when they are called. Femininity, in many places and times, has been a tight cage women have inhabited so ceaselessly that they are not even aware of the bars.

The power to move from one place to another, to learn, work, and wonder, made art possible for some women in the American West. Access to remote places embodied the dream of being beyond the reach of request or command. Like Bertha Bower, the lady artist in Charles Russell's watercolor, countless Western women have moved away from the country of custom and into wild places. They have stood alone, or nearly so, and felt again and again the joy of having the time to contemplate scenes they might never have expected to see. Lillian Wilhelm Smith was a New York–born and –trained artist. She was also a relative of novelist Zane Grey, and traveled to Arizona when offered an assignment to illustrate two of Grey's best-selling books. Not long after, she married a cowboy and moved to Tuba City, Arizona, to run a trading post and guest ranch. This relocation to a place that could not have been further, geographically or culturally, from the high-strung New York art world was for her an artistic blessing. She explored and painted some of the region's most monumental and isolated places, including Havasupai Canyon and

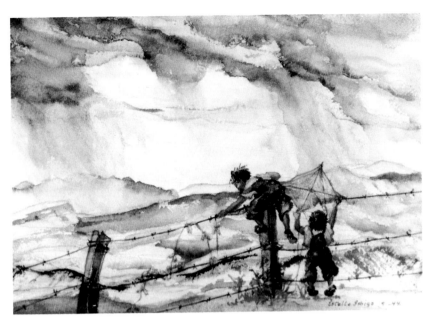

2. Estelle Ishigo, *Children Flying a Kite* (Heart Mountain 1944), 1944

Utah's Rainbow Bridge.[23] Other women painters assuredly found Western landscapes fascinating. Ethel Magafan and Eve Drewelowe, for example, painted Rocky Mountain landscapes tinged with awe and a paradoxically inviting menace.

And of course, a woman, Georgia O'Keeffe, more than any other twentieth-century artist, defined the Western landscape. Nearly fifty years after the fact, O'Keeffe recalled her first visit to Taos in summer 1929: "The summer I spent in Taos I sometimes rode out to the eastern hills late in the afternoon with the sun at my back. No one else seemed to go there. When the sun went down and was not shining in my eyes I would ride back to the Pueblo. The plain was covered with the grey sage that in a few places crept up a bit against the base of the mountains, looking like waves lapping against the shore. It was a wide wide quiet area."[24]

This sense of lonely breadth and clarity marked O'Keeffe's now familiar vision of the Western landscape, and the chance to command such a view certainly rubbed against the grain of conventional femininity, even as it invoked the will to power that weaves all through stories of Western conquest. O'Keeffe used the ironies of her position as a woman, a loner, and an adventuresome interpreter of the West to explore uncharted possibilities in American painting. Sometimes she revealed a view that seemed to go on forever; sometimes she brought mountains so close that she seemed to master them. Every time she painted a flower as big as a mountain, or a skull like the body of Christ, or a hillside as veined as a crone's hand, O'Keeffe unlocked the barred door of femininity and stepped freely into Western space.

As much or more than any woman artist of her era, Georgia O'Keeffe seemed to follow the career path of the male "genius." Her story has generally been told as a tale of a single-minded woman who knew, despite all obstacles in her way, that painting was her destiny, and pursued her art caring little for what else might fall by the way. Children were no part of her world, and lovers and friends had always to defer to the claims of her artist's vocation. And yet even for this most famous and most notably careerist of Western women artists, life held twists and surprises. That first trip to Taos was not on O'Keeffe's itinerary when she and friend Rebecca Salsbury Strand set out from New York. O'Keeffe ran into Mabel and Tony Luhan at a dance at San Felipe Pueblo, and Mabel insisted that they come to Taos. O'Keeffe explained that she didn't have time, and "I thought that was the end of it. . . . In the morning, there was Mabel at the hotel door. She'd already sent my trunk up to Taos. . . . So—we went along."[25] The rest, assuredly, is art history.

If the year 1890 ushered in a period of women's art in the West marked by discontinuities, turnings, and ironies abundant, the year 1945, the end of World War II, demarcates in American women's history a set of ironies frightful and pivotal, excruciating and triumphant. For many women in the American West, the tragedy of war meant the possibility of moving to a new place, psychologically, occupationally, and geographically. The port cities of Seattle, Oakland, Richmond, and Long Beach boomed, as government money flowed in to subsidize shipbuilding. Labor was in short supply, with so many men in the armed forces. And so, for the first time, women had the collective chance to train for, and fill, skilled industrial jobs. The government subsidized a massive propaganda effort to recruit more women workers, the famous "Rosie the Riveter" campaign, and women by the thousands took advantage of their newfound opportunity to work hard for good wages.[26]

Yet, despite their new skills and confidence, despite the invaluable contribution they made to the war effort and the high quality of their work, the Rosies were laid off at the end of the war, redeployed from shipyard to kitchen sink in the name of national security.[27] Nonetheless, many former Rosies would have cause to recall fondly their riveting days as they scrubbed floors and folded laundry, the irony of their picaresque lives not lost on them, but simmering as unfinished business. Other Rosies had no alternative but to keep on working, waiting tables, or cleaning houses for other women, aspiring to more.

And for still other American women, the war had meant a distinctly different, consum-

mately ironic, disruption. Approximately 120,000 Americans of Japanese ancestry lived in the United States in 1941, most of them in the West, 94,000 in California alone. With the bombing of Pearl Harbor, a Western tradition of racial hatred ignited into anti-Japanese hysteria. Popular columnist Westbrook Pegler insisted that every Japanese American man, woman, and child be put under armed guard; Congressman Leland Ford of California declared that any "patriotic native born Japanese, if he wants to make his contribution, will submit himself to a concentration camp."[28]

In February 1942 President Roosevelt issued Executive Order 9066, declaring parts of the country "military areas" from which any or all persons could be barred. All Japanese Americans were affected by this order. In May the War Relocation Authority ordered 112,000 Japanese Americans to leave the West Coast in a matter of days. Nearly all complied, leaving behind farms, homes, and personal possessions. They were sent first to processing centers, then to isolated internment camps in the Western interior, where they lived within barbed-wire enclosures, under harsh conditions, and beneath the scrutiny of armed guards.[29]

Among those subjected to forced relocation was the prolific painter Estelle Ishigo (1899–1990). A European American woman married to a Californian of Japanese ancestry, Ishigo in 1942 began work as a teacher at the Hollywood Art Center. Her employers fired her after two weeks, claiming that their students would object to her Japanese name. Soon after, she and her husband were interned in the Heart Mountain, Wyoming, relocation camp, where they lived for three years. During that time, Ishigo worked as an artist for the War Relocation Authority Reports Division, documenting in paint her own imprisonment.[30]

Once again, a resourceful woman turned her own trauma and bitterness into something more than fruitless anger or paralyzing despair. Among her many camp paintings is a 1944 watercolor titled *Children Flying a Kite* (plate 2).[31] Here the artist surveys a broad, bleak, and windy landscape under a lowering sky. Pale grays, blacks, and browns dominate a background that fades away into the unending reaches that are Wyoming. But in the foreground we see a swatch of green, a barbed-wire fence, and two sinewy children in overalls, one carrying a homemade kite, climbing over the fence. No image captures more poignantly the possible West, a place where visible distances beckon and menace, where enclosures do not always protect but sometimes incarcerate, where human beings are small but significant. Millions of women's eyes have beheld this West, remaking it with their longings, their burdens, and their triumphs every time they have looked out upon it.

Even in wartime, even in a prison nobody has yet been able to justify, set down in the gale-swept shadow of a ruthless Heart Mountain, children clambered over a barbed-wire fence to use the wind as wings for a homemade kite. A European American woman married to a Japanese American man stood within the fence, with her paper and palette and brush, and caught the ironies of the moment. The winds of Wyoming have long since torn to pieces what remained of the fence, though there are assuredly other and higher and even more sinister fences in the West today. But there is also Estelle Ishigo's picture, *Children Flying a Kite*, to remind us that in 1944 a gifted woman and two small children moved through that space, seeing not just the boundary, but more: what lay beyond.

3.
Lucia Mathews, *Woman Sketching*, n.d.

I
Searching for Selfhood
WOMEN ARTISTS OF NORTHERN CALIFORNIA

Susan Landauer

D URING A RECENT VISIT to an exhibition of California art at the Oakland Museum, I happened to overhear a conversation between two middle-aged women. Standing before a display of turn-of-the-century paintings by Arthur and Lucia Mathews, one woman drew the other closer and murmured knowingly, "I understand that Lucia was the more talented of the pair." The remark elicited no more than a sage nod of approval before the two women moved on. There was no need for further elaboration; both knew the story well. Indeed, the fable of the frustrated woman genius, overshadowed and oppressed by a man of equal or lesser talent, has become a staple of our modern mythology ever since Shakespeare's sister made her appearance in Virginia Woolf's *A Room of One's Own* (1929). One only has to think of the recent apotheosis of Frida Kahlo to realize that the topos is alive and well.[1]

The case of Lucia Mathews (1870–1955) raises vexing questions. A look through the scrapbooks the couple kept from the late 1890s into the 1920s—the period covering the height of their careers—brings to mind what Woolf wryly called the "curse" of women: that "anonymity runs in their blood."[2] Page after page is devoted to Arthur's triumphs, clipping after clipping chronicles his success. On the achievements of Lucia, by contrast, there is nothing. The fact is, Lucia never had a one-woman show, and the press was generally silent about her work.[3] How is it that an artist who trained with Whistler and was among the most stylistically adventurous painters in California, who maintained her own studio in San Francisco for many years, and whose social milieu included William Merritt Chase, Frank Duveneck, William Keith, and J. Alden Weir,[4] remained unrecognized in her lifetime as an independent talent?

To understand the fate of Lucia Mathews, it is necessary to examine the complex of issues surrounding gender and artistic identity at the turn of the century in Northern California, a complex further compounded by shifts in sensibility. To modern eyes Lucia's quiet, meditative reveries are in many respects more appealing than Arthur's grand allegorical murals, the very murals that caused critics to lavish praise on him.[5] Yet for their contemporaries, Lucia's paintings conformed too closely to the tradition of the feminine amateur to be taken seriously. While her husband decorated the foyers of theaters, libraries, and the ornate mansions of San Francisco's wealthy elite, Lucia worked mostly in the modest media of pastel and watercolor, producing delicate small-scale works (see plate 3).[6] Like Mary Cassatt, Berthe Morisot, and so many women of the late nineteenth century, her subjects tended to be intimate and domestic—children, gardens, perhaps

a solitary live oak or a Monterey pine. These works commanded small sums, if they sold at all.

Mathews may well have fallen victim to a Victorian ideology that discouraged female ambition, for in spite of efforts of feminist organizations to liberate women from their confining domestic sphere, polite society—in San Francisco as elsewhere in America—viewed professional zeal as unladylike. Art was a socially sanctioned endeavor only if approached with self-deprecating modesty. John Ruskin defined the "proper" role of well-bred upper-middle-class artists such as Mathews in a column entitled "Advice to Young Women," published in the *San Francisco Call* in 1896: "All accomplishments should be considered as means of assisting others. . . if you try only to make showy drawings for praise, or pretty ones for amusement, your drawing will have little or no real interest for you and no educational power."[7] For Ruskin and many other commentators at the turn of the century, artistic "genius" and even "greatness" were an exclusively male preserve. Arthur Edwin Bye expressed a common view when he wrote in 1910 that the greatest artists were characterized by "pure masculinity, oftentimes of a superhuman order," and he wondered whether women could sustain "the force, the strength, the power of concentration, the prophetic insight" that genius required. He seemed skeptical: "To create a child is the greatest aspiration of [a woman's] life, and when she can do that she rightly cares for nothing else."[8]

Bye's adamant tone indicates perhaps an underlying defensiveness, for the ideology of separate spheres, which had kept women from competing in the workplace, was on a collision course with reality. Indeed, Mathews was not entirely representative of her generation: in the face of social resistance, many women artists in San Francisco achieved recognition. Mathews's situation may readily conform to our image of the woman artist reduced to critical neglect in the shadow of her husband's acclaim. But this is only part of the story of women artists in Northern California. Less well known is the degree to which women made important inroads—both critically and institutionally—in the early part of the century. Some of these women achieved national and international fame, only to vanish from view in the postwar period.

Such achievements did not, of course, erase the gender typing that was so much a part of the art world. Even in the "liberated" twenties art criticism continued to reflect the stereotyping of Arthur Edwin Bye. It seemed that the highest praise a woman artist could hope for was that she "painted like a man"—yet women were entering professional ranks in unprecedented numbers. This was particularly true in the West, where the suffrage movement gave women the vote earlier than in other regions of the country, and where universities were chartered as coeducational.[9] By the 1890s women were gaining entry into fields previously dominated by men. An article that appeared in the *San Francisco Examiner* in 1890 welcomed California's "struggling sisters" to the professions of medicine, dentistry, journalism, education, music, and art. The article quoted the highly successful San Francisco artist Alice Chittenden, who said that while the practice of painting was crowded with lady amateurs, there was clearly room for women with talent and diligence.[10]

Women artists in San Francisco had certain advantages over their counterparts in the East, notably in education. Because the women's occupational reform movements of the later nineteenth century roughly coincided with the founding of San Francisco's art institutions, women were able to break in on the ground level of a far less entrenched and tradition-bound art establishment. When the far West's first art academy, the California School of Design, opened in 1874, women were among its earliest members. They also made up the bulk of the enrollment; forty-six of the initial class of sixty were women.[11] And women were among the first students when classes in drawing and modeling from the live nude began in 1886, although they worked in segregated classes into the 1910s (see plate 4, page xiv).[12]

Opportunities for exhibition were also comparatively promising for women in San Francisco during the late nineteenth century. After the California School of Design became the Mark Hopkins Institute of Art in 1893 and moved into the palatial Hopkins mansion on Nob Hill, the shows there every fall became the focal event for artists in California. From the mid-1890s women members of the San Francisco Art Association juried the exhibition and awards committees of these annuals. As early as 1885 the association hosted what may

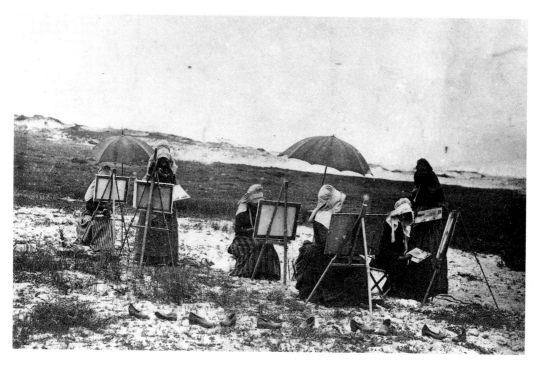

5. The Sketch Club at work on the beach at Pacific Grove, California, c. 1890

have been the first annual all-women exhibition in the United States.[13] On December 15, 1885, 241 pictures by eighty women were displayed in the association's Pine Street galleries, drawing crowds of spectators, including James Phelan, the mayor of San Francisco, M. H. de Young, publisher of the *San Francisco Chronicle*, and the West Coast shipbuilding magnate Irving M. Scott.[14] Although the reportage tended to focus on the artists' gowns and "toilet," the exhibition drew front-page attention from some of the city's newspapers.[15] The most sympathetic response came from the *San Francisco News Letter*, with a review urging San Franciscans to recognize the significance of the event: "I do not think the San Francisco people understand what they have got before them in this exhibition. . . . With the exception of London and Paris, where these displays take place every year, there is not another city which can lay claim to the distinction of holding an annual exhibition of paintings exclusively by lady artists. This is the first in San Francisco, the first in America."[16]

Another event signaling the progress of California women in the arts was the World's Columbian Exposition of 1893 in Chicago. Every state had a pavilion featuring regional products, but California was the only state with its own art gallery.[17] The selection committee, which included William Keith, Arthur Mathews, and the portrait painter Mary Curtis

Richardson, chose ninety paintings, about half by women.

Women artists also found encouragement from organizations promoting the professional advancement of women in the arts. In San Francisco the earliest and most influential of these associations was the Sketch Club, founded in 1887 by nine former students from the California School of Design.[18] Initially housed in a converted horse stable on Jackson Street, the club began as a summer sketching association with excursions to the Monterey coast (see plate 5).[19] Within ten years the Sketch Club's membership—open to amateurs and professionals alike—swelled to nearly two hundred and included most of San Francisco's leading women artists.[20] In its early years the club emulated the older and ultimately far more exclusive all-male Bohemian Club, with a comparable exhibition program and elaborate "high jinks" not unlike the celebrated stag parties at Bohemian Grove.[21] These events, generally involving costumes and exotic banquets, proved a good deal more civilized than the drunken revelries of the men, yet they gave women artists a chance to break free of their confining Victorian roles.

Although San Francisco women were gaining increasing public exposure for their accomplishments in art, opportunities for professional advancement remained circumscribed. Lucrative commissions for art in public architecture, such as those enjoyed by Arthur Mathews,

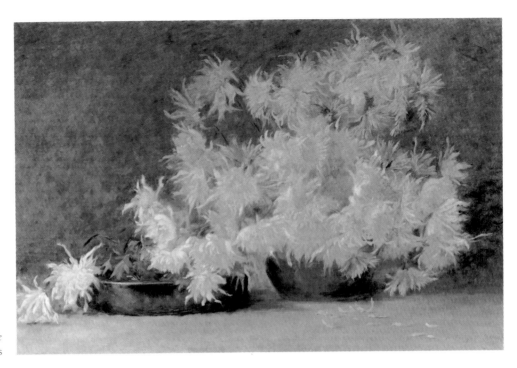

6. Evelyn McCormick, *Still Life with Spider Mums*, c. 1890s

would remain out of reach until the government-sponsored projects of the New Deal. Nonetheless, women were able to earn a living by concentrating on certain socially sanctioned genres. Still-life painting attracted a number of women artists in San Francisco, including Angela Ghirardelli, Evelyn McCormick (see plate 6), Amanda Austin, and Pauline Powell.

Pauline Powell (1872–1912) was among the first African Americans to enter the professional ranks of painting in California (see plate 7). Although the California School of Design was open to blacks, few had the advantages of middle-class life that would allow them to pursue such a risky career. Powell, an Oakland native and a gifted classical pianist, appears to have been self-taught as a painter.[22] While a certain naïveté is evident in her landscapes, works such as *Champagne and Oysters,* about 1890 (plate 8), were sufficiently competent to be included in the Mechanics Institute's exhibition of 1890—probably the first works of a black woman ever shown in California.[23]

Women made significant inroads in still life, but they attained a near monopoly on floral painting, which was in much demand to decorate the homes of San Francisco's nouveaux riches.[24] Alice Chittenden (1859–1944), the most successful floral painter, was among the women artists who allegedly "stormed" the Bohemian Club, breaking the all-male monopoly on the annual art exhibitions in 1898.[25] By the turn of

the century Chittenden had established herself as a leading artist in San Francisco. With five exposition medals to her credit (including a silver medal from the World's Columbian Exposition) she joined the faculty of the Mark Hopkins Institute of Art in 1897.

Chittenden specialized in botanically accurate paintings of California wildflowers. Painting *in situ* on trips throughout the state, including arduous treks to the High Sierra by stage and horseback, she catalogued more than two hundred and fifty species of wildflowers, many now extinct. But Chittenden's paintings of cut roses and chrysanthemums assured her reputation (see plate 9). Typically arranged in sun-drenched outdoor settings—with blossoms strewn on the ground or cascading from baskets or wheelbarrows—these paintings drew much praise from the press.[26] Chittenden was one of the few San Francisco women artists who exhibited in Paris and could regularly sell her work on the East Coast.

In child portraiture, late-nineteenth-century women were able to stake out another genre, using their gender to best advantage. In San Francisco the most celebrated painter of children was Mary Curtis Richardson (1848–1931). Richardson began her career as an engraver working for her father. In the 1870s she and her sister—both ardent suffragettes—established the first women-run engraving company in San Francisco, which ultimately be-

SUSAN LANDAUER

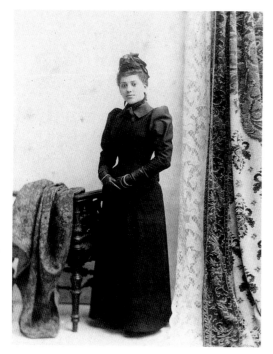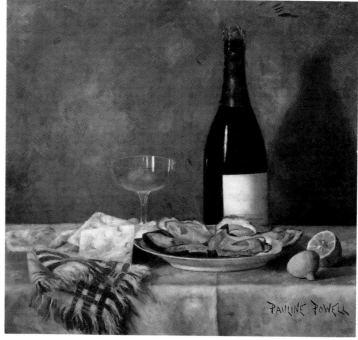

came the Women's Printing Union. Richardson was nearly fifty when she embarked on a second career in painting. After studying with William Sartain at the Art Students League, she won the Norman Dodge Prize of the National Academy of Design for best painting by a woman artist in the United States. From then on Richardson had little trouble securing portrait commissions to paint members of San Francisco's high society and their children. Paintings such as the undated *Portrait of Joseph M. Bransten* (plate 10), depicting the son of the MJB coffee manufacturer, show Richardson's remarkable sensitivity to her subjects and her avoidance of the saccharine sentimentality so common in child portraiture. By the 1910s she was hailed as the "Mary Cassatt of the West" (see plate 11). Charles Keeler singled her out as the most important portraitist in San Francisco, ranking her along with William Keith and Thomas Hill.[27] Yet in spite of her success—and her feminist inclinations—Richardson felt compelled to tell an interviewer: "I am not a woman with a career; I am just a worker."[28]

Such a comment would have been even less convincing if it had come from Grace Carpenter Hudson (1865–1937), a painter who became so prosperous that her young husband left his comfortable practice as a physician, sparking rumors that he, rather than Grace, was the real painter.[29] Although the retirement seems to have caused some marital strain, it

did not hurt the couple financially. Indeed, Hudson could not paint her portraits of the Pomo children fast enough to meet the growing demand. One magazine of the time reported that "no other artist to-day is so popular with the picture-loving public of San Francisco. A canvas from her brush is sold before it leaves the easel."[30]

Hudson opened her studio in Ukiah, California, in 1889, at a time when the native Pomo traditions were rapidly disappearing. Her diaries indicate that she hoped to preserve on canvas what she believed to be a dying race; one of her entries reads: "My desire is that the world shall know them as I know them, and before they vanish."[31] Although in her early paintings she placed her models in fanciful settings much like those found in Victorian daguerreotypes, Hudson's Pomos are indeed ethnographically correct. Critics were taken with her precise detailing of their grime and ragged dress. *Quail Baby* or *The Interrupted Bath*, 1892 (plate 12), exemplifies her sympathetic treatment of Pomo children.[32] The child looks slightly startled, as if caught unaware of the painter's presence. Indeed, the Pomo believed that to capture a person's likeness was to invite death to the individual, making it difficult for Hudson to find sitters.[33]

As feminist art historian Anne Higonnet has observed, by specializing in unusual or marginal genres, women such as Hudson could

7. William White Dames, *Untitled* (portrait of Pauline Powell), c. 1890s

8. Pauline Powell, *Champagne and Oysters*, c. 1890

9.
Alice Chittenden, *Chrysanthemums*, 1892

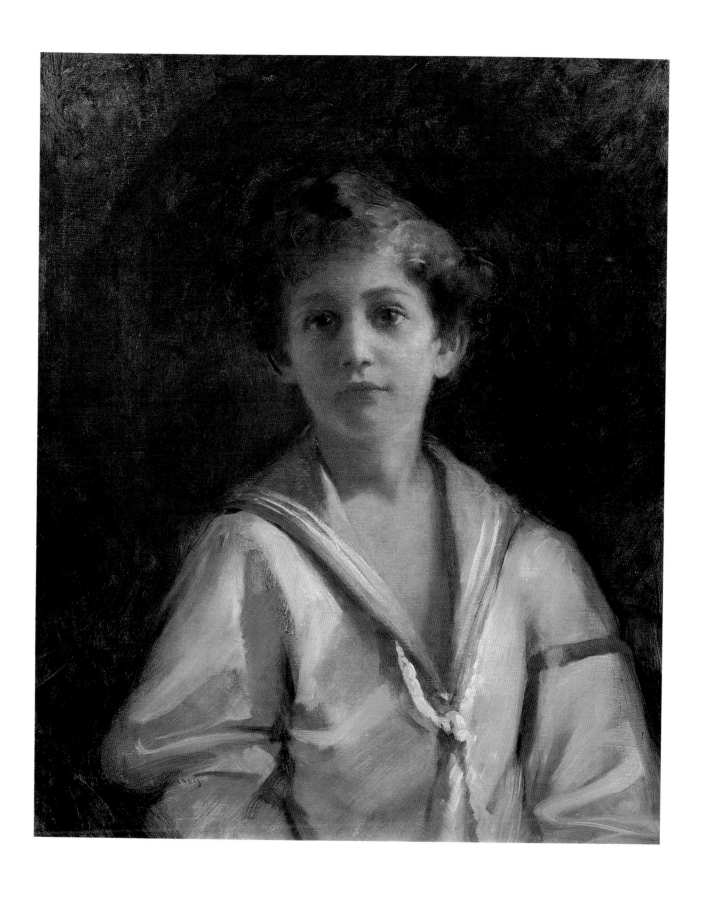

10.

Mary Curtis Richardson, *Portrait of Joseph M. Bransten as a Child*, n.d.

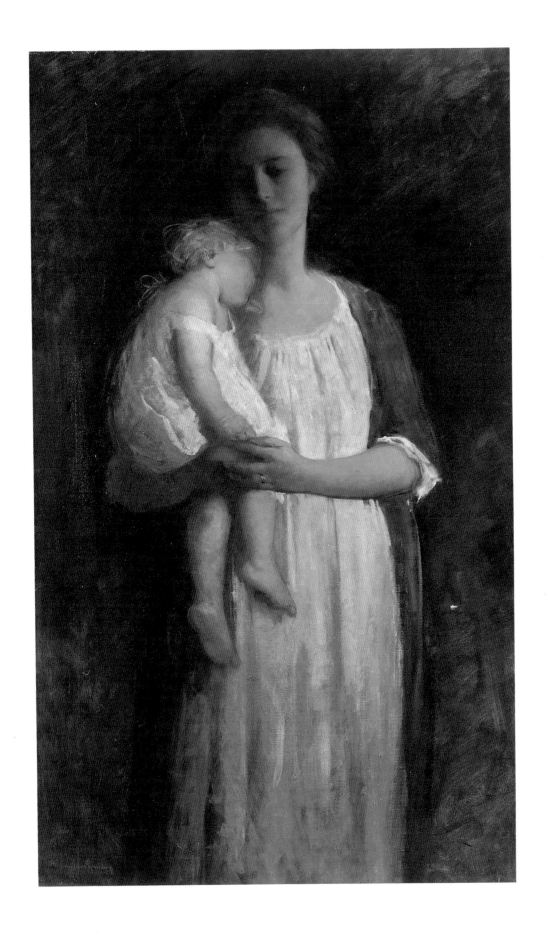

II.
Mary Curtis Richardson, *The Sleeping Child*, 1911

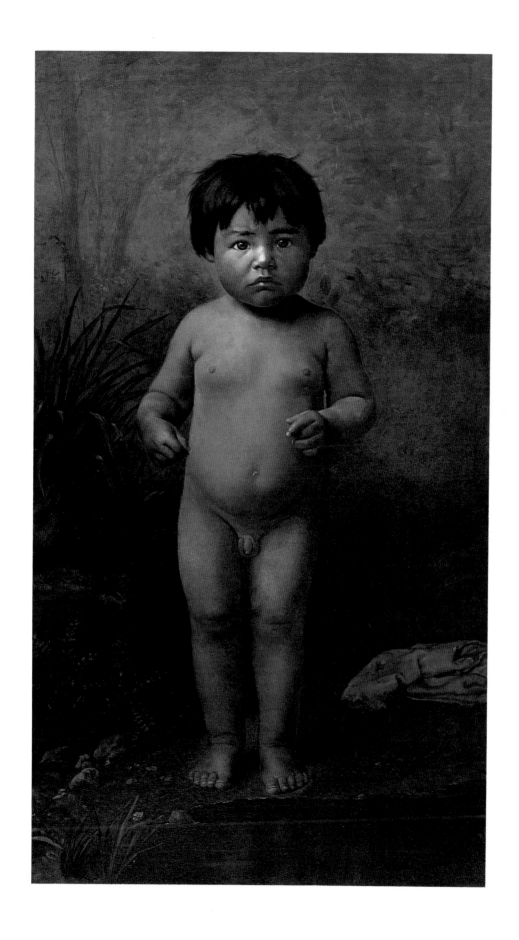

12.
Grace Carpenter Hudson, *Quail Baby* or *The Interrupted Bath*, 1892

13. Evelyn Almond Withrow, *The Spirit of Creation,* n.d.

South Kensington section of London, she made a striking departure from her mentor. After befriending the Pre-Raphaelites William Holman Hunt, Walter Crane, and Edward Burne-Jones, Withrow embarked on a series of paintings with mystic and occult themes. Works such as *The Eternal Saki,* about 1906 and 1907, taken from a passage of the *Rubaiyat,* show Withrow's absorption with Eastern mysticism, an interest common among the British and American fin-de-siècle avant-garde.[36]

One of Withrow's most intriguing paintings, *The Spirit of Creation,* undated (plate 13), reinterprets a familiar nineteenth-century theme, the cycle of human life from birth to death. But rather than follow artistic convention by illustrating the subject allegorically as a man's voyage on the river of life, Withrow presents the human soul as a barely distinguishable flash of light in a swirling vortex of celestial energy. Indeed, like certain paintings of her contemporary Albert Pinkham Ryder, who was similarly inclined toward mysticism, this work verges on pure abstraction.

Withrow's mystic canvases were clearly an anomaly in San Francisco at the turn of the century. California's physical isolation from the art centers of the East and Europe made it difficult for collectors and artists to keep up with contemporary trends, a difficulty compounded by the paucity of museums with public collections. Until 1895, when the M. H. de Young Memorial Museum opened with a selection of Old Masters, there was no public collection of art in San Francisco.[37] The result was that well into the 1910s painting in Northern California remained dominated by a romantic realism enlivened with influences from Art Nouveau and the Munich and Barbizon schools. The progressive styles of the day ranged from the muted, soft-focus reveries of George Inness to the bravura brushwork of William Merritt Chase—much of it rendered in a dark-hued "tobacco-juice" palette.

San Franciscans got their first taste of French Impressionism in the 1894 California Midwinter International Exposition, but it was only after the Panama-Pacific International Exposition of 1915 that the movement won broad-scale acceptance. Displayed in Bernard Maybeck's Neoclassical Palace of Fine Arts, the exhibition brought together the work of Manet, Monet, Degas, Sisley, Renoir, and Pissarro. The

"go far without seeming to break any rules."[34] But toward the end of the nineteenth century, some women artists were able to establish careers within previously masculine domains. Evelyn Almond Withrow (1858–1928) was probably the most versatile of San Francisco's women painters, operating a successful portrait studio while taking commissions for landscapes, still lifes, and highly imaginative interpretations of subjects drawn from the Bible, mythology, and Eastern religion. Withrow epitomized the image of the "New Woman" celebrated by turn-of-the-century radical feminists. Unmarried, self-employed, and seemingly self-sufficient, she was at times compared with George Eliot, not the least because of her famed salons in San Francisco and London, which attracted the local and visiting literati.[35]

Withrow was one of a number of California women artists who opted to study abroad, but while most went to Paris, she chose to train in Munich. There she immediately sought out the American expatriate Frank Duveneck and his "Duveneck Boys," and she studied privately with the painter and printmaker J. Frank Currier, probably the boldest and most experimental exponent of the Munich School. Withrow's subsequent portraits and floral paintings show the influence of Currier in their loose, expressionist style. But in the late 1890s, after establishing a studio in the

American Impressionists Twachtman, Tarbell, and Hassam each had his own room, and for the first time, a fledgling contingent of Northern California Impressionists exhibited, several of whom were women.

Among these early California Impressionists was a woman whom many critics considered the standout of the group, E. Charlton Fortune (1885–1969). Fortune outdid most of her peers—male and female—with the acceptance of seven of her paintings, one of which earned a silver medal.[38] Writing for the *San Francisco Chronicle,* Anna Cora Winchell predicted that "probably none of California's women artists has a brighter future."[39] Other critics echoed this appraisal. J. Nilsen Laurvik, founding director of the San Francisco Museum of Art, observed that Fortune's "impression of actual sunlight is rendered with a surety and vivacity that is destined to place this artist in the front rank of American painters."[40] Some of Fortune's critics may not have been aware they were writing about a woman; like many artists of her generation, Fortune found that a genderless signature could work to her advantage.[41]

Fortune had been preparing for this debut for many years. She had studied at the Art Students League with the iconoclastic Albert Sterner and, more significantly, with Frank DuMond, who taught her modernist principles of dynamic composition. "Don't paint a dog running," he told her, "but put running into the dog."[42] Fortune then traveled throughout Europe and spent time on the Left Bank in Paris absorbing what the galleries had to offer. Although she saw the work of the Cubists and attended the first exhibition of the Futurists in Milan—recalling later that it "attracted mobs"— she returned to California most impressed with Monet, Renoir, and Degas.[43]

In 1912 Fortune established a summer studio overlooking the ocean in Monterey, where she began to produce her best-known works. Paintings such as *Monterey Bay,* 1916 (plate 14), display her rapid brushwork and vivid use of color. Like her colleagues Geneve Rixford Sargeant, Lillie May Nicholson, and even the Fauve-inspired Gertrude Partington Albright (see plate 15), Fortune rarely dissolved the solidity of her subjects entirely, yet managed to produce a sensation of reverberating movement. Most of her paintings concentrated on the surrounding countryside and fishing villages of the coast. Fortune's thematic interests were very different from the elegant domestic interiors that occupied the Eastern Impressionists Cecilia Beaux and Mary Cassatt. Genteel teas and babies' baths were decidedly not a feature of Fortune's daily life. Her paintings reflect the informal lifestyle of a Monterey artist who could be seen on any given day in her trademark corduroy suit cycling through the pines. Her bicycle, according to the local papers, was equipped with a contraption of her own device which, though unwieldy and potentially hazardous, could transport her palette and paints to a new or familiar perch.[44]

Fortune was one of many women artists who found refuge from the social constraints of the city in the seaside art colonies of the Monterey Peninsula. By the mid-teens, the neighboring towns of Carmel, Monterey, and Pacific Grove hosted flourishing communities of artists, poets, and playwrights—collectively known as the "Barbizon of California."[45] The dramatic coastline, with its jagged coves and salt-bleached cypresses, attracted men and women artists alike, but women found a society especially congenial to their sex. Indeed, the first art association on the peninsula, the Arts and Crafts Club in Carmel, was founded in 1906 and initially staffed entirely by women. The catalyst was Elsie Allen, a former editor for *Harper's* and a retired professor from Wellesley College, who made certain that women were well represented in the club's annual exhibitions.[46] The Arts and Crafts Club came to full fruition with its summer school of art, which opened in 1910 and continued through the mid-1920s, staffed by, among others, the visiting New York artists William Merritt Chase and George Bellows, both of whom encouraged their students to paint the formerly "unpaintable" sights of Monterey.[47]

Lillie May Nicholson, Rowena Meeks Abdy, Jeanette Maxfield Lewis, Margaret Bruton (see plate 16), and Evelyn McCormick were among the women of Monterey who specialized in painting more picturesque views of rustic barns, teeming wharfs, and fisheries along the bay. Evelyn McCormick (1869–1948), one of the first women artists on the peninsula, began her career in San Francisco as a landscape painter, working in an Impressionist vein that some critics compared with Hassam and Monet.[48] McCormick's summer studio in Pa-

14.
E. Charlton Fortune, *Monterey Bay*, 1916

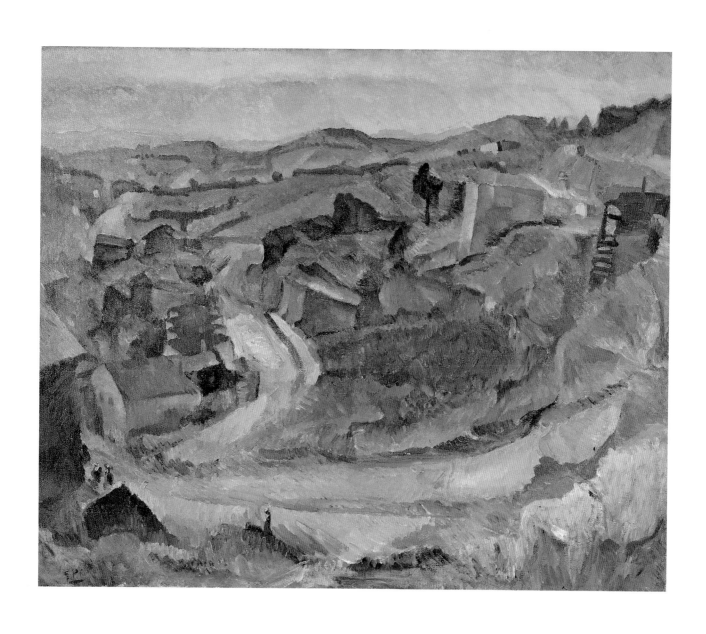

15.
Gertrude Partington Albright, *Below Twin Peaks (San Francisco)*, 1925

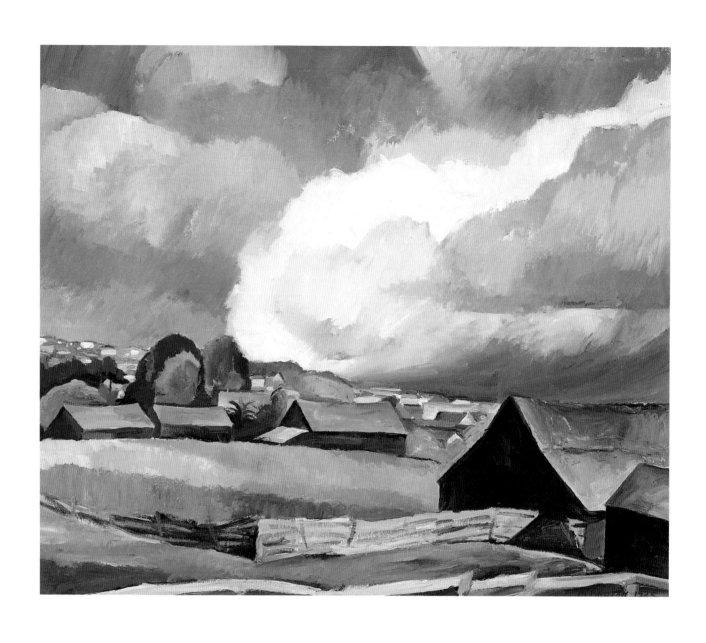

16.
Margaret Bruton, *Barns on Cass Street*, 1925

cific Grove became a rendezvous for the artists and poets around Xavier Martinez, George Sterling, and Joaquin Miller. In the 1920s, after moving into Monterey's Old Custom House, she entertained the crew members of the nearby whaling station, who occasionally posed as her models.[49] McCormick became best known, however, as a chronicler of the peninsula's historic buildings. Paintings such as *The Robert Louis Stevenson House,* about 1933 (plate 17), depicting the boarding house where Robert Louis Stevenson rented a room in 1879, show McCormick's characteristically pellucid, crystalline light, which seems to freeze her subjects in place. Although softer and less abstract, paintings such as these ally her with Precisionists like Charles Sheeler, who also painted cropped views of buildings in the clear noonday sun.

Another well-known painter of landmark buildings, especially the crumbling missions and adobes of Monterey, was Mary DeNeale Morgan (1868–1948). Perhaps no woman artist is more closely identified with the Monterey-Carmel area. Known to friends and colleagues simply as "DeNeale" (like Fortune, she signed her work using only an initial for her first name), Morgan served as director of Carmel's club and school for many years and helped organize the Carmel Art Association in 1927. Her canvases in oleo tempera, a blend of pigments especially suited for brilliant effects, portray Carmel's Spanish architectural heritage in broad, sweeping strokes.[50] More often, she painted the undulating sand dunes of the coast, sometimes studded with golden California poppies. But the theme that she returned to again and again—indeed, that became the leitmotif of her long career—was the wind-sculpted Monterey cypress. Morgan never tired of painting this distinctive tree in all conditions of weather, especially through the golden haze of late afternoon or thrashing in a violent storm (see plate 18).

Morgan, like Fortune and many other women living on the Monterey peninsula, never married and remained free to devote herself to painting without fear of social censure. In an atmosphere where nonconformity and eccentricity were not only tolerated but encouraged, women had fewer obstacles to parity with men. The art colony, of course, had its counterpart in the Bohemian enclaves within America's cit-ies during the late nineteenth century. San Francisco possessed its own demimonde, quite self-consciously modeled after Montmartre—complete with its own "rue de Montgomery" and Black Cat Café—in the section of the city bordering North Beach and Telegraph Hill. The low-rent studio building known as the Montgomery Block, or "Monkey Block," housed numerous women and became the hub of artistic activity in San Francisco.[51]

Although Anne Bremer (1872–1923) never took a studio in the Montgomery Block, she became closely associated with the "Monkey Blockers" in the 1910s. A socialist whose acquaintances included Jack London and George Sterling, Bremer became an agitator for both artists' and women's rights. She served as president of the Sketch Club in the 1900s, organizing what was probably the most critically acclaimed women's exhibition to date, in February of 1906, and shepherding San Francisco's artists through the disastrous earthquake that followed just two months later.[52]

From the beginning of her career Bremer was allied with the most progressive contingent of artists in San Francisco. As early as 1902 she exhibited two paintings in the first exhibition of the California Society of Artists, a secessionist group formed in reaction to the "restrictive, stifling attitudes" of the San Francisco Art Association.[53] Bremer's early paintings, mostly portraits and landscapes, were characterized by a moody tonalism akin to that of Whistler. After seeing a Post-Impressionist show at Alfred Stieglitz's 291 gallery, her work underwent a dramatic change. This exhibition convinced her to return to Paris to study Post-Impressionism firsthand. When Bremer returned to San Francisco in 1911, she found herself virtually alone in practicing a gestural, high-keyed style of abstraction indebted to Cézanne, Vlaminck, and van Gogh (see plate 19). Porter Garnett, a critic for the *San Francisco Call,* pronounced her "the most 'advanced' artist in San Francisco."[54] Garnett judged her work "masterly," a term usually reserved for men, but most critics were thoroughly perplexed by her distortion of natural color and form.

Bremer exemplifies one of the more interesting phenomena in the history of women's art during the first part of this century: the evolving alliance between feminism and modernism. Although modern art was slow to catch

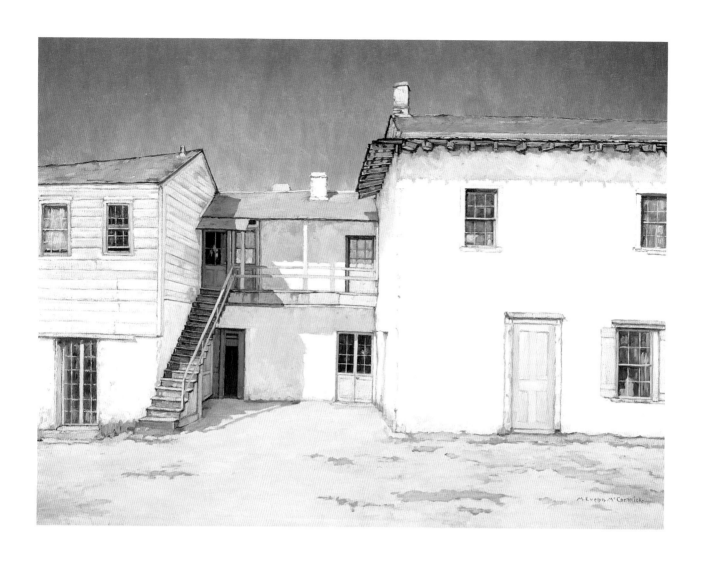

17.
Evelyn McCormick, *The Robert Louis Stevenson House*, c. 1933

on in Northern California, many of its earliest champions were women. Thus the first modernist gallery in the Bay Area was opened by Beatrice Judd Ryan in 1924; the most progressive critic during the 1920s was Florence Lehre; the most radical promoter-collector of modernism before World War II was Galka Scheyer; and the single most influential figure in fostering modernism in Northern California was Grace McCann Morley, the director of the San Francisco Museum of Art, whose ambitious exhibition program paralleled New York's Museum of Modern Art, thereby helping to make San Francisco the second city of modernism after the war.

Yet, in spite of this support, the relationship between modernism and feminism has always been marked by ambivalence. An alliance between the two might seem natural and inevitable given their common liberating drive. Indeed, the majority of American modernists voiced a view that women should be given the chance to promote their work as equals. Unfortunately, however, this was not always the case. Dorr Bothwell, for example, recalls that modernist sculptor Ralph Stackpole told the women in his sculpture class that "the place they really belonged was in bed."[55] As Whitney Chadwick has argued, modernism is at odds with feminism in its essential premise—the equation of artistic creativity with male potency, an equation that can be traced to the earliest stages of vanguard ideology, and further still to its roots in Romanticism.[56] In San Francisco, as elsewhere, those women modernists judged to have a "masculine" hand were generally the most critically acclaimed. Directness, simplicity, and power—the traits most prized in modernist abstraction—nearly always carried connotations of masculinity. These were the characteristics that led critic Ruth Pielkovo, for example, to praise Bremer's painting as showing "truly masculine verve and executive sweep."[57] Such gender-traiting encouraged women to adopt masculine patterns of behavior. Wearing men's clothing and hair styles—as Claire Falkenstein did in the 1930s—was one way of symbolically claiming masculine rights (see plate 20).

The modernist ideology of sexual difference also had its obverse side: the notion of a uniquely feminine sensibility. Women were sometimes perceived as having special capacities to intuit and express emotions in paint. For

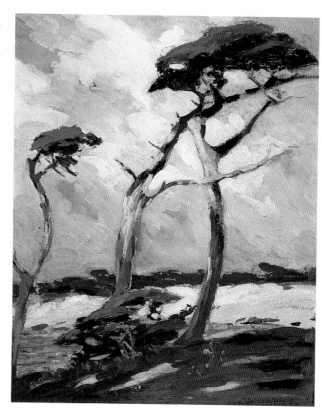

18. Mary DeNeale Morgan, *Cypress Trees—17 Mile Drive*, n.d.

many art commentators in the 1920s, Georgia O'Keeffe's work epitomized the feminine view. As O'Keeffe's partner Stieglitz explained, "Woman *feels* the world differently than man feels it. The woman receives the world through her womb. That is the seat of her deepest feeling. Mind comes second."[58]

Henrietta Shore (1880–1963) suffered from similar stereotyping. During the 1920s, when the two showed during the same month in New York, Shore at the Erich and O'Keeffe at the Anderson Gallery, critics could hardly tell apart their "uniquely female imagery." In a review subtitled "Two Women Painters Lure with Suave Abstractions," the critic Henry Tyrrell summoned up Biblical imagery of the woman as seductress.[59] Pondering whether their "sonorous symbolism" resulted from a primordial feminine sensuality, Tyrrell surmised: "Perhaps this art manifestation underneath the surface is nothing new but only what every woman knows and has known all through the ages." Shore's paintings, he imagined, exemplified "smothered passion" and "dark destiny or original sin, something like that."

Such criticism incensed Shore, who found particularly irritating the patronizing tendency of critics to use her first name (which for those who knew her was not Henrietta, but "Henry"). More important, these critics persisted in see-

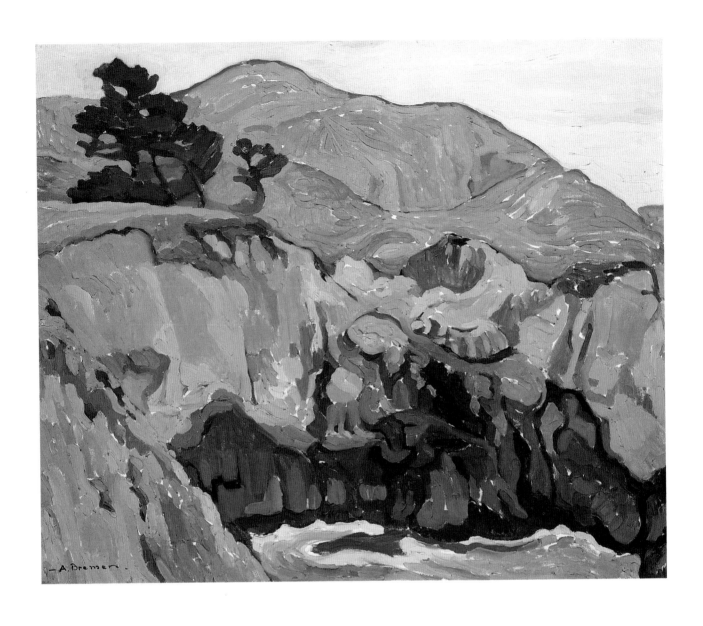

19.
Anne Bremer, *The Highlands*, n.d.

ing her work as conveying feminine sexuality rather than the ambitious metaphysical themes she intended to express. Much like Arthur Dove, Shore seems to have incorporated the teachings of Eastern philosophy with a study of Theosophy to construct an abstract aesthetic that distilled the universal "spirit harmony" or "life rhythm" underlying natural things. Paintings such as [Cypress Trees, Point Lobos], about 1930 (plate 21), show her flattening and simplification of forms to their bare essentials—here, the twisting, rhythmic trunks and branches of the trees appear embraced in a spirited dance.

Although she denied belonging to any of modern art's "isms," Shore became affiliated with numerous avant-garde groups and developed a reputation as one of California's most progressive modernists.[60] After studying with Robert Henri at the Art Students League, she helped found the Los Angeles Modern Art Society in 1916 and the progressive New York Society of Women Artists in 1920. During the late 1920s she traveled to Mexico, where she painted portraits of José Clemente Orozco and Jean Charlot.[61] And in 1927, while in Los Angeles, she befriended Edward Weston, whose photography she seems to have influenced. Despite these impressive professional associations, Shore slipped into relative obscurity not long after moving to Carmel in 1930, and her last significant works were a series of murals commissioned by the Treasury Department's Section of Fine Arts in the late 1930s.[62]

Shore was apparently never happy being on relief. Although she was chronically short of money, she found it deeply humiliating to sign a document stating that she needed charity.[63] For most women artists, however, the New Deal projects of the Roosevelt administration came as a godsend. They not only provided financial sustenance in difficult times but afforded a chance—the first in American history—for women to participate in large-scale public commissions. Only a handful of women with national reputations, such as Mary Cassatt, had earlier been able to break through the profitable male monopoly of mural painting.[64] Yet, while the projects gave women artists in Northern California unprecedented opportunity, they were not entirely egalitarian. Much has been made of the gender-blind policy of the Section of Fine Arts, which awarded commissions on the basis of anonymous competitions.[65] To put

this in perspective, however, the section sponsored only a small fraction of the period's mural commissions. The great majority of murals in California were sponsored by the Public Works of Art Project and the Federal Art Project, both of which demonstrated a pronounced bias against female artists. Only sixty-five of the roughly three hundred murals in California were made by women.[66]

Ultimately, despite the "ideology of largesse" and the flourishing reform movements of the New Deal era, the 1930s were comparatively stagnant for feminism.[67] In her recent study of Section art and theater, Barbara Melosh has identified this paradox: "The New Deal stands as the single example of a liberal American reform movement not accompanied by a resurgence of feminism. Instead, the strains of economic depression reinforced the containment of feminism that had begun after the winning of suffrage. As men lost their jobs, wage-earning women became the targets of public hostility and restrictive policy."[68] Indeed, married women with careers were widely denounced in the media as undermining the stability of the home. The era was characterized by the slogan "Don't take a job from a man!"[69]

Correspondingly, there are few traces of feminist consciousness in the public art of women in Northern California. Helen Forbes (1891–1945), an artist whose easel paintings portrayed forbidding, almost hallucinatory visions of Death Valley (plate 22), where she lived by herself in a deserted hotel, was hired to paint animal frescoes for the Mother House at Fleishhacker Zoo in San Francisco. Most of the subjects women chose to paint reaffirmed traditional gender roles. Thus, the making of history was a heroic masculine affair for Edith Hamlin, who excluded women from her mural of overland pioneers for the Tracy post office.[70] In some New Deal murals women could be found alongside men, working together or fighting for a common goal, as in the Coit Tower fresco *California Agriculture*, 1934, by Maxine Albro (1903–1966), which depicts men and women harvesting oranges. There is, however, a simpleminded domesticity to this cheerful scene: the women laborers in Albro's painting seem blissfully naive; one even appears to be going directly from the field to a dance in her lacy dress and pearl necklace.[71] Albro offers a striking example of a woman artist whose political progressivism did not encom-

20. Claire Falkenstein, *Self-portrait,* 1930

23. Diego Rivera and Emmy Lou Packard at work on mural for the Golden Gate International Exposition on Treasure Island, 1940

pass feminism. She believed strongly in social reform and may have maintained Communist sympathies. When a scandal erupted over the Communist iconography in the Coit Tower murals—a controversy fueled by Diego Rivera's influence on their design—Albro responded with thirties-style bravado, refusing to paint out the disputed elements. Yet for all her fervor, she seemed unconcerned about the forces in American society that were keeping the demands of feminism at bay.

Albro was only one of several San Francisco women artists who worked directly with Rivera on various murals throughout the city. Rivera, who became an instant celebrity when he arrived in the Bay Area in 1930 to paint a fresco in the new San Francisco Stock Exchange, hired numerous women to assist him with his various projects, including Jean Goodwin, Marian Simpson, and Emmy Lou Packard. Packard, who had studied with Rivera in her teens in Mexico, was among the artists most deeply affected by his style, which combined a chunky-figured Social Realism with fresco techniques gleaned from Giotto and the Quattrocento Italian "primitives." Her most significant collaboration with Rivera was the 1,650-square-foot fresco at the Golden Gate International Exposition on Treasure Island in 1939–40, painted on site before crowds of spectators (see plate 23).

If many Northern California women art-

ists were swept up in the Rivera mania, Jane Berlandina (1898–1970), who worked on the Coit Tower murals in 1934, was not. Instead of adopting Rivera's style, Berlandina used a starkly reductive palette and fluid modernist line. Berlandina was a visible member of the city's avant-garde during the 1930s, having begun her career as an abstractionist in Paris, where she studied with Raoul Dufy. Her paintings ranged broadly in approach, some making a nod to the depression era's vogue for peasant themes (see plate 24), others showing a heated expressionism strangely at odds with neutral subjects such as potted flowers. But the works that captured the attention of critics and made a name for Berlandina in New York were her watercolors, which utilized the lessons of Dufy to brilliant effect. Rapidly executed with jarring colors in unexpected juxtapositions—a favorite combination was burnt orange against electric blue—they seemed to manifest the "push-pull" theories that Hans Hofmann would later make famous.

Berlandina may well have met Hofmann during her first year in the Bay Area, where the German expatriate made his first stop in this country, teaching at the University of California, Berkeley, during the summers of 1930 and 1931. Hofmann's own work at that time, a pastiche of Picasso, Matisse, and Cézanne, seems to have made less of an impact than his garrulous personality and zealous promotion of modern

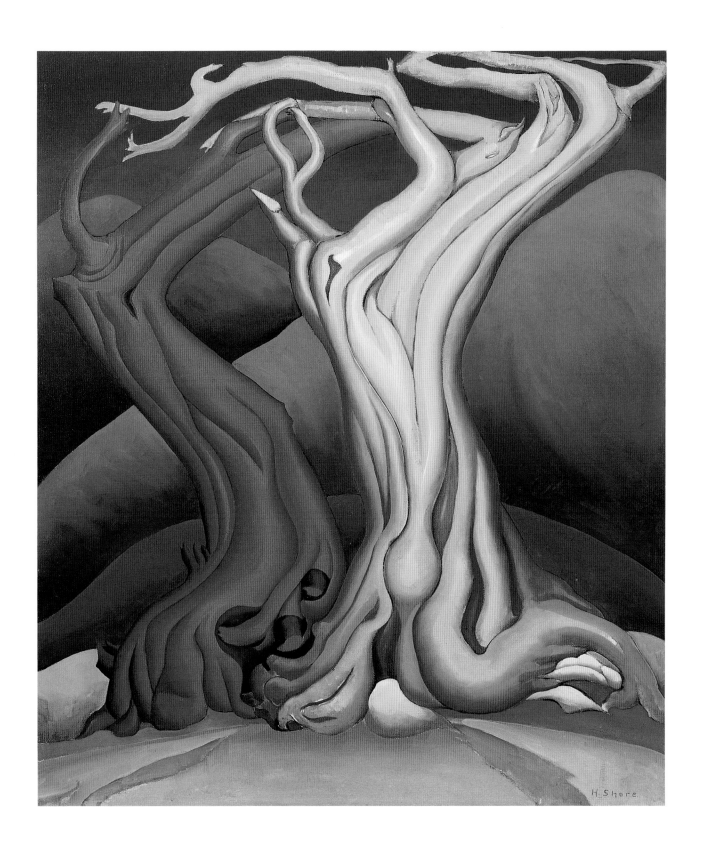

21.
Henrietta Shore, *Untitled [Cypress Trees, Point Lobos]*, c. 1930

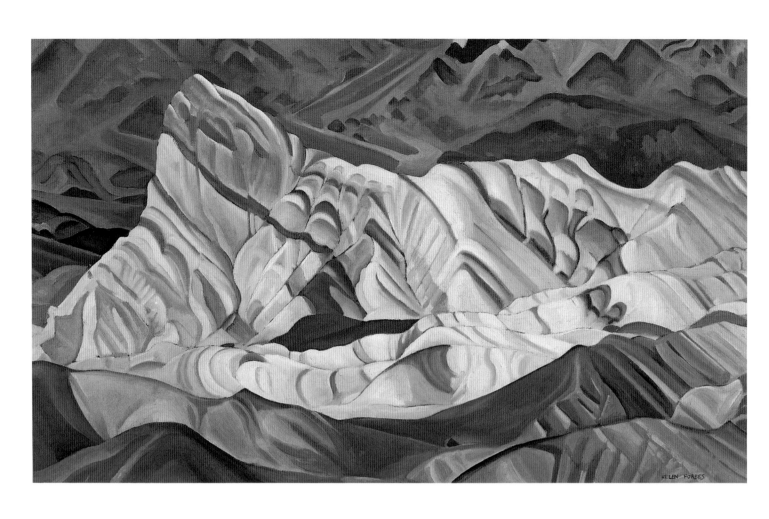

22.
Helen Forbes, *Manley's Beacon, Death Valley,* c. 1930s

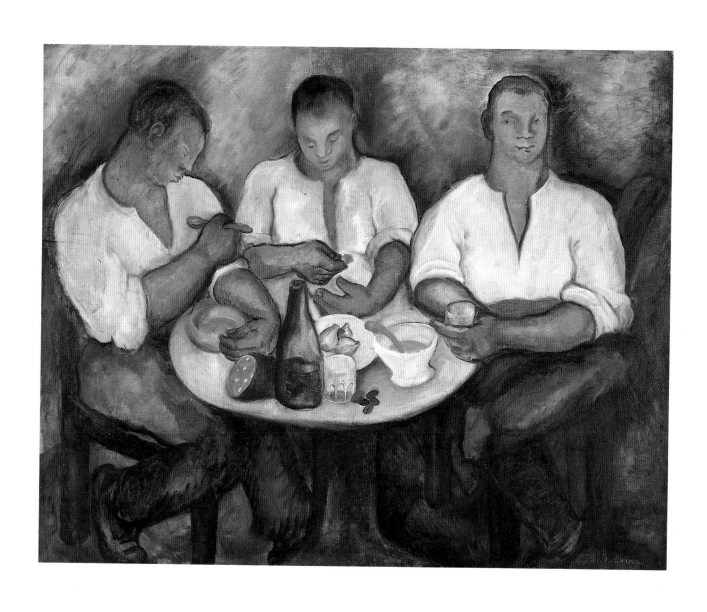

24.
Jane Berlandina, *The Feast*, n.d.

art. Although his stay was short, he developed a core following in Berkeley's art department, a group that ultimately came to be known as the Berkeley School.[72]

When art historians discuss the Berkeley School, they tend to refer to Erle Loran, John Haley, and Worth Ryder, but the artist who seems to have understood Hofmann's teachings best was Margaret Peterson (b. 1902). Peterson began teaching at Berkeley in 1928 and became a self-described disciple of Cubism early in her career. By the mid-1930s she was working in an abstract mode that owed something to Braque as well as to the Mexican modernists Carlos Mérida and Rufino Tamayo, both of whom she met in Mexico City during her solo exhibition at the Biblioteca Nacional in 1934. Her sophisticated understanding of the spatial dynamics of late Cubism appears in paintings such as *Three Women*, 1938 (plate 25), with its flat, simplified shapes in bold colors that simultaneously advance and recede.

Most of the other women of the Berkeley School worked in a style closer to the pastel confections of Dufy than the muted abstractions of Picasso. For artists like Virginia McRae, Leah Rinne Hamilton, (1904–1960) and Miné Okubo, watercolor was the medium of choice, and they worked rapidly, without preparatory drawings. Miné Okubo (b. 1912), a Japanese American familiar with the rapid-fire techniques of *sumi* ink painting, was among the most spontaneous. This is readily apparent in *Berkeley Family Backyard*, 1937 (plate 26), with its wet washes of rich color and loose calligraphy. Her world of family backyards, however, soon ended, for Okubo was one of more than 110,000 individuals of Japanese descent forced into concentration camps after the bombing of Pearl Harbor. There, Okubo produced a powerful group of pen-and-ink sketches of life in the camps, which she later used to illustrate her important book *Citizen 13660* (1946).

Okubo was not alone in using this alienating experience as an inspiration for art. Several publications have recently uncovered the considerable wealth of painting created in the Japanese relocation camps.[73] Yoshiko Yamanouchi and Hisako Hibi were among the artists who produced moving scenes of the internment. Miki Hayakawa, who studied at the California School of Fine Arts (formerly the Mark Hopkins Institute of Art) in the 1920s, exhibited Cézanne-inspired landscapes and portraits widely in the Bay Area before she was relocated to Santa Fe in 1942 (see plate 27).

The war had, of course, a tremendous impact on all of California's artists. Whether Surrealist, Expressionist, or nonobjective, they responded to the ferment by turning away from political reality and inward toward the private realm of individual imagination. For women artists, the shift marked what can only be described as a sea change. For the first time, women were able to engage in prolonged and extensive self-examination without societal reproach. Of course, there had been instances of psychological probing before the war. Certainly, Henrietta Shore stands as an example of an artist who drew sustenance from an interior dialogue. Nonetheless, the 1940s witnessed the first broad-scale development of an iconography centered on women and women's experience. Self-portraiture, a genre previously dominated by men, gained widespread currency in the women's art of Northern California. An index of the new emphasis on subjective experience can be found in Leah Rinne Hamilton's paintings of the San Francisco docks at wartime—in the foreground of each is a figure of the artist herself surveying the scene (see plate 28).

Surrealism, which appeared only in fits and starts in San Francisco before the war, provided fertile ground for women artists exploring autobiographical themes. Dorr Bothwell (b. 1902) (plate 29), one of San Francisco's most prominent practitioners of Surrealism, painted numerous self-portraits composed of epigrammatic symbols drawn from private dreams and fantasies. Some of these paintings are metonymic—a single motif, such as an egg, a hand, or a part of the female anatomy serves as a stand-in for the artist herself. In *Self-Portrait*, 1942 (plate 30), Bothwell brings together a number of highly personal symbols of the creative psyche. Sitting in a contemplative semi-lotus position (a habit Bothwell acquired during her two-year stay on a remote island in Samoa), she shows herself wearing a dunce cap—a reference to what she called the "unfathomable magic of art."[74] A bluebird, which has nested in her bosom, pours forth from its beak a stream of paint the colors of the rainbow, while a cat, both nemesis and apparent friend to the bird, signifies the artist's unconscious impulses, the mysterious sources of creativity. This painting, like those of many women Surrealists, merges

SUSAN LANDAUER

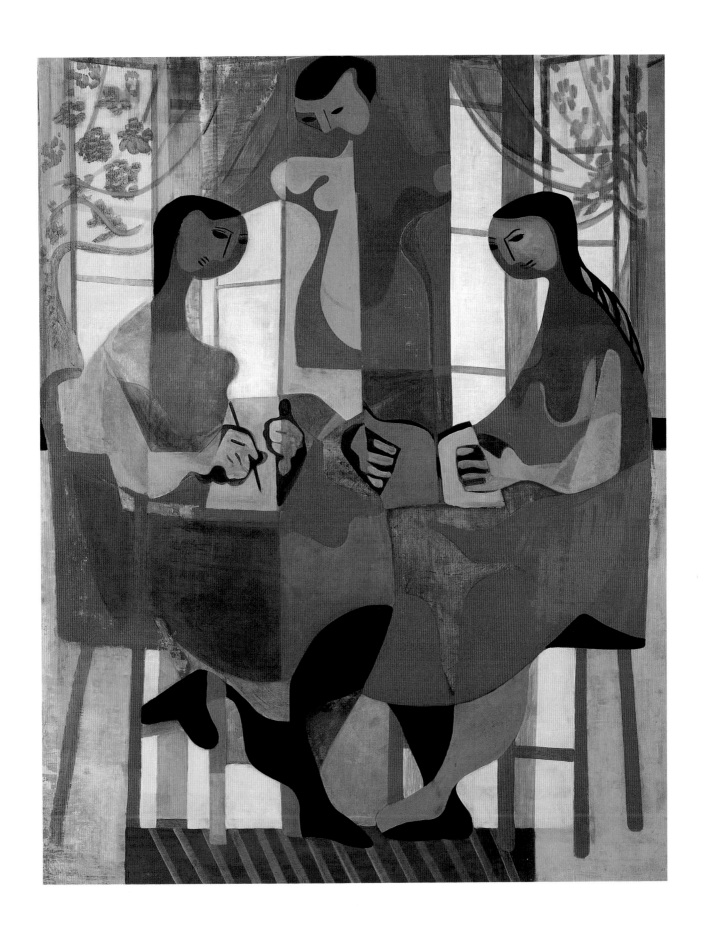

25.
Margaret Peterson, *Three Women*, 1938

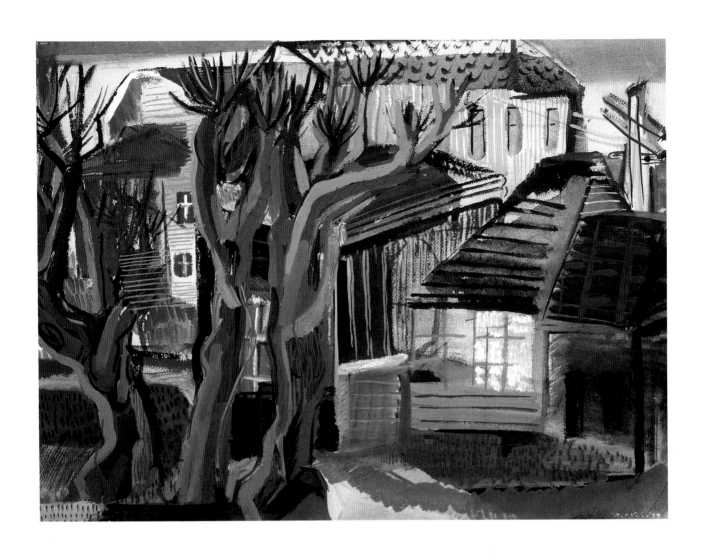

26.
Miné Okubo, *Berkeley Family Backyard*, 1937

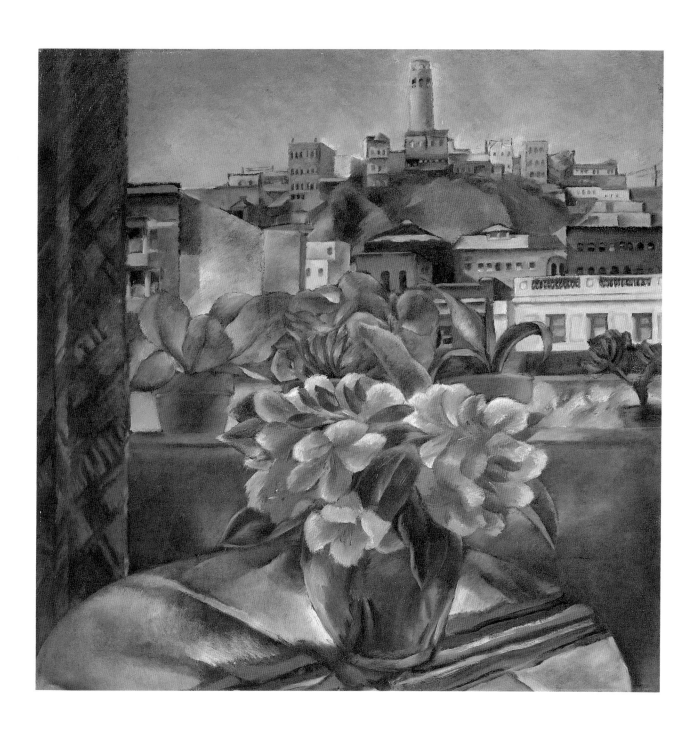

27.
Miki Hayakawa, *From My Window: View of Coit Tower*, c. 1937

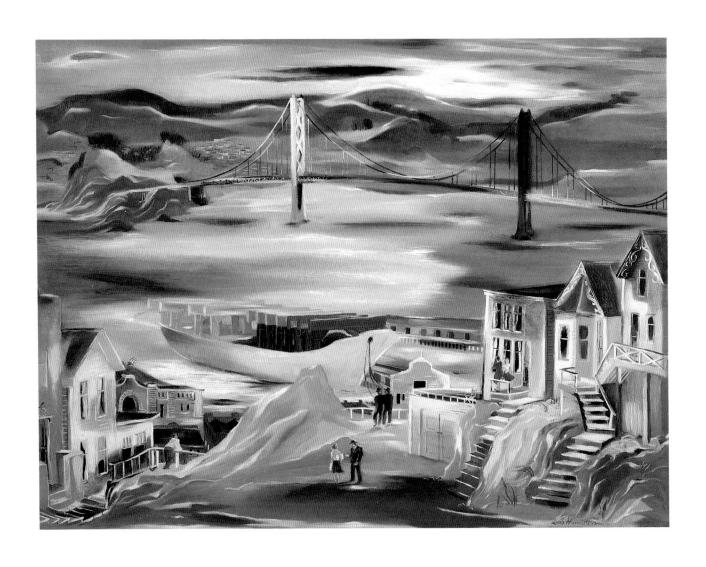

28.

Leah Rinne Hamilton, *Untitled [San Francisco Bay]*, 1942

such binary extremes as mind/body, rational/irrational, and art/nature. As Gwen Raaberg has shown in her compelling study of women and Surrealism, precisely those dichotomies "functioned to identify woman with the rejected terms—body, irrationality, and nature—and situate her in an inferior position."[75] Bothwell has thus utilized the most basic principle of Surrealism, the conflation of opposites, to arrive at a corrective definition of her artistic identity.

Although Bothwell distanced herself from André Breton and his associates and even rejected the designation of Surrealist, her painting of the war years comes closer to the orthodox movement than that of other San Francisco artists. Most, like Adaline Kent and Claire Falkenstein, preferred a more abstract approach that could be just as revelatory. The paintings of Ruth Armer (1896–1977), for example, were deeply autobiographical, anticipating the Abstract Expressionism that would sweep through the Bay Area after the war. Her work of the 1940s and 1950s can be understood as a visual diary, recording the phases of her life and responses to historical events. The painting during the war years tended to be dark and forbidding, composed of ragged shapes that call to mind the later work of Clyfford Still (see plate 31). After 1945, however, her palette brightened considerably, reflecting the expansive confidence of the postwar era.

Armer's optimism aside, the postwar period ultimately proved devastating for women artists, particularly for those on the West Coast. With America's new economic, political, and military supremacy, New York replaced Paris as the major art capital and the New York School emerged as the central movement in modern art. The arrival of the New York School meant two things for California women artists. First, the concentration of artistic interest in New York disadvantaged Californian artists of both sexes, driving many to build their careers in Manhattan. Second, Abstract Expressionism carried the masculine image of modern art to new extremes, in essence adapting the raw physicality of Hemingway to painting in oil.

29. Dorr Bothwell, c. 1938

The notion that muscle, alcohol, and American art went together disenfranchised women artists more than ever before.

In retrospect, women artists in California have always had two strikes against their admission to the canon of American art: their gender and their place of residence. Yet they were on the whole more successful than one might imagine. Although they faced many of the same problems women experienced elsewhere—notably domestic constraints and gender-biased critics—they were on average more successful than their Eastern counterparts. As founders and leaders of Northern California art establishments, they had greater exhibition opportunities and access to influential teaching positions, which helped to prevent the "ghettoization" of women artists observed elsewhere by many feminist art historians. Although women artists in Northern California certainly faced discrimination—at times succeeding only because of the "maleness" or "femaleness" of their art—they did not quite experience what Whitney Chadwick has described broadly as an "exclusion from the major movements through which traditional art history has plotted the course of Western art."[76]

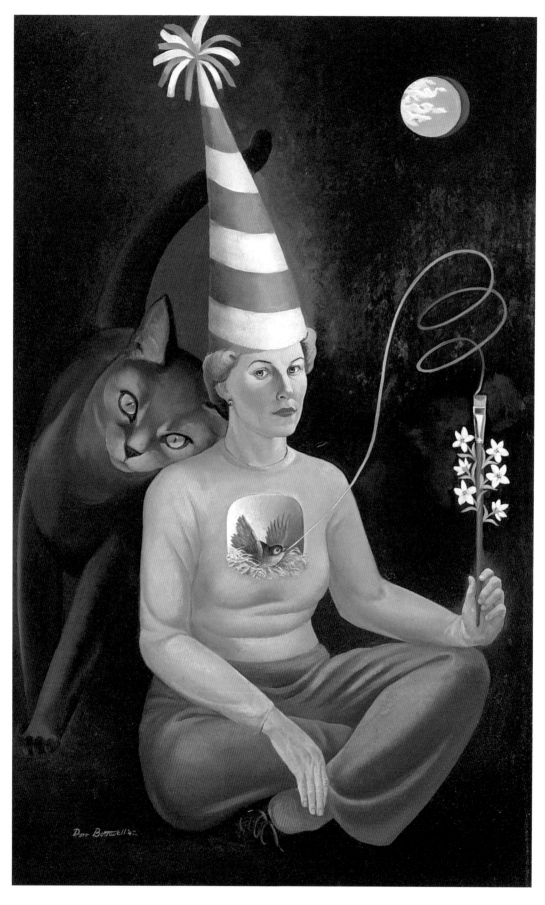

30.
Dorr Bothwell, *Artist (Self-Portrait)*, 1942

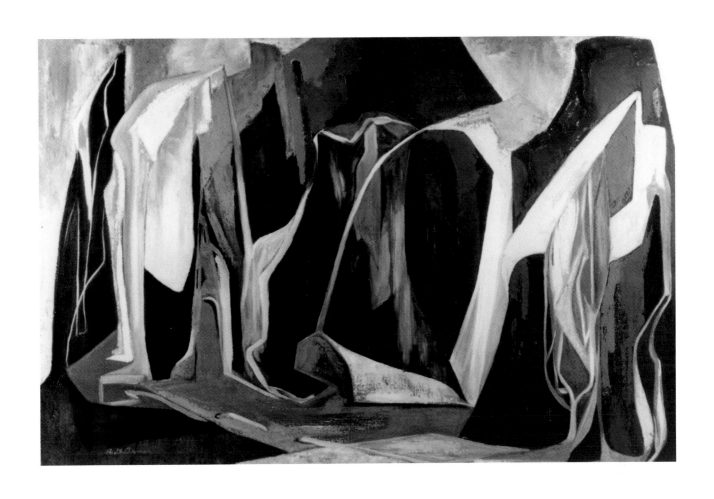

31.
Ruth Armer, *Untitled*, c. 1940s

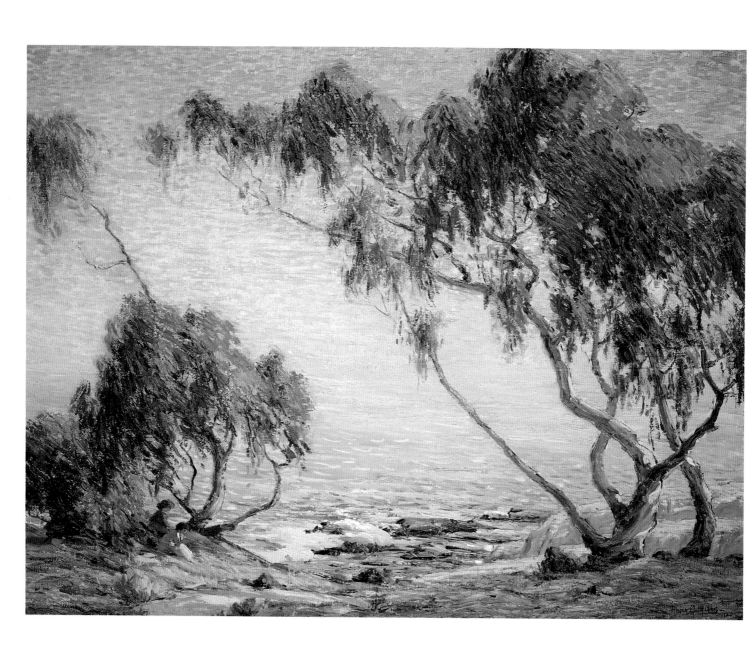

65.
Anna Hills, *Spell of the Sea,* 1920

II
"Islands on the Land"
WOMEN TRADITIONALISTS OF SOUTHERN CALIFORNIA

Patricia Trenton

"IT IS AS IF YOU TIPPED THE UNITED STATES UP," remarked Frank Lloyd Wright, "so all the commonplace people slid down into Southern California."[1] United States Senator James Phelan said about California, "You can't tell the truth about it without lying about it."[2] Pragmatists called the region a paradox: a desert, facing an ocean and hemmed in by the mountains.

Over the years boosters, tourists, real estate promoters, and the national press have been unable to describe or even agree on a name for the area. Among the more popular historical epithets are Iowa by the Sea, a geographical Pleiades, Cuckooland, the American Italy, the Land of Sunshine, Nineteen Suburbs in Search of a City, and Eden on Earth. Even today Southern California is often called La-La Land or the land of fruits and nuts, along with other questionable sobriquets.[3]

Author Carey McWilliams described the Los Angeles of the 1920s as "a community at the end of a long trail of migration; . . .[it] has become the junkyard for a continent. . . . Incessant migration has made Los Angeles a vast drama of maladjustment: social, familial, civic and personal."[4] And Irvin S. Cobb wrote, "Los Angeles is a vast cross-section of the Corn Belt set down incongruously in a Maxfield Parrish setting."[5] Pejoratives and hyperboles aside, the Los Angeles basin was to become the major "island" of art and culture in Southern California.

The frenetic land boom of the 1880s, perhaps the greatest and most interesting of the century, was a combination of low-priced railroad fares, unparalleled optimism, boosterism,

magnificent climate, media hype, and finally a speculative land rush fanned to a white heat and overexploited by unscrupulous promoters. The paradox was real. Many of the new immigrants from the East Coast and the Midwest were God-fearing middle-aged conservatives from stable environments. Most were educated, civic-minded, and financially able to make immediate contributions toward land development.

In this cauldron of activity conservatives or traditionalists were able to flourish by establishing their presence in these communities—"islands on the land"—of Los Angeles, Pasadena, Santa Barbara, and San Diego, and the political base they formed at times controlled the whole.[6] In the late 1880s the boom fizzled, and growth in the 1890s was slower but still significant. During the next several decades the region's magnetism generated successive land booms accompanied by a sizable increase in population.[7] Southern California's conservative presence extended to the painters who settled in the southern part of the region, among them the women artists to be discussed here. With very few exceptions these women were well-educated, privileged, and white.[8]

This land of new opportunities and sec-

ond chances was far different from the competitive, established, male-dominated art bastions in the major cities, with their restricted opportunities for women artists. Portrait painter Cecilia Beaux had made news in the East when she remarked in 1910 that "the few obstacles that confronted her in this country have now been removed. A woman now has every opportunity that a man has. . . . There is no reason why a woman cannot become as great an artist as a man."[9] But Southern California women painters were already breaking new ground, gaining accessibility and acceptance in what was recognized as the last frontier in the United States. Many of these women displayed special attributes, best described by Linda Nochlin in her provocative essay "Why Have There Been No Great Women Artists?": "For a woman to opt for a career . . . in art, has required a certain unconventionality. . . . And it is only by adopting, however covertly, the 'masculine' attributes of single-mindedness, concentration, tenaciousness, and absorption in ideas and craftsmanship for their own sake, that women have succeeded . . . in the world of art."[10]

A successful career in art during the last decade of the nineteenth century and the early decades of the twentieth required dedication, fortitude, and sacrifice, especially for a woman. Although the limited market in Southern California was growing rapidly, the cultural base was still thin and most collectors focused on European paintings. While the obstacles for women artists declined significantly in the 1880s and 1890s, some still remained. Women were not permitted to attend anatomy lectures at the prestigious but ultraconservative National Academy of Design in New York until 1914, and from 1825 to 1953 only 75 women out of a total of 1,300 members were offered membership or associate membership.[11] Women who were serious-minded about professional careers in art were also reluctant to marry, fearing a loss of independence. To some extent, this explains why many women artists seldom married in their teens, often postponing marriage until after their mid-twenties. Most of the married artists discussed here fall within this group and probably shared similar attitudes. In a 1910 interview Cecilia Beaux referred to the myriad obligations of women that sap vitality and the time needed to develop and succeed: "With all the opportunities we give women, in one re-

spect we stand tremendously in their way. We encourage them to get started, then we demand too much of them." She added that "a man who does a man's work is a normal human being. A woman who does a man's work is a kind of *superwoman*. She must be two selves, one who supplies energy for her part of the world's work, the other, the woman who fulfills the obligations custom has laid upon her."[12]

The thirteen professional women artists presented here have been selected from among the dozens of conservative painters active from 1890 to 1945 in Southern California. Many of the early painters were amateurs; others might be categorized as semiprofessionals (painting for pleasure, and occasionally selling pictures to friends); a small number received professional training. Most of these thirteen traditionalist women painters arrived in Southern California with mature skills and continued to perfect their techniques. All of them painted representationally, each in an inimitable style, without entertaining radical changes. Their subject matter was safe and uncontroversial, even as modernism was being introduced to Southern California by more experimental and innovative artists in the first decades of the twentieth century. An exception was the essentially conservative Donna Schuster, who experimented with modernist ideas from the mid-twenties onward, always, however, under the influence of a male artist-mentor.

Three of the more recognized painters among the relatively few professionally trained artists in Southern California during the 1880s and 1890s were Edith White (1855–1946), Ellen Farr (1840–1907), and Fannie Eliza Duvall (1861–1934). White and Duvall never married and Farr's career only gained momentum after she was widowed. All three interacted professionally and actively helped to mold viable art colonies, in Los Angeles in the 1880s and in Pasadena in the 1890s and later. White, whose Quaker family migrated to California by wagon caravan in 1859, grew up in Northern California, was educated at Mills Seminary (today's Mills College), and studied art at the California School of Design in San Francisco, before opening a studio in Los Angeles in 1882. Farr, the widow of a Civil War hero and congressman, came to Pasadena in 1886, invited by the manager of the exclusive Raymond Hotel to open a studio on the premises. Two years later Duvall

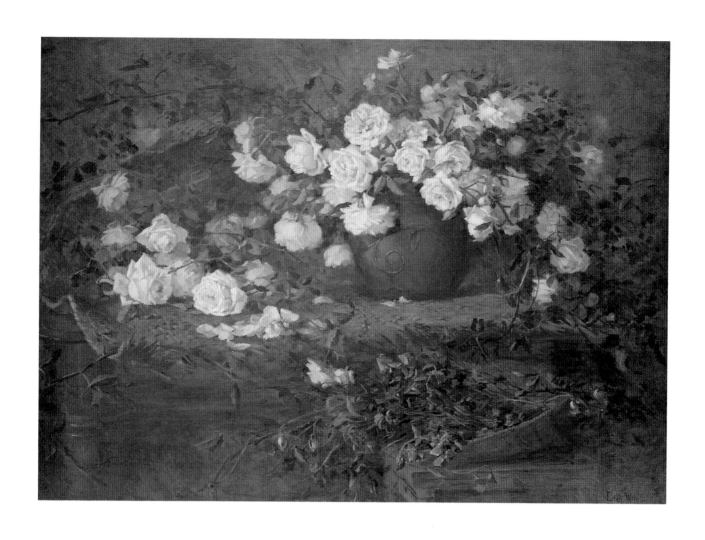

32.
Edith White, *Untitled [Yellow, White, and Pink Roses with Sweet Peas]*, c. 1892

established a studio and home in Los Angeles, but throughout her career Paris remained her second residence. Each of these painters pursued her career under the banner of conservative art.

Edith White gained early recognition for the realistic renditions of roses that eventually became her signature. Hard work and perseverance advanced her career, and in 1892 she relocated to New York for further study at the Art Students League. Her painting of white roses was prominently displayed "on the line" in a spring exhibition in New York City.[13] Another picture, on a grand scale, of yellow, white, and pink roses with sweet peas, earned critical acclaim in an exhibition at MacBeths, the prestigious gallery of American art (plate 32, page 43). Returning to Southern California in 1893, White settled in Pasadena, where her career prospered.[14]

While White was known for her flower paintings, Fannie Duvall excelled at a variety of genre subjects, painting some of her best work in the early 1890s at her studio flat in Los Angeles. *Chrysanthemum Garden in Southern California,* 1891, quickly established her reputation after its selection for the Fine Arts Gallery at the 1893 World's Columbian Exposition in Chicago. A few years later Duvall painted a picturesque scene of old California, *[First Communion],* 1897 (plate 33), capturing with an impressionistic brush the light and color of the girls' white dresses against the adobe red of San Juan Capistrano Mission.[15]

Another type of subject attracted the prolific Ellen Farr, who became well known for her many versions of the lacy foliage and vivid red berries of the exotic pepper tree (see plate 34); one of these versions was exhibited in the California Fine Arts Gallery at the 1893 Columbian Exposition in Chicago. The pepper tree, or "Peru," was an early import to Southern California from Peru and a fascination for tourists.

The lifestyles and career paths of these three painters are studies in contrast. Edith White, formally educated, deeply religious, and with "a serene strength of personality," became involved with the philosophy of the Theosophists: "Diety, the Absolute, Infinite, All-powerful, Divine Essence [permeates] the life of everything that breathes, and [expresses] itself even in the *flowers*."[16] White's concentration on floral studies is certainly compatible with this philosophy.

Edith White's wish to marry was discouraged by her father, who did not want suitors to interfere with her career in art, and White remained under the influence of her parents throughout her adult life. Her strong sense of family obligation prompted her move to Los Angeles in 1882 to care for an ailing brother; in 1897 her mother urged her to join the Pasadena Theosophical Society.[17] Five years later White and her parents moved to Point Loma (seven miles from downtown San Diego), where Katherine Tingley, known as "The Purple Mother," had established the picturesque headquarters of the Universal Brotherhood and Theosophical Society.[18] For twenty-eight years Edith White directed the art instruction at the Raja-Yoga School (see plates 35 and 36), and in her *Memories* she wrote: "I had ample time to continue in my chosen life work and was able to carry out original ideas in painting without considering the commercial side of it."[19]

White spent her more productive years in a single location, while Fannie Duvall traveled extensively and established residence in both Europe and California. Interviewed by *Los Angeles Times* art critic Antony Anderson, Duvall commented: "I think an artist should be moving about perpetually, to keep artistically alive. . . . If he remains in one place too long he's apt to stagnate. . . . He needs to get new ideas, different points of view, other standards of performance. In Paris he finds 'Artistic Atmosphere,' that bracing ozone so necessary to the artist's life."[20] Although progress had been made by the last decade of the nineteenth century, the residue of Victorian ideologies prevailed for almost another century before gender references, such as "he" and "one-man," were replaced.

An active member of Los Angeles's art community, Duvall was instrumental in founding the first public exhibition gallery at the local Chamber of Commerce.[21] At forty years of age, she enacted her commitment to perpetual movement by enrolling at the James Abbott McNeill Whistler school of art in Paris. Paris at this time not only attracted the best artists but also provided inexpensive living, a bohemian night life, and, most important, access to established teachers. The Spanish painter Antonio de la Gandara introduced Duvall to pastels,[22] and one of her first pictures in this medium, *The Choir Boy,* was exhibited at the Paris Salon, the ultimate symbol of success. Stranded

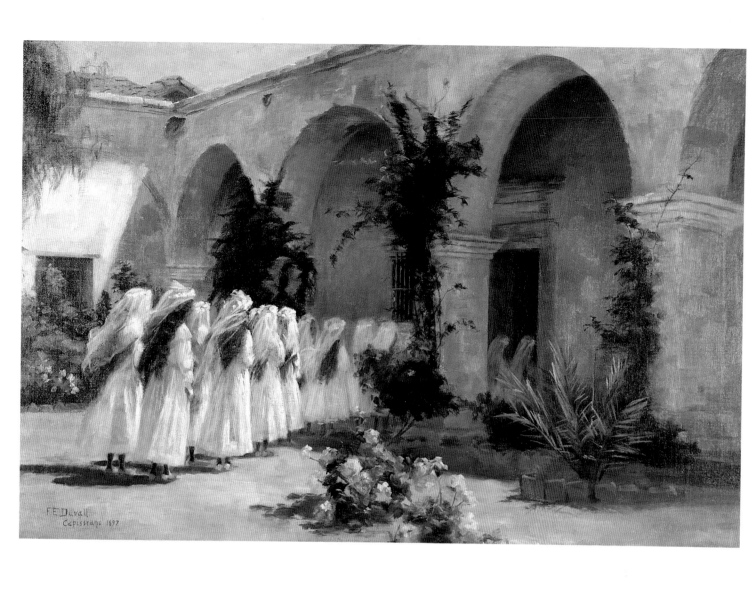

33.
Fannie Eliza Duvall, *Untitled [First Communion, San Juan Capistrano Mission]*, 1897

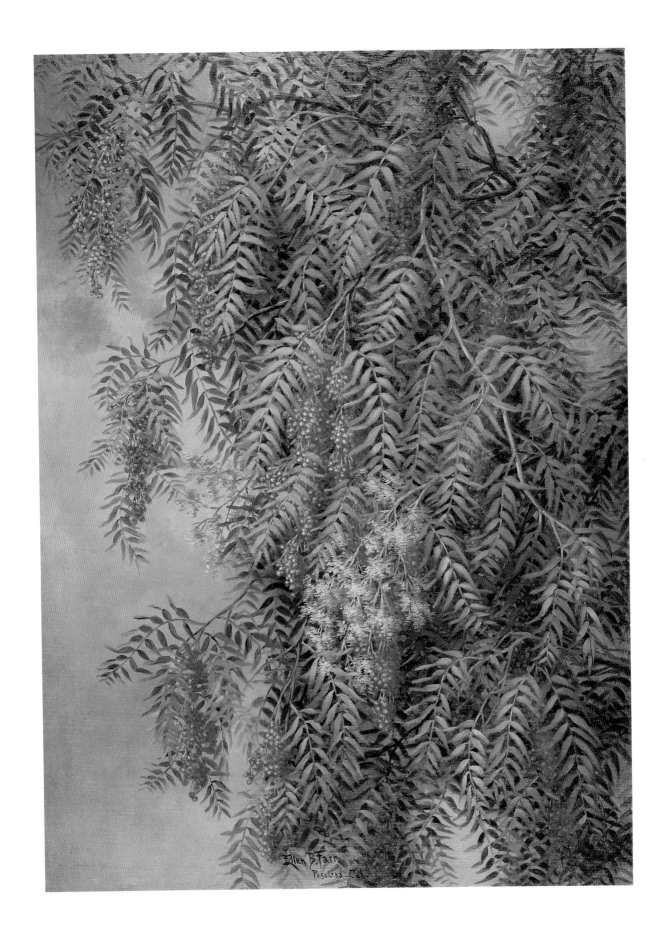

34.
Ellen Burpee Farr, *The Pepper Tree*, c. 1893

35. Edith White,
Raja-Yoga School, n.d.

in Europe at the outbreak of World War I, Duvall remained in Paris, which had become her second home.[23] Unmarried, she lived and traveled extensively with an English companion, Frances Blagg, who was later a major beneficiary in her will.[24]

Although Ellen Burpee Farr married and raised a family, not until after she was widowed did she establish a reputation as a painter. Farr, an East Coast mainliner, whose family dates to the time of the Revolution, married Evarts Worcester Farr, whose family traced its ancestry back to 1639, when the first Farr emigrated from England to Lynn, Massachusetts.[25] A hero of the Civil War, Evarts Farr was admitted to the bar and later elected to the Forty-Sixth Congress. In Washington, D.C., where the Farrs lived for several years (plate 37), Ellen Farr mingled with the most powerful men in the nation and also found time to study art with Louis-Mathieu-Didier Guillaume, a renowned French artist. In 1880 she was suddenly left a widow with three children, an experience that required her to make some difficult decisions.[26]

In 1886 the self-assured, well-organized Farr made her most important decision by moving to Pasadena.[27] In *A Truthful Woman in Southern California,* Kate Sanborn described Pasadena in 1893 as the "'Crown of the Valley'— nine miles from Los Angeles, but eight hundred feet higher and with much drier air. . . . Yes, Pasadena seems to me as near Eden as can

be found by mortal man. . . . Then the Climate—spell it with a Capital . . . Glorious! Delicious! Incomparable! Paradisiacal!!!"[28] Of all the "islands on the land," Pasadena was considered the most distinctive, upscale, and desirable. The Raymond Hotel, known as the playground of the wealthy, attracted Easterners during the winter season. Farr established a studio-residence there when it first opened (plate 38), and when it closed for the summer in 1887 she relocated nearby. In 1894 she set up a summer studio in a beach cottage on Catalina Island (plate 39), another favorite retreat of the wealthy. In Pasadena, in 1895, Farr built an adobe Mission-style residence on the land of an old vineyard. There she entertained, displayed her rare collection of American Indian baskets, and frequently exhibited her work. The lavishly decorated studio with its exotic furnishings—oriental rugs, objets d'art, and carved furniture—offered an aesthetically seductive ambience for selling art. While Farr never remarried, she was active in Pasadena society, a member of many of the women's clubs, and, with Edith White, served on numerous local exhibition committees.

Of the thirteen conservative women painters discussed here, nine married. Six of the nine married couples provide an opportunity for insights into the relationship of husband and wife, either when both were artists or when the husband followed another career.[29]

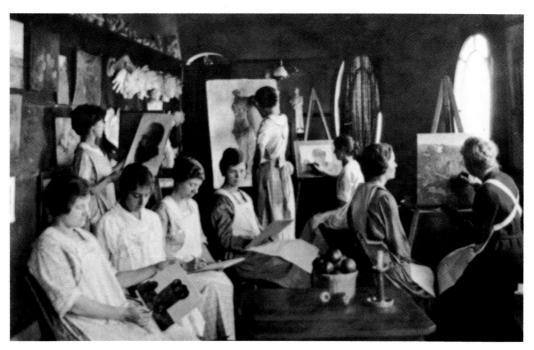

36. Edith White (far right) instructing students in one of the girls' art classes at Point Loma, n.d.

Alberta McCloskey (1855?–1911), Marion Wachtel (1877–1954), Adele Herter (1869–1946), Jessie Botke (1883–1971), and Elsie Payne (1884–1971) were married to artists, while Kathryn Leighton (1876–1952) was married to a prominent attorney. The personal relationship between two creative talents married to each other provides a fascinating scenario—working, eating, and sleeping side by side, sharing the same studio, sketching and sometimes painting together, in some instances in competition with each other. Potential for personality conflicts—particularly prevalent among artists because of temperamental factors and competitiveness added to the physical intimacy between artist-spouses—posed a significant likelihood of divorce and even spousal abuse. Despite the complexities of partnership, there was no divorce among the six couples. The McCloskeys, however, did separate but religion negated divorce, and the Paynes separated only to reconcile considerably later. The Wachtel, Herter, Botke, and Leighton marriages were ostensibly secure, comfortable, and traditional in terms of values, suggesting a compatibility between spouses. For each couple, however, the professional and personal relationship was unique.

The first of these couples to arrive in Southern California were the McCloskeys. Known for their portrait paintings, they frequently worked in tandem on a single commission, and both signed the painting, with William's signature first. Alberta was assertive and accomplished as a painter, musician, writer, and lecturer (plate 40). Possessed of a keen mind, she was the catalyst of the team.

When Alberta and William McCloskey left Denver to visit her family and establish residency in Los Angeles, in June 1884, the city was growing rapidly, but the cadre of artists was small and consisted mostly of nonprofessionals.[30] The McCloskeys, skilled in both portraiture and still-life painting, found acceptance in the community for the quality of their work as well as for Alberta's vivacity and energy. The McCloskeys were constantly active, exhibiting, fulfilling portrait commissions, and teaching a painting class. Teaching provided immediate income, increased exposure to the public, and clearly validated their professional status as artists in the community. Alberta's schedule was full—painting, lecturing to women's groups, caring for the children, entertaining, running the family business—and enjoying the acceptance of a community starved for art. The limited market for art and the lack of artistic stimulation in Los Angeles brought the McCloskeys to New York in 1886, where they continued to paint even more portraits as their client base expanded along the Atlantic coast. Their exhibition schedule was heavy, and they had expanded their subject matter into genre pictures. The most unusual and successful of their compositions, however, were the still lifes of tis-

sue-wrapped oranges that both Alberta and William produced at this time.[31] These masterful still lifes were the culmination of the McCloskeys' artistic efforts, each producing paintings so similar in style and technique that identification without signatures would be difficult. The striking similarities suggest that they may have worked in tandem in this genre as well. Oranges in the last decades of the 1800s were still a luxury item on the East Coast. Shipped from California, wrapped in tissue, the orange rapidly gained acceptance for its flavor and color as an exotic fruit. Most of these paintings include a rich, dark, velvet background as a foil for the bright orange fruit, an expensive luxury that appealed to affluent Easterners. Alberta renders the oranges smoothly and meticulously to create an illusion that fools the eye (plate 41) in a still life reminiscent of the Peale family tradition that employs shallow, table still-life settings.

After six years in New York City, the McCloskeys moved once again, this time to Paris, where their work was not only accepted but praised by some of the leading art luminaries of the day: "[Jean-Léon] Gérôme, one of the leading artists and teachers in Paris, recognized their genius and ability, and voluntarily presented them with a credential letter, which was purely a testimonial to their art."[32] The Parisian critic Armand Sylvestre spoke of their work as "possessing the delicacy of [William Adolphe] Bouguereau and the strength of [Léon] Bonnat."[33] The severe Parisian winters and William's frail health brought the McCloskeys back to Los Angeles in 1894, where they opened a studio and resumed their efforts to obtain portrait commissions. In 1895 prominent Los Angeles businessman and land developer Harris Newmark posed for his portrait (plate 42), a picture that displays the simple format and formula they used. In a lecture to Friday Morning Club members, Alberta shared the McCloskeys' working methods. One of the artists entertained the sitter to put him or her at repose, while the other painted the portrait. The background was carefully calculated to complement the complexion and coloring of the sitter, and a strong Rembrandtesque light brought face and hands into prominence, while the rest of the figure was shrouded in darkness. Their intention was to portray the character and spirit as well as the physical attributes of the sitter.[34]

37. Mrs. Evarts Worcester Farr (Ellen Farr), Washington, D.C., 1879

After a year in Los Angeles the McCloskeys left for San Francisco, a move, like others, prompted by portrait commissions. Years later the McCloskeys' daughter described Alberta as a "high-liver" and a "spendthrift," and William by contrast as conservative but unable to control his multitalented spouse, who decided how and where to live regardless of cost. (William eventually suffered a nervous breakdown.)[35] Alberta's slight physical deformation, the result of a childhood injury, may have caused her to feel that her life span might be shortened and, in turn, may explain in part her attempt to crowd as much as possible into each day. In 1895 Alberta was interviewed by a Mrs. A. E. Grady of the *Atlanta Constitution,* who described her in glowing terms: "There are some people who should have monuments erected to them before their death. And in meeting Mrs. McCloskey it has been forcibly brought to me."[36]

A provocative characterization of another of the married couples was given by artist

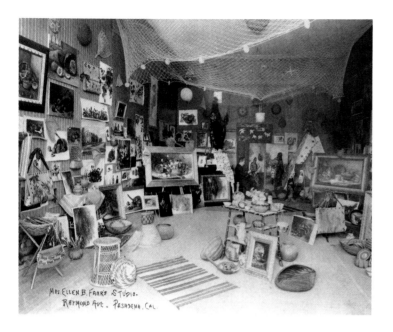

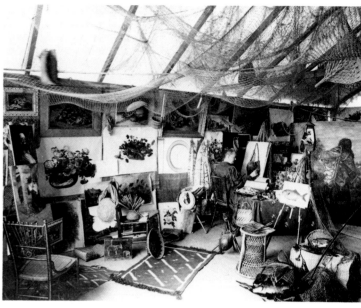

Luvena Vysekal (whose nom de plume was Benjamin Blue) in the *Los Angeles Times* on November 19, 1922:

> This is to be the portrait of a name—a famed name that is the official appelation of a pair of popular painters—a name that when attached to a picture is as good as a check. . . . A connoisseur might go so far as to try to determine which is whose and whose is which.
>
> As like are they as two peas in one pod. Alike in theme, in treatment, in feeling and tempo. Eucalyptus trees in the foreground. Blue and purple hills in the distance. California! Perfect team work, rare congeniality, two souls with but a single thought. But ah! There is a difference. Smell them! Taste them! His'n are oil! Hern are aquarelle! And they say that water and oil never mix! Well, they surely are mixed there. After you've decided which is oil and which isn't, you may state your preference. Since I'm dieting, I'll choose water color.[37]

This was "a perfect union of minds, hearts and aims," wrote art critic Antony Anderson in *Elmer Wachtel: a brief biography*.[38] Anderson was referring to the storybook marriage of Elmer Wachtel to Marion Kavanaugh in 1904. Of all the married artists in this group, the Wachtels were the most compatible professionally. They played, worked, sketched, and painted together, painting the same scenes but in different media. Marion was twenty-seven when she married Elmer, ten years her senior; both were mature and extraordinarily talented individuals. Elmer was particularly gifted as a musician, having to choose between music and art as his profession, and he was a skilled craftsman as well. Their third studio-residence on the banks of the Arroyo Seco in Pasadena, near Linda Vista, became a setting for their exhibitions and entertaining, as well as a gathering place for the local artists who made early California history. According to Elmer's grandniece, Virginia Hansen-Moller, Marion had confided in her late in life that "it was Elmer's choice not to have children; it probably would have interfered with their relationship and planned sketching tours together."[39] The Wachtels' marriage of twenty-five years was filled with extensive travel, by horse, on foot, and in a custom-designed and -equipped automobile, throughout Southern California, the high Sierra (see plate 43), and the Southwest, where they painted at Arroyo Hondo, Walpi, and Oraibi. On these trips they sketched and painted, often enduring the hardships of these remote areas—living among Native Americans and Catholic monks in New Mexico and Arizona.[40]

At the time the Wachtels were married, Elmer was already recognized as a teacher and artist, known for his ability "to fire the spark of genius in others."[41] Some historians have written that Marion Kavanagh left Chicago and came west to study with William Keith, who

in turn referred her to Wachtel for instruction. It is unlikely that it happened in this way, because Marion had already studied at the School of the Art Institute of Chicago and was teaching art in Chicago's public schools.[42] After her marriage, Marion Wachtel's career as a painter began to flourish, undoubtedly influenced by her painter-teacher husband. Of the many conservative painters of her time, Marion received unusually broad media coverage from art critics. Dudley Crafts Watson, a Chicago lecturer and critic, wrote: "The land of heavenly climate and grand vistas is still more glorified by Mrs. Wachtel. That state should endow her handsomely as an agent, and send her paintings broadcast, with full instructions as to the nearest railway office, and they might be entitled The Magic Call of California, for they make us want to go."[43] Los Angeles Times critic Antony Anderson, best described as never seeing a picture he didn't like, was completely captivated by Marion Wachtel's painting for more than a decade. "To me, the water color landscapes of Marion Kavanagh Wachtel are the most notable being painted anywhere," he wrote; and years later, "Mrs. Wachtel paints with a masterly skill, and with a breadth of brushwork and a freedom of expression that places her at once among the world's greatest exponents of the art of the modern aquarellist."[44] Sunset Clouds #5, 1904 (plate 44), exemplifies the poetry and spiritual insight of Wachtel's early watercolors, which are unlike her later decorative work with its sweeping vistas of sunlit valleys, vast hills, and distant bluish or purple mountains—a picture-making formula she shared with her husband.

Marion Wachtel exhibited widely—with two one-woman shows at the Los Angeles Museum of History, Science and Art—and received several prizes from the Pasadena Society of Artists: First Prize in 1940 for Approaching Storm; the Lang Prize in 1941 for Mount Moran; and the McBride Award in 1944 for Green Hills.[45] She was the only woman artist included in The Ten Painters Club of California, established in 1919 as the "foremost Painters of the West."[46]

A long-planned trip to Mexico in 1929 ended sadly with Elmer Wachtel's unexpected death. When Marion resumed painting, she returned to oils with some success, as her awards indicate. Pedro de Lemos, director of the Stanford University Museum and Art Galleries, best described why Marion Wachtel's paintings will endure: "Wachtel paints livable pictures. No other artist has created as much romance in California landscape painting as this talented California woman. . . . No California artist has had more of . . . [her] paintings reproduced in color printings for use in American home decoration than Marion Wachtel."[47]

The meeting of Adele McGinnis and Albert Herter, in contrast to that of the Wachtels, took place in a foreign setting. Adele was seriously pursuing an artistic career in Paris, after studying with Gustave Courtois, William Adolphe Bouguereau, and Tony Robert-Fleury. Shortly thereafter she and Herter married, in 1893, and began to raise a family before moving back to New York several years later. Albert was a man of enormous vitality and articulateness as well as a successful entrepreneur (the founder of Herter Looms) imbued with strong Victorian ideologies. Adele worked with him on many of the important Herter Looms commissions, usually in the shadow of this dynamic man. The Herters were described by Grace Wickham Curran in the American Magazine of Art in June 1927: "They are both intensely artistic, with tastes, sympathies and aspirations so harmonious that wherever they are they create an environment of beauty, not only of material things but of heart and spirit as well. . . . Mrs. Herter, although always frail in health, has been not only a painter of great distinction, but a mother wise and devoted in a rare degree."[48] Adele Herter was an accomplished professional painter, a member of the National Association of Women Painters and Sculptors and represented in a number of important exhibitions. Her active involvement with Herter Looms, however, prevented her from exhibiting extensively.

After Albert Herter's mother died, in 1913 in Santa Barbara, the Herters began to convert her estate-residence, El Mirasol, into an exclusive hostelry for wealthy travelers. Santa Barbara was another of the early "islands on the land," noted for its climate, scenic grandeur, and palatial homes—a destination-resort for wealthy conservative Easterners. It was also an art center of considerable importance that included an active artists' colony. In 1914 the Herters established a second residence in Santa Barbara. (Their sumptuous East Hampton, Long Island, home was described by Amy L. Barrington [House Beautiful, April 1919] as "a

40. Alberta McCloskey, n.d.

42. William and Alberta McCloskey,
Portrait of Harris Newmark, 1895

perfect fielde of delite."[49]) Together the Herters worked on the monumental task of converting El Mirasol, and Adele attended to every detail of the furnishings. Assisted by Albert, designer David Imboden, and several of Herter Looms's young designers, among them Jessie Arms (later Jessie Botke), she painted a remarkable series of mural decorations in the newly created Desert Room: "Against a background of aluminum leaf glazed with a dull gold, loom faintly the desert ranges, and in the foreground are many varieties of cactus and other desert flora."[50] Several decades later Frank Lloyd Wright pronounced the series "one of the most beautiful wall coverings in the world."[51] In a similar vein, Adele Herter created mural decorations using cactus motifs for the dining room at Casa del Sueño in Montecito, the former residence of Amy du Pont (plate 45). These were described in *House Beautiful* in May 1931: "On walls covered with silver leaf are conventionalized clouds in glazed gold and low mountains of architectural character in copper color. The middle ground is sand color, outlined, as are all the forms, in reddish purple, and in the foreground are cactus plants delicately drawn in their lovely natural shades of tea rose, salmon, and coral with blue-green foliage. These plants are also conventionalized and completely border the room in a rhythmic rise and fall that acknowledges the architectural setting and placing of furniture."[52] Fascination

with cactus plants and their artistic possibilities also led to paintings by artists such as Henrietta Shore, Louise Everett Nimmo (plate 46), and others at this same time. The popularity of cacti in the 1890s was renewed in the twenties and thirties, as seen in Southern California houses and gardens as well.

Adele Herter's work resembles her husband's in its beauty of color and decorative quality, but it is softer, more delicate, and frequently misattributed to Albert. Her frequent use of pastel in numerous still lifes and portraits probably affected the colors and tonalities of her mural work.

As active members of the Santa Barbara Community Arts Association, the Herters contributed their expertise on numerous occasions and also offered generous financial assistance. They staged art exhibitions and became involved in a number of plays at the Potter Theater as well as in the organization of the local symphony.[53] On February 1, 1951, they were given a two-person commemorative exhibition at the Santa Barbara Museum of Art in recognition of their contribution to the arts.[54]

Jessie Arms and Cornelis Botke exemplify the successful husband-and-wife team in which the wife is the dominant figure. Although Jessie Botke was recognized as the premier decorative bird painter of her era, she was quick to give her husband Cornelis credit for the murals they worked on together, not by signature

PATRICIA TRENTON

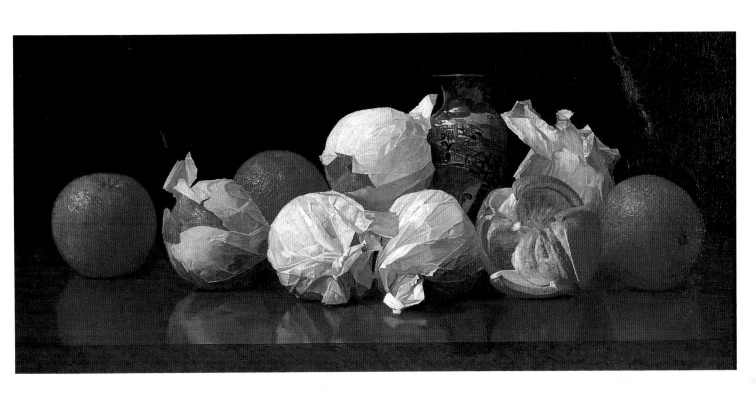

41.
Alberta McCloskey, *Still Life, Oranges with Vase*, 1889

43. Marion Kavanagh
Wachtel, *Crystal Craig
and Lake George near
White Lodge,* c. 1925

but in the media, at every opportunity. In an interview with Ernest Watson in 1949, Jessie Botke pointed out that "artist teams are much more common now than they were when we were married [1915]," and she added without hesitation, "They work. I can't conceive of myself living with anyone but another artist. Cornelis and I lean heavily on each other for advice, criticism, and encouragement. Our work is not at all alike, but when it comes to commissions such as murals and other large jobs, we can adjust ourselves to the other's style and do the orders as a team."[55] Jessie Botke was outspoken, aggressive, and early in her career in the avant-garde of women's liberation, marching and demonstrating in New York City's suffragette parades of 1911 and 1912.

After working in Chicago, New York, San Francisco, Carmel, and Los Angeles, Jessie and Cornelis Botke found their Shangri-la in Santa Paula, California, a small citrus community near Santa Barbara, where they lived on a ten-acre ranch purchased in 1929. An old carriage barn made an ideal studio, which Jessie described as "big enough to swing a cat in" (plate

47). A review of Jessie Botke's life and artistic accomplishments reveals a hardworking artist, irreverent in many respects, yet throughout her life close to the Christian Science Church and its message that we are "*entitled* to express energy, vitality, and joy." Forever prodding, pushing, and exploring, she apparently required little sleep and was energized and refreshed by her work.

Botke's road to fame as America's most recognized decorative painter of birds began in New York, where she was employed by Albert Herter's firm, Herter Looms. Botke found this her best educational experience, despite almost four years at the School of the Art Institute of Chicago. An assignment to paint a white peacock led to a predilection for white birds—pelicans, geese, ducks, cockatoos, and especially peacocks inspired her to a high level of quality. Her work was so unique that Santa Paula banker-artist Douglas Shively, in an interview by the *Ventura County Star–Free Press,* said, "A finer craftsman never lived. . . . She cannot be copied, for a copy would be instantly recognized. She had a corner on the market—and that's not an easy thing to do." Botke's abilities as a craftsman and colorist led to several major mural and frieze commissions, including those from the Kellogg Company, Battle Creek, Michigan; Noyes Hall, University of Chicago; the Oaks Hotel in Ojai, California; and others. Although the commissions were Jessie's assignments, Cornelis put aside his own art to assist her on these major projects. By any measure the teamwork of this couple was exemplary (see plate 48). Jessie's work was widely exhibited by major museums and art galleries in New York, Chicago, Los Angeles, San Francisco, and other cities. She once remarked, "I feel like Midas: everything I have sells."

Botke developed her unique mature style gradually. She had studied her models—birds—at zoos across the country and in Europe. In 1941 and 1942 the Botkes even built their own aviary, stocking it with white and blue peacocks, silver and gold pheasants, ducks, and pigeons—but no cockatoos. "They can cut chicken wire as if it were thread," Jessie explained.

From Botke's early plein-air paintings, made while she was a student, to the graphic style of her decorative friezes and bird paintings with their fanciful landscapes, exhibited in the teens and twenties, she arrived at her fully developed style of the thirties. Her inspi-

44.
Marion Kavanaugh (Wachtel), *Sunset Clouds #5*, 1904

45. Adele McGinnis Herter, *Desert Mural,* dining room of Casa del Sueño, Montecito, California, 1920s

46. Louise Everett Nimmo, *The Giant Century,* c. 1935

ration came from a number of sources: initially from medieval and Renaissance tapestries and then from Japanese art for design and composition, with elements of Flemish, French, and Italian art for her landscape backgrounds and still lifes (plate 49). By the late 1930s she had already begun to tilt the picture plane forward and to organize her composition on a diagonal with large forms placed against the picture plane (plate 50). Far more often Botke relied on a simple format, utilizing colorfully plumaged birds on branches of flowering foliage set against metallic-leaf backgrounds (her signature) that could be interchanged or arranged to the client's or the artist's own preference (plate 51).

Continuing to paint even when she lost sight in one eye, and ever alert, Botke bartered a painting for cataract surgery. In an era when many women artists were forced to abdicate their careers, Jessie successfully integrated her work with her personal and public life.

In talking about her own career in relation to her painter-husband, Edgar, Elsie Payne "remembered another artist couple [the Botkes] whose relationship had been quite different from hers. . . . The devoted husband, Elsie was told, had waited on his wife 'hand and foot and did other things for her and thought she was so wonderful because she could paint. Mine,' she remarked with a note of bitterness, 'never gave me time to paint! I was always busy waiting on him, packing and unpacking.'"[56] Edgar

Payne's view was that "no matter how talented or able, a woman's place was to be at her husband's beck and call."[57] Elsie Payne's talent was overshadowed by Edgar Payne's domineering personality; although he admired her work, he never promoted it as she did his (plate 52).

When Elsie and Edgar married in Chicago on November 9, 1912, she was a well-established commercial artist earning a handsome living. Edgar, mostly self-trained, was beginning to be recognized for his work not only in the Chicago area and on the East Coast but also in Paris, where he was invited to become a member of the Union des Beaux-Arts et des Lettres in 1912. From the time of their marriage in 1912 until their separation in 1932, they moved frequently to work on commissions and exhibitions, living in Chicago, San Francisco, Canyon de Chelly, Glendale, Laguna Beach, and Los Angeles. A two-year European excursion included visits to Paris, Rome, Venice, Chioggia, Switzerland, London, and numerous other locations for sketching and painting. Their daughter Evelyn, born in 1914, attended almost a dozen different schools before she entered high school. It was a troubled marriage, with Edgar dictating most of the family decisions as his career prospered. Although Elsie worked on many of his major mural commissions, her major responsibilities were the care of their daughter and the household as well as the support and promotion of her husband's career.

47. Studio interior of Jessie Arms and Cornelis Botke, Wheeler Ranch, Santa Paula, 1994

Elsie apparently enjoyed the excitement of meeting clients, dealers, critics, and being the wife of a successful painter, but the disenchantment with Edgar's old-fashioned notion of a woman's place festered until she left the marriage in 1932. While there was no evidence of physical abuse, Elsie's mental state required psychotherapy to restore her energies and to allow her to emerge from under the domination of her husband. Once they separated, Elsie Payne began to teach, paint, and exhibit in her Beverly Hills studio, and she became active in many organizations, including the Women Painters of the West, the National Society of Arts and Letters, and the California Art Club.

In 1942 her painting *A Decent Burial,* based on an experience in Italy years before, won several major prizes. "With a new self confidence, inspired by such recognition, and a modest success with her gallery and school,"[58] she became increasingly involved in civic activities. During World War II she made pastel portraits of servicemen at local USO clubs and presented them to the sitters. *The Thrifty Drug Store,* painted about 1945, signaled a change of direction in her style (plate 53). From the decorative stylized patterning of her early work, she turned to regionalist subject matter, painted in a bold, realist manner. Zooming in on the female food server at the counter, she called attention to the wartime demand for women in jobs formerly held by men. Honored by

Women Painters of the West as an "outstanding oil painting" at the Pasadena Art Institute in 1950, *Bus Stop,* about 1943 (plate 54), expresses the same social concern by placing the bold figure of an African American woman prominently against the foreground plane as she waits wearily for a bus in downtown Los Angeles. Elsie's interest in the role of women in society, as seen in these paintings, reflects her own unfulfilled life. The Paynes never divorced, however, and when Edgar contracted cancer in 1946, Elsie returned to nurse him until his death on April 8, 1947. Although she was embittered when they separated, they maintained contact, and after Edgar's death she actively promoted his work as she continued to pursue her own successful career.

While the Payne relationship was a troublesome one that did not enrich Elsie Payne's work, the other artist teams functioned in atmospheres that fostered artistic production. Both members of the Botke and Herter partnerships retained their distinctive styles but each spouse was able to adapt to the other's work. The McCloskeys and the Wachtels were the closest stylistically, benefiting from the interaction with the partner, the Wachtels able to maintain their individual identities by working in different media.

Another marriage, that of Kathryn and Edward Leighton, proved that stereotypical gender roles do not always deter a successful

48. Jessie and Cornelis Botke painting the I. Magnin, Los Angeles, mural panel with cranes, 1939

president of the prestigious California Art Club, the largest and most influential art organization in Southern California, representing a conservative membership.

Kathryn's brother, Frederic Thomas Woodman, a member of the Harbor Commission and from 1916 to 1919 mayor of Los Angeles, helped the Leightons establish a social and political base. Indeed, Woodman's office resembled an art gallery, resplendent with Kathryn's paintings. As a painter Kathryn later displayed enormous versatility with subjects that ranged from portraiture to desert scenes to the big screen paintings of glacial scenery (plate 55).

In 1923 the Leightons and their son motored north in their camper to Banff and the Canadian Rockies for a summer of sketching, painting, and vacationing; in 1925 they traveled to Glacier National Park in Montana.[60] Kathryn Leighton's work as a landscapist is described in the *Los Angeles Evening Herald* of February 27, 1926: "The first to bring to galleries here the strange, wild charm of Glacier National Park for an entire exhibit, Leighton has a masculine sweep and strength to her brush, and few men painters can outdo the virility of her sunbathed peaks and wind-winnowed snowfields." Antony Anderson wrote in his *Los Angeles Times* column "Arts and Artists" on May 3, 1925: "Kathryn Leighton's election [to Painters of the West] is due to several important reasons. One is her splendid and persistent efforts for the cause of art in Los Angeles. Another is her strength as a painter. To say that she paints like a man may be no special compliment to her, but no doubt the virile [male] members of Painters of the West feel it to be so." "Masculine sweep" of the brush, "virility," and "strength" used to describe a woman's work were the highest praise. Like other women artists of her day, Leighton was undoubtedly aware of such comparisons that subtly deemphasized the achievements of female artists.

The trip to Glacier National Park in summer 1925 was fortuitous in another respect. The Leightons were invited by cowboy artist Charlie Russell and his wife Nancy to their summer home, Bull Head Lodge, on Lake McDonald, Montana, from August 12 to 26.[61] Kathryn had met Russell during a party at artist Jack Wilkinson Smith's studio in Los Angeles in June 1924.[62] Russell always regaled his guests with

partnership. Edward Leighton's financial support, the summers away from his law practice, and his companionship on vacations, enabled Kathryn to benefit as an artist from their bond and most likely contributed to her success as one of the foremost painters of Native Americans at a time when the subject was reserved for males. "If you should chance to be idling along West Forty-Sixth Street [Los Angeles] some night [looking for the studio of Kathryn Woodman Leighton—the artist who painted nearly 700 portraits of Indians], you might be startled to hear the quiet of that residential district mysteriously broken by the throb of war drums, the stamping of moccasined feet and the sharp blood-chilling whoops of Red Skinned Raiders. That would mean that authentic Indians from far and near were holding one of their occasional pow-wows."[59]

After graduating from art school in 1900 Kathryn Woodman married Edward L. Leighton, at that time the youngest lawyer to pass the New Hampshire Bar. Completely supportive of his wife's career, Edward was eager for her to succeed as a painter. After moving to Los Angeles in 1910 the Leightons worked to establish themselves in their respective careers: Edward attained prominence as a lawyer, while Kathryn gained recognition in the community as a painter, mother, and civic-minded clubwoman. For several years she was a vice

49.
Jessie Arms Botke, *White Peacock, Cockatoos and Flowers* or *Romance of Eld,* 1931

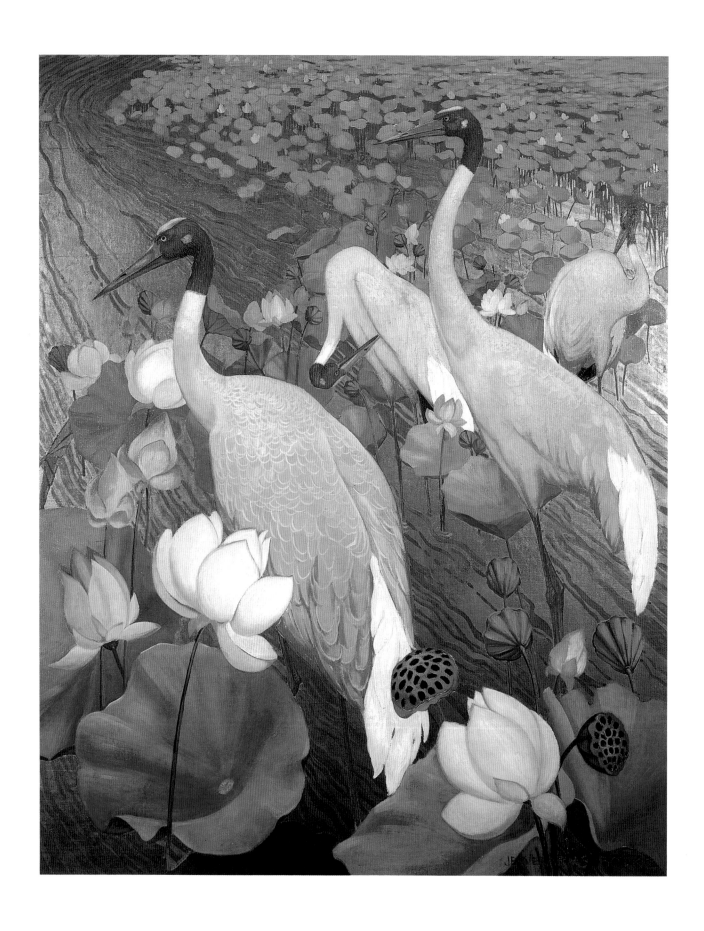

50.
Jessie Arms Botke, *Demoiselle Cranes and Lotus*, c. 1934

51.
Jessie Arms Botke, *Sulphur Crested Cockatoos*, c. 1942

52. Elsie Palmer (Payne),
c. 1905–10

53. Elsie Palmer Payne,
The Thrifty Drug Store, c. 1945

tales of Native Americans and other romanticized figures of the West, and it is very likely that on this visit Kathyrn was inspired to paint the Blackfeet.[63] Undoubtedly Russell was helpful in either making a recommendation, effecting important introductions to the Blackfeet, and/or suggesting contact with the Great Northern Railroad. The Great Northern with its presence in the Northwest sought to preserve a true record of the rapidly vanishing Native American civilization. In the summer of 1926 the railroad invited Leighton and her family to Glacier National Park as their guests for three months. Bringing together the chiefs of the Blackfeet tribe, the railroad maintained a large camp for the chiefs' stay and paid them for modeling. Leighton's assignment was to accurately record this Native American tribe in its traditional habitat and costume.[64] At the end of summer railroad officials were elated with Leighton's results and bought twenty of the paintings, reportedly at top prices.[65] The pictures were later sent on tour across the country with an accompanying lecturer on Native American lore.

The success of these paintings gave impetus to a new career for Kathryn Leighton at age fifty. She was propelled to fame as the world's outstanding painter of Native American portraits. Her portrayals of the Blackfeet chiefs, tribal members, and medicine men earned her the name "Anna-Tar-Kee" (beauti-

ful woman in spirit) and adoption into the tribe. Leighton spoke with high regard and affectionate understanding of her Native American friends: "I am trying to put on canvas the nobility of the old Indian as I see him, the beauty of colour, the dignity of tradition and the fundamental beliefs of our first American people. . . . I have painted all of the Blackfeet Indians in the colours of the sacred paints they use on their faces; you will notice their hands are usually a different colour."[66] In her quest to preserve the customs and traditions of the vanishing Americans, Leighton made annual pilgrimages with her husband and son to a large number of the Indian tribes: Blackfeet, Mohawk, Sioux, Cherokee, Iroquois, Hopi, and others with little-known names, such as the California Pala and Cupa.

Major exhibitions of these Native American portraits were held in Los Angeles, Chicago, and Boston, as well as in London and Paris, where they were glowingly reviewed by European art critics.[67] Many of Leighton's Indian portraits were painted in her studio, with Native American actors from Hollywood as models. One of the more important figures she painted was Chief Standing Bear (1861–1939), known also as Luther Standing Bear, "the Hereditary Chief of the Oglala Tribe of the Sioux Nation." This painting won first prize at a Friday Morning Club exhibition in June 1928 (plate 56).[68] Chief Standing Bear, a leader in the Na-

PATRICIA TRENTON

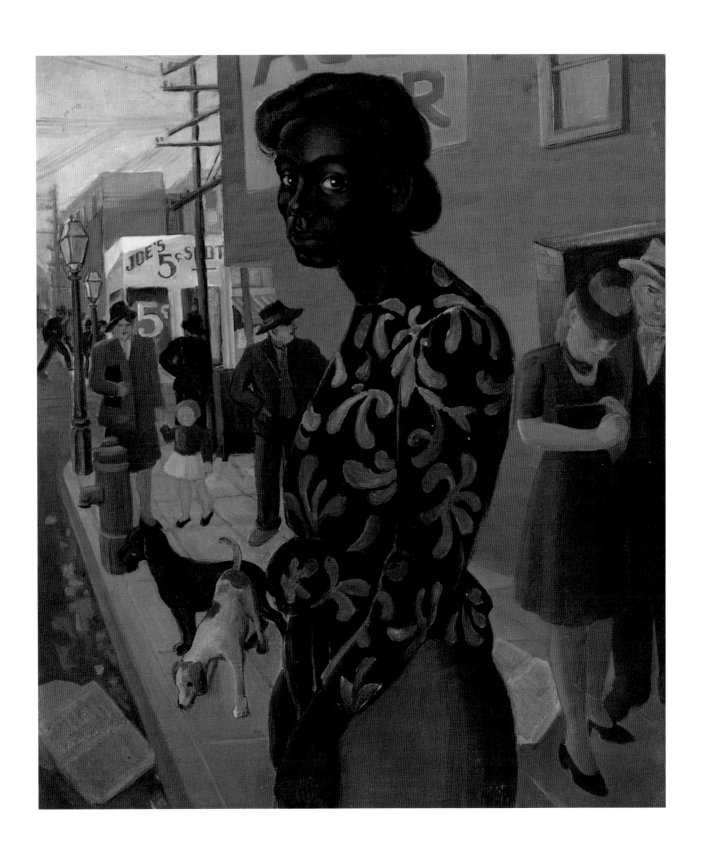

Elsie Palmer Payne, *Bus Stop*, c. 1943

55. Kathryn Woodman Leighton,
Grinnell Glacier, c. 1923

tive American world, was an interpreter with the Buffalo Bill show on its visit to England in 1902 and author of *My People the Sioux;* he was also instrumental in bringing many of the Sioux to Hollywood to act in films.[69] In this version of *Standing Bear,* one of several by Leighton, the chief is represented in his mature years, "in a meditative mood, having put aside the war-bonnet and tribal insignia in which he often . . . appeared for artists."[70]

Kathryn Woodman Leighton was not only an American painter of international renown but also a woman who managed to preserve her role as a homemaker. Jehanne B. Salinger, a reporter for the *San Francisco Examiner,* captured the essence of Leighton in this role: "A woman of . . . good New England stock, her primordial interest in life was in her home. . . . She had kept her life a unit, making her career suit her home life, adapting her home life to the needs of her career."[71]

While critics praised Leighton's paintings for their masculine attributes, the work of most women artists of her time was part of a Victorian tradition established in the early nineteenth century, when genteel women painted flowers and domestic objects. Edith White, Nell Walker Warner (1891–1970), and Lula Adams (1879–1952) (of whom little is known) belonged to this tradition (plate 57).[72] Although White had been called a "preeminent painter of roses," the reviews of Warner's flower paintings were even more radiant. In 1936 a writer for the *Christian*

Science Monitor observed that "California flowers allow Nell Walker Warner to continue a work that has acclaimed her America's foremost painter of flowers." Antony Anderson of the *Los Angeles Times* characterized Warner as "positively one of the ablest painters of flower studies America has produced."[73] The July 11, 1931 issue of the *Literary Digest* featured Warner's *In the Library* on the cover, and the critic described her achievement in glowing terms: "She succeeds in recreating that living fragility that is the essence of flower beauty."

Although Warner is known for her still lifes, her versatility as a painter is seen in her work from three summers at Cape Ann in New England. There, Eastern art critics commented favorably on her depictions of boats, wharves, and "life-like" surf. Professionally trained by painters Nicholas Fechin, Fritz Werner, and Paul Lauritz in Los Angeles, she received one-woman exhibitions in Los Angeles, New York, Portland (Oregon), Oklahoma City, and Hawaii. On a visit to Hawaii, Warner was particularly enthralled with the pure colors of the flowers, and the exotic flora and fauna of the island made ideal subjects for her compositions.[74] *Torch Ginger* (plate 58) is an outstanding example of this work and unlike her usual, full-to-overflowing floral bouquets set on reflective table-top surfaces along with familiar still-life objects (plate 59). Warner undoubtedly chose her subject from one of the many local Hawaiian gardens, and she rendered individual petals and flowers with a precise technical elegance.

Although divorced from her first husband, Bion Smith Warner, she continued to use his name professionally even after she married Emil Shostrom in 1945. Now financially secure, she was able to travel abroad and study with French and Spanish masters. To further her career, Warner belonged to a number of organizations. She was a president of Women Painters of the West and a member of the Glendale Art Association as well as other clubs in Pasadena and Los Angeles.

White and Warner gained their reputations as flower painters, while Louise Everett Nimmo (1899–1959) found her niche and inspiration in studies of cacti and succulents peculiar to the deserts of Southern California, Arizona, and New Mexico. Daughter of the well-known Los Angeles artist Mary O. Everett (1876–1948) (plate 60), who shared her studio

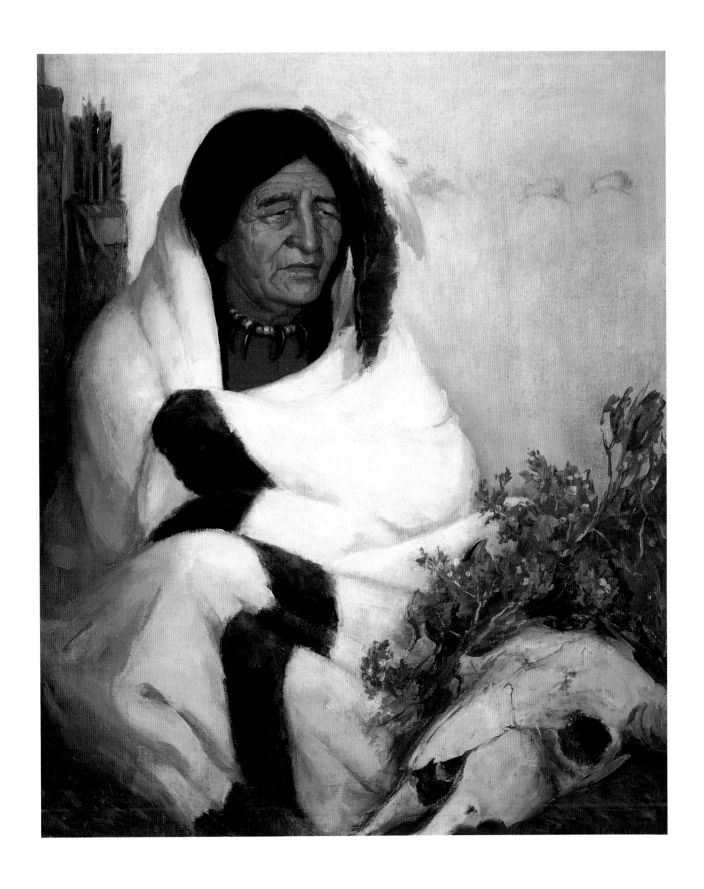

56.
Kathryn Woodman Leighton, *Chief Standing Bear*, c. 1928

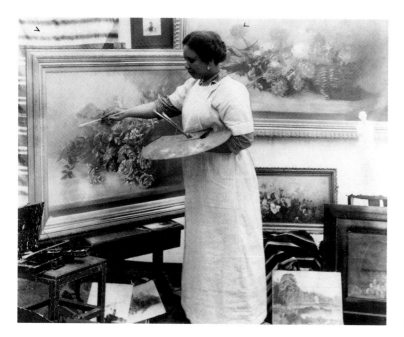

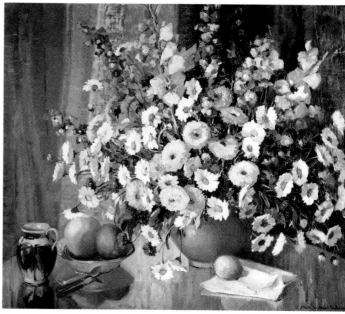

(see plates 61 and 62), Nimmo as a child traveled to Europe with her mother, gaining invaluable exposure to the arts in Paris and Italy. Years later Nimmo returned to study at the Fontainebleau school of fine arts and at the Académie Julian. Nimmo had begun her career as a sculptor, but when her brother Richard married California sculptor Eugenie Everett (b. 1908), Nimmo dropped sculpting to avoid competition with her new sister-in-law. In an interview with Eugenie Everett on February 27, 1993, Nimmo was described as "conservative by nature, very stable, with an engaging personality."

Nimmo's arrival in Los Angeles in 1919 was perfectly timed. The roaring twenties marked an influx of new immigrants even greater than that of the 1880s, and real-estate exploitation resulted in an ever-expanding art market. While Jessie Botke spent days at a time watching, photographing, and sketching birds in zoos and aviaries, Nimmo would often "make solitary sketching trips along the desert trails . . . observing the various types of plant and animal life, absorbing . . . the mystery, the vastness, the silence—those elements out of which such strange forms of life are evolved and nurtured."[75] Many of her paintings from the 1930s of cacti or succulents were in a modernist idiom, with enlarged flattened forms tilted toward the picture plane, but the subjects were still readily identifiable (plate 63).[76]

In 1931 the painter had married Ray Nimmo, a practicing lawyer and former district attorney in Los Angeles. It was a compatible marriage of two mature adults. Ray Nimmo was very supportive of his wife's career and often joined her on plein-air sketching trips. As a tribute to his wife, he wrote a foreword to an exhibition catalogue of her work shown at the Friday Morning Club in January 1933:

> The Southwest offers to artist interpreters of nature an infinite field. Here one finds vivid color and fantastic forms. . . . Few have discovered the beauty of form and color revealed by the hardy flora of the desert. That sturdy sentinel, the giant Sahuaro, is indeed an heroic figure, while the delicate ocotillo, the temperamental cholla and robust prickly pear are interesting companions pictured in the arid wastes.
>
> . . . I am indeed proud of the manner in which my wife has presented her subjects and the subtlety with which she has brought out the rugged beauty of her Cactus friends.

Another of the "islands on the land," Laguna Beach was probably first discovered in the late 1870s by artists who were captivated by its scenic beauty.[77] From that time, painter after painter came to depict the unique light of the area that blended sea, mountains, and desert, and they produced landscapes reminiscent of those painted in the south of France. For Anna Althea Hills (1882–1930), capturing

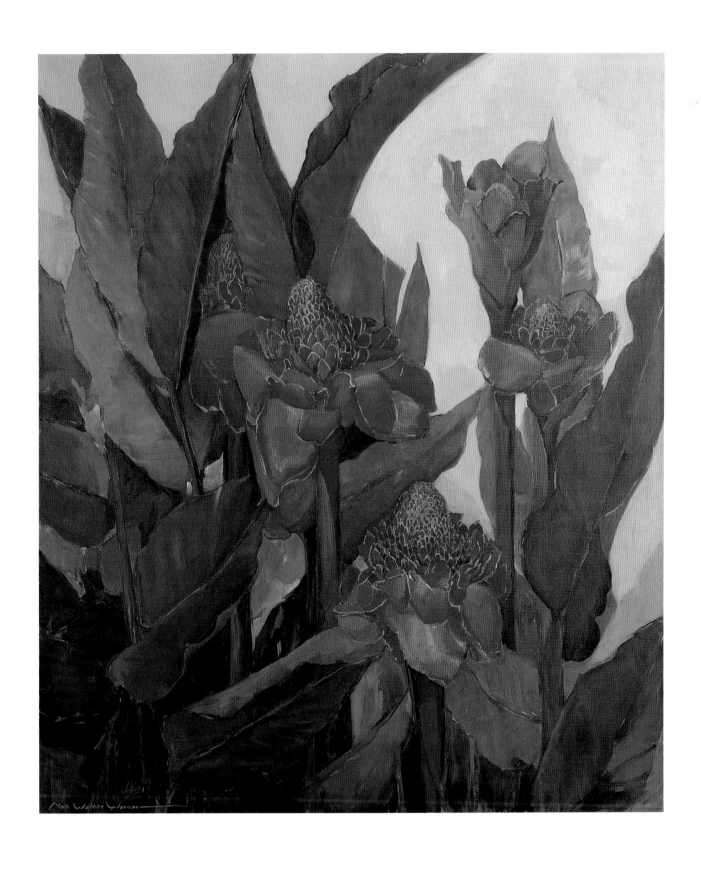

58.
Nell Walker Warner, *Torch Ginger,* n.d.

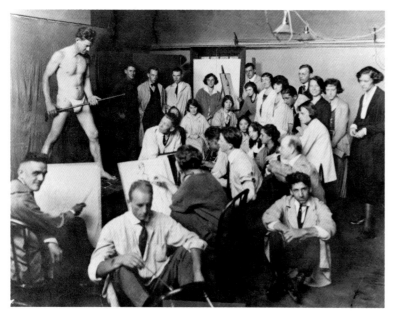

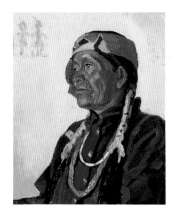

60. Mary Orwig Everett, *Tolano—Governor of San Ildefonso, Tewa, N.M.,* 1930

TOP LEFT
61. Otis Art Institute Fine Arts students life class (including Louise Everett), 1921

TOP RIGHT
62. Louise Everett Nimmo, Mary Everett, and Eugenie Everett's studio in Los Angeles, c. 1935

the unique light and landscape of Southern California was a new demand. Hills was trained in the darker "tonalist" style prevalent at the academies and schools in both Europe and the United States at the turn of the century, but after moving to Laguna Beach in 1913 she began to adopt a higher chromatic range and a more colorful Impressionist palette and brushwork to delineate forms (plate 64).[78]

Art critic Melinda Wortz wrote of the painter's work in the *Los Angeles Times* on January 31, 1977: "Hills . . . evokes the essential and specific optical sensations aroused by the Southern California landscape." Historians and critics remember her for paintings of the slender, sunlit eucalyptus that use the decorative, sinuous and often rhythmic forms of the so-called Eucalyptus School (plate 65, page 40).

A native of Michigan, Hills studied at the School of the Art Institute of Chicago and at Cooper Union in New York, as well as during a summer with artist-teacher Arthur Dow.[79] She taught for several years before traveling to Paris for further study at the Académie Julian. Living in England, Holland, and France, she remained in Europe for almost four years. In 1913 she moved to Laguna Beach with her sister (also unmarried), where she opened a studio and taught part-time as she pursued a career in landscape painting (plate 66).[80]

Anna Hills was brought up in a deeply religious household in which both her father and a brother were Presbyterian ministers. In Laguna she was actively involved with the church and supervised its Sunday school for ten years. Physically energetic, despite a severe spinal injury, she frequently took adventurous trips into remote mountain areas to sketch. Her greatest recognition came from the dynamic leadership she displayed as president of the Laguna Beach Art Association for six years (1922–25 and 1927–30); in 1929 she was instrumental in establishing a permanent location for what is now the Laguna Art Museum.

Unlike Anna Hills, Donna Schuster (1883–1953) was a liberated woman (plate 67).[81] Like Hills, however, Schuster was instrumental in founding and serving in various women's organizations: she was first vice president of the newly formed Woman's Art Club of Southern California in 1921, an active member of Women Painters of the West, a founding member of the California Water Color Society, and a member of the progressive Group of Eight painters. Many of the other conservative women artists also developed networks of support as they organized art clubs and associations, and founded schools and museums where they exhibited, taught, and promoted art.

Schuster's painting *Sleep,* an impressionistic nude in a hammock, painted in Southern California about 1917, marked a radical departure from her usual subject matter at that date (plate 68). Its daring brought shock waves in a

PATRICIA TRENTON

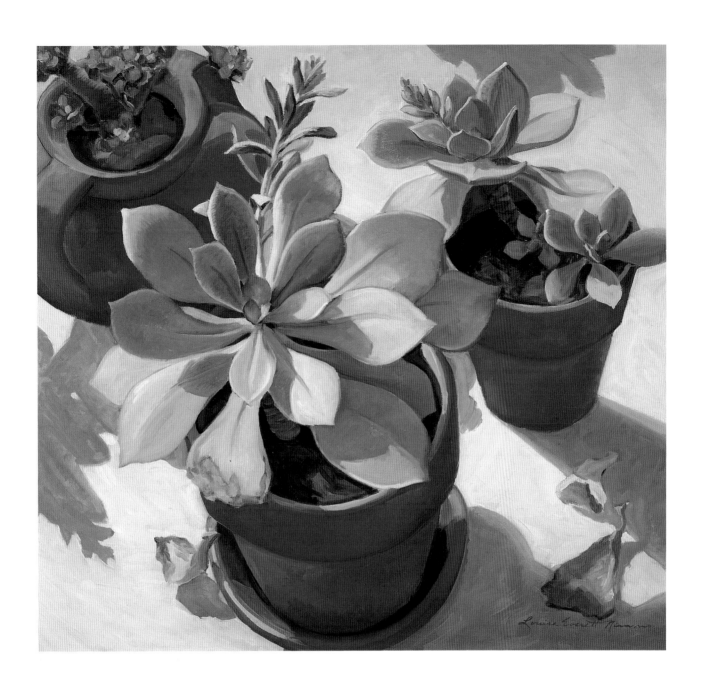

63.
Louise Everett Nimmo, *Untitled [Succulents]*, c. 1933

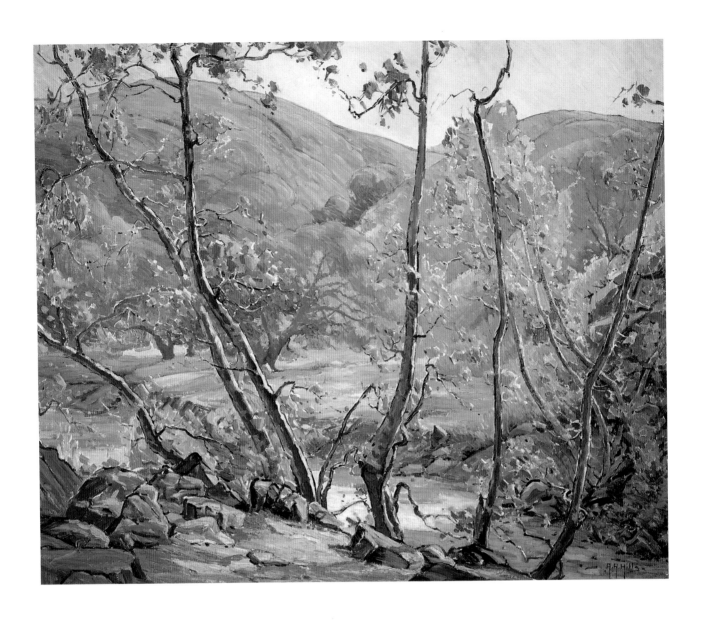

64.
Anna Hills, *Untitled [Sycamores]*, n.d.

review by art critic Jessie Maude Wybro in *The Graphic* on October 20, 1917: "Oh johnny, oh johnny! What malign spirit ever induced her to perpetrate 'sleep,' a nude with shoulders hunching out of a hammock that sends one running quick for a blanket to cover them up!" Like the American Impressionist Frederick Frieseke, Schuster posed a nude model in an outdoor setting with dappled, colored light playing on her soft feminine body. Unlike Frieseke, an expatriate who was exposed to more liberal European attitudes toward the nude, Schuster was not free from the puritanical restrictions of her native land.

Schuster received her early art training at the School of the Art Institute of Chicago and later studied under Edmund Tarbell at the School of the Museum of Fine Arts in Boston. She continued to develop her skills on a summer sketching tour in Belgium with William Merritt Chase in 1912 and two years later attended his summer class in Carmel.

The American sector of the 1915 Panama-Pacific International Exposition in San Francisco was dominated by Impressionists, including Schuster, who won a silver medal for her watercolors; the European sector, in contrast, featured Cubism, Orphism, and Futurism. Throughout her career Schuster was her own model for the women in pictures that explored new techniques, such as *Le Petit Déjeuner, Early Breakfast,* and a number of self-portraits (see plate 69). Why Schuster painted so many self-portraits over a twenty-year period is rather puzzling—a lack of self-identity or self-importance perhaps, ego, immaturity? It certainly was not loneliness. Schuster's roving eye involved her with a number of male suitors, including artist-etcher David Tice Workman, a former student at the Museum School in Boston, with whom she spent an idyllic summer at Howard Lake in Minnesota.

In 1920 *Los Angeles Times* critic Anderson characterized Schuster as "eternally youthful," "somewhat impatient," "painting with happy abandonment," "strong willed," and with "a delicious sense of humor." Luvena Vysekal also described her: "a flashing vitality in every movement," "insistent in her youth," "aggressive," "loving the limelight," and "emitting an effulgence of exuberance that exhausts the onlooker."[82] Although Schuster's earlier work was essentially impressionistic, throughout her ca-

reer she sought the most advanced trends in art, enrolling repeatedly in classes with recognized artist-teachers and experimenting in both oil and watercolor with techniques and styles developed by modernist painters.

As tastes in art changed and interest in Impressionism began to fade, the flatter, more two-dimensional forms and nonrepresentational colors of modernism were rapidly gaining momentum in this corner of the West. Schuster was more open to the new and more innovative than most of the several early women artists of Southern California who bridged the conservative movement and modernism.

The uncontroversial art of these Southern California painters was typical of painting in the region from about 1890 to 1945. The legacy of many traditionalist women artists like Jessie Botke, Kathryn Leighton, Marion Wachtel, and Donna Schuster reinforced the acceptance and popularity of the conservative movement in California. Despite the support for these painters by collectors and art critics,

66. George E. Hurrell, Anna Hills in her Laguna Beach studio, c. 1919

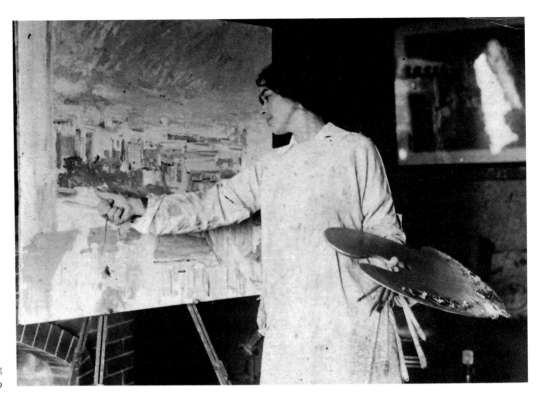

67. Donna Norine Schuster painting at her easel, Los Angeles, 1929

modernism began to emerge in the early part of the twentieth century. First perceived in some circles as a novelty rather than a serious direction in art, modernism began to challenge the dominance of more traditional art through deliberate group efforts in the 1920s.

As American artists continued to travel and study in Europe, particularly in Paris, they became vehicles for the importation of modernism. With the rise of Hitler and Europe's shifting political climate in the late 1930s, there was an exodus of European artists to this country. Many of them had been associated with avant-garde movements in Europe, and along with a new breed of American painters they set the stage for the rise of Abstract Expressionism in the 1940s.

With the accelerating trend toward modernism, the appeal of conservative art began to wane, and a rebellion against the new styles

surfaced. Recognizing the loss of support for their art, and its economic implications, Southern California conservatives fought back by forming the Los Angeles branch of the Society for Sanity in Art in 1940. Spearheaded by Edgar Payne, the group included most of the conservative women painters, although not his wife, Elsie.[83] In the society's constitution, Payne outlined some of their goals: "The object of this Society shall be: To encourage and promote an art that is based on sound, fundamental principles. To uphold, practice and teach those essentials which translate quality in nature and create quality in craftsmanship. To display, exhibit, and publicize works of art that are *sane, understandable* and built upon tradition and precedent of the past as well as new contemporary ideas."[84] Clearly, in 1940 there was still a large conservative camp that promulgated the virtues of representational art in Southern California.

68.
Donna Norine Schuster, *Sleep*, 1917

69.
Donna Norine Schuster, *The Black Hat*, 1911

87.
Helen Lundeberg, *Microcosm and Macrocosm*, 1937

III

The Adventuresome, the Eccentrics, and the Dreamers

WOMEN MODERNISTS OF SOUTHERN CALIFORNIA

Ilene Susan Fort

"I HOPE TO SEE . . . a painting by a woman that really is a woman's painting," remarked Stanton Macdonald-Wright (1890–1973) on the occasion of the 1942 exhibition *Women Painters of the West*. "Man, having usurped the field primarily, has made for painting a male criterion and unfortunately women have fallen for it."[1] Internationally famous by this time, Macdonald-Wright had advised many women painters since he returned to his native Southern California in 1919. Although he had been responsible for the modernist tendencies in some of their work, the issue of gender nonetheless blinded him to their achievements.

From about 1910 until World War II, a significant number of progressive Southern California artists were women. Their art and their activities encouraged the birth of the region's culture as we know it today. Most of these women were based in the urban areas of a region that no longer typified frontier life but was witnessing a nascent intelligentsia. The largest contingent was active in the Los Angeles–Hollywood–Pasadena communities: Mabel Alvarez, Elise Cavanna Seeds Armitage (who signed her work just Elise), Anni Baldaugh, Belle Goldschlager Baranceanu, Dorr Bothwell, Grace Clements, Meta Cressey, Annita Delano, Helena Dunlap, Helen Lundeberg, Henrietta Shore, (Fanny) Adele Watson, and Beatrice Wood. Elanor Colburn and her daughter Ruth Peabody painted in the seaside community of Laguna Beach, while Agnes Pelton pursued her art alone in Cathedral City near Palm Springs. Among those working in San Diego and its neighboring ranches were Anni Baldaugh, Belle Baranceanu, Esther Stevens Barney, Dorr Bothwell, Alice Klauber, and Margaret (Margot)

Rocle. Adele Watson excepted, most of these artists were active in local art organizations and exhibitions and also contributed to more distant California shows. Some made their presence felt on the national scene in about the same degree as their male counterparts.

These painters were instrumental in founding early modernist clubs and associations. Helena Dunlap (1876–1955) and Henrietta Shore (1880–1963) helped form the Los Angeles Modern Art Society in 1916, the city's first such organization; by its second exhibition, in 1918, Cressey had joined; and when it reorganized in 1919 as the California Progressives, Caroline H. Bowles (active 1916–1920) and Luvena Buchanan Vysekal (1890–1939) became members. These groups were usually ephemeral, because they lacked local financial support. In 1923 a new Los Angeles association emerged that included several women among the twenty-four painters exhibiting as the Group of Independent Artists. Later, equally determined associations appeared in the smaller cities. Colburn, Peabody, and Irene

not limit the women's opportunities as much as it might have on the staid East Coast, for Southern California was far more open and freethinking. Women received numerous solo exhibitions in local art galleries and institutions as well as in Northern California museums.

Southern California women played a major role as local critics, which may explain why women painters in the region attracted as much attention as men. As early as 1916 Beatrice de Lack Krombach wrote comments on art for local San Diego newspapers; during the early 1920s in Los Angeles, Alma May Cook, Sonia Wolfson, and a number of other women writers for *Saturday Night* were active critics; in the 1930s Hazel Boyer Braun, Katherine Morrison Kahle, and Marg Loring in San Diego each had her own newspaper column, while Julia Andrews, Esther Stevens Barney, and Eileen Jackson occasionally wrote on art.[5] A critic's gender, however, did not guarantee a favorable review. Most critics neither emphasized the gender of modernist painters nor extolled the feminine qualities of their work. Most critical accounts were descriptive when they focused on the progressive nature of the work, and writers of both genders, initially confused about the new trends, remained reluctant to change their minds.

Although women modernists had gained considerable recognition, their reputations quickly faded after World War II. The progressive nature of their art more than their gender has caused their neglect in the historiography of Southern California. Not until the 1980s did historians, curators, and collectors realize that modernism had been a vital current in Southern California art long before the 1950s, the decade usually acknowledged as the birth of avant-garde painting in this region. Two landmark exhibitions, *Aspects of California Modernism, 1920–1950* (1986) and *Turning the Tide: Early Los Angeles Modernists, 1920–1956* (1990) were crucial in altering this perception, as were retrospectives devoted to Baranceanu, Lundeberg, Pelton, and Shore.[6] Yet even the revisionist surveys presented the role of women as minor: only five of the twenty artists in the 1990 exhibition were women. In reality as many women as men were creating vanguard art. Ignored as well are the positions of empowerment women held in increasing numbers, not only as critics but also as teachers, patrons, and deal-

Robinson (1891–1973) established Laguna's first secessionist group of modernists, the Contemporary Painters, in 1931; eight years later Peabody, Rocle, and Jean Goodwin (1903–1986) contributed to the first exhibition of Laguna's new Progressive Art Center.[2] Baldaugh, Bothwell, and Rocle, as well as Katherine Morrison Kahle (1877–1971), Ruth Ortlieb (active 1920s–30s), and Ruth Townsend Whitaker (active 1916–1935) were among the San Diego Moderns, formed in 1933.[3]

In their competition for the right to exhibit, gender placed these artists at a disadvantage. In 1919 Helena Dunlap was attacked for defending the modernists in a debate among Los Angeles artists over allowing the California Progressives to exhibit at the local museum. Dunlap explained that the issue had become sexist; critic Antony Anderson summarized her position in his *Los Angeles Times* column: "She has been accused, she avers, of having only selfish aims. . . . She . . . believes that some men . . . hold such an attitude toward women that when they (the women) stand up for what they believe to be right and just, they are at once accused of being 'troublemakers'. . . . 'Equal chance was our motto,' writes Miss Dunlap."[4] A few years later, advised by one of her female teachers, Bothwell changed her first name from Doris to the more neutral Dorr to avoid exclusion from competitive exhibitions on the basis of gender. Such discrimination, however, did

ers.[7] Annita Delano (1894–1979) and Galka Scheyer in Los Angeles and Alice Klauber (1871–1951) and Beatrice Krombach in San Diego were among those who helped shape the course of contemporary art in the region during the first stage of modernism.

The character of the Southern California modernist explains to a great extent her artistic choices. Highly independent, she represented the new, free-thinking woman. Well-educated and sure of herself, she did not require the intellectual or financial support of a man. Elise (1905–1962) was perhaps the most unorthodox: six feet tall, striking, with purple-tinted hair, she thought nothing of sending the collector Walter Arensberg a greeting card decorated with three buxom, smiling nudes frolicking in a chorus line (plate 70). Southern California, especially Los Angeles, was suitable territory for these liberated women—a place, even in the early decades of the century, where self-sufficiency was lauded and eccentricities commonplace.

Most of the California modernists discussed here represented a certain social class, with families from affluent backgrounds. Alice Klauber's father was a successful entrepreneur in Nevada and Northern California before his arrival in San Diego in 1870. Adele Watson's parents were prominent Ohioans who sought the winter warmth of Pasadena for their invalid son in the early 1890s. When the Toledo Museum gave Watson her first solo exhibition, the opening tea headed the society page of the local newspaper, and the columnist noted that Watson maintained her own painting studio "although [she was] fitted by birth and wealth to lead in society."[8] Mabel Alvarez arrived somewhat later; before the Alvarez family settled in Los Angeles in 1906, her father was physician to the queen of Hawaii.

Meta Gehring (1882–1964), the daughter of a prosperous Cleveland brewer, married Bert Cressey (1883–1944), son of a wealthy Compton rancher, and her family inheritance contributed

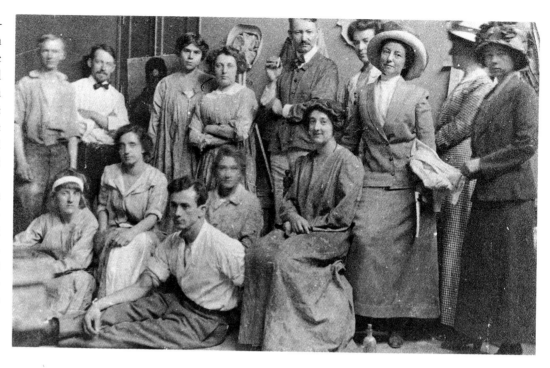

71. Robert Henri's 1912 summer school class in Spain (including Alice Klauber, Meta Gehring, Bert Cressey, and Esther Stevens)

to the Cresseys' carefree existence. Without the need to sell their work, many of these women did not have to satisfy the conservative taste of the marketplace. Among the few who had to support themselves, some created potboilers for the local trade—Agnes Pelton (1881–1961), for example—reserving their most radical paintings for their own pleasure, with little expectation of selling them.

Several of the women had already established careers before settling in California. Elanor Colburn (1866–1939) in Chicago, Pelton in New York, and Shore in Toronto had been successful painters, and Beatrice Wood (b. 1893) was a member of the radical New York Dada group. Some were talented in the performing arts: Rocle as a modern dancer and Wood as a stage actress; Elise originally moved to Hollywood at the request of W. C. Fields to act with him in the movies. Despite the achievements of the feminist movement in the early twentieth century, only free spirits would pursue those careers in the arts that still were considered rather disreputable.

These women painters had varied attitudes about marriage. Early on, Watson was quite cynical about the institution of marriage, and her attitude toward romantic love never changed. She wrote to her sister (who had experienced a brief, unfortunate marriage), "I guess the only happy people are the ones who have work to do and are quite finished with

72.
Meta Cressey, *Under the Pepper Tree*, c. 1926

73.
Henrietta Shore, *Floripondes*, c. 1925

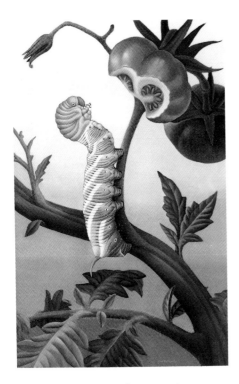

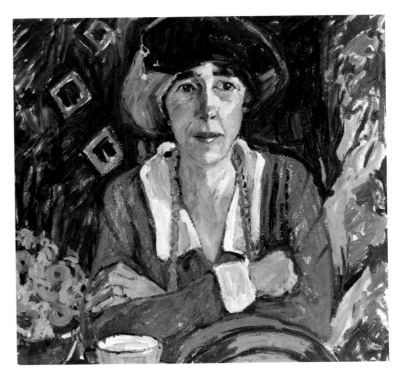

74. Dorr Bothwell,
The Devout Vegetarian,
c. 1933

75. Anni Baldaugh,
Murial, c. 1926

the opposite sex or care lightly."[9] Seven of the modernists remained single; Belle Baranceanu (1900–1988) and perhaps Mabel Alvarez (1891–1985) were disappointed in love. Whether the single status of the others—Delano, Klauber, Pelton, and Shore—was a conscious decision to devote themselves to a career, a matter of sexual preference, or fate is unknown. Pelton considered her abstract paintings her family.[10] Baranceanu and Shore's lesbianism has been conjectured.[11] But issues of sexual orientation are difficult to prove given the code of decorum that prevailed among middle- and upper-class women. Delano was so aware of the public tendency to wonder about single women that, to avoid being labeled a lesbian, she never shared an apartment.[12]

The independent spirit of the California modernists, however, did not preclude wedlock. Yet, while the majority of these painters did marry, few had traditional marriages. Less than half bore children and a significant number—Baldaugh, Barney, Bothwell, Colburn, Lundeberg, Peabody, and Wood—continued to support themselves and sometimes their families with their work and related activities. Bothwell, Cressey, Elise, Lundeberg, and Rocle all married fellow artists. Margaret Rocle (1893–1981) had taught her husband Marius (1897–1967) to paint. Elise and Helen Lundeberg (b. 1908) wed their mentors, Merle Armitage (1893–1975) and Lorser Feitelson (1898–1978) respec-

tively, before they developed their own ideas, and their work was determined by their husbands' interests.

Often the women were outspoken. Agnes Pelton, the granddaughter of abolitionist editor Theodore Tilton, demonstrated her liberal tendencies when she illustrated *When I Was a Little Girl* (1913), written by the suffragette Zona Gale.[13] Watson thought nothing of speaking her mind, even if it was to contradict a close male friend. Her mentor, the Armenian poet Kahlil Gibran (1883–1931), inspired her first mature painting, but she insisted on thinking for herself. After a visit to Gibran's studio, she wrote her sister, "Well, he hates me more than ever for having opinions of my own. . . . I am absolutely through arguing with him—his ideals are not mine—he . . . nearly expired when I told him he was inconsistent."[14] Gibran's reputation cast him as a great lover and Watson may have been one of his loves, but she refused to play the beautiful muse inspiring the poet. She ended the letter insistently, "He likes the airy fairy . . . variety—so can have her by the dozen if he likes as far as I am concerned." Shore had the opposite experience with photographer Edward Weston (1886–1958), a close friend during the late 1920s. He so valued her opinion—perhaps because she was already a successful painter—that he encouraged her comments and did not mind her "beastly" frankness.[15]

Dorr Bothwell (b. 1902) was at least as

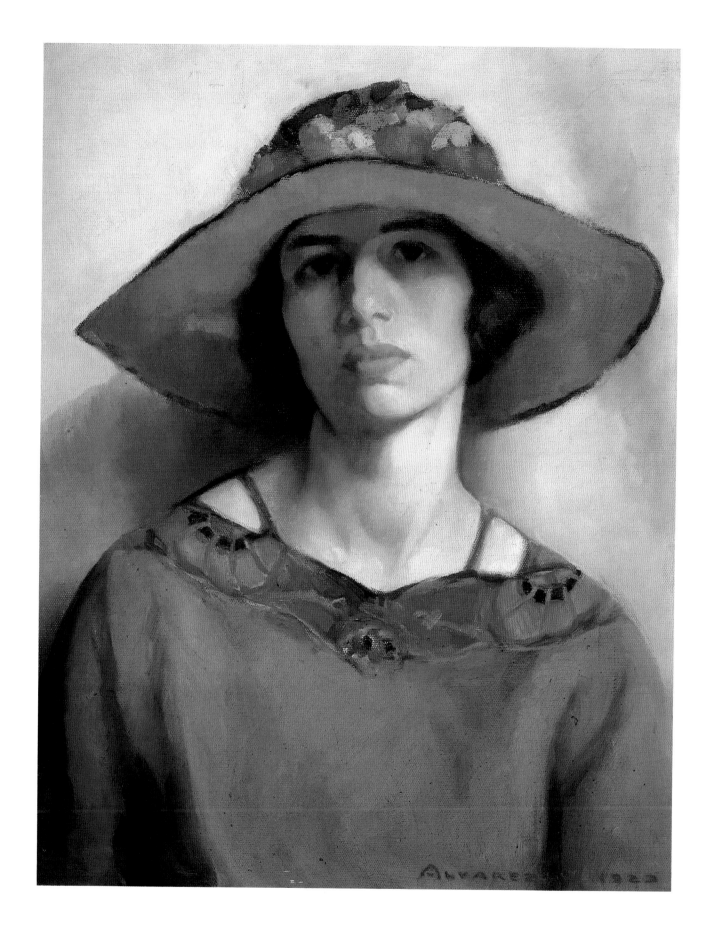

76.
Mabel Alvarez, *Self-Portrait*, 1923

outspoken and demanding as Shore and Watson. Although she married, she did not allow matrimony to impinge on her art. Indeed, her union with sculptor Donal Hord (1902–1966) was short-lived, because it was not one of complete equality. Hord would not share the household chores, even though he realized that time for creative work was as precious to her as it was to him. In 1993 she explained that she had expected the type of liberated marriage that only became typical in the 1980s.[16]

Most of the women were just as adventuresome as the men. Travel and the fresh stimulation it offered were part of their education. Yet their frequent visits to exotic locales had an element of escapism from conventional middle-class American society. Dunlap and Pelton explored the world extensively. Dunlap preferred destinations less visited by tourists, such as India. Bothwell was dauntless; captivated by the film *Moana,* she spent a year and a half living with the Samoans on the remote island of Tau. Both Dunlap and Bothwell thrived in hot, tropical lands, where the continuous array of picturesque subjects and the dazzling light became the sources of their sparkling palettes. Bothwell sent her first serious work back to California for exhibition, a group of small canvases of Samoan villages painted with hot tones in a flat, highly simplified manner based on the color theories of her San Francisco teacher Rudolph Schaeffer (1886–1988), but no doubt encouraged by Paul Gauguin's example. After working in Los Angeles for two decades, Alvarez returned to Hawaii in late 1930 to document the disappearing native population.

Mexico had a similar allure as a romantic and exotic retreat for Americans dissatisfied with life in the industrial age, especially during the depression,[17] and its proximity encouraged visits. Dunlap and Shore went to Mexico in 1927, and Rocle traveled there several times in the next decade, first with Kahle in 1931. Both Shore and Rocle typified the attitude of American artists of the period, idealizing the country's peasant class as figures in harmony with the land. Californians could learn about contemporary Mexican art and politics through the Mexican muralists, and they needed not even leave the state to do so, since Diego Rivera (1886–1957), Alfredo Ramos Martínez (1872–1946), José Clemente Orozco (1883–1949), and David Alfaro Siqueiros (1896–1974) all spent time in California. Baranceanu became acquainted with Rivera in the 1930s;[18] Alvarez watched Orozco paint his *Prometheus* mural at Pomona College in 1931; and Rocle owned paintings by both Rivera and Orozco.[19]

Although Carey McWilliams dates modern Los Angeles from about 1920,[20] progressive tendencies in Southern California art emerged in the teens. During the pioneering phase of modernism, roughly the interwar period, painters espoused a succession of major trends from Post-Impressionism and Realism to Surrealism, Cubism, and nonobjective painting.

Although the Southern California experience had special regional characteristics, it was substantially shaped by modernist activity elsewhere. New local art museums expanded the public's awareness of contemporary American trends, especially the work of The Eight, through special exhibitions and loans from private collectors. Some Californians became involved with the avant-garde firsthand during their studies in the East and abroad. Returning students Rex Slinkard and Annita Delano proselytized the new ideas through their teaching.

During the 1910s several women modernists arrived in California after attending academies in New York, Philadelphia, and Europe. Because of their training with prominent figure painters such as William Merritt Chase (1849–1916) and Robert Henri (1865–1929), they were not primarily interested in landscape, as were the then-popular plein-air painters. They often painted their friends, families, and domestic surroundings, since women could pursue such subjects without leaving home.[21] Despite the independence of these early women modernists, the public arena was still considered a male domain to be avoided by any proper young lady.

Native-born Helena Dunlap was the first woman to be called a modernist. In 1911, when she exhibited paintings at the Steckel gallery in Los Angeles, the critic of the *Los Angeles Times* noted, "We need pictures like hers in Los Angeles, because they are 'so different.'"[22] Donna Schuster (1883–1953) arrived on the scene a few years later in 1914, and the palettes of both women caused heated debate because critics saw them as different from the work of established resident painters. Although Impressionism and Post-Impressionism were already entrenched and even old-fashioned in Europe and

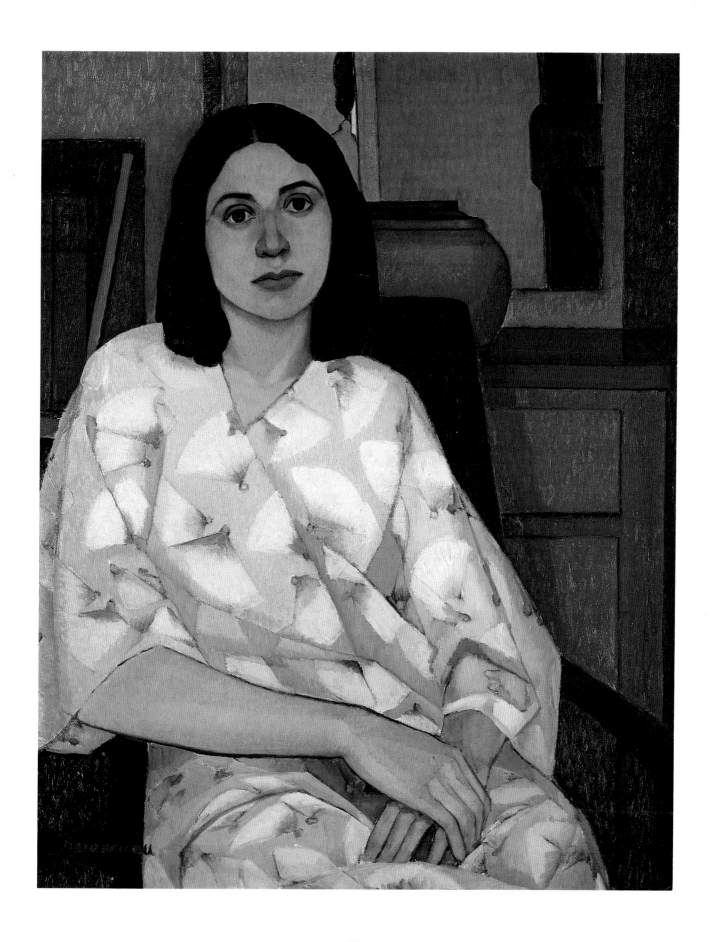

77.
Belle Baranceanu, *The Johnson Girl*, c. 1930

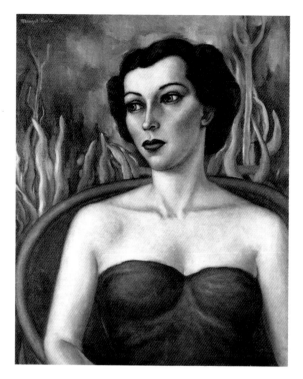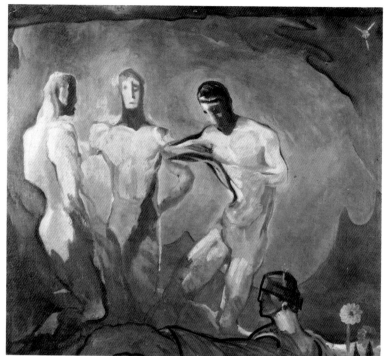

78. Margaret (Margot) Rocle, *Eileen*, c. 1939

79. Rex Slinkard, *Ring Idols*, c. 1915–16

on the East Coast, they were new to Southern California. Dunlap and Schuster brought sunlight and color to Southern California painting slightly before the better-known Giverny Impressionists Guy Rose (1867–1925) and Richard Miller (1875–1943) arrived on the scene (in 1914 and 1916, respectively). During the 1910s the work of all four painters served as a link between traditional and more progressive trends.

Although Schuster occasionally applied her colors in slashing strokes, as in *In the Garden, 1917,* she tended more often to evince a more controlled, calm paint handling.[23] It was left to Henri and his students to encourage the use of a vigorous Post-Impressionist brushwork among Southern California artists. The leader of The Eight, a group of New York artists who in the early 1900s championed the realistic depiction of everyday lower-class life, Henri was also a beloved teacher, who exhorted his students to abandon academic study of the nude by leaving the studio to record life around them.

After participating in Henri's summer class in Spain (plate 71), Klauber returned home to San Diego in autumn 1912. She soon was followed by some of Henri's other pupils. Henrietta Shore settled in Los Angeles in 1913, Meta Gehring (now married to another Henri student, Bert Cressey) came the following year, and Esther Stevens (1885–1969), as Mrs. Walter Barney, arrived in San Diego in 1921 (Margaret

Rocle only began to paint in California about 1925).[24] The presence of Henri himself, in La Jolla in 1914 at the invitation of Klauber to help organize a contemporary art display for the 1915 Panama-California Exposition, and a decade later in Los Angeles to complete portrait commissions, further encouraged a following. When Henri died, Esther Barney wrote that "meeting him was an event in a lifetime" and that his influence was inestimable.[25] Earlier, the Los Angeles modernists had accorded Henri, along with fellow Ashcan painters George Bellows (1882–1925) and William Glackens (1870–1938), honorary membership in their secessionist society.

Henri's disciples brought to California an appreciation of the environment, particularly of the aspects that made the region special. The Southern California sun and air transformed Meta Cressey, who devoted her entire mature oeuvre to capturing the natural glories of the region in views of her large garden in the Hollywood Hills, the family ranch in Compton, and the flowers in nearby areas. At times she incorporated figures into her compositions, but her people were usually of secondary importance and obscured by a jungle of natural growth. Like her friend Shore and other women modernists, Cressey focused on the unique and thriving vegetation of the region and its climate: cacti, lilies, pepper trees (see plate 72). In 1915,

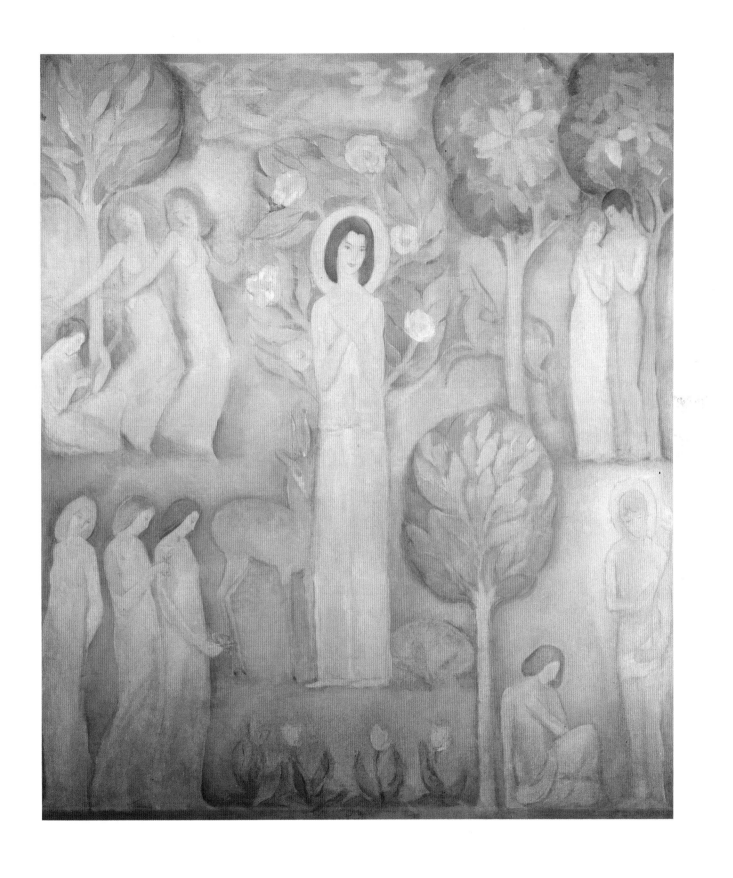

80.
Mabel Alvarez, *Dream of Youth*, 1925

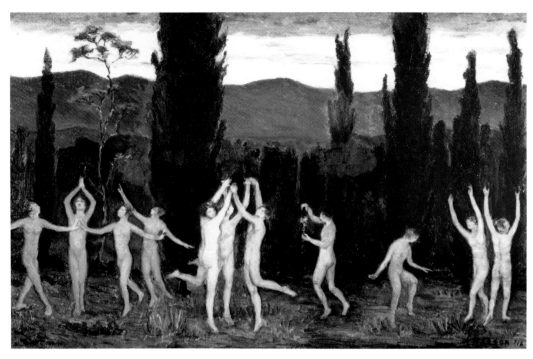

81. Adele Watson,
Murmurs of the Air, 1916

she included her husband and son in what was perhaps her first view of Compton's pepper trees. Cressey retained the vigorous handling of her teacher, using thick impasto, but the wildness of her brush stroke sometimes became frenzied, proclaiming her exuberance over the Southern California experience. The region's climate also caused her to abandon Henri's palette of deep blacks. The warm, brilliant sun led her to luxuriate in dazzling yellows, oranges, persimmons, crimsons, and greens, while the shadows cast by the sun became rich purples and blues, dramatic complements to the golden lights.

In Los Angeles, Shore also lightened and brightened her palette in the late 1910s, but not until she returned in 1923, after a three-year stay in New York, did she begin to depict local flora, animals, and rocks. During her visit to the East she had abandoned the painterly handling of Henri in a series of pure abstractions, and a visit to Mexico in 1927 further encouraged this simplification. Her California nature studies thus are flatter and more decorative, stylized in their organic shapes and emphasis on form and contours (see plate 73). By focusing on a single shell, plant, or individual branch of flowers and presenting it on a large scale in a closely cropped composition, she created images analogous to Georgia O'Keeffe's 1920s flower paintings. Unlike O'Keeffe's sensual images, Shore's plants and flowers often convey a monumentality that sug-

gests the power and mystery of California's natural environment.

Barney, Bothwell, Cressey, and Schuster also painted fruits and plants close up, creating flat, bold patterns by forcing the horizons high up or eliminating them altogether. In *The Devout Vegetarian* (plate 74), Bothwell zoomed in on a caterpillar eating the fruit from a branch of a persimmon tree. Barney lived on her husband's ranch in Ramona and there began to study the arid climate's distinctive foliage. By the mid-1930s the interior decorations that she sold under the name Star Stevens popularized such interpretations.[26]

Predictably, the academically trained artists Alvarez, Baldaugh, Baranceanu, Cressey, Dunlap, Rocle, and Shore were figure painters. For Anni Baldaugh (1881–1953) portraiture was a lucrative endeavor; the others more often preferred to paint themselves or their friends or families. Baldaugh probably retained a more conservative Impressionist handling in her portraits because these were commissioned works, since she also painted some wonderfully powerful Fauve figure studies, such as *Murial,* about 1926 (plate 75), with glowing warm colors and bold brushwork. Love of color and exuberance of handling characterize most figure paintings of the late 1910s and 1920s by these women. Mabel Alvarez painted herself several times, but her most compelling self-portrait was a rich-hued canvas in which she

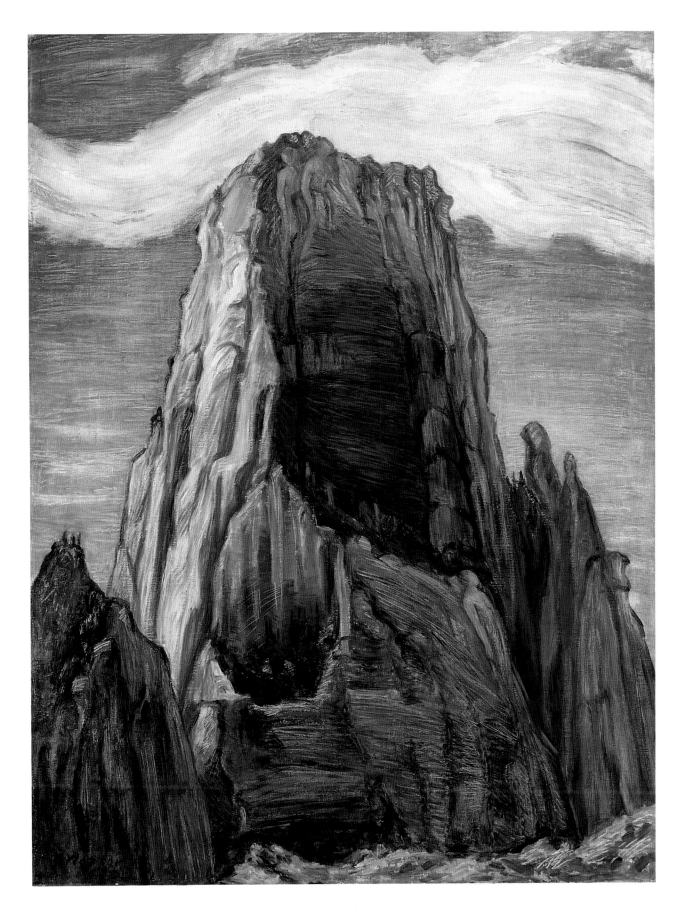

82.
Adele Watson, *The Winged Rock*, 1931

83.
Agnes Pelton, *Memory*, 1937

wears a large-brimmed hat (plate 76). The purchase of hats consumed much of her time, and, if her diary records are accurate, this suggests that Alvarez was not an artist solely absorbed in her work.

Belle Baranceanu's and Margaret Rocle's portraits from the 1930s are quite different. In *The Johnson Girl*, about 1930 (plate 77), Baranceanu's soft, tonal colors underscore the sitter's touching, somewhat sad face. Rocle selected an even more somber, almost ghoulish palette to portray her close friend Eileen Jackson in about 1939 (plate 78). The painting is quite haunting, not only in its grayish skin tones, green dress, and blood-red upholstered chair, but also in the mysterious, worm-shaped bushes growing in the background. Baranceanu and Rocle moved away from the extroverted, joyous figure paintings of the first modernists to a more inward-probing investigation that paralleled other Southern California painting of the 1930s.

Beginning in the 1920s artistic investigations of a more introspective character engaged Southern California women modernists, and these painters responded with imaginative figurative, symbolic, and abstract paintings. Some inquired into the meaning of life on a personal level, others into more universal, philosophical questions. Their search took many forms. Some sought guidance through religious or metaphysical beliefs, others through an investigation of the psyche, still others through Surrealism. Southern California was especially conducive to the development of art forms of an imaginative, metaphysical, and psychological nature. By the turn of the century the region had begun to attract eccentrics, mystics, and faith healers, and by the 1920s it was the home of countless cults and religions, both orthodox and esoteric.[27] Pianist Francis Grierson helped make San Diego a center of psychic and occult activity as early as the 1880s, and much later created a stir in Los Angeles with his book *Psycho-Phone Messages* (1921). But Southern California's status as the land of metaphysics largely resulted from the popularity of Theosophy.

Theosophy was part of the region's attractiveness to occultists and psychics. By the mid-1920s a branch of the society in Laguna Beach was sponsoring lectures and discussion groups.[28] In 1926 Theosophist Annie Besant

84. Agnes Pelton, drawing from her diary, January 1, 1937

acquired property in the Ojai Valley, north of Los Angeles, and there thousands sought spiritual solace with the new young messiah, Jeddu Krishnamurti. Southern California not only became the world headquarters of Theosophy and New Thought but was also the home of Aimee McPherson and her Angelus Temple, headquarters of the Foursquare Gospel, as well as to a host of other smaller esoteric groups now long forgotten. It also was a major publishing center for magazines, newspapers, and books on mysticism, spiritualism, and other metaphysical philosophies. So strong was the spiritual air that even such zealous realist writers as Hamlin Garland and Upton Sinclair wrote books on psychic research and spiritualism after moving to the region.[29]

During the early part of the century, people of a more spiritual inclination believed that women were experiencing an "increasing psychism." Theosophist Claude Bragdon called them Delphic women, women who exhibited extraordinary powers that enabled them to penetrate the higher and more universal layers of consciousness.[30] The religions of some of the women artists may have encouraged such ideas. Raised as a Quaker to believe that one could commune with God through meditation, as a young child Bothwell determined to become an artist after a mystical experience involving colored light.[31]

Mabel Alvarez may have been the first

woman modernist to explore alternative religions and philosophies. Dissatisfied with her life, in 1916 she began searching for the meaning of existence, first discussing Theosophy with her teacher, William Cahill (1878–1924).[32] But she found even greater insight in the ideas of Will Levington Comfort, a writer and philosopher who had quickly become the leading local guru after he moved in 1917 to Krotona, a colony in the Hollywood Hills that boasted an occult temple, a psychic lotus pond, tabernacles, a library, and a Greek theater. Alvarez read several of Comfort's books, followed his newsletter, and attended his many lectures, including "Follow the Dream."

On June 8, 1919, Alvarez wrote in her diary that Comfort's ideas were becoming clearer all the time.[33] That day she also visited the Rex Slinkard (1887–1918) memorial exhibition at the Los Angeles Museum. Slinkard, a popular early teacher in Los Angeles, created ethereal, tonalist figure paintings about his own mysterious private world (see plate 79). Moved by these pictures, Alvarez wrote: "All emotion. A dream world of the spirit—nothing of the material physical world—strange and lovely color and compositions and subjects. He worked entirely from within." Only two months earlier she had determined to be more diligent in the spiritual "quest within" herself and decided that it was "useless to paint when it does not come straight from the center. Better to say nothing at all."[34]

Alvarez's introspective journey did not find fruition in her art until she began her highly symbolic canvases in 1925. For the next eight years she created these dreamscapes, as she called them; usually small, often they featured a woman seated in a meditative yoga position. Comfort had advocated meditation (which he called "breathing mystically") as a way of finding inner truth and peace of mind, and Alvarez had followed his advice. In her paintings the seated woman is usually framed by a mandala and accompanied by ancillary figures symbolizing universal female archetypes.[35]

The complex, large-scale *Dream of Youth,* 1925 (plate 80), is Alvarez's quintessential dreamscape. Although cloaked in classical terms, the four vignettes in the corners surrounding the large central female figure symbolize the course that even contemporary maidens hoped their lives would follow, from female companionship, through music and merriment, to courtship, and eventually romantic love. Throughout her journal entries Alvarez recorded her desire to express emotion in her art, rather than representation.[36] She was well aware of the role of color in achieving this and surely was acquainted with the philosophical and aesthetic theories that equated the effects of color with human emotions.[37] In 1901 Annie Besant and C. W. Leadbeater had published *Thought-Forms,* a highly popular philosophical treatise that explained the psychological significance of specific colors, and in 1912 Wassily Kandinsky (1866–1944) wrote *Concerning the Spiritual in Art,* an exploration in aesthetic terms of how color produces "a correspondent spiritual vibration" in the viewer.[38] In both instances, green was considered soothing, denoting equanimity, adaptability, and in its more delicate shades the divine power of sympathy. Alvarez selected a soft, celadon green as the dominant hue of *Dream of Youth* to create a calm, gentle mood, suggestive of the spiritual harmony and contentment she had finally achieved through Comfort's teachings.

For both Adele Watson (1875–1947) and Agnes Pelton the spiritual experience of the Western landscape was the inspiration for mature imaginative works. In New York during the 1910s both women began painting canvases indebted to the symbolic, arcadian landscapes made famous a few years earlier by New York artist Arthur B. Davies (1862–1928) (see plate 81).[39] Watson did not overthrow the tyranny of Davies until the late 1920s, when she emancipated her figures from their earthbound status by letting them soar through the skies above dramatic landscapes. Although Davies occasionally evoked the West in his backdrops of high-peaked mountain ranges (he had traveled there in 1905), his art was not about the region. By contrast, Watson made annual summer visits home, and she incorporated the rolling mountain ranges and dramatic coasts of California into her early arcadian scenes.

In September 1930 Watson was painting at Zion National Park, and it may have been at that time, if not slightly earlier, that she began her anthropomorphic landscapes. In these, her figures had grown larger and returned to earth, seemingly imbedded in rock (see plate 82). A group of lithographs from the late 1930s and early 1940s reveals the models for the cliffs in Watson's mature paintings, the dramatic geo-

85.
Agnes Pelton, *Alchemy* or *Pluto*, 1937–39

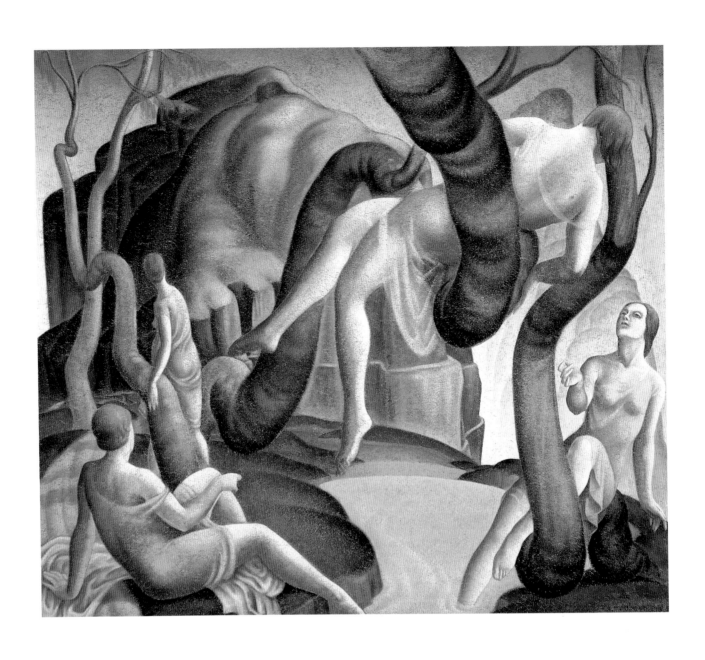

86.
Helen Lundeberg, *The Mountain*, c. 1933

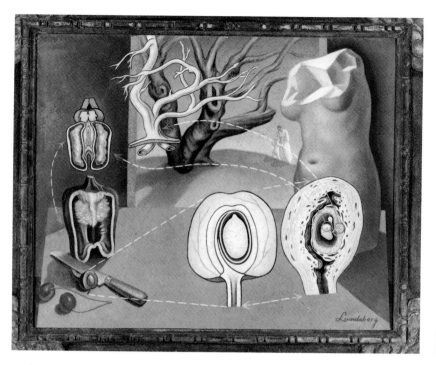

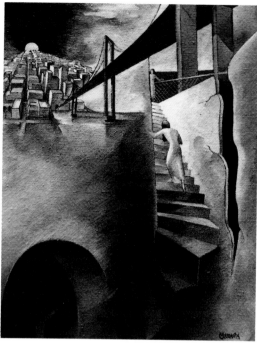

88. Helen Lundeberg, *Plant and Animal Analogies*, 1933–34

89. Grace Clements, *Pilgrimage of the Psyche*, 1934–43

logical formations of soaring peaks, canyons, and buttes she would have seen on her journey from Pasadena through southeast California to Arizona, New Mexico, and Utah.

Watson did not belong to an organized religion, but she shared with Gibran a love of beauty and an appreciation of nature.[40] Her letters written during visits to Zion and Bryce canyons reveal her awe at their grandeur. Both New York and Los Angeles critics admired her anthropomorphic canvases, and Arthur Millier of the *Los Angeles Times* referred to her "mystical union" as "quite beautiful," with no parallel among other artists of the region.[41] This interpretation of Western landscape, however, had a precedent in the allegorical Grand Canyon landscapes that Eliot Daingerfield (1859–1932) painted in 1913 after visiting the West. But Watson's greater intimacy with the region allowed her to convey the West's power more convincingly. Daingerfield's allegorical nudes were lethargic, but Watson's symbolized the vital natural forces, constantly moving as if to burst their crusty prisons or whirling speedily to suggest the metamorphosis of spirit into hard rock.

Believing that color was essential to her art because it was "apprehended emotionally,"[42] Agnes Pelton renounced idealized figure painting in 1925 for color abstraction. Her initial nonfigurative work consisted primarily of undulating biomorphic forms similar to those in Arthur Dove's nature abstractions. Within a few years these were replaced by shapes that suggested rays, stars, orbs, and other beams of light floating in space. Pelton did not intend them to be literal representations; her abstractions were to be new, unfamiliar experiences in seeing, they were to serve as "little windows, opening to the view . . . a region not yet visited consciously or by intention, an inner realm, rather than an outer landscape."[43]

After searching worldwide for a place best in accord with her personality, in 1932 Pelton settled permanently in the California desert, in the small town of Cathedral City. She found its solitude perfect for her communion with nature, and there, during the next fifteen years, she painted her most beautiful mystic visions. Pelton constantly recorded her thoughts, dreams, and spiritual experiences in a diary. From it we glean that she was well versed in astronomy, astrology, and metaphysical writings on the stars and universe, as well as in Asian art and philosophy, for she quotes frequently from Comfort, Katherine Tingley, and other Theosophists and mystics.[44] Pelton looked to them for guidance: on August 16, 1932, she quoted Tingley, "Take ten minutes a day and absolutely surrender your lower self to the higher self."[45]

Pelton's habit was to paint outdoors when the light was soft and the sky a rich blue, ei-

ther early in the morning or at twilight after the sun had set behind the mountains. Her abstractions were mental images, impressions that came to her in moments of reflection, just as a line of verse comes to a poet; the only difference was that she saw it "in form and color and the poet . . . in sounds and words."[46] Pelton often compared her painting to music. An accomplished pianist, she evinced the late nineteenth-century Symbolist idea of synesthesia, finding analogies between the senses of sight and sound.

Pelton's art typified the evolution of early twentieth-century American abstraction. Like Arthur Dove (1880–1946) and Georgia O'Keeffe (1887–1986), she evolved her mystical abstractions from a nature-oriented art with nonsacred associations.[47] Flowerlike forms emerge from a silver-white vase in *Memory*, 1937 (plate 83), and in other paintings they float near swelling, colored shapes. Yet cosmic imagery dominated much of her mature visionary work.

On January 1, 1937, Pelton drew a pencil sketch in her diary with color notations of celestial formations she had seen in the sky: a brilliant white diamond floating above gold and white half-moons and clouds in a dark blue sky (plate 84). Shortly thereafter, she painted *Alchemy* (plate 85) and wrote the following poem: "The golden glow of earth transcending / the cloudy barrier in white response / to the diamond light, in revelation."[48] Two months later, after reading an article on Pluto, Pelton realized that the nocturnal experience she had recorded in her diary was of that planet. Named for the Greco-Roman god of the underworld, Pluto is the outermost planet in our solar system, discovered in 1930. For skygazers of that decade it was truly a "revelation." And Pelton was a magician, performing an alchemic transformation by painting an awesome, mysterious vision from the flickering lights she observed in the sky.

Light, to Pelton, signified beneficence and life.[49] The clouds and other amorphous forms that vibrate in her paintings may relate to the idea of "thought-forms," the occultist belief that an aura surrounding and emanating from a person derives its shape from that person's mental state. According to Besant and Leadbeater, a person sees the world through these thought-forms and the vision is tinged by their colors and vibrations.[50] The serenity Pelton derived

from living in the desert enabled her perception of the universe to be untainted by worldly details. Dane Rudhyar, one of her earliest supporters, described her paintings as "a victory of light over darkness, and of life over death," truly "psalms of integration sung to the Spirit in man."[51]

While Pelton's art was completely personal, unlike that of any other woman or man working in Southern California, it shared aesthetic and philosophical concerns with other Western modernists. In 1937 Pelton's close friend Raymond Jonson (1891–1982) asked her to join him and others in New Mexico in forming the Transcendental Painting Group. Pelton and Florence Miller Pierce (b. 1919) were the only women members. Their aim as nonrepresentational painters was to "carry painting beyond the appearance of the physical world, through new concepts of space, color, light and design, to imaginative realms that are idealistic and spiritual."[52] Active for only a few years, the group received important recognition in 1940 when the Guggenheim Museum in New York exhibited seven of their paintings.

Even some women whose art was not affected by metaphysical pursuits fell under the spell of these ideas as they searched for meaning in their lives. So enthralling did Wood find the writings of Madame Blavatsky, Besant, and Leadbeater that she joined the Theosophical Society in 1923, and after later moving to Los Angeles she made pilgrimages to hear Krishnamurti speak in Holland and Ojai; she settled in his theosophical colony in 1948.[53] Grace Clements's exploration of Eastern religions led her to become an astrologer; years after she gave up painting, she charted the opening of the Armory Show to demonstrate that the stars indicated that the day was auspicious for "a revolt against orthodox" ideas.[54]

Given the openness of Southern California to alternative lifestyles and spiritual beliefs, it is not surprising that Surrealism also took a strong hold here. Interest in the new aesthetic first arose from a fascination with Freudian and Jungian theories. Freud lectured at Clark University in Worcester, Massachusetts, in 1909 and Jung at Fordham University in New York three years later. Some Americans received their ideas warmly as an impetus toward sexual and political reform. Progressive New York painters and writers studied and sometimes underwent

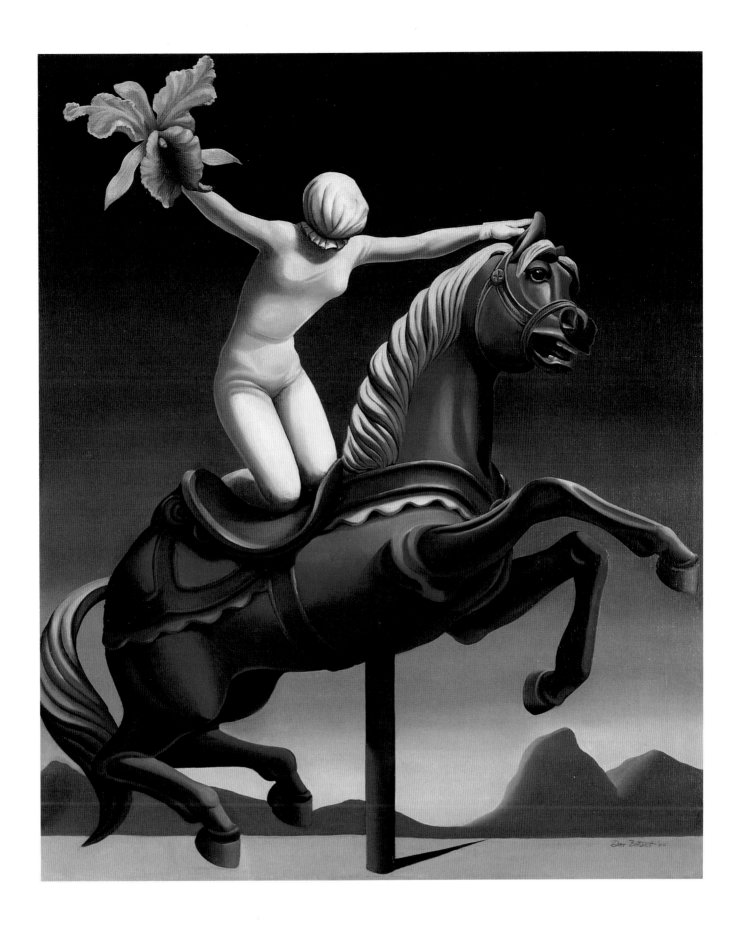

90.
Dorr Bothwell, *Hollywood Success*, 1940

91. Elanor Colburn or Ruth Peabody, diagrammatic drawing based on dynamic symmetry, n.d.

psychoanalysis,[55] and in the following decade comparable developments occurred in Los Angeles. Sometime in the late 1920s Annita Delano and Galka Scheyer began to participate in small discussion groups organized by faculty members of the California Institute of Technology in Pasadena, where the new psychological theories were translated and discussed. At about the same time, Delano, who was teaching at the Southern Branch of the University of California (now the University of California, Los Angeles), shared an interest in Surrealism with members of the school's psychology department because of the movement's focus on the creative unconscious. Although their discussions encouraged Delano to seek out many of Freud's disciples and associates when she visited Vienna during summer 1928,[56] she was not inspired to paint Surrealist imagery.

Surrealism offered women an alternative way of rebelling against the societal expectations forced upon many educated young women. Barney, Bothwell, Clements, Lundeberg, Shore, and Rocle all created paintings that have been or could be considered Surrealist.[57] By rejecting the mythical passive woman and the erotic fantasies created by men, these painters were able to delve into their own physical and psychic reality, gaining increasing self-awareness.[58] Consequently, their art was often about themselves, even when the objects they depicted were not those of conventional portraiture.

Women and their generative powers traditionally have been associated with nature, and for these Surrealist painters it became a metaphor for their reality as women and for their powers of artistic creation. Weston once said of Henrietta Shore, "When she paints a flower she IS that flower."[59] Her manner of depicting lovely blossoms, standard symbols of femininity, against the void of an empty sky or sea leaves the viewer pondering whether Shore felt isolated because of her sexual preferences. In her close-up images of a single cactus, the prickly, sturdy plant parallels Shore's heavyset physique and her determination to pursue her own artistic course.

A dominant thread running through all of Helen Lundeberg's paintings during her long career, even in an early work such as *The Mountain* (plate 86), is the self-referential element. A retiring person who allowed her extroverted husband to be the central focus, Lundeberg preferred to speak solely through her art. Scattered throughout her forest scene are women straddling enormous, undulating tree trunks or in close conjunction with them. Rather than bear fruit, the trees become phallic elements essential in the generative process of woman. The painting's title ignores this aspect altogether, referring instead to the large hill in the background—the mountain, another standard allusion to women.

In *Relative Magnitude,* 1936, an astronomer peers curiously through a telescope at the sky. The painting's title indicates the importance of astronomy to the artist.[60] Joseph Solomon nicknamed Lundeberg a "high priestess" who would rather "dream about other planets than think of this world."[61] Floating celestial bodies appear in her surreal images as early as 1934, and they become the sole subject of a series of hard-edge paintings Lundeberg produced in the 1960s. The science of astronomy received considerable attention during the 1930s as a result of several major scientific discoveries: not only was Pluto seen for the first time, but asteroids were identified and Albert Einstein announced that the secret of the universe related directly to the red shift of distant nebulae. In *Microcosm and Macrocosm* (plate 87, page 74) Lundeberg incorporated another of her many partial self-portraits, this one as "the thinker," into the cosmic view of a distant planet. This painting, as well as *Cosmicide,*[62] 1935, demon-

92.
Elanor Colburn, *New Earth*, 1933

93. Ruth Peabody, *Untitled [Abstractions]*, c. 1935

strates her desire to probe a concept of herself as a miniature being in a larger universe.

In 1934 Lundeberg and Feitelson published the brochure *New Classicism,* the only Americans to issue a Surrealist manifesto.[63] Because of its debt to its European predecessors, New Classicism (or Subjective Classicism) soon became identified as Post-Surrealism. The involvement of Grace Clements (1905–1969), Philip Guston (as Philip Goldstein) (1913–1980), Lucien Labaudt (1880–1943), Knud Merrild (1894–1954), and others led to a movement that quickly achieved national attention. A group exhibition at the San Francisco Museum of Modern Art in 1935 later traveled to the Brooklyn Museum.

Lundeberg and Clements were instrumental in the formulation and promotion of Post-Surrealist ideology. Lundeberg authored the movement's theoretical manifesto (her *Plant and Animal Analogies* [plate 88] was the only painting reproduced in it), and Clements wrote the first full discussion of the group's theory for the March 1936 issue of the radical national journal *Art Front.*[64] Although they rejected the roles of the unconscious and the accident—so crucial to their European predecessors—the Post-Surrealists also emphasized the subjective, now in terms of introspection and contemplation. Disparate objects, seemingly placed at random, represented for them a reordered reality stylistically indebted to the metaphysical

paintings of Giorgio de Chirico (1888–1978) and the veristic Surrealism of Pierre Roy (1880–1950) and Salvador Dalí (1904–1989).

Grace Clements's Surrealist paintings were grounded in her early 1930s architectural images about the formal relationships between flat planes in space. Highly indebted to Cubism, she disassembled walls of buildings, bridges, and other manmade objects and recombined them into synthetic collage arrangements. She designed many of her Surrealist paintings around enigmatic alleyways, long, distorted vistas, and partial buildings (see plate 89). "I am concerned with relationships," she explained, "because it is through relationships that we know reality. . . . A painting must contain its own order, hence its own reality. . . . The laws of the macrocosm are equally important in the microcosm. Our concept of the universe is necessarily abstract; our understanding of its order is likewise abstract."[65] Post-Surrealism was an intellectual form of art that naturally appealed to intelligent women such as Lundeberg and Clements. Clements was perhaps the most intellectual of the group of women modernists: in the 1940s she abandoned painting to pursue a career as a writer on modern art and design.

Dorr Bothwell vehemently maintains that she was not a Surrealist.[66] Her denial echoes that of the women Surrealists in Europe and probably stems from the same cause: their rejection of the basic Surrealist premise that woman plays a servile role to man, that she completes man, she is only brought to life by him, and she serves as his muse.[67] Nevertheless, like the California Surrealists, Bothwell explored her inner self in her art, through the juxtaposition of figures and objects different in scale and seemingly unrelated. Bothwell was a lover of cats, and not surprisingly a feline with hauntingly reflective eyes parades confidently through several of her paintings, almost as her alter ego. A fun-loving person, Bothwell often infused her imagery with an element of whimsy. Despite the seeming hyperrealism of her depiction of a caterpillar in *The Devout Vegetarian,* the title actually alludes to Bothwell. She ridicules the Hollywood success stories of blonde starlets in another painting (plate 90) of an actress frolicking nude on a circling carousel horse.

Abstraction and the nonobjective did not

inspire many local women or men during the 1920s and 1930s. Only infrequently did the region's art museums or commercial galleries exhibit such radical European painting, although Louise Upton, curator of art at the Los Angeles Museum, was more amenable to it.[68] Progressive art made moderate inroads primarily in Los Angeles, largely from the efforts of a small body of promoters and supporters: Arensberg, Armitage, Louis Danz, Delano, Macdonald-Wright, and Scheyer.

Stanton Macdonald-Wright's presence and personality probably were more of a stimulus than his art, for he painted his most extreme works, the Synchromist abstractions, before returning to Los Angeles from Europe. Although several men followed his lead in tentative experiments with Cubism and color abstraction, few women became his disciples, despite his teaching at the local Art Students League and his reputation as a womanizer. Although his pure, intense palette inspired Mabel Alvarez and perhaps Donna Schuster to heighten their color during the 1920s, his abstract compositions did not directly influence any of the women.

Walter Arensberg and his wife Louise moved to Hollywood from New York in 1921, bringing with them a private collection unmatched in California, including numerous Cubist, Dadaist, metaphysical, and Surrealist paintings. They opened their home to anyone seriously interested in art, and during the 1930s it became a salon that promoted the avantgarde: Clements, Elise, Lundeberg, and Wood are definitely known to have visited. The Arensbergs' presence was the region's single most important force for progressive art.[69]

In 1924 Galka Scheyer, who was determined to promote the Blue Four, moved to the West Coast to lecture and organize special exhibitions. Annita Delano was instrumental in helping Scheyer present several shows in the late 1920s at the Southern Branch campus of the University of California, where Delano not only taught but also served as curator, and in 1930 at the Los Angeles Museum.[70] Through these exhibitions Californians could examine firsthand Feininger's Cubist paintings and Kandinsky's early spiritual abstractions, as well as the late nonobjective Bauhaus compositions. Although Delano was perhaps the local woman artist most abreast of modernist currents, she

94. Ruth Peabody, *Untitled,* c. 1938

surprisingly never relinquished representation in her own painting. During her travels in Europe in 1928 and 1930–31, she discussed art with some of the most progressive painters and theorists of the day. But even this firsthand exposure did no more than heighten her use of expressionist color and invigorate her brushwork. Delano's modernism, however, informed her teaching, especially her courses on design and architecture.

Certain pseudoscientific color and compositional theories, originally promoted by Henri and his circle, established the importance of the pure, formal elements of line, color, and composition and enabled artists who were bewildered by the radical art from Europe to approach modernism through scientific, universal principles.[71] Dynamic symmetry, with its mathematical system, guaranteed the artist a harmonious design. Mabel Alvarez experimented with it in 1925 when she was composing *Dream of Youth,*[72] but Elanor Colburn and her daughter Ruth Peabody (1898–1967) utilized it most, beginning in the late 1920s. They may have been introduced to the compositional device by Frederick John de St. Vrain Schwankovsky (1885–1974), a Los Angeles art teacher active in the Laguna Beach Art Association. A strong promoter of modernism, Schwankovsky believed in the concepts of syn-

esthesia and the spiritual in art as espoused by Kandinsky; he sold a color wheel and pamphlet (a practical treatise) that explained the power of color to convey emotional experiences in nonrepresentational terms.[73] Schwankovsky also lectured on dynamic symmetry.[74]

Shortly after Schwankovsky settled in Laguna Beach, in 1926, Colburn moved away from her impressionist landscapes to figure paintings conceived as arrangements of simplified planes and based on the laws of dynamic symmetry (see plate 91). Often her pencil drawings beneath the paint surface remain partially visible, revealing the composition's intricate plotting of lines, shapes, and patterns. By focusing on such a universal image as a mother and child (plate 92), Colburn demonstrated that subject matter was not important.[75] She explained that "the New Art is . . . based on laws of harmony and growth, laws obeyed by nature and the universe, . . . Life, Energy and Power are always in the abstract, which seems to me to be a very happy compromise for today."[76]

For years Peabody also designed harmonious figure compositions that were similar to those of her mother, Elanor Colburn. But in the 1930s she used compositional theories as a basis for more daring explorations, disintegrating recognizable still-life objects and figures by extending and breaking up the diagonal lines of dynamic symmetry. Eventually Peabody created a series of small-scale analytic Cubist compositions (see plate 93), although at least once she completely abandoned any referential motifs to design a completely nonobjective, Constructivist composition in red, white, and black (plate 94). In 1939 the Fine Arts Gallery of San Diego presented her abstractions in a solo exhibition, the first show of its kind by a regional artist.

Peabody probably would not have made the jump from representation to abstraction and nonobjectivity if it had not been for Louis Danz, a prominent figure in California circles. Danz was a composer of contemporary music, a popular lecturer on modern art, and during the early 1930s president of the Laguna Beach Art Association. He achieved international recognition as a psychologist with several books on aesthetics: well versed in Freudian and Jungian psychology as well as Surrealism, Danz stressed the importance of instinct and rejected subject matter in art. An excerpt from his book *The*

Psychologist Looks at Art (1937) was the text for Peabody's 1939 exhibition catalogue: "I call an abstract work of art a *neural structure*. . . . A neural structure . . . never says anything about a *thing; it is in itself the object.*"[77] By neural structure Danz meant that the relationships between color, line, and shape in art were extensions of the artist's nerve patterns, which made abstract art truly emotive in character. Interviewed the year of her solo show, Peabody echoed Danz: "The abstract is in all art whether it contains subject matter or not. Subject matter is purely personal and I feel no need for it. My interest is in form, color, and emotion."[78] Her titles *Ascending Destiny, Sound-time,* and *Split Personality* suggest that spiritual, psychological, and aesthetic theories were all at play in her abstractions.

Although Agnes Pelton was the pioneer woman abstractionist in the region, and her beautiful canvases are far more progressive than those of local female and male contemporaries, Elise most consistently pursued the nonobjective. Merle Armitage probably first encouraged Elise to relinquish her acting career for art. A leading music and art impresario in Los Angeles, he designed, wrote, and edited numerous books on art, music, dance, and aesthetics. Elise and Armitage's close friend Danz collaborated with him on some of these. Elise's book-design work no doubt made her aware of the insignificance of subject matter and the value of pure, formal elements. Both Armitage and Danz promoted her art in the monograph *Elise,* which appeared in 1934, shortly after she had turned to abstraction.[79]

Elise's modernism appeared full-blown with her first drawings and lithographs, made from 1932 to about 1935 for printmaker Lynton Kistler. Her thin, sweeping, drawn lines in *[Succulents]* (plate 95) show the fluid, arching movement and sense of delicacy that became a hallmark of her lyrical painted abstractions. While still retaining references to the real world, she investigated formal elements through the concept of movement: a series of arcs echoes the spinning of a bright red top in one early painting (plate 96), and in another, two spirals suggest racing automobiles on the new Pasadena Freeway.[80]

Elise, as well as Oskar Fischinger (1900–1967), Knud Merrild, and Pelton, were the few Southern California modernists to understand and reflect the influence of Kandinsky

in their art. Dane Rudhyar's identification of Pelton with Kandinsky probably was a case of shared sources in occultist books; her paintings before the late 1930s display little of Kandinsky's abstract vocabulary, and she did not mention him in her diary until 1946.[81] But Elise's drawings of the mid-1930s are already arrangements of pure line and simple two-dimensional, geometric shapes (see plate 97) analogous to Kandinsky's Bauhaus paintings of the 1920s and to the theories expounded in his book *Point and Plane to Line* (1926; English trans. 1947).[82] The sparest of flat and solid geometric shapes in harmonious balance characterize her brightly colored mature paintings; by 1939, at the New York World's Fair, she exhibited the totally nonobjective painting *Out of Space* (plate 98).

Despite the exposure of urban class struggles and their resultant violence in the writing of Upton Sinclair and Louis Adamic,[83] the myth of Southern California persisted. And the city's growth at the expense of its picturesque harbor and its orchards and citrus groves interested few Los Angeles modernists. While San Pedro in the late 1920s was a major port that had recently witnessed the free-speech fights of the International Workers of the World, Donna Schuster preferred to perceive the harbor area as a quaint fishing village. Even Belle Baranceanu, during her 1927–28 visit to Los Angeles, only hinted at the changes. Although she had painted the industrialized areas of Chicago, in California she gravitated instead to the brightly colored views of the Hollywood Hills with their quaint houses and winding roads. While she depicted a brick factory, so essential to the booming construction industry (see plate 99), and recorded the growing clusters of buildings, Baranceanu disregarded the new manmade metropolis downtown. Only her simplification of buildings into industrial boxes and her use of a dizzying, elevated perspective suggest the congestion and explosion the area was on the verge of experiencing.

Nor did the depression greatly alter modernist perspectives. The affluent modernist woman had insulated herself in her own world, or had idealized the reality beyond her home. Even in their most intimate written accounts, these artists rarely acknowledged the reduced circumstances of the majority. Watson once remarked to her sister that she was looking for a cheaper studio and mentioned her finances

95. Elise, *Untitled [Succulents]*, c. 1934

for the first time, but Alvarez seems to have been scarcely aware of the reduced circumstances of so many people.[84] Barney, Bothwell, and some of the other women found their finances especially strained, but only the lifestyle and art of Cressey were greatly affected. Cressey had lived comfortably up until 1929, but after the crash she had to sell her jewelry, and eventually she and her husband gave up both of their residences. Bert Cressey handled the drastic changes well, but Meta never recovered from the loss of her house and garden. They had become the center of her closed, comfortable world, and when circumstances took them away she reacted by giving up painting.

The only woman modernist to respond to the social changes in her art was Grace Clements, who made references to poverty and unemployment in her Cubist and Surrealist scenes (see plate 100). Clements may have painted some if not all of these images in San Francisco (there are allusions to the city's highrises and bridges), and her change of environment may partially explain her choice of subject matter. Clements, however, was always interested in social problems, searching for a cause to promote;[85] in the 1930s leftist politics may have encouraged her belief that socially conscious artists should create a revolutionary art form that answered fundamental human needs.[86]

This does not imply that women modernists were not active in the regionalist movement and the federal art projects of the period. On the contrary, women were actively supported by the federal agencies (although they

96. Elise, *The Spinning Top,*
c. 1935–42

97. Elise, *Descent, 1935*

were often selected for subordinate positions on the mural projects), since the government in principle was promoting the concept of democracy in art. Regionalism and the "federal art aesthetics" adopted by the various government agencies, however, encouraged a return to a more conservative type of art, a basically figurative art with recognizable icons, such as "the farmer" and "the housewife," in simple narratives. Despite these aesthetic limitations, a significant number of women modernists were active in the projects, both those that were welfare-based and those predicated on winning competitions. Baranceanu, Clements, and Lundeberg were awarded major mural projects, Clements winning the commission to decorate the Long Beach Municipal Airport administration building. Barney, Bothwell, Colburn, Elise, Lundeberg, and Peabody also contributed prints, paintings, and architectural decorations, usually working within the officially sanctioned aesthetics.[87] As American Scene painters in the region, the modernists promoted the idea of

California as a paradise, a concept born of turn-of-the-century boosterism but continued by the Hollywood film industry.[88]

The government projects were an important finale to the first phase of modernism in Southern California, because they finally brought the women into the public arena. The contributions of women painters could no longer be ignored or minimized. By the 1950s, when America had recovered from the war, Southern California women modernists finally stood on par with the men, as the major contributions of Helen Lundeberg and June Wayne attest. Women artists were now more visible and vocal, but they would still have to wait two decades longer for widespread critical recognition. This recognition came with the feminist movement of the 1970s, so clearly evidenced in Los Angeles by the founding of the Woman's Building in 1973. Yet the women who pioneered modernism during the decades between the two world wars had to wait even longer for national attention.

98.
Elise, *Out of Space*, 1938

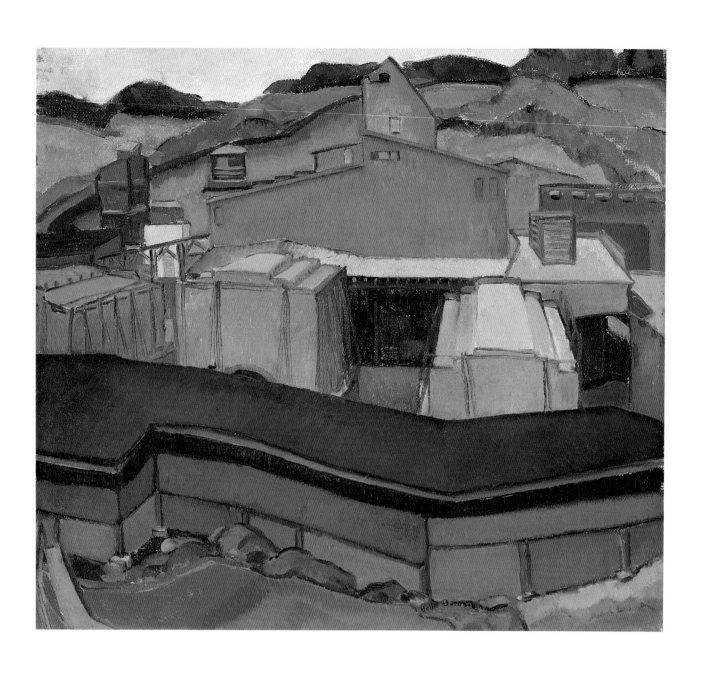

99.
Belle Baranceanu, *The Brick Factory—Elysian Park, Los Angeles,* 1927

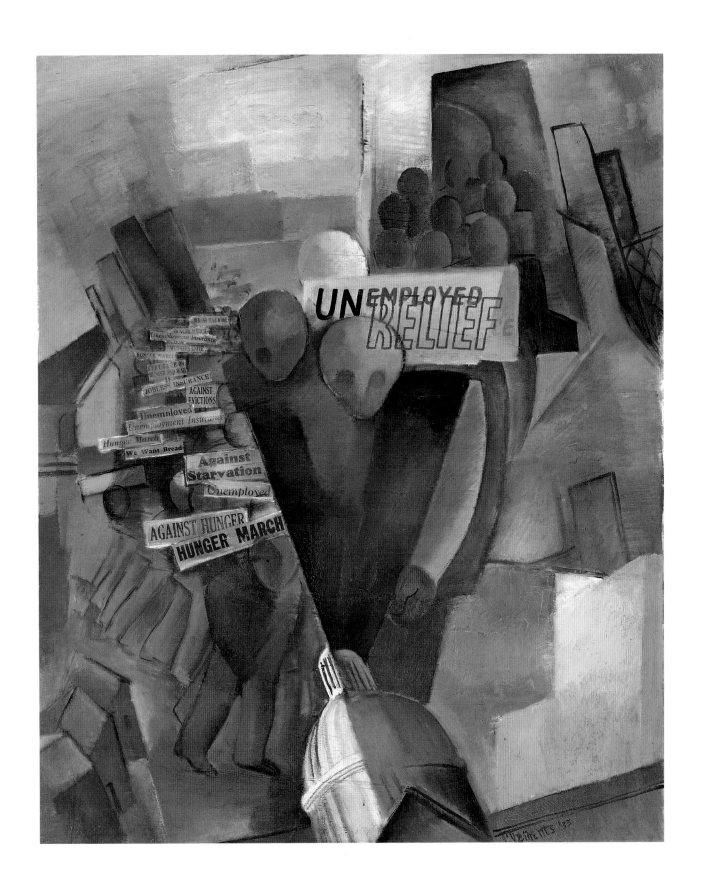

100.
Grace Clements, *Winter, 1932,* 1933

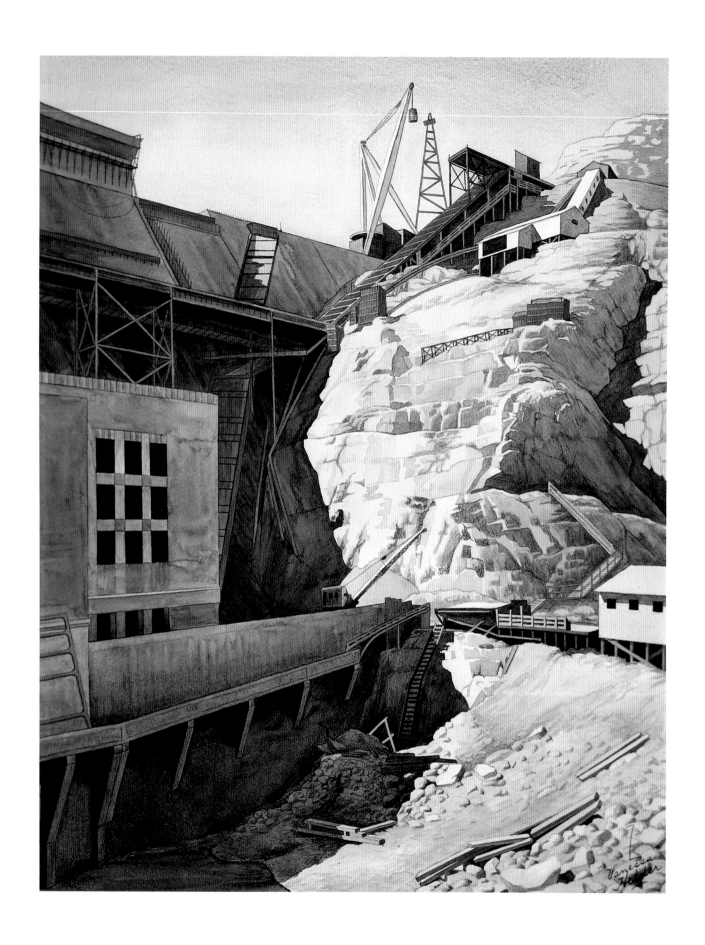

114.
Z. Vanessa Helder, *Rocks and Concrete*, c. 1940

IV
Northwestern Exposure

Vicki Halper

NELLIE CENTENNIAL CORNISH, a Seattle piano teacher proudly named for her celebratory birth date of July 4, 1876, later wrote of her long-awaited trip to the East Coast in 1904: "I soon found out that art and learning and the history of this country were just as much the center of interest in Boston as salmon fishing, timber, and gold were back home."[1] Cornish noted the economic factors contributing to the Northwest's explosive growth since the mid-nineteenth century as a supplier of goods to California and Alaska during the gold rush and to San Francisco after the fire of 1906. Although Seattle was founded by people with big dreams who called their original encampment *Alki* New York, or "New York by and by," the talk was economic, not cultural, at least where men gathered.

For some, however, and particularly for women, settlement would always be synonymous with art as well as commerce. While the first professional American artists to enter the Northwest were men who accompanied geographic surveys like the United States Exploring Expedition in 1842, women artists came to stay. Nancy M. Thornton, perhaps the first nonnative artist of either sex to reside in Oregon, taught classes at the Oregon City Seminary in 1847. Sarah J. Rumsey (active 1865–1875) was the first professional artist to advertise in Oregon. Women in the Northwest taught the art classes, started the art clubs, and created many of the art institutions that are still the lifeblood of regional cultural activity. In addition to her work as a portraitist and genre painter, Anna Belle Crocker was director of the Portland Art Museum and its extremely influential art school from 1909 to 1936; Gertrude Bass Warner founded the University of Oregon Museum of Art in the early 1930s and was its first director;

Margaret E. MacTavish Fuller and her son Richard donated the funds to build the Seattle Art Museum, opened in 1933, and filled it with their collection of Asian art. And Nellie Centennial Cornish, an energetic disciple of progressive education, in 1914 founded an innovative interdisciplinary school of the arts, named for her and still vital today. She turned to women to back her efforts, to bail the school out of debt, and to counteract the naysayers, like *Seattle Times* owner Joseph Blethen, who opposed a new building for the school in 1919 because "people were not anxious to spend their money for unnecessary things."[2]

At the turn of the century the arts were seen as a woman's arena, proper for a girl's cultural development and peripheral to the essential commercial concerns of the society, which were handled by men. All Northwest artists shared equally an isolation from the great Eastern cultural centers and felt bound to leave home to study. For a young man, however,

101. Myra Wiggins,
Edge of the Cliff, c. 1902

102. Imogen Cunningham,
On Mt. Rainier 6, 1915

study away from home might be seen as a statement of rebellion against the economic mainstream, while for a young woman, traveling east was part of her cultural polish.

Art practice and education were two of the few professions open to women before World War II, and women generally outnumbered men in these fields. For example, Spokane city directories list 125 artists between 1889 and 1910.[3] Seventy-one are clearly women, identifiable by first names or form of address. Most other names show only the first initial, leaving the sex unclear. Jack Cleaver, curator of collections at the Oregon Historical Society, notes the "tremendous impact of women" on the early development of the Oregon art community in three key areas: "They dominated art exhibits at the Oregon State Fair, various Portland fairs, and county fairs during the nineteenth century. Oregon art teachers in the last century were almost exclusively women. [And] with one exception [the Portland Art Club, established 1885] women were well represented in early organizations of artists."[4] By 1941, when the first regional *Who's Who in Art* was published by Marion Brymner Appleton, 54 percent of the 216 painters listed in Oregon and Washington were women.

Little remains of the work of the impressive numbers of earlier women artists active before 1930, and it can be found most readily in local historical societies and in the homes of the artists' descendants.[5] Some of this work

achieves excellence, while much of it is of indifferent quality, with pedestrian subject matter and/or rudimentary technique, and in poor condition. Preservation in private hands depends on loving relatives—initially children or nephews and nieces—but the size of a private collection is in no predictable ratio to the artist's excellence. Paintings deposited in public collections are more likely to have been chosen because of merit—a purchase award from an exhibition, for example. Tracing a painter's work from an example uncovered in a museum, however, may yield only disappointing seconds to the collected piece. Similarly, the volume of an artist's preserved life history does not guarantee the quality of her art. With the greatest regret one turns from a most fascinating personal tale—such as that of Eliza Barchus, who when widowed bartered art for dentistry and carpentry and sold landscapes at roadside stands[6]—to face a hackneyed painting.

Eleven distinguished painters from Washington and Oregon are discussed below, yet they are not a small sampling from a pool of extraordinary talent. The numbers of extremely good, rather than regionally prominent, women artists will be increased when other media are included. A larger list would embrace, among others, internationally known photographers Myra Wiggins (see plate 101) and Imogen Cunningham (see plates 102 and 124), printmaker Helen Loggie (see plate 103), metalsmith Ruth

103. Helen Loggie, *Drawing for "The Twisted Cedar,"* 1930

104. Harriet Foster Beecher in Port Townsend, before 1915

Penington, and Native American artists such as basketmaker Jennie Kanim.

The Columbia River forms a clear divide between Oregon and Washington. In 1887 a traveler could ride the Northern Pacific Railroad between Portland and Seattle with a one-night stop in Tacoma. Otherwise it was multiple train lines, wagons, and stagecoaches with a ferry across the river, or steamboats along the coast and up the Columbia to Portland, until paved roads and cars became prevalent between World War I and World War II. Artistic communities developed separately in each state, and although Oregon was settled earlier and developed its artistic institutions sooner, the first accomplished Northwest woman painter for whom there is a record appeared in Washington.

Harriet Foster Beecher (1854–1915) (plate 104) opened Seattle's first art studio in 1881, when the new settlement was just thirty years old. The census of 1880 counted 3,533 inhabitants. Beecher's pupils would include Emily Inez Denny, the first child born to white settlers, and other daughters of the local elite. The studio was a beach cottage on stilts with rear views of the coastline and Native American encampments, the subjects of Beecher's most successful watercolors (see plate 105).

The route that took Beecher from Indiana to San Francisco to Puget Sound is ostensibly clear—from birthplace, to art studies, to husband and family. Her frustration at the loss

of the sophisticated Bay Area art community is hinted at in an early sketchbook: "I found all [my students] most interested in home beautification, which consisted chiefly in decorating furniture, mirrors and screens—with flowers, birds and butterflies. [But] they are willing to study from nature, which is pleasant."[7] Beecher herself painted heavy oil portraits in the Dutch and German tradition and transparent watercolor scenes. In her watercolors she favored intimacy over majesty, ignoring the area's towering mountains and subduing its ocean by concentrating on the beach. She included signs of human activity, particularly the boats and camps of Native Americans, which make her watercolors subtle, adept additions to the historic record begun by earlier male explorers, naturalists, and missionaries.

The paintings of Beecher and her students were shown in regional and national expositions—in particular San Francisco's Panama-Pacific International Exposition of 1915, for which Beecher was the sole female among the five jurors for the Washington State Hall of Fine Arts. At this and other expositions, paintings were presented to a wide audience and supported artists' claims to national reputations. Tacoma painter Abby Williams Hill (1861–1943) (plate 106) was a major beneficiary of the fair's comingling of art and commerce. She exhibited the results of her railroad commissions to paint wilderness scenes along Western routes— a lure to tourists and new settlers—at the

105.
Harriet Foster Beecher, *A Camp on the Tide Flats, 1897*

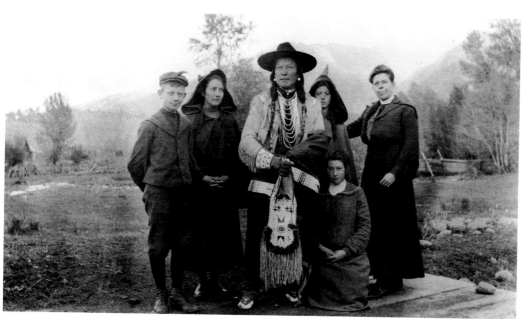

106. Abby Williams Hill in Montana, 1905

World's Colombian Exposition in Chicago (1893), the Louisiana Purchase Exposition in Saint Louis (1904), and the Lewis and Clark Exposition in Portland, Oregon (1905). After the fairs the paintings were returned to Hill, a Washington resident from 1889 to 1910, and they exist along with her journals at the University of Puget Sound, Tacoma, one of the largest extant collections of work by any early Northwest artist.

Hill's skill was rarely equal to her task. Unlike Beecher, who beautifully fit her subject and format to her abilities as a sensitive atmospheric watercolorist, Hill had a restricted technical vocabulary for the rugged mountains, towering vegetation, or flowing water she painted between 1903 and 1906. In the face of the daunting landscape of the mountainous West, her early training with William Merritt Chase was insufficient and left her craving further study. Her journals (which also were her letters home) reveal her artistic frustrations as well as her pride when flattered. In 1902, camping on the Columbia River with her children, she wrote, "I have been indulging in such a fit of discontent over my work that I was ready to poke it all in the fire and rush home on the first train. . . . I have worked away, enjoying the tramps, the sunshine, the wonderful views and atmospheric effects, but not succeeding in my work to my satisfaction. I should study more under a master."[8] Four years later she

glowed under the praise of Montana painter Edgar Samuel Paxon, who "gave me great praise for my work, said my technique was better than his, my drawing fine and my coloring far better than Mr. [Joseph Henry] Sharp's who could not touch me."[9]

What Hill did possess was an incredible drive to be in the wilderness, unhampered by city codes of dress and living a life that honored her austere missionary and abolitionist upbringing in Grinnell, Iowa. At the same time, her Spartan ways brought her a unique status as a woman artist camping on her own.[10] Year after year Hill left her husband for extended camping trips into the wilderness with two or more of her four children, teaching them with the progressive methods she advocated as a state representative to the Congress of Mothers, befriending and depicting Native Americans, and enthusiastically painting to fulfill her contracts. Her freedom was secured by the railroads, which paid for her and her children's transport, and by an inheritance that made her financially independent of her spouse.

After leaving the Northwest for California and travels in the Southwest, Hill painted one of her most successful works, *Niguel Canyon: Wild Mustard*, 1919 (plate 107). This small but strong California landscape of a less majestic place than the Cascades or Rocky Mountains has the authority and sensitive luminosity lacking in most of Hill's grander works.

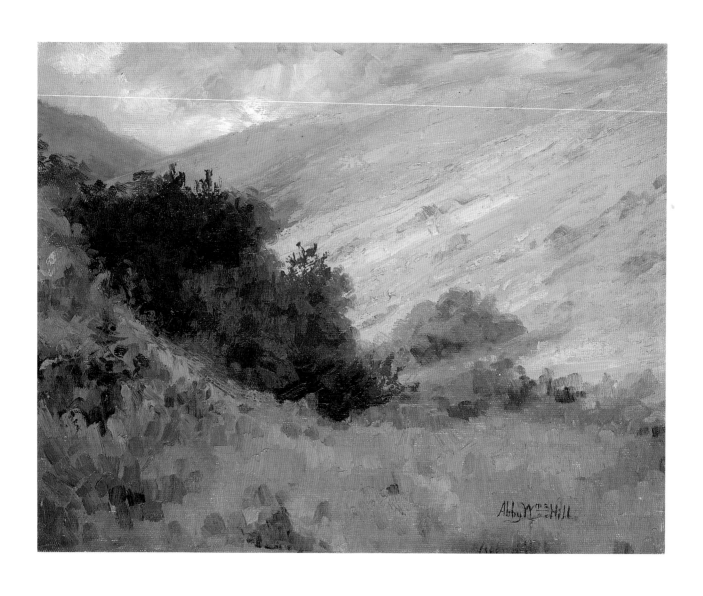

107.
Abby Williams Hill, *Niguel Canyon: Wild Mustard*, 1919

Painted after a long period during which she primarily tended to her husband, it has a directness and freshness that shows what she could achieve free of contractual obligations. Perhaps her art, though not her personal needs, might have been served better by a different patron than the railroads, whose interest lay in extolling the West to potential travelers.

Unlike Hill, Tacoma painter Anna Gellenbeck (1883–1948) left neither a journalistic record nor an abundance of canvases. Her few extant works show, however, a dramatic flair that Hill lacked. Gellenbeck's *Richardson Highway, Alaska* (plate 108) illuminated the Washington State Historical Society's crowded stacks and is the best of a few works donated by a relative upon leaving the Northwest. The artist migrated from Minnesota to Tacoma as a young woman in about 1912. At least three of her siblings also came to Tacoma, and Gellenbeck, who was unmarried, lived with one or more family members, possibly keeping house for a brother with whom she traveled. There is no record of formal art training and Gellenbeck's obituary in the *Tacoma Times* calls her self-taught.[11] She was recognized in the 1920s for her landscape paintings of Montana, and she exhibited in Chicago and New York; press reports also mention portraits of Catholic clergymen and religious scenes. Her landscapes were both criticized and admired for their strangely limited, purplish palette.

Gellenbeck's panoramic mural of massive hills leading down to the Columbia River in central Washington exists now only in poor photographs. An audacious adornment, painted for her own sedate dining room, it suggests an artist of some daring. This hint of boldness is supported by the expansiveness of a scene painted a few years before her death. In *Richardson Highway, Alaska*, Gellenbeck seems to be one of the region's few twentieth-century exponents of the spectacular, a noteworthy rarity given the natural grandeur of the Northwest landscape.

Beecher, Hill, and Gellenbeck were all principally plein-air painters, uninterested in moralizing or narration. Their brushwork was fairly loose, though not Impressionist, but their painting was basically descriptive. It is easier to assess a 1940s Gellenbeck beside an 1890s Beecher than to place it in the context of the avant-garde movements rocking Europe in the early twentieth century. The Northwest was not, however, entirely isolated from Post-Impressionist and Cubist styles. Not only did artists tend to travel widely but Marcel Duchamp's *Nude Descending a Staircase*,[12] revealed to Americans at New York's trailblazing Armory Show of 1913, came to Portland in 1914.[13] Even before the 1930s, a time of strong European influence through exhibitions (particularly of German Expressionism) and visiting artists, teachers of modernism settled in Portland and Seattle.

Among the first of the modernist artist-teachers in Washington were Peter and Margaret Camfferman (1881–1964), who built their lifelong home Brackenwood on rural Whidbey Island in Puget Sound in 1915. They had met at the Minneapolis School of Fine Art, where Margaret, a Minnesota native, and Peter, a Dutch immigrant, were students. Before migrating west, they studied at the New York School of Design with Robert Henri, the nation's foremost exponent of Populist Realism (dismissively called the Ashcan School by critics), and his teaching colleague, Kenneth Hayes Miller.

The Camffermans' earliest work is unknown and was probably dispersed to relatives in Minnesota after their deaths. By the mid-1930s the Camffermans had revisited New York for a year, traveled in Mexico and Europe, and studied with modernist André Lhote in Paris. *View from Old Homestead Ranch* (plate 109) shows Lhote's influence in its restricted palette, flattened masses, and blocky foliage. Though compositionally similar in its overlapping triangular hills to Hill's *Niguel Canyon: Wild Mustard*, Margaret Camfferman's planar vision reflects her exposure to Post-Impressionist abstraction. Her confidence in a personal style and her readiness to simplify form have supplanted Hill's trust in nature's appearance.

By the mid-1930s the University of Washington had an art department staffed with modernists Ambrose Patterson (who arrived in Seattle in 1918) and Walter Isaacs (who was hired in 1923). The Camffermans, who shared the School of Paris influence, were a tangential part of the academic community and occasional visitors to the urban Seattle art scene, which had achieved a new coherence fostered by the federal art projects of the Great Depression. Margaret, however, was a central figure in the women's art community, organizing and hosting outings, lectures, and teas. In a photograph

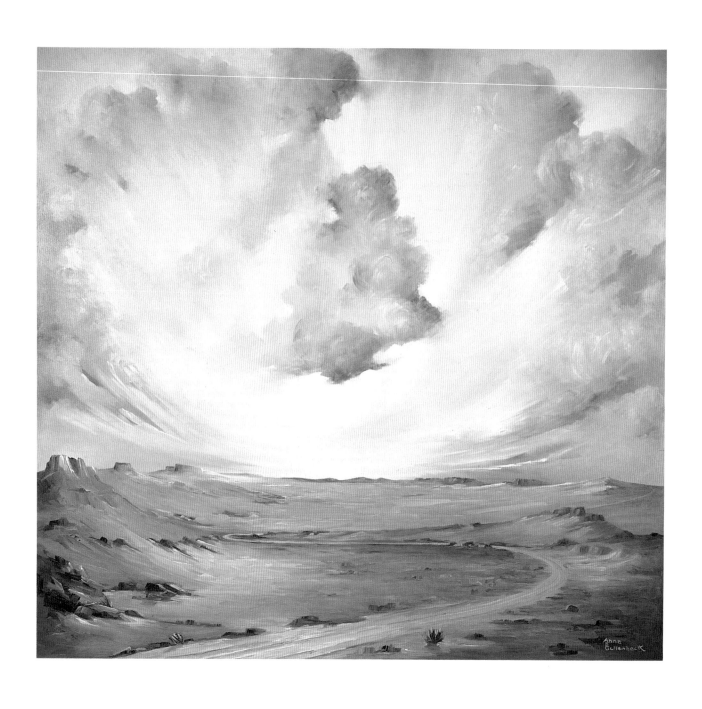

108.
Anna Gellenbeck, *Richardson Highway, Alaska,* 1944

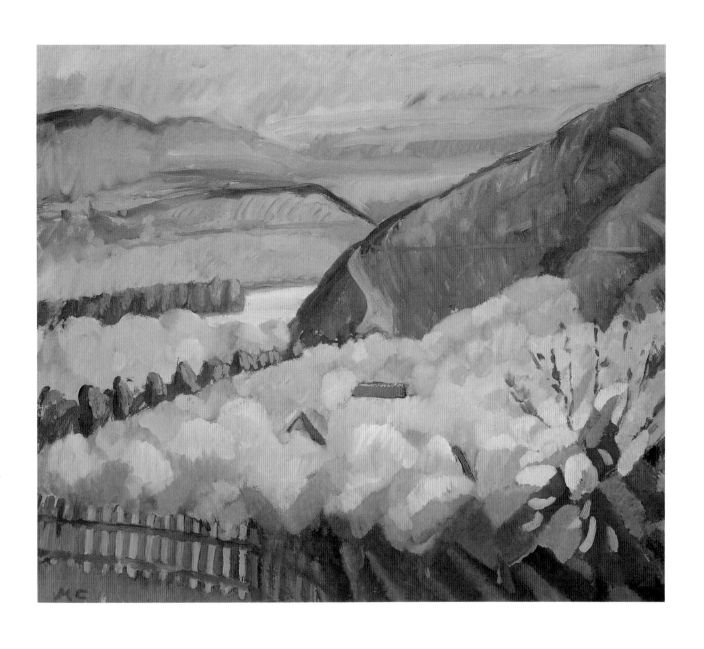

109.
Margaret Camfferman, *View from Old Homestead Ranch*, 1936

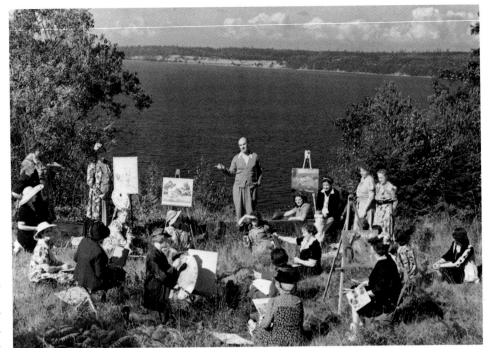

taken on Whidbey Island in the mid-1930s, at the time *View from Old Homestead Ranch* was painted, she stands nearby while Peter teaches a class of the Women Painters of Washington (plate 110).

Women Painters of Washington was, and still is, a society of serious artists, founded in 1930 for fellowship, artistic stimulation, and promotion of members' work, probably in response to the formation of the Puget Sound Group of Northwest Men Painters at the end of the 1920s. The women's organization generally attracted those whose primary self-identification was homemaker rather than artist. Women with academic ties, like Viola Patterson, or great artistic drive, like Margaret Tomkins, did not join. Among the society's founding members were Dorothy Dolph Jensen (see plate 111), Myra Albert Wiggins, and Elizabeth Warhanik, women whose painting broke no new ground stylistically but whose achievement was often admirable.[14] Margaret Camfferman remained an active member until her death in 1964. Z. Vanessa Helder and Yvonne Twining Humber were active in the group, although their memberships did not overlap.[15]

Z. Vanessa Helder was instrumental in arranging a 1936 East Coast exhibition of work by members of the Women Painters of Washington at the Grant Studios, a gallery near the Brooklyn Museum. In a report covering New York's response to the Westerners, the *Seattle* *Times* noted that "art critics of the East were surprised at the subject matter of the display and at the absence of Indians and Cowboys." The Seattle reporter then quoted the art critic of the *New York Sun*, who adeptly managed to insult artists both three thousand miles and three miles from central Manhattan: "That film-fostered notion that the West is so different is apparently a delusion. Washington state is certainly far enough west, but the group of women painters from there who are exhibiting at the Grant Galleries are as decorous and unadventurous a lot in their paintings as you could find in Brooklyn itself."[16]

The Great Depression of the 1930s activated regional artists, for the federal art projects of the Roosevelt era granted them the recognition, and often the income, they formerly lacked. William Cumming's acutely observed and articulately partisan *Sketchbook*, a lively memoir of the artist's youth, friends, and enemies, centers on an important group of male artists in Seattle whom critics of the 1940s and 1950s defined as the Northwest School.[17] No female artist or art organization is described at any length, although women appear in important roles as active supporters of the arts. If Cumming had been employed at the Spokane Art Center rather than in Seattle's Federal Art Project, his story might be different, for he would have been closely associated with accomplished women artists, and the eastern

region's hard, clear light might have received the literary attention granted solely to the misty coastal atmospherics that characterized the Northwest School.

The Spokane Art Center, established in 1939, was recognized at the time as one of the Federal Art Project's most flourishing institutions, noted for its success in bringing art classes as well as exhibitions to the whole community. Artists brought from the East mixed with regional artists, who vied for positions at the center. Some of the Northwest's most important women artists—New Yorker Hilda Deutsch (née Grossman) and Seattleite Z. Vanessa Helder—worked together on the staff under the direction of the painter Carl Morris, whom Hilda later married. Margaret Tomkins, a recent California transplant, accompanied her husband James FitzGerald to Spokane in 1941 when he replaced Morris as director.

Hilda Morris (1911–1991) applied to the WPA in 1938 with a desire to work or teach away from home. She brought a cosmopolitan background to the Spokane Art Center, where she established a sculpture department, and a broad knowledge of the international art world gleaned in New York from her family, from museums, and from classes at the Art Students League and Cooper Union. In the Northwest she found a landscape that would be a continual inspiration to her art (though rarely its direct subject), and an interest in non-European, particularly Asian, cultures that matched her own interest. When she and Carl Morris (1911–1992) married and moved to Seattle in 1940, they found their worldliness and artistic interests duplicated in those of artist Mark Tobey (1890–1976), with whom they established a long friendship. The couple's move to Portland a year later created a rare and strong artistic link between the two cities, but may have contributed to the Morrises' exclusion from the canon of artists later defined, particularly by curator-critic-artist Kenneth Callahan (1905–1986), as the Northwest School (Tobey, Callahan, Morris Graves, and Guy Anderson).

In 1939, the year Hilda Morris arrived in Spokane, her watercolor *Landscape* (plate 112) won a purchase award at the Seattle Art Museum's Northwest Annual, a central event in the region's artistic calendar since 1914 and continued by the museum between 1933 and 1975. *Landscape* is a rare early example of

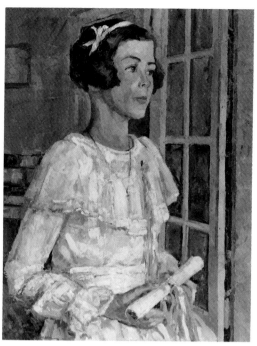

III. Dorothy Dolph Jensen, *The Graduate,* c. 1933

Morris's painting, for she was a noted modernist sculptor until the 1980s, when she began to exhibit powerful, abstract *sumi* paintings as well. Some of the *sumi* paintings are strongly linked to her sculptures by title and form, and are companion works rather than preliminary sketches. These two-dimensional works are a reminder that the young Hilda Morris consciously became a sculptor to establish artistic independence from her husband, who was a painter. She exhibited her painting, a medium in which she showed great early promise, only after her reputation was firm.

In *Landscape* nature and settlement are distinguished by angle and stroke. The hillside, depicted with lush washes, is the stable natural presence that anchors a sharply tilting scene whose receding telephone poles and houses threaten to plunge off the picture plane. The artist's stroke is confident and original. The powerful brushwork of her future painting is predicted, though this is one of the last known times she would depict human constructions in her work.

While the male often dominates in the marriage of two artists, Hilda was rarely seen as an adjunct to Carl. Her marriage, along with that of Margaret Tomkins and James FitzGerald (1910–1973) seems a model of mutual professional support and achievement, accomplished without renouncing children or career. In these two cases, one of each pair was a sculptor and

112.
Hilda Morris, *Landscape*, c. 1939

113.
Z. Vanessa Helder, *Coulee Dam Looking West*, c. 1940

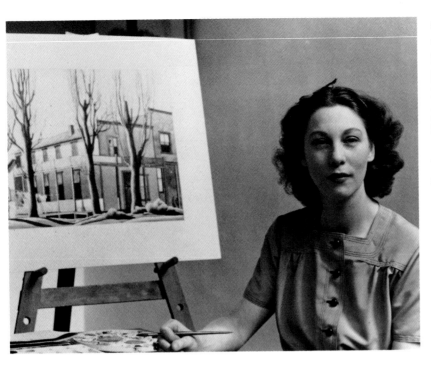

115. Z. Vanessa Helder, 1941

equal to and as compelling as the primal forces with which it competes—the water and rocks. In scrutinizing this parity Helder is essentially independent from other precisionists like Ralston Crawford or Charles Sheeler, who depict manmade structures as self-sufficient, often solitary, and physically remote from nature.

A native of Washington state, Helder lived in New York in the mid-1930s as a scholarship student at the Art Students League. By the time of her employment at the Spokane Art Center from 1939 to 1941, she had exhibited so regularly in the East that the *New York Times* art critic, announcing her second one-person show at the Grant Studios, noted that her work "is familiar to New York gallery-goers."[19] Helder's employment in Spokane as a watercolorist and lithographer was fortunate, since her vision was so compatible with the intensity and dryness of the light and land. Twenty watercolors from this time were purchased by Spokane's Cheney Cowles Museum in the 1950s and are beautifully preserved there.

In 1943 Helder married John S. Paterson, an architectural engineer, and they moved to Los Angeles. The same year, she exhibited in two shows at New York's Museum of Modern Art, *Americans, 1943* and *American Realists and Magic Realists*. Twelve of her watercolors, including *Rocks and Concrete*, were shown in the second exhibition, along with the work of Hopper, Sheeler, Shahn, Wyeth, and others. Helder continued an active career, often exhibiting with the national societies she belonged to, but apparently ceased showing in New York in the mid-1940s.[20] Her later work was largely dispersed at her death, a fate more frequent with childless artists; her California career has not been studied.

Margaret Tomkins (b. 1916) (plate 116) arrived in Spokane in 1941 when her husband, Seattle native James FitzGerald, became the art center's last director before its activities were severely curtailed by the second world war. Born and educated in Los Angeles, Tomkins moved north to teach briefly at the University of Washington in 1939. She saw this as a move from a vital art scene (she had seen Picasso's *Guernica*[21] in Los Angeles) to a static one. "I couldn't find *any* scene," she recollected in 1984, as she noted the failure of local painters to react to developments in twentieth-century art.[22] Tomkins judged Spokane less harshly than Se-

one a painter, establishing a visible independence that reinforced each's individuality. In addition, none of the four was employed by a university for any significant length of time, leading to greater parity of social status, unencumbered time, and financial need. With other couples, such as Viola and Ambrose Patterson or Anne and David McCosh, similarity of painting styles and the high visibility of the professor males (Ambrose at the University of Washington; David at the University of Oregon) made independent evaluation of each artist's work more difficult. If the woman's work was admired, her career was seen as stunted by association with her professional husband; if the woman's work was disliked, any recognition she achieved was attributed to her husband's prominence. In either case, the spouse becomes an essential part of her appraisal.[18]

Morris's *Landscape* possesses an unsettling quality because of its skewed, emotional force. In her watercolor are the seeds of an expressionism that she, like some artists of the later New York School, would translate into gestural abstraction. In contrast, the Spokane-period watercolors of Z. Vanessa Helder (1904–1968) (plate 115) are unsettling because of an opposite, austere precision. Architecture and landscape receive equally cold scrutiny and obdurate mass in *Coulee Dam Looking West* (plate 113) and *Rocks and Concrete* (plate 114, page 106). Human engineering—the dam—is depicted as

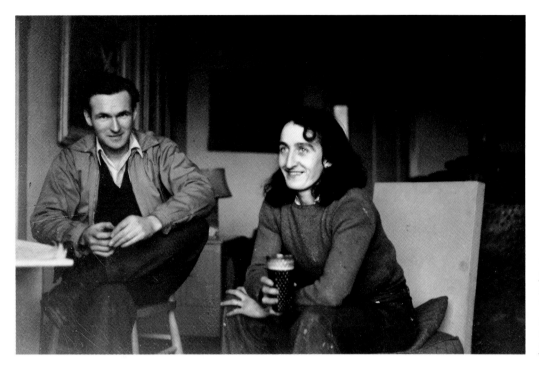

116. Margaret Tomkins and James FitzGerald in their Seattle studio, c. 1945. Written on reverse: "Us—that's a beer that gave me that ecstatic look, also very tired from planting at the moment and Jim from sculp."

attle, for she valued the open-mindedness of its population and its readiness to learn.

Most of Tomkins's early work was destroyed in a 1959 studio fire. Two of her submissions to the Northwest annuals were purchased by the Seattle Art Museum in the 1940s, before the artist's anger about the institution's intricate relationship with the small group of artists who came to be called the Northwest School led her to boycott the yearly competition.[23] Her anger was over politics rather than style, since her debt to Morris Graves and Kenneth Callahan is evident in the change of her work from a regionalist to a Surrealist style after moving north.[24] In both *Metamorphosis* (plate 117) and *Anamorphosis* (plate 118), Tomkins's absorption of local and European Surrealism is evident, for she created, with artists like Salvador Dalí, a mutating world with irrational juxtapositions and bizarre transformations of nature. Tomkins described her intent as depicting "the changing possibility, mentally and physically, of objects you look at . . . that transformation of energies from, say, a material object into a more intuitive one."[25] Despite the increasing abstraction of her later work, she never deviated from this belief that the visible world was the foundation for the transformative act of painting.

The worlds suggested by Tomkins's two paintings differ. The earlier *Metamorphosis* is somber and disturbing, with winged forms that are part driftwood, part prehistoric bird, part plane, flying through a bleak brown landscape. *Anamorphosis*, with its twining veins and roots and lighter palette, implies continual change and more desirable outcomes. Its lush fecundity and suggestion of a uterine-like enclosure are possibly related to the birth of her first child, Jared, in 1944 and to the changes in her own body and life at that time.

Tomkins is not identified with any group in the Northwest. Whether from choice or "injured sensibilities," as William Cumming suggests,[26] she maintained an independence from the academics and the mystics even though she shared their Surrealist sensibilities. Tomkins particularly dismissed identification with women painters as a group, finding them self-pitying and lacking in the clarity, balance, and energy it took her to be artist, mother, and wife.[27]

The painter's fierce individualism, ambition, and unwavering focus set her apart from the Women Painters of Washington, a group whose lectures and teas often pair gentility and art. Yvonne Humber (b. 1907) (plate 119), who arrived in Seattle in 1943, typifies that group as it has remained since its founding. "My art was secondary to living," she recently stated, noting the time she was obligated to care for aging parents and downplaying her artistic achievement and ambition in the self-deprecating manner common to women artists of her generation. "Women were considered homemakers prima-

117.
Margaret Tomkins, *Metamorphosis*, 1943

118.
Margaret Tomkins, *Anamorphosis*, 1944

rily and that's the way I thought of myself."[28] She was sponsored by Myra Wiggins in her successful bid to join the Women Painters, and has been a lifelong member.

Though Humber, a Massachusetts native, studied at the National Academy of Design in New York from 1925 to 1931 (an alternative to college that was acceptable to her family), her experience was cloistered by the old-fashioned training available there. Unlike the rough-and-tumble Art Students League in the 1930s—where men and women worked crowded together, sketched living models, studied under genre painters, and advanced by survival of the fittest—the academy segregated women and had them paint from plaster casts. Humber was aware of modernists like John Marin, whom she saw at Alfred Stieglitz's gallery, but her acquaintance with hard-edge Realist painters Edna Reindel, Paul Cadmus, and Luigi Lucioni contributed most to her disavowal of the prevalent Impressionist brushwork and turned her towards a genre style that she nurtured in Boston's Federal Art Project and then brought to the Northwest.

Public Market (plate 120) was exhibited in Humber's one-person show at the Seattle Art Museum in 1946, an exhibition that resulted from the first prize she won at the previous year's Northwest Annual. (Her husband's reaction to the award was, "I knew you painted, but I didn't know I'd married a real artist!")[29] The scene is of Seattle's lively Pike Place Market, painted and extensively sketched by Mark Tobey but rarely depicted by others. Humber adeptly relegates crowds to the rear of her scene and focuses foreground attention on particular activities of the market—buying and selling, meeting, watching, walking. The clothing is wartime drab; the fruits are colorful; the women are isolated or in pairs, quietly preoccupied. The painting is notable for its unfashionable setting, focus on work rather than relaxation, and absence of sentimentality.

Given the scarcity of regional urban genre painters, Humber stands out as a recent migrant from the East Coast with transplanted interest in the people and structures of the city's core. In 1945 she could hardly be called a Western regional painter except for her local subject matter. Her situation is only slightly more extreme than that of other artists in the area who came from other places or studied else-

119. Yvonne Twining Humber at her Seattle Art Museum exhibition, 1946

where, or both. This variety of imported influences has frustrated attempts to define an inclusive regional style and has helped elevate one subgroup of male artists who were linked by friendship, philosophy, and medium as the Northwest School.

The arts community south of the Columbia River was not included in early descriptions of the Northwest School. Hilda and Carl Morris might have been candidates for the group had they remained in Washington. They were not, however, living in Seattle during the incubation of the Northwest School in the 1930s, nor did their friendship with Mark Tobey embrace other members of his circle, and they continued to identify with New York rather than Northwest artists during their lifetimes. The couple left Seattle for Portland in 1941 for Hilda Morris's job at the art museum school and Carl Morris's mural commission in Eugene.[30] The move separated them from Seattle by about two hundred miles and placed them in a culturally disparate locale. Portland was an older, wealthier city with an earlier commitment to the arts and with fewer mercenary tendencies than Seattle—"gentility and just a hint of stagnation" was historian Nancy Wilson Ross's characterization in 1941.[31]

State fairs brought art to the Oregon public as early as 1861. Arts organizations—the Portland Sketch Club and the Oregon Art Association, both organized in 1895—were the first regional societies to include women and were heavily dependent on their participation. The

120.
Yvonne Twining Humber, *Public Market*, c. 1944–45

121.
Clara Jane Stephens, *Park Blocks*, n.d.

Portland Art Association built its first museum, now called the Portland Art Museum, in 1908, and paid for its first art teacher in 1909. The museum and its school, run by women and instructing far more girls than boys,[32] had a dominating local influence in the arts since Portland was without a major university. An early employee of the museum's school, Clara Jane Stephens (1877–1952) taught Saturday children's classes, and probably other sessions, there from 1917 to 1938. Stephens was a native of Great Britain who migrated to Portland in her youth, and who remained unmarried and left no close relatives at her death, explanation for the paucity of biographical information and the dispersion and loss of her work. Her studies in New York at the Art Students League with Kenyon Cox and William Merritt Chase remained her predominant influences, supported by Portland Art Museum shows such as the 1916 exhibition of New York Realists that included work by John Sloan, George Luks, William Glackens, George Bellows, Ernest Lawson, Robert Henri, and Guy Pene du Bois. European abstraction, also shown at the museum (for example, in its 1914 selections from the Armory Show and 1927 exhibition of work by Wassily Kandinsky, Paul Klee, Lionel Feininger, and Alexei Jawlensky), apparently did not affect Stephens. Her compositions, however, sometimes hint at the modernist influence of photography in her use of bird's-eye perspective and close-up distortion.

Park Blocks (plate 121), variously dated from the mid-1920s to mid-1930s,[33] shows why Stephens had achieved a degree of international recognition by 1925, the apparent height of her career, with a solo exhibition in New York and mentions in the French press. The painting has commanding scale, authoritative brushwork, an interesting composition—the towheaded center-of-interest is circled by a ring of close-up children and distant adults—and a sweet subject that just avoids sentimentality. The painting was made by someone sure of her skills and adept at engineering visual complexity, a painter who stayed within a realist framework inherited from Impressionism and who possessed the gentility that characterized her adopted city.

The generational difference and contrast in training between Humber and Stephens is clear. Stephens employed a loosely brushed

style for a theme of convivial relaxation quite French in feeling, while Humber courted a tighter, grittier realism associated with regionalist styles of the Great Depression. This realist style was as rare in Oregon as in Washington, and was nonexistent among women living in the region before 1930. Anne Kutka McCosh (1902–1994) (plate 122) imported an East Coast urban vision and wit to Oregon and was acutely aware of the meager ("stinking" she called it) art scene in her new town, Eugene.[34] Part of a large New York immigrant family, McCosh had come from a headier milieu—working at the Art Students League in the 1920s (where her brother-in-law Homer Boss was an influential teacher) and serving on its governing board; managing the Gladys Roosevelt Dick (GRD) Studio Gallery in New York, down the hall from José Clemente Orozco; and painting at the Tiffany Foundation's Oyster Bay retreat, where she met her future husband, whose appointment to the University of Oregon faculty brought the couple to Eugene in 1934.

In 1991 McCosh noted that *Leaving the Lecture: The Faculty Wives*, 1936 (plate 123), was her "Renaissance painting—formal composition, underpainting, modeling, glazing—the whole thing."[35] The painting was clearly important for her, since she lavished such attention on it and since the artist was herself a new member of the group depicted. Perhaps McCosh identified with the young woman in the center of the scene, whose sophisticated urban stylishness is in contrast to the dowdy dress of her older companions and the small-town church in the background. It seems that the lot of faculty wives—to be in the audience, not at the lectern—had not changed with the generations. The women are sharply observed but not belittled, and their situation and poses are atypical for a group portrait. The implied focus of the painting is on their minds, not their bodies or beauty. They are heavily clothed and seen from the rear; there are no children in tow; and they are engaged in sober discussion, not gossiping over tea. McCosh remarked in 1989, "Of course the women had to have been faculty wives! After all, they asked such intelligent questions."[36]

Certainly, some women did hold faculty positions in regional institutions before 1945, though their strength and influence had diminished since the founding period. The segrega-

122. Anne Kutka McCosh in New Mexico, 1934

124. Imogen Cunningham, *Portrait of Maude Kerns*, c. 1915

tion of women in childhood education and home economics, ever-increasing requirements for higher degrees, and anti-nepotism regulations prohibiting employment of both husband and wife all worked to the detriment of professional women.[37] In addition, married women were not permitted to hold regular teaching positions in elementary and secondary schools since that conflicted with their proper roles at home and took income away from male wage earners.[38]

Maude I. Kerns (1876–1965) (plate 124), an Oregon native and daughter of pioneers, headed the Normal Arts Department (art education) at the University of Oregon for twenty-six years but was never granted the rank of full professor. She taught both painting and crafts and she was eulogized for her skills at flower arranging. When Kerns reluctantly retired in 1947, she was at the height of her late success as a nonobjective artist, noted in New York but isolated in Eugene.

Kerns remained single and counseled her female students to be "more than baby-making machines" if they desired careers in art.[39] While her single status allowed her to teach in Seattle high schools between 1906 and 1921 and the absence of a professor-husband permitted university employment, family obligations still remained paramount; Kerns cared for her mother and sister for prolonged periods. When Mark Rothko, who saw her work in New York at the behest of mutual friends, suggested in

1951 that she should have had the courage to stay in the East and join the avant-garde, she remarked, "Of course, he did not know that a woman can't just do as she wants to."[40]

Like many other aspiring female professionals (including Georgia O'Keeffe and Agnes Martin), Kerns had earned a teaching degree with the formalist and orientalist Arthur Wesley Dow at Columbia University Teachers College in New York, which she attended from 1904 to 1906. She sought the revolutionary art of Europe during a 1913 trip abroad, although her early work did not reflect its influence. Exposure to the spiritualism of Christian Science (a religion that was espoused by Dow and that she joined in 1907) and familiarity with Eastern philosophy gained on an extensive visit to Japan in 1928 with Gertrude Bass Warner (art collector, Christian Scientist, and future founder of the University of Oregon Museum of Art), presaged her conversion in the 1930s to a nonobjective style based on Wassily Kandinsky's belief that timeless, universal spiritual truths and abstract shapes were linked.[41]

In her sixties, at the end of the 1930s, Kerns began to produce her most important work. After summers studying with modernists Hans Hoffman, Alexander Archipenko, and Rolph Scarlett, Kerns began to study (sometimes by mail) and exhibit at the Guggenheim Foundation's Museum of Non-Objective Art.

123.
Anne Kutka McCosh, *Leaving the Lecture: The Faculty Wives*, 1936

Directed by Baroness Hilla Rebay, the foundation promulgated Kandinsky's philosophy and style through classes and critiques. Letters from her old teacher Rolph Scarlett, who worked at the foundation, encouraged and instructed her. "Keep away from heavy, earthy colors. They have no cosmic quality," he advised in 1939, reinforcing Kerns's predilection for blue.[42] By 1941 Scarlett was emphatically complimentary, quelling a sixty-five-year-old artist's fears of being too imitative and too feminine. "Nonsense! I personally cannot see what you are talking about. Your things are boldly conceived and directly carried out. If that [feminine] mood is upon you or [your works] are beautifully delicate if you are so inclined, [they are] always strong fresh and *vital*. So just go on and listen to that feminine streak; it won't let you down. If you could see the piffling ugly junk that the office gets, you'd soon lose your feeling about your imagined 'anemic lady-like studies.'"[43]

Kerns exhibited at the foundation's semiannual shows between 1941 and 1951, when Rebay's leadership ended. In 1946 Kerns also exhibited some of her nonobjective paintings at the Seattle Art Museum. The museum purchased *Composition #27* (plate 125), an accomplished work in which transparent planes and floating circles suggest movement and light—an ethereal geometry. Kerns's painting should have been sympathetic to the museum's curator, Kenneth Callahan, who championed Mark Tobey's abstract, calligraphic paintings with their overlay of Asian and Bahai spirituality. On the contrary, Callahan, who doubled as the city's major art critic, wrote, "There is no idea expressed or attempted requiring our thought and attention. There are no subtleties to challenge our mind or wave us emotionally. Of all painting today [nonobjective art] is closest to and most clearly reflects the cold, scientific, mechanized phases of our life today that is overemphasized in a world which needs humanism more than at any time in centuries."[44] There is no indication whether Callahan's statement increased Kerns's self-doubts, or if she saw the irony of being accused of scientific materialism when her fears were of being too delicately feminine and her intent bordered on Platonic metaphysics.

In the handwritten manuscript of an incomplete and apparently autobiographical novel about a professor forced by age to retire, Kerns wrote that the protagonist held an awkward place straddling the centuries—"born between the four o'clock tea hour and the five cocktail."[45] The description also suits Kerns, whose late embrace of the avant-garde seems at odds with the persistence of her imposing Edwardian posture and mien. Kerns certainly stood apart from her peers—in her dress, manner, age, and adherence to nonobjective art. By 1945 she seems artistically isolated from her immediate environment—less of a Northwesterner than immigrants Foster, Hill, and Camfferman, who painted from nature, or than Humber, who had just arrived but depicted local scenes. Kerns was caught in the most troubling dilemma of regionalism—that regional art is seen as interesting only if it shows provincial characteristics, such as local color or stylistic naïveté. It was the fate of Kerns, who lived in the West her entire life but was involved with ideas emanating from Europe and New York, to be called "derivative" rather than "internationalist" or "universal."[46] Scarlett's assessment of her painting was correct. Kerns was a strong practitioner of an established style. Some of the freshness and strength of her late paintings might be attributed to her physical remoteness from other practitioners of the style. Becoming a nonobjective artist in Oregon was an act of need and courage, not a submission to fashion.

There is no one Northwest style represented by the women discussed here. Defining a style is an act of exclusion, omitting artists who do not fit, perhaps failing to notice them altogether. The definer is helped by unity of time and place, by friendships among artists, and by their access to exhibition space and the print media. The Northwest School exemplified these conditions since it started with close friends, a critic and curator among them, in close proximity, and at one time—the years encompassed by the Great Depression and World War II. In studying women painters of Washington and Oregon, the time frame is widened, the geographic boundaries stretched, and the friendships deemed tangential to the search for those we have ignored, or perhaps failed to notice altogether.

125.
Maude I. Kerns, *Composition #27*, 1944

143.
Dorothea Tanning, *Guardian Angel*, 1946

V

No Woman's Land

ARIZONA ADVENTURERS

Sarah J. Moore

THE ROLE OF WOMEN looms large in the development of art in Arizona. Throughout the late territorial and early statehood period—roughly 1900 to 1940—women artists lived and worked in Arizona in increasing numbers, despite its harsh realities and parched environment. At first glance, one cannot resist asking, Why Arizona? Although many artists came for health reasons, the salubrious effect of the dry desert air could not have been enough to sustain extended careers in an area with no principal art centers, negligible patronage, and minimal if any formal support for art activities. Indeed, the state's reputation as "all cactus, rattlesnakes and bad men"[1] was not entirely a fiction; the arid landscape was matched in large part by the sparseness of cultural vigor.

Yet women artists came, bringing with them significant formal art training and professional experience to challenge the vast, unyielding expanse that was Arizona in the first decades of the twentieth century. The migration pattern of women artists to Arizona largely paralleled that of other independent women who found aesthetic and personal sustenance in the vast and remarkably varied environment of the Southwest. The quality of life and the possibility of escape from social constraints and traditional domestic roles, as well as the light, magnificent vistas, geographical and psychological space, rich archeological ruins, and numerous highly diverse native people attracted many women artists. All of this in turn informed their work and their lives. Nancy Parezo recently noted that "successful women [in the West] had to be independent, unconventional, tenacious, stubborn, and ambitious. They had to want a career and a life beyond the home."[2]

Among the earliest and most sustained pictorial records of the daily life and traditions of the Hopi of northern Arizona were the canvases and photographs by New York–trained artist Kate Cory (1861–1958), who lived in Oraibi and Walpi for seven years. Chicago artist Jessie Benton Evans (1866–1954) moved to Phoenix in 1911 and built an elaborate villa, where she painted impressionist views of the Salt River Valley. Katherine Florence Kitt (1876–1945) (plate 126) offered formal art training in her Tucson studio before she was named head of the art department at the University of Arizona in 1928, a position she held for seventeen years. Another New York–trained artist, Lillian Wilhelm Smith (1882–1971), came to Arizona in 1913 with her cousin by marriage, Western novelist Zane Grey, to illustrate his book *The Rainbow Trail*; Smith remained in Arizona for the rest of her life. During the 1920s the state's first professional artists' associations were organized almost exclusively by women, and exhibitions featured more work by women art-

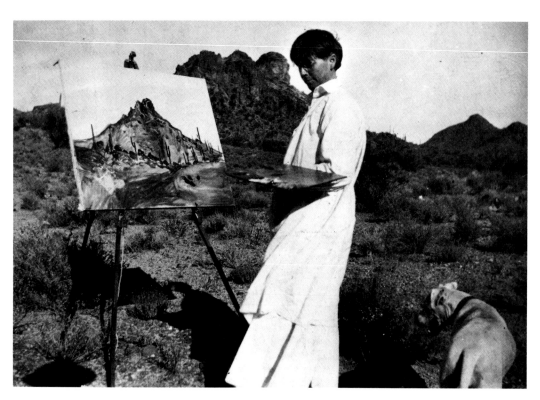

126. Katherine Kitt in Tucson, Arizona, c. 1898

ists than by male artists. In 1928 Philadelphia-trained painter Mary-Russell Ferrell Colton (1889–1971) cofounded the Museum of Northern Arizona; in addition to her post as art curator, she was a prolific landscapist as well as a portraitist of the local Native American population. Women artists were actively involved in the federal arts projects in the 1930s, including May Noble (1878–1966), who chaired the Arizona Committee of the Public Works of Art Project. In the late 1930s and early 1940s, landscapist and muralist Edith Hamlin (1902–1992) lived part-time in Tucson with her husband Maynard Dixon (1875–1946) and painted desert landscapes. Surrealist Dorothea Tanning (b. 1910) painted in Sedona in the 1940s, as did her husband Max Ernst (1891–1976).

While the sheer number of women artists in Arizona during this period attests to the strength of their presence, any assumption of a shared motive, agenda, or style is both reductive and overly simplistic. So too is the notion of a single narrative that can illuminate our understanding of women artists in Arizona. "The Southwest is many things to many people."[3] In addition to gender, however, there are other common denominators. The most notable is that all were artists with advanced formal training and professional experience, and all were at least relatively privileged, if

not necessarily wealthy, white, middle-class women. They were "women with the means to purchase books and the leisure time to read them."[4] Moreover, almost without exception, all of these artists came from other places—for reasons that varied from poor health to marital obligations to a search for freedom—and most of them stayed, making Arizona their home. Perhaps the most striking common ground for these Anglo women artists is their virtual absence from the art-historical record, an invisibility that belies both their number and their impact on the development of art in Arizona.

Contemporary scholars of women's history have noted the absence of a definable historiographic tradition in women's history in which to debate and revise interpretations. "Instead," as Joan Scott notes, "the subject of women has been either grafted on to other traditions or studied in isolation from them."[5] The historiography of the West in general, and Western art in particular, has been characterized by a preoccupation with the frontier as the site of rugged male individualism, of heroic exploits by daredevils who confront and subdue the challenging environment and its inhabitants with coarseness and exuberance. Because it celebrates characteristically masculine traits and bows to heroic stature, this historiographic tradition makes it difficult to see

SARAH J. MOORE

ordinary lives of either women or men. When women are infrequently introduced in the historical narrative, they are defined by a limited number of stereotypes that reflect widely held notions of femininity and the domestic sphere. A popular contemporary perception of Arizona was perhaps best expressed by territorial senator Ben Wade: "Arizona [is] just like Hell—all it lacks is water and good society."[6]

Much of the terminology of the history of the American West is highly problematic as well. Jensen and Miller have noted that the terms "West" and "frontier" are often used interchangeably and with stunning imprecision.[7] Moreover, the language frequently used to describe both the frontier experience and art of the West is reflective of gender assumptions. Such terms as *virile, adventuresome, heroic, daring, brave* in effect either render women invisible or marginalize their less-than-heroic accomplishments. This essay retraces the careers of European American women artists who helped decide, define, and invent what art was in Arizona during the first decades of the twentieth century.

Among those who most clearly demonstrated a plucky independence and rejection of social conformity was New York–trained artist Kate T. Cory, who in 1905 stepped off the train at Canyon Diablo, sixty-five miles south of the Hopi Reservation in the high desert mesas of northern Arizona. Cory paused as she gazed upon "the endless desert" and feared that the loquacious train porter's declaration was correct, that she was "one of Arizona's unfortunate pilgrims." "It took me half a minute to reinstate myself mentally in the ranks of the sound in body," Cory noted, "and another to be quite sure I had not been dropped at some prehistoric ruin."[8] Cory had come to northern Arizona to join a proposed artists' colony at the urging of her colleague and fellow artist Louis Akin (1869–1913). Akin first came to Arizona in 1903, commissioned by the Santa Fe Railroad to paint the Hopi, and he stayed for eighteen months. During a social gathering at the Pen and Brush Club in New York in 1905, Akin recounted dazzling tales of his experiences and proposed a colony of painters, writers, and musicians on the Hopi Reservation. Cory was attracted by the idea and purchased a round-trip ticket to Seattle, planning to visit relatives there and then return to New York by way of

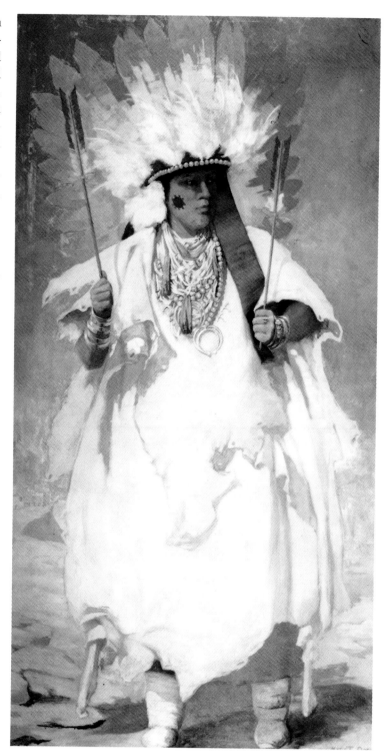

127. Kate T. Cory, *The Buffalo Dancer* [Komanci Mana], 1919

128. Kate T. Cory, *Untitled [Palhik'Mamantu/Dance of the Water Drinking Girls]*, c. 1905–12

Canyon Diablo. She did not use the return ticket, however, but remained on the Hopi Reservation for seven years, first in Oraibi and later in Walpi. Of the ill-fated artists' colony Cory wrote, "It materialized that Louis' plan did not bring the party to the reservation and thus I became the 'colony'."[9]

Cory's accomplishments were remarkable by any standards, particularly when one considers the utter lack of artistic patronage and support with which she was surely familiar. The artist was forty-four years old when she began her Arizona sojourn. She had studied at Cooper Union in New York as well as at the Art Students League, she was a member of several professional artists' organizations, and she earned her living as a commercial artist. Indeed, her stay as a single white woman in Arizona was discussed in a contemporary journal as exceptional.

After a brief stay in the so-called government village, a mile below the reservation, Cory befriended several of the Hopi women and rented two rooms on the top floor of the highest house in Oraibi, on First Mesa. Of her new home she wrote, "You reached it by ladders and little stone steps, and made your peace with the growling dogs on the ascent; but oh! the view when you got there."[10] The accommodations were modest at best—less than twenty square feet for her main living space—but Cory, apparently unhampered by the discomforts, seems to have adapted to her new life on the reservation: "Their customs and daily life are so different from our own that in their midst one feels transported to another age, and the busy world outside becomes vague and remote. The home letters are echoes from a place we used to be familiar with, and the world news at large almost as if it comes from another planet."[11]

Aside from the physical hardships she had to endure—water, for example, was only available six hundred feet below the village[12]—her isolation made contacts with colleagues virtually nonexistent, while access to equipment and supplies was severely limited. During her seven years on the Hopi Reservation, Cory nonetheless produced an enormous body of photographs, over six hundred images, recording both sacred and social ceremonies as well as virtually all aspects of daily Hopi life. Her achievement was all the more remarkable in that Cory was untrained as a photographer and worked under the most primitive conditions—her darkroom in Walpi used rainwater collected in barrels from runoff, from which she often had to extract mice and other small rodents.[13]

Cory was not the first artist to photograph

the Hopi. Between about 1895 and 1913, at least three other photographers—Edward S. Curtis (1868–1952), Adam Clark Vroman (1856–1916), and Joseph Jacinto Mora (1876-1947)—visited the Hopi Reservation and recorded aspects of ceremonial and daily life.[14] Cory's body of work was unusual, however, in its inclusiveness (only Cory and Mora spanned the ceremonial calendar), its rejection of stereotypes and self-conscious posing, its preference for the vernacular rather than the heroic, and its particular interest in and genuine cultural sensitivity to both the quotidian and the ceremonial life of Hopi women.[15] For example, *[Palhik'Mamantu/Dance of the Water Drinking Girls]*,[16] about 1905–12 (plate 128), depicts a social dance of the Mamzrau (a women's society) that features four women and one young man, the women wearing elaborate *tablitas*, in a dance that takes place outside the Kachina season. *[Comanche Dance]*, about 1905–12 (plate 129), depicts a social dance in which women participate and wear elaborate feather headdresses with long braids of hair hanging down on either side of the face. A comparison of this photograph with a painting of the same subject is instructive. In *The Buffalo Dancer [Komanci Mana]*, 1919 (plate 127, page 133), Cory depicts a life-size female dancer who displays her elaborate buckskin robe, feather headdress,

and adornments, holding an arrow in each hand.

One of Cory's most ambitious paintings, *Return of the Kachinas*, 1912?–35 (plate 130), represents the final morning of the Niman ceremony, a sixteen-day rite that ends the Kachina season in July, soon after the summer solstice.[17] The ceremony concludes with the disappearance of the Kachinas beyond the edge of the mesa, symbolizing a return to their spiritual home in the sky. Cory suggests this return of the spirits with a row of mystical dancing figures in the clouds above the pueblo, reflecting her understanding of the Hopi belief in the unity of the different spheres of life. Hopi scholar Barton Wright has observed that Cory's painting is ethnographically correct in its details, particularly the brilliant costumes and headdresses of the Hemis Kachinas, and that it reflects her sophisticated understanding of Hopi ceremonies. This accuracy is consonant with Cory's usual method of working. She often did sketches on site, some of them perhaps in color, from which paintings were later finished in the studio. Of *Return of the Kachinas* Cory wrote: "I had not finished it on the reservation when I left. . . . This was painted out of doors to get best light. For delicate clouds and figures. This is just at sunrise."[18] An interest in documentation and ethnographic accuracy

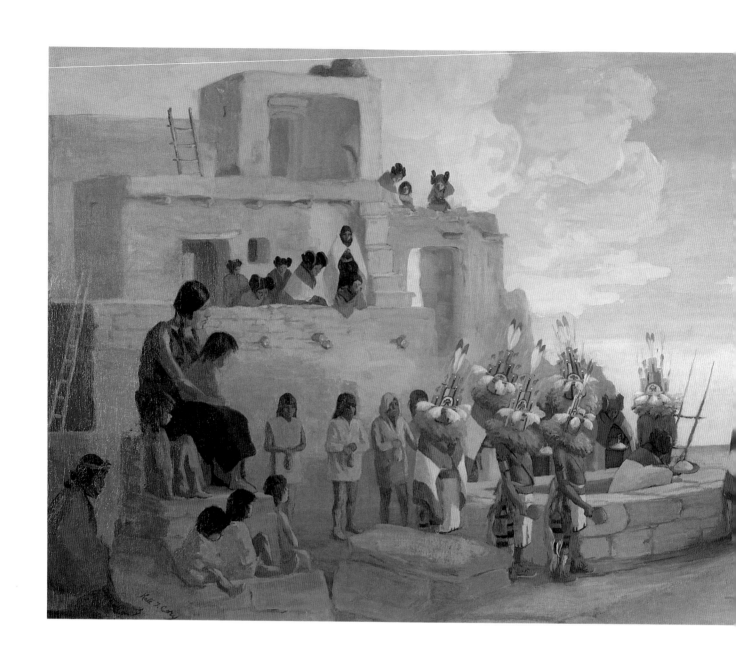

130.
Kate T. Cory, *Return of the Kachinas*, c. 1912?–1935

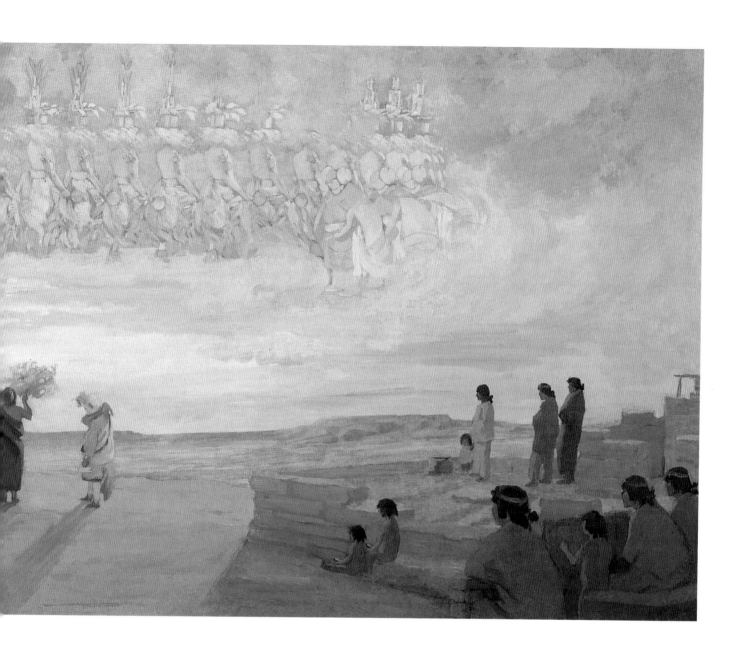

131. Hopi Craftsman Show, 1930

132. Mary-Russell Ferrell Colton, *Edmund Nequatewa*, 1942

pervaded all of her work. Her commitment to recording Hopi life was not confined to visual expressions; during her seven years on the reservation she wrote several articles, maintained a journal, and compiled a partial dictionary of Hopi-English that featured over seventy pages of words and phrases and twenty-odd pages of grammatical notes.

In 1912 Cory left the Hopi reservation and moved to Prescott, Arizona's first territorial capital, where she spent the remainder of her life painting Arizona subject matter. Her national reputation as an artist was demonstrated when she submitted her painting *Arizona Desert* to the International Exhibition of Modern Art, better known as the Armory Show, held in New York and Chicago in 1913.[19] Cory increasingly isolated herself, however, eventually abandoning her contacts with the Eastern art establishment. In 1921, a group of Anglo businessmen in Prescott established an organization, the Smoki People, for the ostensible if problematic preservation of Native American rites and ceremonies of the Southwest and their presentation to an Anglo public.[20] Cory was instrumental in advising the organization about costumes, ceremonies, and artifacts, particularly for the annual dances. In 1934 and 1935, government funds through federal relief programs allowed the Smoki People to build their own museum, and at this time Cory completed and/or donated several of her paintings of the Hopi.[21]

In 1912, the year Arizona was admitted to the Union and Kate Cory moved from the Hopi Reservation to Prescott, the Philadelphia-trained artist Mary-Russell Ferrell Colton traveled to the Colorado Plateau of northeastern Arizona on a honeymoon trip. The lure of the haunting grandeur of Arizona and its native people brought the Coltons back to Flagstaff for successive summers until 1926, when they settled there permanently. In 1928, at a time when northeastern Arizona was geographically isolated and sparsely populated, the Coltons founded the Museum of Northern Arizona as a "Museum of Science and Art," with Mary-Russell Ferrell Colton as curator of art and ethnology. The artist-curator "played a key role in the development of several significant programs that endure today as an integral part of the museum's identity. Furthermore, her money was critical to the financial survival of the institution."[22]

The art department was as vital to the museum as its commitment to research and the display of archaeological, ethnographic, and geological materials. As curator of the art department from its inception in 1928 to 1948, Colton engineered an ambitious exhibition program that featured the work of Arizona artists and craftspeople. The Arizona Artists Arts and Crafts Exhibition, held annually from 1929 to 1936, for example, was one of the important early exhibition venues for Arizona artists.[23] Colton's professional experience as an artist

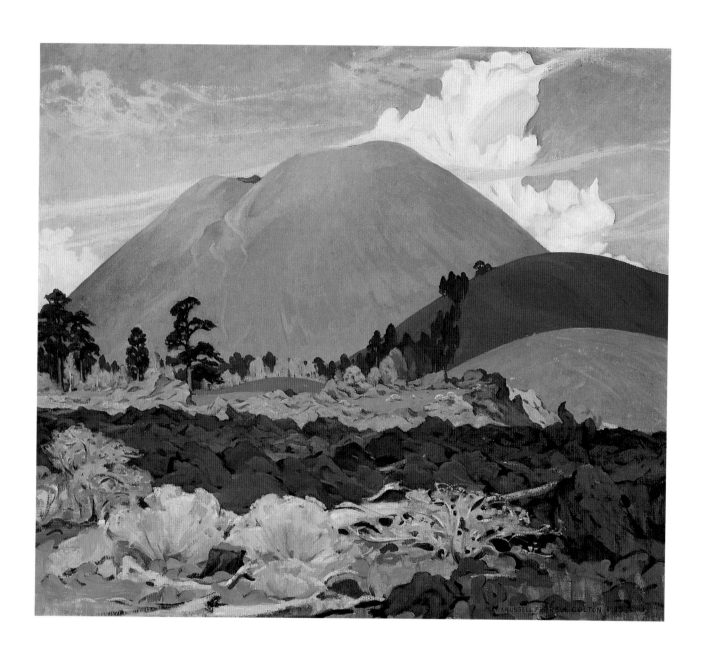

133.
Mary-Russell Ferrell Colton, *Sunset Crater*, 1930

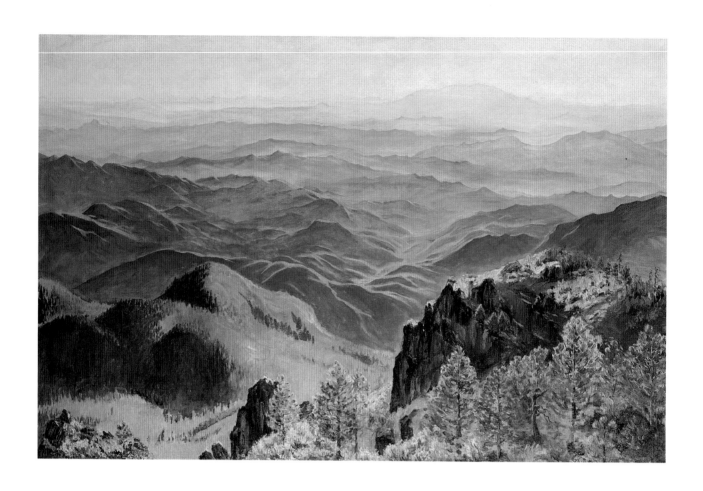

134.
Lillian Wilhelm Smith, *Blue Beauty of the Bradshaws*, c. 1936

surely fostered her interest in these annual exhibitions. After graduating from the Philadelphia School of Design for Women in 1908, she developed an interest in landscape painting, a genre in which she later distinguished herself in Arizona. At the same time, she opened a studio in Philadelphia, worked as a commercial artist and painting restorer, and became associated with a group of ten Philadelphia women artists with whom she continued to exhibit, intermittently, for over thirty years.[24]

Of more lasting significance was the annual Hopi Craftsman Exhibition, instituted in 1930. The origins of this exhibition reflect Colton's, and by extension the museum's, commitment to education, ethnology, and preservation and support of Native American arts. All of these areas, she felt, were grossly misunderstood and underappreciated by the American public: "We have welcomed the art of many nations," she noted, "but the unique and purely American art of our own native Americans has been ignored."[25] Plate 131 provides a view of the museum during the first exhibition. A number of Hopi crafts are exhibited along the back wall, including large bed blankets, undecorated utility wares—such as cooking, water-carrying, and storage jars—and a braided-cotton wedding sash. Colton's painting *Hopi Maiden*[26] is on the wall; it portrays a married woman (only unmarried Hopi women wore their hair in whorls) holding a Second Mesa coiled basket.

The inclusion of this painting within the exhibit of "Old Hopi Work" suggests that Colton thought of her portraiture of Native Americans in both an aesthetic and an ethnographic context.[27] In the room a Hopi weaver—all Hopi weavers were men—works on a vertical loom. The exhibition demonstrated not only the utility and beauty of Hopi crafts but also their production as a living tradition, albeit displayed in a museum.

Colton's commitment to the preservation and dissemination of Native American crafts was not limited to the annual Hopi Craftsman Exhibition. She organized several traveling exhibitions of Hopi arts and crafts that were seen in, among other places, New York, Philadelphia, and Washington, D.C. In 1942 she added an annual Navajo Craftsman show to the museum's calendar of exhibitions, conducted a detailed study of traditional Hopi vegetable dyes, and published extensively on Hopi arts, crafts, and culture.[28] Colton also coauthored a number of articles with Edmund Nequatewa (1880?–1969), a Hopi who worked with her as an interpreter and liaison.[29] Colton's 1942 painting of Nequatewa (plate 132) is a highly symbolic portrait, designed to reveal the artist's understanding of the intersection of the material and spiritual worlds that distinguished Hopi beliefs. Seated on an animal skin, the aging Nequatewa engages the viewer with a determined yet inscrutable expression. The back-

136. Jessie Benton Evans's studio,
Phoenix, c. 1930

ground, by contrast, is filled with vaporous male figures who represent the spiritual realm, and in effect represent Nequatewa as accurately as does his physical likeness. This portrait was among Colton's most engaging and sympathetic works, a sure reflection of her personal ties with and deep respect for the sitter.

Among Colton's most accomplished landscapes is *Sunset Crater,* 1930 (plate 133), a depiction of one of the volcanic cinder cones in the San Francisco Peaks. In addition to its aesthetic value, the painting resonates with her broad interest in Hopi culture. Sunset Crater was believed to be the home of the beneficent Kana-a Kachinas of the Hopi, a venerated site since prehistoric times.[30] The basis for such Hopi legends was published in the 1930s when the Archaeological Survey of the Museum of Northern Arizona uncovered "a ninth-century Arizona Pompeii under the volcanic ash from Sunset Crater." This find led in part to the designation of Sunset Crater as a national monument.[31]

Another adventuresome woman who welcomed the challenge of Arizona in the first decades of the twentieth century was Lillian Wilhelm Smith, who in 1912 had her first glimpse of "the Wild West" at the Buffalo Bill show held in New York's Madison Square Garden. With her formal art training at the National Academy of Design and the Art Students

League recently completed and with an introduction from her cousin by marriage, Zane Grey (1872–1939), she was permitted backstage to paint the Native American participants in the show. One year later, she joined Grey on one of the earliest expeditions to Rainbow Bridge. Four years earlier Arizona archaeologist Byron Cummings had been among the first Anglos to record and discuss this natural wonder in northeastern Arizona.[32] One of Smith's paintings of the site, *Spanning the Canyon Like a Graceful Rainbow,* was reproduced as the frontispiece for Grey's *The Rainbow Trail,* published in 1915.[33] She also accompanied Grey on subsequent expeditions to remote areas of Arizona, returning to New York for only brief visits. In 1924 she married Jess R. Smith—an outdoorsman, cowboy, forest ranger, and guide—and made Arizona her home.

Throughout the 1920s and 1930s Lillian Smith and her husband traveled throughout Arizona, where she specialized in landscape painting and also did occasional portraits of Native Americans. Of her experiences she later wrote, "His [Jess Smith's] great love for the beauty of nature, his knowledge of the Southwest, and his pride in [my] work motivated many trips to remote places of solemn grandeur and rare beauty, when he did the camping chores while [I] painted."[34] A contempo-

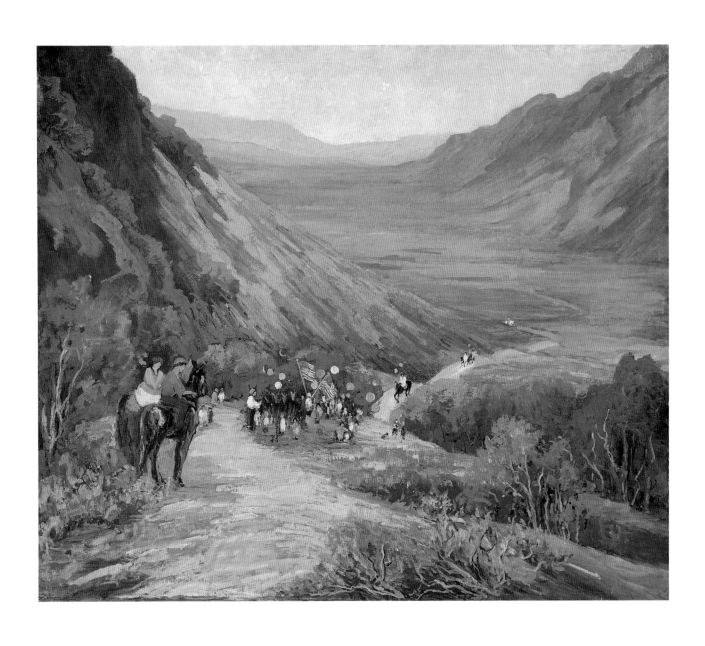

137.
Jessie Benton Evans, *Desert Picnic, Arizona,* c. 1930

rary newspaper account described the location from which she painted *Blue Beauty of the Bradshaws,* about 1936 (plate 134), on one of these trips: "The past week has seen the return to Phoenix of Lillian Wilhelm Smith, well-known artist, who has spent the past several months in the vicinity of Crown King intently at work on a panoramic view of the mountain ranges as seen from a forty-foot fire tower up the mountain from the town at an altitude of seven thousand feet. During the weeks she worked on the painting, Mrs. Smith saw no one except Mr. Smith . . . who first brought to her attention the magnificent view from the mountain fire tower in this almost inaccessible region."[35] Such arduous working conditions were not unusual for Smith, who became best known for her panoramic views of remote areas throughout Arizona. One writer later noted that "her paintings incline to the panoramic and are often of documentary value. She shows herself not only a romantic but also a thoroughly trained artist and lover of beauty at whatever cost in experience."[36] On Smith's "plucky adventuresomeness" a friend remarked, "This gentle artist has had more adventures than a cowboy around our Arizona."[37]

Without the advantage of urban centers to support the development of the arts in Arizona, local and statewide agencies—whose agendas were not strictly (or sometimes not even remotely) art related—became inadvertent art patrons for Arizona artists. Among the most important of these was the Arizona State Fair, held annually in Phoenix beginning in 1905.[38] With agendas similar to those of the international exhibitions of the nineteenth century, but on a far smaller, regional scale, the Arizona State Fair emphasized industry, technology, education, and entertainment. Numerous attractions and free exhibitions ranged from midway shows to balloon ascents, fireworks, parachute jumping, bicycle races, beautiful baby and ugliest man contests, and demonstrations by the noted local hypnotist Dr. Jonas, who in 1905 "place[d] his assistant in a trance and buried him for six days," the entire duration of the fair.[39]

In 1914 the first annual Arizona Art Exhibit was held at the Arizona State Fair under the auspices of the Art Exhibition Committee of the Women's Club of Phoenix. With Phoenix artist May Noble as the chairperson of the Jury of Selection, these annuals were intended to "bring to the front Arizona artists of various accomplishments of brush, pencil, charcoal, camera and decorative work."[40] In addition to prizes awarded in all departments—including painting, photography, ceramics, arts and crafts, watercolor—one picture, usually a prize winner, was purchased for a permanent municipal art collection.[41]

Artists throughout the state of Arizona participated in the State Fair annuals, including Kate Cory, Mary-Russell Ferrell Colton, Marjorie Thomas (1885–1978), May Noble, Lillian Wilhelm Smith, Lucy Drake Marlow (1890–1978), and Jessie Benton Evans, who took over as chairperson of the jury in 1925. Notable is the preponderance of works by women artists. Indeed, at the Third Annual Arizona Art Exhibit in 1916, all fifteen exhibitors were women. These numbers reflect both the defining role of the Women's Club of Phoenix in the Arizona State Fair annuals and the sheer quantity of women artists living and working in Arizona during this period.

Women's clubs generally played a formative role in the development of art in Arizona. Not only were they instrumental in organizing and sustaining the annual art exhibitions at the State Fair, these clubs were behind virtually all of the state's first professional artists' associations in the 1920s. In Tucson, for example, the local women's club began in the teens to sponsor exhibitions of works by its membership and invited artists. Recognizing the growing sophistication and unfulfilled needs of local artists, the art committee of the Tucson Women's Club proposed the organization of the Tucson Fine Arts Association in 1926. Within a year the association established its headquarters at the newly constructed Temple of Music and Art (plate 135), which featured an auditorium, artists' studios, and a gallery for art exhibitions.[42] The importance of the Tucson Fine Arts Association and its new home were given wide coverage in contemporary periodicals. One observer noted that "for those remaining few who consider Arizona an artistic waste space this exhibit [of the Tucson Fine Arts Association] would be a keen shock. Arizonans are painting Arizona, of that one is certain on entering the gallery." Another declared: "The Temple of Music and Art is the work of women. . . . It is built on a foundation of caliche, true, but its firmer foundation rests

138.
Marjorie Thomas, *Four White Mules*, c. 1930

139. Lucy Drake Marlow,
Study in Gray, 1933

bought forty acres at the base of Camelback Mountain, where she built an elaborate Italian-style villa—tiled sunken gardens, cypress-spired courtyards, and groves of oranges, figs, and pomegranates lent an air of European elegance. There, Evans held regular salons for the Phoenix culturati and visitors from the East and Europe (plate 136).

The desert landscape of the Salt River Valley first captivated Evans, and it remained the primary subject of her broadly handled, high-keyed impressionist views for the next forty years. The desert's rare beauty took Evans, as it did many, by surprise. Her biographer noted:

> "Desert" still means, to the majority of us, just one thing: the Sahara type, vast wastes of sand, utterly devoid of vegetation, save at the rare oases, broiling sun, blinding glare, desolation. But there is altogether another kind of desert in our own southwest, a desert of which Arizona seems to have the monopoly, glowing with all the colors of the rainbow, blossoming with weird, beautiful growths which the layman is at a loss to classify. . . . This is the desert which is reflected in the paintings of Jessie Benton Evans, who lives in the very midst of it [and] knows and loves it as a cherished friend.[46]

Desert Picnic, Arizona, about 1930 (plate 137), exemplifies Evans's panoramic desert views, with its high-keyed palette that captures the ever-changing quality of light. Commenting on the "Arizona desert's miracle," Evans wrote: "I think that real beauty exists where we least expect it, in an unrevealed sense, disclosing itself as we earnestly search for it, thus stimulating our creative faculties. The desert seems to me always alluring and illusive; its spirit is sweeping and vital and its voices form a chorus of endless song. It never allows one to work in an imitative way, which would certainly rob it of its charm." Comparing it to European landscape, the artist concluded, "There is a virgin freshness in the hills and barely trodden trails of the Southwest that one misses in tired, worn Europe."[47]

While support for the arts by women's clubs established a structure that enabled artists to exhibit and sell their work, its impact remained largely regional. By contrast, government support for the arts in the 1930s was a boon to Arizona women artists, particularly with the Public Works of Art Project (PWAP), and it positioned their work within a national

on [women's] ideals, the need of something to lift us to better and higher things of life."[43] Although not limited to women, the membership of the Tucson Fine Arts Association consisted overwhelmingly of women, as did its sister organization in Phoenix.

The early development of the arts in Phoenix and the Salt River Valley largely paralleled that of Tucson. Support by local women's organizations led to the founding of the Phoenix Fine Arts Association in 1925 and the Arizona Artists' Guild in 1928. In 1937 the Phoenix Fine Arts Association was an influential sponsor of the Phoenix Federal Art Center, established under the auspices of the Federal Art Project of the Works Progress Administration (WPA). The Phoenix Federal Art Center functioned as an exhibition hall and school, while solidifying Phoenix's role as the principal art center of the state for exhibitions, training, and patronage.[44]

Among the artists to benefit from the fledgling support for the arts by the local women's clubs was Jessie Benton Evans, who came to Arizona in 1911, at age forty-five, because of poor health. Benton's professional experience in the arts before her Arizona landfall was extensive. After graduating from the School of the Art Institute of Chicago in 1899, she spent several years abroad, chiefly in Italy and Paris. In Paris she exhibited with the Société des Artistes Français and the Société Nationale des Beaux-Arts.[45] On her arrival in Phoenix, Evans

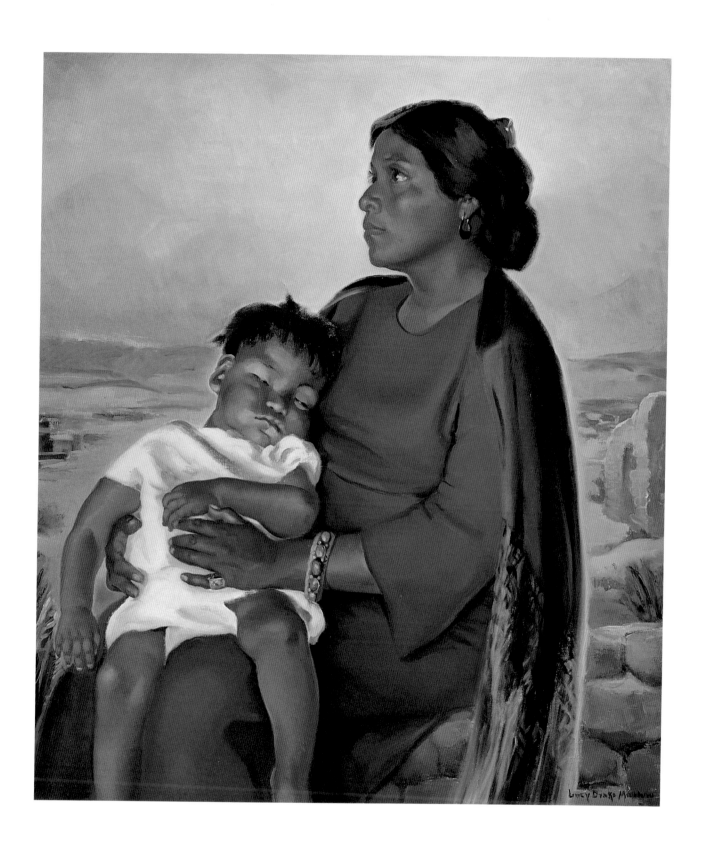

140.
Lucy Drake Marlow, *[Indian] Madonna*, 1940

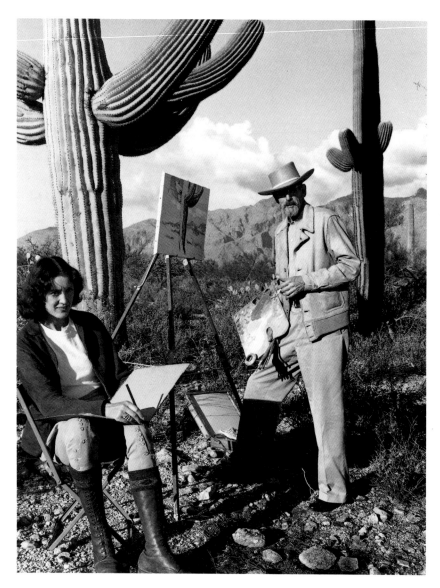

141. Maynard Dixon and Edith
Hamlin on a sketching trip among
the giant saguaro cactus in Arizona,
c. 1943

context. Assessing the value of PWAP support for Arizona artists, one contemporary commentator observed: "Of interest to the artists of Arizona and of significant cultural value is the Public Works of Art Project. . . . It is expected that something similar to a renaissance in painting and mural decoration may result from this official recognition by the government of the Arizona artist and his work."[48] Although short-lived—work began in January 1934 and ended in late April that same year—the Arizona Commission of the PWAP, chaired by May Noble, hired fifteen artists, seven of whom were women. Among the most prominent were Lucy Drake Marlow and Marjorie Thomas.[49] Both were active members of their local art communities—Tucson and Phoenix respectively—and both had brought with them to Arizona the sophistication of their academic training and, in Marlow's case, extensive professional experience as well.

Thomas moved to Arizona because of her brother's poor health, in 1909, just after she graduated from the School of the Museum of Fine Arts in Boston. Describing herself as an "artistic pioneer," Thomas began what became a lifelong career recording the transformation of the Salt River Valley.[50] Marlow received her formal training at the Carnegie Institute in Pittsburgh and the Pennsylvania Academy of the Fine Arts in Philadelphia in the teens; she continued her studies in Provincetown and then established herself as an academic figure and portrait painter in the Pittsburgh area, fulfilling painting commissions and teaching art classes in the 1920s. In 1927 Marlow moved to Tucson, because of her daughter's frail health, and there became associated with the recently founded Tucson Fine Arts Association. In addition to her work as a portraitist and occasional desert landscapist, she established an important though short-lived art school with painter and photographer Frederick Sommer (b. 1905).[51]

Thomas and Marlow each received commissions from the PWAP to paint several canvases reflecting various aspects of life in Arizona. Thomas's *Saturday, Rounding Up,* and *Stragglers* depict the early settlements in Scottsdale, north of Phoenix, focusing in particular on the use of mule teams for excavating the Salt River canal, which transformed the Phoenix area into a desert oasis. *Four White*

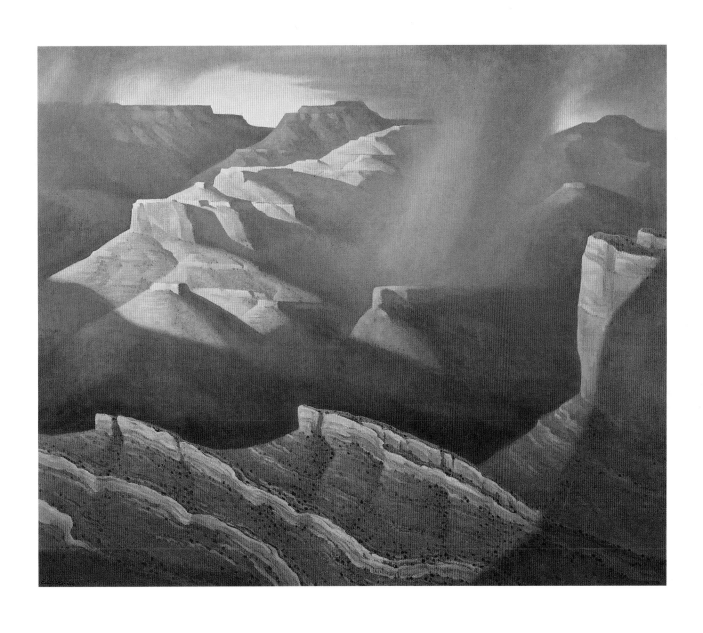

142.
Edith Hamlin, *Canyon of Flame and Storm*, 1940

Mules, about 1930 (plate 138), is related to these works and reveals Thomas's skill in rendering the anatomy of the animals tethered together on a hilltop and seen from below against a bright blue sky. These vernacular pictures suggest her interest in the daily realities of transforming the desert landscape. Thomas's paintings were among the first PWAP-commissioned works presented to Governor Moeur of Arizona and displayed in his executive office.[52]

Given Marlow's reputation as a portraitist and figure painter, it is not surprising that her PWAP commission included likenesses of important figures at the University of Arizona, Tucson,[53] as well as two figure paintings, *Spanish Girl in China Poblana Costume*[54] and *Reverie.*[55] *Study in Gray,* 1933 (plate 139), is closely related to *Reverie;* both are portraits of Frances Sommer, one of Marlow's favorite models and the wife of Frederick Sommer, with whom Marlow taught. *[Indian] Madonna,* 1940 (plate 140), is among a series of portraits of Native American women that Marlow painted between 1928 and 1940. Many of these portraits feature a single woman or, as in this case, a mother and child, depicted with dignity and reverence. In *[Indian] Madonna,* the ennobling of the mother holding a sleeping child and set against a vast desert landscape may refer to the matriarchal basis for many of the Native American cultures of the Southwest; it may also reflect Marlow's familiarity with the art-historical tradition of Madonna figures. This image demonstrates the problematic popularity of the so-called Indian Madonna as she was construed and interpreted by European American artists, male and female. Professor Barbara Babcock argued recently that such imagery can not only relegate the Native American woman to the outskirts of culture and history but also can objectify and commodify her.[56]

Between 1935 and 1945, two well-known women artists, Edith Hamlin and Dorothea Tanning, worked intermittently in Arizona. That neither artist made Arizona her permanent home reflects her personal history. It also suggests an ending to the chapter on the role of women in the art of Arizona during the first decades of the twentieth century.

Edith Hamlin moved to Tucson in 1939 with her artist-husband Maynard Dixon. Hamlin met Dixon in San Francisco in 1920, when she began her studies at the California School of Fine Arts with muralist Ray Boynton (1883–1951). After graduating in 1924, Hamlin moved to New York, returning to San Francisco in 1931 after travel in New Mexico and Arizona. One of many California artists to benefit from the federal art programs of the WPA in the 1930s, Hamlin painted murals at Coit Tower and Mission High School. While she was at work on the Coit Tower murals, she and Dixon became reacquainted. They married in 1937 and in 1939 moved their winter residence to Tucson, spending summers in Mount Carmel, Utah.[57] Between 1939 and 1946, the year of Dixon's death, Hamlin devoted much of her energy to his failing health. She continued, however, to sketch during their many trips around the Southwest. A 1943 photo of Dixon and Hamlin (plate 141) shows them at work in the desert around Tucson. Often they visited the Grand Canyon, only about a hundred miles south of their summer home. *Canyon of Flame and Storm,* 1940 (plate 142), was probably inspired by Hamlin's many visits to the site and clearly reveals her working method and approach to the Western landscape. Although Hamlin suggested that her sketches were factual and designed to accurately capture variations in topography and geological formations,[58] this painting is more an evocation of mood than a description of topography. The canyon's vast expanse is rendered in a series of simplified, abstract shapes, and dramatic shadows enhance the painting's two-dimensional design. This simplification of form and flattening of the picture surface suggest Hamlin's training and experience as a muralist. Shortly after Dixon died, Hamlin returned to her home in San Francisco, where she remained for the rest of her life.

In 1943 the Surrealist painters Dorothea Tanning and Max Ernst first traveled to Sedona, Arizona. They were impressed by a landscape so charged that Tanning wrote, "If Wagner had seen this his music would have been louder than it already is."[59] Tanning met Ernst in New York in the early 1940s. At that time she was part of the Surrealist circle of artists, some of whom she had met in Paris just before the outbreak of World War II. In 1946, shortly after they married, Tanning and Ernst moved to Sedona, where they stayed until 1953. Of the haunting quality of the high desert landscape, Tanning wrote: "In that camera-sharp place where the only electricity was in such thun-

derous lightning, there were no sounds in the afternoon save the hum of the heat. It was so intense, so lurking, so aged, that we the intruders felt also quiet, intense and strangely tiptoe, as if in peril. It bounced like coiled springs off the burning red rocks and melted the tar on our paper roof. It came inside to sit on my eyes."[60]

This intensity and sense of imminent peril informed many of Tanning's paintings from the Arizona period, such as *Autoportrait*,[61] in which a nude female figure, ostensibly Tanning, stands on a precipice overlooking the vast and formidable Sedona landscape. The image has an emotional tautness and a portentous edge, as do many of her works from the forties, which often explore female adolescence as both incipient sexuality and menace.[62] In *Guardian Angel*, 1946 (plate 143, page 130), for example, a dizzying maelstrom of beating wings and swirling drapery rips hapless children from their beds; the icy blue palette is relieved only by a passage of brilliant red over the body of one of the apparition's victims. Such psychological tension and eerie ambiguity reflect Tanning's exploration of the realm of dreams and suggest a pictorial response, however obliquely, to the Arizona landscape. "Imagine the pure excitement of living in such a place of ambivalent elements," she wrote. "Overhead a blue so triumphant it penetrated the darkest spaces of your brain. Underneath a ground ancient and cruel with stones, only stones, and cactus spines

playing possum. The evilest creatures of nature crawled, crept, scurried, slithered and observed you with hatred, but saved their venom while you kept your distance, when warned. . . . The red dust, the junipers, infinitesimal desert blooms, the stones. Even the stars shed perfume with their light."[63]

In 1909 Sharlot M. Hall (1870–1943)—poet, writer, and contributor to Charles Lummis's magazine *Land of Sunshine* (later called *Out West*)—was named Territorial Historian of Arizona, the only salaried position in the territorial government occupied by a woman. Her appointment by Territorial Governor Richard E. Sloan was not gratuitous. Hall had established herself as a devoted chronicler of Arizona history and was committed to dispel the popular misconception of Arizona as "peopled by train robbers, desperadoes, gamblers, and prostitutes."[64] In keeping with her self-styled posture as a fervent early feminist, Hall wrote an article in 1912 (the year of Arizona's statehood) highlighting the accomplishments and role of women in Arizona who "broke trails for us." Although not dedicated exclusively to artists, Hall's words can be read as a paean to the formative and defining role of women artists in Arizona. "Of those brave and wise and loving women . . . Arizona had her full share. Whatever of fine nobility we may grow in the future we shall owe an enduring debt . . . to the women whose memory is our best inheritance."[65]

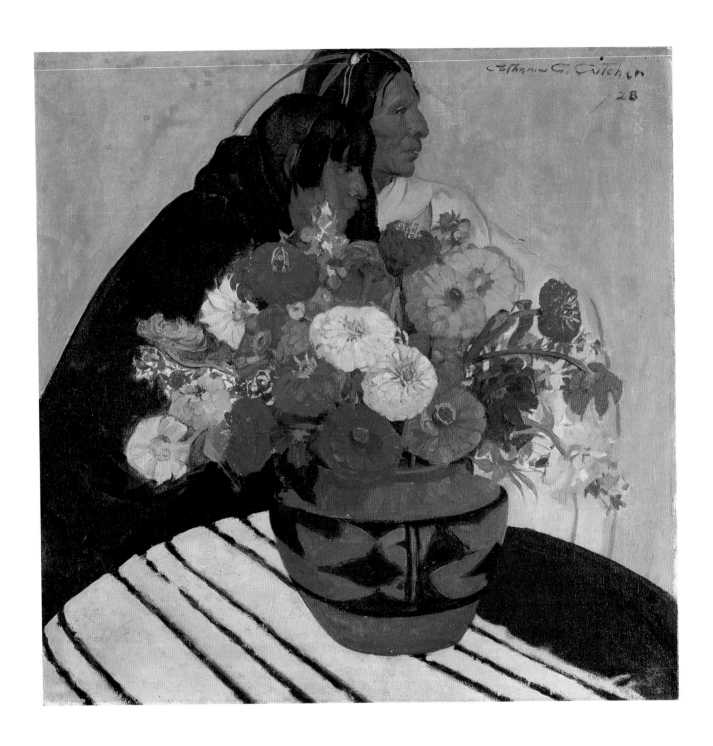

158.
Catharine C. Critcher, *Pueblo Family*, 1928

VI

Inner Voices, Outward Forms
WOMEN PAINTERS IN NEW MEXICO

Sandra D'Emilio and Sharyn Udall

There is another sort of beauty playing always about the Pueblo country, beauty of cloud and rain and split sunlight. . . . Everywhere peace, impenetrable timelessness of peace, as though the pueblo and all it contains were shut in a glassy fourth dimension, near and at the same time inaccessibly remote.—Mary Austin[1]

FREDERICK JACKSON TURNER pinpointed the passing of the American frontier in 1890. Virginia Woolf declared, "On or about December 1910, human nature changed." Willa Cather remarked that "the world broke in two" after World War I. And Mabel Dodge Luhan insisted that her new world began in 1917, upon first arriving in New Mexico. Later, recalling her first impressions, Luhan wrote: "For the first time in my life I heard the world singing in the same key in which my life inside me had sometimes lifted and poured itself out."[2]

While we may accept or discard the implications of these dates, clearly the decades bridging the nineteenth and twentieth centuries brought profound change. Most aspects of American life sustained the impact of multiple cultural crises—crises sparked by the erosion of past certainties and the sense that a new, modern sensibility was emerging in many fields, including the visual arts. And, as the world quickened its pace, those changes also made their way more rapidly into the formerly isolated Southwest.

In 1890 the largely rural Territory of New Mexico, with a population of only 160,000, seemed remote from the cultural capitals of America and Europe. Before New Mexico's statehood in 1912, the territory's cultural expressions in literature and the visual arts looked most often to the past. But, unlike the East, where social, cultural, and political values derived from classical European American traditions, the Southwest admitted much from its multicultural past, both colonial and indigenous. In New Mexico cultural roots lay deep in a Spanish colonial heritage, in a thriving

Pueblo people, and in the enterprising Anglos who pioneered along the Santa Fe Trail.

With the dramatic entrance of the Atchison, Topeka & Santa Fe Railroad into the Territory of New Mexico in 1878 (its track largely followed the Old Santa Fe Trail), the area became linked to one of the greatest transportation systems in the world, extending from both the East and West coasts.

In 1892 W. F. White, the railway's advertising campaign manager, commissioned Thomas Moran to do a painting of the Grand Canyon. Obtaining copyright, the railway printed thousands of lithographs of this splendid painting for distribution to offices, clubs, schools, and railroad depots in the East and Midwest. Moran's image captured the imagination of a multitude of potential tourists.

Expanding the corporate advertising campaign in 1900, William Haskell Simpson, the railway's promotional genius, began to commission other artists to paint the magnificent landscape of the Southwest and its native cultures and people. In 1903 Simpson purchased the first work for the Santa Fe Railway collec-

144. Catharine Carter Critcher,
Taos, New Mexico

tion, a view of Arizona's San Francisco Peaks by Chicago artist Bertha Menzler Dressler (1871–1947). The Santa Fe collection eventually grew to more than six hundred works. Other women artists whose paintings entered the collection were Alice Cleaver (1878–1944), Marion Kavanaugh Wachtel (1877–1954), Marjorie Helen Thomas (1885–1978), and Taos artist Ila McAfee (1897–1995). Asked about her first impressions of Taos, McAfee said, "[Taos] was so different then, the village was small and the Indians remained uninfluenced by the invaders. Once I asked one of them, 'What did you call this country before the Europeans came?' 'Ours,' he told me."[3]

From 1890 to 1945, a significant number of women painters worked in New Mexico, particularly at the art colonies of Taos and Santa Fe. Although their lives and careers are generally less well known than those of their male counterparts, in a culture rich in women's contributions of all kinds their work has left a profound imprint.

To accomplish this work in turn-of-the-century America, women painters had to overcome both personal and professional obstacles. Even as new opportunities began to appear, full equality was hampered by lingering cultural ambivalence about women. In the waning nineteenth century there was widespread concern that American culture was becoming "feminized," a phenomenon linked by cultural his-

torian T. J. Jackson Lears in 1981 to "the increasing dominance of a female audience in a society where women had become the keepers of the cultural flame."[4] That "feminization" was seen in 1899 as enervating—threatening to the vigor of American writing, painting, and music. With growing numbers of women in artistic pursuits, alarmists warned of an ensuing general cultural malaise. One male observer cautioned that "if the entire culture of the nation is womanized, it will be in the end weak, and without decisive influence on the progress of the world."[5]

In 1899 a writer in *Scribner's Magazine* complained that "moral invertebrates" throughout America, avoiding responsibility for their own actions, had made life "a kind of infirmary."[6] The maladies of modern life all contributed to this condition: the tyranny of the clock, the pressures of urbanization, and changing social mores. Women were thought particularly susceptible to (and to a degree responsible for) a whole range of nervous disorders bedeviling fin-de-siècle America. These vaguely defined ailments were called "neurasthenia."

A too-common prescription for women whose ailments were thought to result from excessive nervous strain was the protracted "rest cure." A legacy of Victorian-era medicine, it isolated patients from nervous stimuli in an effort to "fatten" and "redden" them for the return to active life.[7] Deprived of even books,

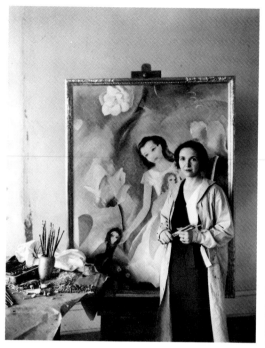 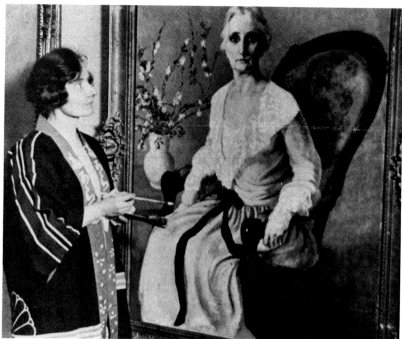

paper, and pencil, the patient endured a cure sometimes worse than the disorder itself.[8]

Similar ideas carried over into the visual arts. Griselda Pollock has written of the spaces allocated to women in her study of the experience of Mary Cassatt and Berthe Morisot.[9] While male artists painting in Paris found their subjects in the modern urban spaces of cafes, brothels, and bars, respectable women painters were consigned by gender and class restrictions to the domestic spaces of parlors, dining rooms, and private gardens. Femininity, Pollock argues, shaped women's spaces and limited women's access to modern subjects in the second half of the nineteenth century.

For European American women painters who came to New Mexico, the place seemed an antidote to many of the social ills they had experienced in urban areas. Liberated from her Midwestern constraints, Alice Corbin, who moved from Chicago to New Mexico in 1916, felt newfound freedom to express the difficulties she experienced being not only a poet but a woman poet. She wrote:

> What greater grief could be
> Than to be born a poet—and a woman!
> To have to turn to every trivial task,
> And leave the best unfinished.[10]

In the Southwest some of the restrictions of bourgeois society were absent, or at least unenforced after the turn of the century. New Mexico also offered a place in which the light, the arid desert, the vast scale of land and sky, and the Native American and Hispanic cultures all ignited the imaginations and lifted the creative spirits of these women.

In their sunlit expansiveness the spaces of New Mexico seemed to offer the promise of emotional and spiritual renewal to women as well as to men. During a 1922 visit to Taos, Catharine Carter Critcher (1868–1964) (plate 144) wrote: "Taos is unlike any place God ever made I believe & therein is charm & no place could be more conducive to work—there are models galore & no phones—The artists all live in these attractive funny little adobe houses away from the world, food, foes and friends."[11] Henriette Wyeth (b. 1907) (plate 145), daughter of renowned illustrator N. C. Wyeth, came to New Mexico in 1929 as a young bride with husband Peter Hurd, a painter and native New Mexican. From the start, she recalls, "I loved this valley [Hondo Valley] immediately. The Southwest gave me a whole new language— new vistas to paint."[12] After studying and painting in Paris and Rome in the twenties, Louise Crow (1891–1968) (plate 146) declared: "Nowhere in the United States or Europe have I found the clear air, the brilliant sunshine, the stimulating color, the exciting landscape, the all-year climate, together with the human elements to be found in New Mexico."[13]

The climate of New Mexico had long been

145. Henriette Wyeth, c. 1928

146. Louise Crow studying a portrait she painted of her mother, 1928

147. Mabel Dodge Luhan
and Tony Luhan

148. Cady Wells, *Mabel Dodge
Luhan, Frieda Lawrence, and
Dorothy Brett at Kiowa Ranch,* 1940s

a haven for health-seekers, particularly those who sought relief from respiratory ailments. As the new century advanced, New Mexico offered escape from attitudes about the presumed delicacy of women's physical and mental constitution. The choice to reject the blandness and artificial amenities of Western civilization in favor of an energetic, outdoor life empowered many women. And in acting decisively to travel, to explore, and to adapt to a new environment, they attacked self-doubt in their personal and professional lives. Traveling by car from Chicago in summer 1920, Laura van Pappelendam (1883–1974) wrote: "I was wild about these camping/painting trips. Generally my younger brother went with me. We camped in all kinds of conditions and places. Snakes have come up in tent rooms when we camped over their holes. . . . There is no better way to see the landscape than to be sleeping out."[14]

For some women, New Mexico's therapeutic environment seemed to embody particularly female qualities. Alice Corbin (1881–1949) felt that spirit in the land. As she recovered from tuberculosis, Corbin began to think about the land in gender terms. She knew that Native Americans regarded the land as both living and gendered; they revered both Mother Earth and Father Sky. Now Corbin expressed her own sense of the New Mexico desert as female, in contrast to the masculinized energy of the modern city:

After the roar, after the fierce modern music
Of rivets and hammers and trams,
After the shout of the giant
Youthful and brawling and strong
Building the cities of men,
Here is the desert of silence,
Blinking and blind in the sun—
An old, old woman who mumbles
 her beads
And crumbles to stone.[15]

Men, Corbin suggests, struggle to subdue, possess, and mark the earth. In cities this aggressive transformation is noisy and visible, while in the ancient desert silence reigns over the female land. Uncorrupted by the jackhammer and the slamming of steel, the land challenges masculinized notions of what Annette Kolodny has termed "massive exploitation and alteration of the continent."[16]

Among the other literary women who found New Mexico a therapeutic place was Mabel Dodge Luhan (1879–1962), whose account of her own complex life experiences, world-weariness, and eventual self-healing in New Mexico runs to four volumes. For many of her readers she became a leading symbol of the New Woman: self-determining, sexually emancipated, expansive in her ideas about art, society, and politics. With her fourth husband, Tony Luhan (plate 147), a Taos Pueblo Indian, Mabel envisioned a new Eden at her Taos compound—a place where European Americans

149. Georgia O'Keeffe near "The Pink House," Taos, New Mexico, 1929

150. Horace T. Pierce, *Florence Miller Pierce in Taos, New Mexico,* February or March, 1938

could absorb the redemptive lessons of Native American art and life. She encouraged a number of other women as well, among them Willa Cather, Georgia O'Keeffe, Rebecca Salsbury Strand, and Dorothy Brett, to fulfill their artistic promise in New Mexico. In his foreword to Luhan's book *Edge of Taos Desert,* John Collier, Jr., confirms the impact Luhan had on those who gathered around her: "Mabel's fulfilling Taos life should be seen against the background of the confused revolutionists and artists who constitute her early history, and with whom Mabel shared the struggle to recover lost humanism and elemental reason, which she finally perceived in the primeval Indian world."[17] The long friendship shared by Luhan, Brett, and Frieda Lawrence, known collectively as the "Three Fates" (plate 148), was marked by their mutual attachment to D. H. Lawrence and their competition as cultural doyennes of Taos.

One of the painters Luhan invited to New Mexico was Georgia O'Keeffe (1887–1986) (plate 149), whose health had suffered during the late 1920s and early 1930s. O'Keeffe immediately found New Mexico a therapeutic place, both for her art and her physical being. After her first summer's stay, in 1929, she wrote to painter Ettie Stettheimer: "I have had four months west and it seems to be all I needed . . . I haven't gained an ounce in weight but I feel so alive that I am apt to crack at any moment. . . . I laughed a great deal—I went every place that I

had time to go—and I'm ready to go back East as long as I have to go sometime."[18]

Casting aside the buttoned-up, restrictive dress of the day, O'Keeffe and her friend Rebecca Salsbury Strand (at this time married to photographer Paul Strand) donned trousers for comfort in the outdoors, as did the painters Gina Knee (1898–1982), Dorothy Brett (1883–1977), Florence Miller Pierce (b. 1918) (plate 150), and Margaret Lefranc (b. 1907). Although an earlier generation of women painters in New Mexico still wore Eastern dress (see plate 151), it was hardly suitable for an active outdoor life. Riding a horse astride, climbing a mountain, gardening, or baking bread outdoors, as Olive Rush did, demanded clothing chosen for freedom of movement. Native American painters Tonita Peña (plate 152), Pablita Velarde (plate 153), and Pop Chalee (plate 154) were generally photographed in their native clothes, often wearing native jewelry as well.

Freedom to make new choices marks the experience of most women painters in New Mexico. To subsume their diverse experiences into narrow categories would deny them the variety and breadth of men's experience. The artist's sense of her creative self as feminine, for example, varies from person to person, depending on personal choice or social factors. Nonetheless, there are significant commonalities. Considerations of family, ethnicity, training, professionalism, public identity, and the

151. Mary Greene Blumenschein,
Taos, New Mexico, 1920

mundane task of making a living, allow us to better understand how women's experiences in New Mexico were at once similar to and different from women's experiences elsewhere.

For centuries, being born into a family of artists or to parents sympathetic to art often eased the way for a career in painting. Henriette Wyeth's father, N. C. Wyeth, surrounded his children with art books and reproductions of paintings by Goya, Velázquez, and Dürer. "To talk to father was being talked to by God. He was a brilliant draftsman and taught all of us to observe and see. Art was a part, not apart, from our lives," Henriette Wyeth recalled.[19]

Another artist who was encouraged by her family, Mary Greene Blumenschein (1869–1958), had become highly successful in Paris, but stopped painting almost completely after arriving in Taos in 1919 with her husband, painter Ernest L. Blumenschein. Trained in some of the best schools in America and Europe, Mary Greene went on to win the gold medal at the Paris Salon d'Automne in 1902 (the second woman so honored, after Mary Cassatt). In Taos she turned from painting to jewelry design. A recent biographer noted that "Blumenschein had proven himself to be a dominating chauvinist who wanted a wife to be housewife, mother, and caretaker of the family home while he went around the country painting. This would not have been a problem had he encouraged her to have her own career.

But he did not, and she subjugated her interests to his."[20]

Changes in women's education at about the turn of the century opened new doors to professional careers. Within the span of these women's lives, dramatic shifts and intersections occurred. Briton Dorothy Brett learned dancing with Queen Victoria's grandchildren and first experienced the West vicariously at a London performance of Buffalo Bill's Wild West show, a cowboys-and-Indians extravaganza created by Rebecca Salsbury's father. Brett went on to study art at the highly professional Slade School in London, became a member of the Bloomsbury group, and followed D. H. and Frieda Lawrence to New Mexico in 1924. Olive Rush's education began at progressive Quaker Schools, while Rebecca Salsbury (plate 155) attended the innovative Ethical Culture School in New York. Everywhere art training possibilities widened as old barriers fell; schools not only welcomed women but allowed their full participation in coeducational life-drawing classes. During 1891–92 Catharine Carter Critcher and Olive Rush (1873–1966) studied at the Corcoran School of Art in Washington; both later continued their studies in Paris. Margaret Lefranc lived in Europe from 1920 until 1933, exposed to the most advanced training in Berlin and Paris. No longer constrained by the necessity of a constant chaperon, women had begun to travel more widely in Europe.

Rush and Alice Schille (1869–1955) sailed for Europe in 1913. Barbara Latham (1896–1989) and a woman writer friend bicycled through Brittany in 1924, gathering material and preparing illustrations for magazine stories. A few years later Latham and her artist-husband Howard Cook spent six months in France. As young women, Louise Crow, Henriette Wyeth, Agnes Tait (1897–1981), and Mary Greene Blumenschein absorbed the art and architecture of Europe and studied with some of the Continent's greatest painting teachers.

Their varied training and backgrounds made many of New Mexico's women painters open to other cultures. New Mexico, in particular, offered in its surviving native peoples subjects that seemed "exotic," mystical, and vaguely therapeutic in their premodern character. Dorothy Brett, for example, believed with Mary Austin and Mabel Dodge Luhan that Native American life possessed a certain rhythm that linked it to the deepest core of being. "What I really like to paint," said Brett, "is the spirit of a Race, the Life behind the Life of a people."[21] That spirit is depicted in a number of Brett's works.

Artists tired of "hackneyed European subject matter" found in New Mexico a subject unique to America—the Native American. By the turn of the century, European American attitudes toward Native Americans had changed. No longer seen as "savages," they were perceived as people in harmony with the rhythms of nature. However romanticized such ideas may seem today, they were part of the appeal to women and men who painted in the Southwest.

Pueblo dances and myths became major themes in the vocabularies of many artists. One of Mary Greene Blumenschein's stylized, Art Deco–influenced works depicts an Acoma Pueblo myth that includes antelope man, with references to fertility, planting, and growing (plate 156). The eagle dancers and drummers of San Ildefonso Pueblo became the theme for Louise Crow's award-winning work at the Paris Salon d'Automne in 1921 (plate 157). The Pueblo drummer, standing second from the left in her mural-size work, is Dieguito Roybal, who is also the subject of one of Robert Henri's 1917 oils. Catharine Carter Critcher's *Pueblo Family* (plate 158, page 152) portrays a classic Taos couple, and includes a Pueblo pot filled with zinnias. In many paintings by the Taos Society of Artists (Critcher was made the only woman member in 1924), Native American artifacts are important compositional and decorative elements. For these artists, the Native American represented the exotic, the spiritual, and the primitive—embodying values that they felt were missing in the industrialized cities they had chosen to leave. For many, the reason for coming to New Mexico was to experience a "New World Eden,"[22] the place that held a promise of renewal.

155. Peter Stackpole, *Rebecca Salsbury (Strand)*, 1937

Celebrating and preserving the diverse cultures of New Mexico enabled European American writers, artists, and cultural activists to learn more about women's lives outside their own tradition. They were inspired by earlier efforts by women to document and preserve the cultural heritage of the region. As early as 1905 ethnomusicologist Natalie Curtis had published her *Songs of Ancient America*. In 1918 Mary Austin (1868–1934) was hired by the Carnegie Foundation to study the economic and social conditions of Spanish-speaking New Mexicans (plate 159). She soon moved to Santa Fe to explore "the possibility of the reinstatement of the hand-craft culture and of the folk-drama."[23] In that era of renewed interest in native crafts worldwide, Austin and other members of the art colonies undertook to sustain Spanish and Native American arts in the state. When the Indian Arts Fund, founded in 1925, began to collect ancient and modern pottery, blankets, baskets, and silver, it insured the preservation of Native American women's—and men's—finest work. That same year, Austin helped to found the Spanish Colonial Arts Society. Key women poured their energies into the society and several successor organizations: the Native Market, founded by Leonora F. Curtin, and the Colonial Hispanic Crafts School, founded by Concha Ortiz y Pino in 1929, encouraged the teaching, marketing, and appreciation of the revived Hispanic arts of tin work, weaving, fur-

niture making, and wood carving. Women were especially active in the fiber arts: spinning, dyeing, *colcha* embroidery, weaving, and rug making.[24] Rarer were Hispanic women's efforts in painting, or in making *santos*, the carved and painted religious images highly sought by collectors. Although many *santeras* (women who carve and paint) and other Hispanic women painters have emerged since 1945, they were rare before this time.

Deploring the fragmentation of modern society in urban centers, a writer for *The Atlantic Monthly* in 1886 contrasted city life with communal existence in rural cultures: "No doubt there are lives that do go on with apparently unbroken coherence—tranquil, native or village lives, whose sun always rises over the same horizon, and whose radii of interests from year to year go out to the same unchanged circumference. Here the constantly overlapping continuity of the neighborhood existence helps to keep a man's own thread of personality unbroken." Or a woman's. The experiences of Native American women painters in New Mexico, however, though steeped in communal traditions, were far from uniform.

Division of labor by gender made it extremely difficult for Native American women to achieve success in areas traditionally assigned to men, especially easel painting. Most early twentieth-century easel painters and painters of religious objects were men, while women were usually the potters, weavers, basketmakers, and quill-and-bead workers.[25]

Despite these difficulties, several Native American women did become successful easel painters. San Ildefonso and Cochiti painter Tonita Peña, or Quah Ah (Little Bead or Pink Shell) (1895–1949), became the first Pueblo woman painter. Although this was atypical, Peña was encouraged by her family, her teachers, her three husbands, and archaeologist and museum director Dr. Edgar L. Hewett, who gave her art supplies and purchased her work. Art instructor Dorothy Dunn offered Peña and many other Native American students, such as Pablita Velarde, Pop Chalee, Gerald Nailor, Fred Kabotie, and Awa Tsireh, support and inspiration in classes at the Santa Fe Indian School, beginning in 1932. A mother of eight, Peña found time to paint daily in addition to farming, cleaning, cooking, baking bread in the *horno* (oven), and caring for her children. Paint-

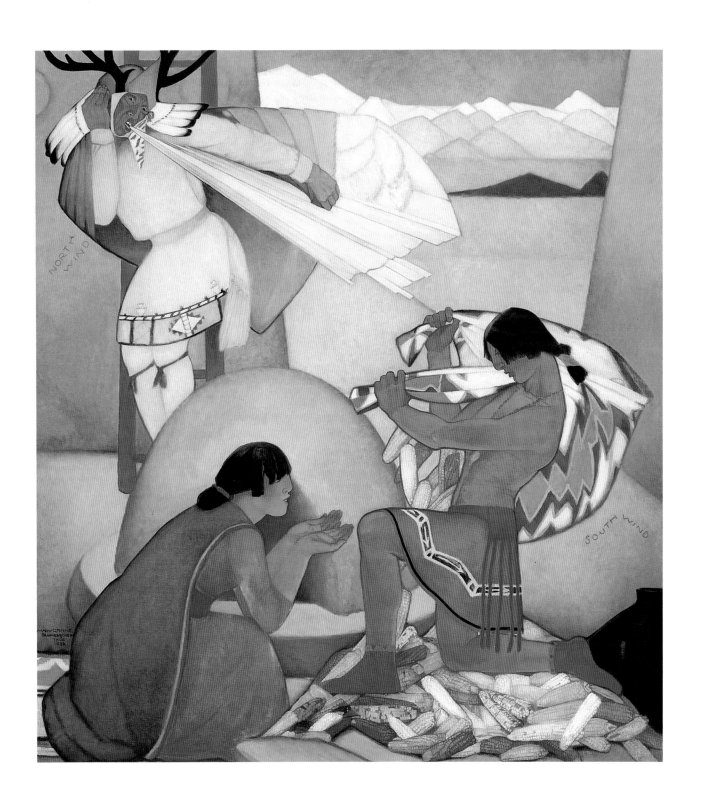

156.
Mary Greene Blumenschein, *Acoma Legend,* 1932

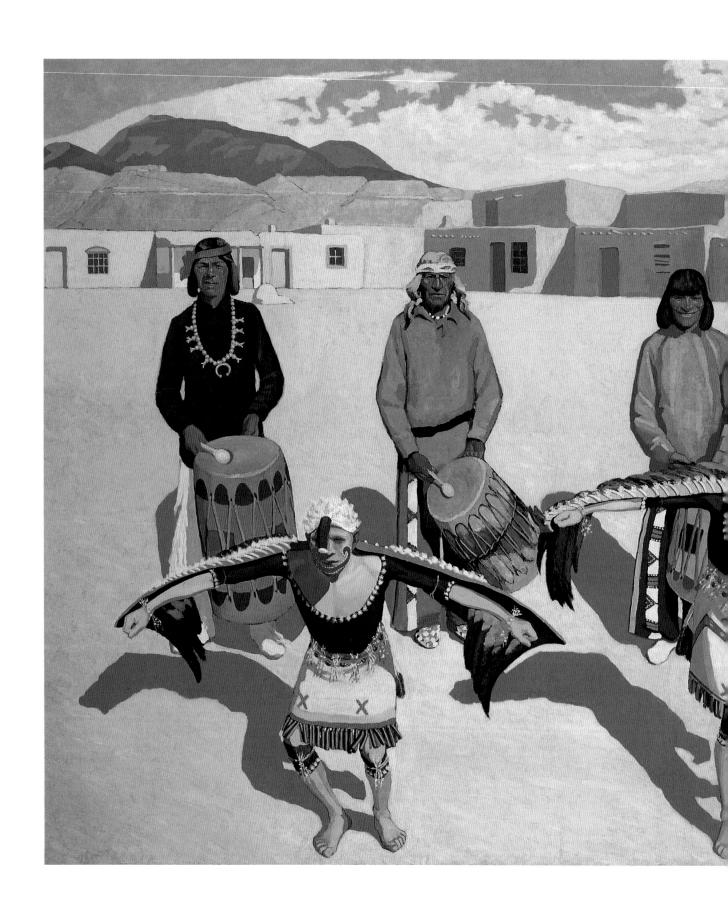

157.
Louise Crow, *Eagle Dance at San Ildefonso*, 1919

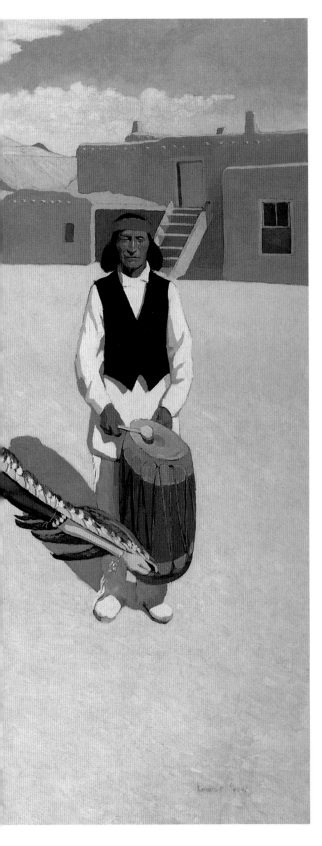

ing was clearly an integral part of Peña's life. In one of her monthly columns on New Mexico's artists, Ina Sizer Cassidy wrote:

I have watched Tonita Peña of Cochiti, for instance, with watercolors and virgin paper, absorbed in materializing her concepts of the ceremonial dances and I have watched her plastering the walls of her *adobe* home, small palms outspread smoothing the velvety brown mud over the surface with care and creative concentration. I have also watched her in the ceremonial dances in the *plaza*, her consecrated hands waving evergreen wands, rhythmically keeping time to the measured beat of drum, and tread of her bare feet on the hot earth, and there is in all of these activities the same creative aesthetic quality which had made her one of the outstanding Indian painters of New Mexico, and I believe the only Indian woman to attain this newly revived expression.[26]

Women performing daily tasks and Pueblo dances became the main themes in Peña's animated and lively works. Her narrative and descriptive paintings, like those of early Native American male painters, lacked perspective, modeling, and background or foreground, as seen, for example, in *Buffalo Dance* (plate 160).

It was more problematic, however, for Santa Clara painter Pablita Velarde, or Tse Tsan (Golden Dawn) (b. 1918), who clearly related her early frustrations when she said, "Painting was not considered woman's work in my time. A woman was supposed to just be a woman, like a housewife and a mother and chief cook. Those were the things I wasn't interested in."[27] Tonita Peña was her first role model. Dorothy Dunn offered her early encouragement and support and became her lifetime friend. In spite of extreme hardship, Velarde persevered in her desire to become a painter. "You just have to stick to it if you are going to be successful. You have to be a very strong person just to stick it out, no matter what happens."[28]

In a recent interview Velarde further explained what is important to her about being an artist:

I'm at a point where I can pass [on] some of my own expertise and some of my learning and my own feeling . . . something that comes from my heart and from my own belief. . . . I think I have accomplished what God put me here on earth for. I'm satisfied

159. Will Connell, *Mary Austin,*
Santa Fe, New Mexico, 1932

both a sensitivity to its past and a sense of the possibilities and freedom it offers. But the very act of painting landscape underwent changes in the years between 1890 and 1945. The same cultural upheavals that questioned women's roles were also questioning the subjects chosen by artists.

By the turn of the century, for example, critics saw American landscape painting on the decline. A casualty of the rush to modernity, American landscape as a power for defining national character and an example of moral order and aesthetic harmony seemed worn and outdated. Newer painting tended to focus instead on the self and states of mind.

In New Mexico, landscape was never displaced as the abiding center of the painter's experience. In painting, despite the presence of an avant-garde, the power of the environment was seldom disregarded completely, whether or not landscape was the visible subject.[32] Nor was landscape painting by women in New Mexico merely escapist, a distraction from urban modernity and its pressing psychological, social, and political issues. As Royal Cortissoz wrote in 1894, and as J. B. Jackson, Paul Shepard, Stephen Daniels and others have more recently pointed out, the times we live in are embedded in the works of our landscape painters.[33] Landscape and its representation in the visual arts are partly social constructs, just as gender itself is.

Those landscape constructs take many forms. The imprint of tourism on the land is evident in Barbara Latham's *Tourist Town, Taos* (plate 163); that of religion in Gina Knee's *Near Cordova, N.M.* (plate 164) and Georgia O'Keeffe's *Black Cross with Red Sky* (plate 165); that of the color and harmony of Native American ritual in Dorothy Brett's *San Geronimo Day* (plate 166); that of the Hispanic woman in Agnes Tait's *Lane in Santa Fe* (plate 167); and that of local adobe architecture, native artifacts, and indigenous trees in Laura van Pappelendam's *The Stone Wall* (plate 168). In addition, formal overlays offered the painter endless ways to interpret the landscape, as in Alice Schille's Fauve-inspired *Pueblo, Drying Clothes* (plate 169) with its vestiges of human life drying on the clothesline.

Instead of inhabiting the indoor domestic spaces that had constricted Morisot and Cassatt, New Mexico's women painters chose to venture outdoors on foot, on horseback, by wagon or

with the work that I have done so far and this is the way I want to leave my world when I go back to Sandy Lake and become a Cloud Person. I want the earth to remember me through my work.[29]

Velarde's carefully painted works often depict Pueblo dances and the daily activities of women. In *Life Inside a Pueblo Home* (plate 161), for example, traditional roles are documented according to gender.

Early experiences of Taos painter Merina Lujan, also known as Pop Chalee (Blue Flower) (1906–1993), were unusual in that her Taos Pueblo father had married an East Indian woman. After her parents divorced, Chalee was raised by her father at the Taos Pueblo. Early encouragement to study art with Dorothy Dunn at the Santa Fe Indian School came from Mabel Dodge Luhan, whose husband, Tony Luhan, was Chalee's uncle.[30] Chalee's imaginative and fantasy-like works abound with mythological animals, especially horses and deer. *Three Leaping Deer* (plate 162) is representative of her paintings, which are "more like Persian miniatures, the leaves and branches so delicately patterned, so lace-like; her animals delightfully naive. They are painted as an East Indian or a Persian would paint them."[31]

For many women painters in New Mexico the importance of place was embodied in the austere high-desert landscape and legendary light. That sense of place has involved

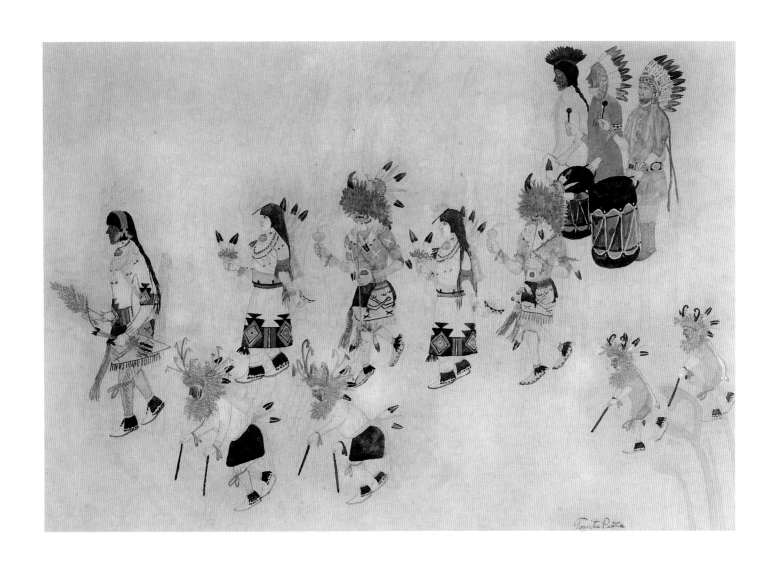

160.
Tonita Peña, *Cochiti Pueblo Indian Buffalo Dance*, c. 1920

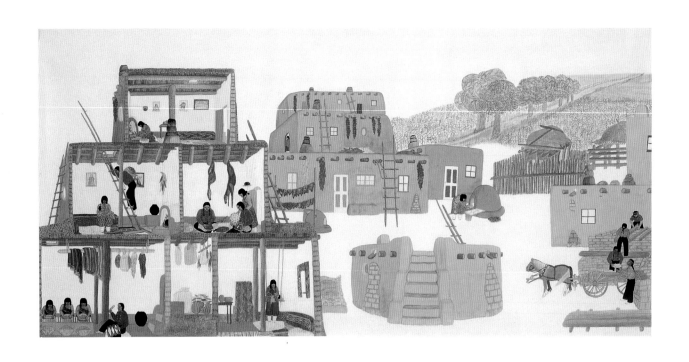

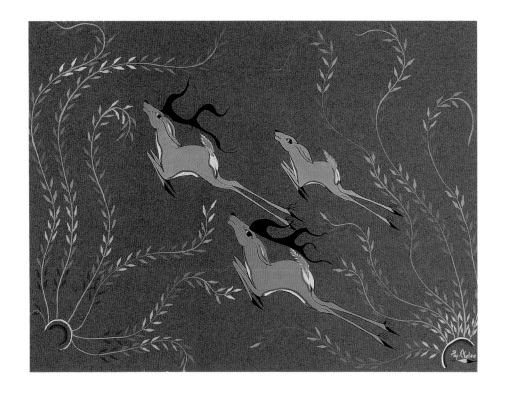

161.
Pablita Velarde, *Life Inside a Pueblo Home* (Santa Clara Pueblo), 1939–40

162.
Pop Chalee, *Three Leaping Deer*, c. 1942

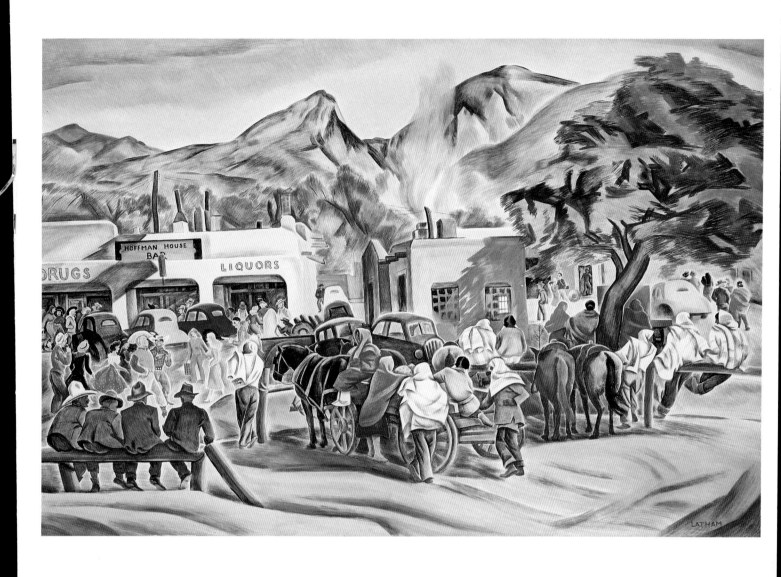

163.
Barbara Latham, *Tourist Town, Taos*, 1940s

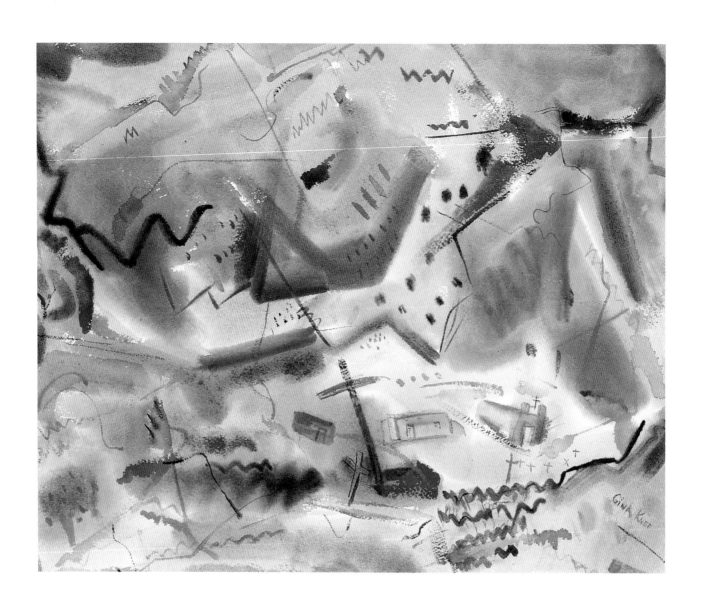

164.
Gina Knee, *Near Cordova, N.M.,* 1943

automobile. Seeking subjects far beyond the home, they ranged into the town plaza, the Native American village, the roads, and the distant mountains. What they found was more space than they had bargained for, imaginative as well as geographic space. National Academy of Design member Gene Kloss (b. 1903), for example, explored the rhythms of the Rio Grande and the formal qualities of pattern, light, and color in her landscape *Old Taos Junction Bridge* (plate 170). Although primarily known as a printmaker who skillfully etched "the dignity and beauty of the people of the Taos area . . . the magic of the mountain and the land"[34] (plate 171), Kloss also expressed her response to the landscape in paint.

In imaginative ways most of the painters combined landscape with figures (or other signs of human presence), defining landscape by human tenancy, not by heroic wilderness. Often there is ambivalence about humanity's effect on the land, expressed with great flexibility and variation. The artists developed pictorial codes that demonstrate either the land's affinity for human presence (in the case of Schille, Knee, Brett, van Pappelendam, Blumenschein, Velarde) or (as in Latham's case) warnings about the potential for human disruption. Among many of these painters a conviction arose that the natural and human worlds must nurture and support each other.

Even O'Keeffe, who often painted "pure" landscapes (*Red Hills with Pedernal*, plate 172), the human presence is frequently suggested by her treatment of a flower or animal bones, or simply by her morphological landforms that recall the human body. Some of O'Keeffe's painting is strongly reminiscent of Mary Austin's vision of the land as woman: "If the desert were a woman, I know well what like she would be: deep breasted, broad in the hips, tawny, with tawny hair . . . eyes sane and steady as the polished jewel of her skies."[35] Though few would deny these allusions today, O'Keeffe steadily resisted such linkages during her lifetime, aware of the critical bind she faced. Creating out of her own experience subjected her repeatedly to the label of "feminine," while painting with the heroic agency of males risked the denial of some part of herself. The categories of "female" and "artist" were still largely incompatible. O'Keeffe publicly chose artist.

Although landscape was a central focus

165. Georgia O'Keeffe, *Black Cross with Red Sky*, 1929

for women painters in New Mexico, they also made important contributions in other genres. In still life and portraiture, for example, long considered special provinces of women painters, New Mexico stimulated new responses to familiar subjects.

Rebecca Salsbury James (1891–1968) (married to rancher Bill James in 1937), largely self-trained, painted *[Elk Tooth and Magnolia]* (plate 173) in the folk-art medium of oil on reverse glass. The result is a powerful sweep of rhyming shapes, at once simple and highly sophisticated. In some of her still lifes, Henriette Wyeth included New Mexico *santos* with native vegetables and flowers, and Georgia O'Keeffe turned repeatedly to still-life subjects derived from forms of the Southwest desert.

Portraiture, which Linda Nochlin has cited as an area particularly suited to women's capacity for sensitive personal analysis, was a longtime preoccupation for several of New Mexico's women painters.[36] Olive Rush painted the formidable Mary Austin at the end of the writer's long career, dressed in the comb and Spanish shawl she often wore to express her affinity with New Mexico's native women. Margaret Lefranc, whose subjects often included herself (plate 174), painted a perceptive rendering of her friend Annette Rada, a photographer and one of the active professional artists working in the state in 1939. Louise Crow and Agnes Tait painted numerous portraits both

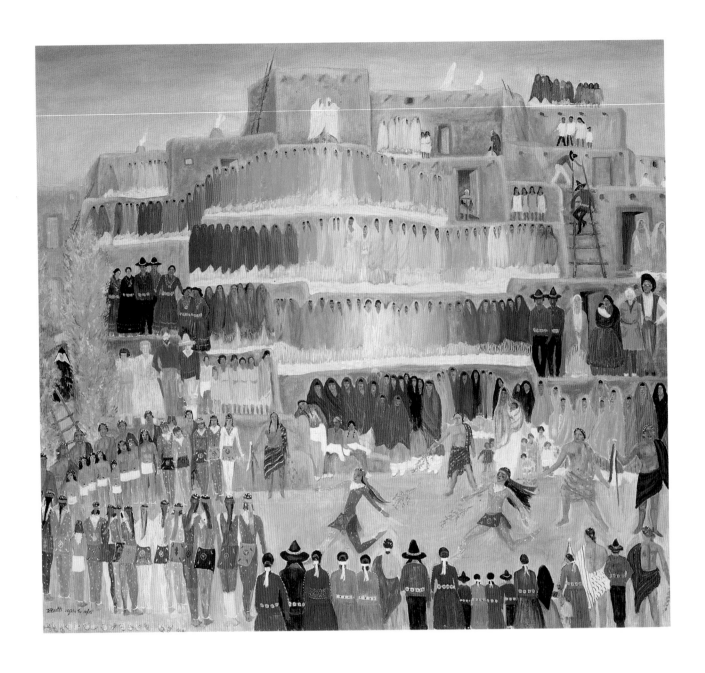

166.
Dorothy Brett, *San Geronimo Day, Taos*, 1924–65

167. Agnes Tait,
Lane in Santa Fe, 1945

before and while they worked in New Mexico. Catharine Carter Critcher, a recognized portrait painter in Washington, D.C., portrayed native Taos women and their children while she was in New Mexico. Henriette Wyeth often included objects that related to the subject's interests or personality, as she did in the *Portrait of Witter Bynner.* A New Mexico poet, writer, translator, and avid collector of Chinese art, Bynner's reflective pose is enhanced by the subtly painted Chinese scroll in the background (plate 175).

Landscape, genre scenes, Native American rituals, Hispanic mission churches, and adobe architecture persisted as subjects in paintings of artists funded by New Mexico art programs during President Franklin Roosevelt's New Deal. For many painters, such as Olive Rush (plate 178), Pablita Velarde, Pop Chalee, and Agnes Tait, this was a first experience with murals. Gene Kloss executed some of her finest etchings working in art programs, and Dorothy Morang (1906–1994) continued to make abstract easel paintings.

Abstraction, part of the broader trend of modernism, came to New Mexico soon after the epochal Armory Show of 1913. Artists who had taken part in or witnessed this exhibition brought experimental ideas with them to the

Southwest, testing innovative theory and practice on new subjects. In the decades following the Armory Show nearly every modernist development, from Cubism to Abstract Expressionism, appeared in New Mexico painting. In her *Blue Forms* (plate 176) and *Rising Red,*[37] Florence Miller Pierce demonstrates an early sophisticated awareness of spiritual content in art and of Kandinsky's color theory. A founding member (with her husband, Horace Towner Pierce) of the advanced Transcendental Painting Group in 1938, her career nonetheless faltered until decades later. Dorothy Morang (plate 180), whose artist-critic husband was largely responsible for publicizing the Transcendental Painting Group, fared even worse. She worked alone, producing vibrant abstractions (plate 177) that suggest her understanding of the concept of synesthesia. An accomplished pianist, Morang reveals through her titles and rhythmic forms the ways in which music and visual imagery interweave.

Throughout their careers, many women artists in New Mexico earned some of their livelihood by teaching. A former student of Joaquín Sorolla y Bastida's at the Art Institute of Chicago (plate 179), Laura van Pappelendam later was an instructor there for over fifty years, leaving summers free for painting. Louise Crow,

168.
Laura van Pappelendam, *The Stone Wall*, 1925

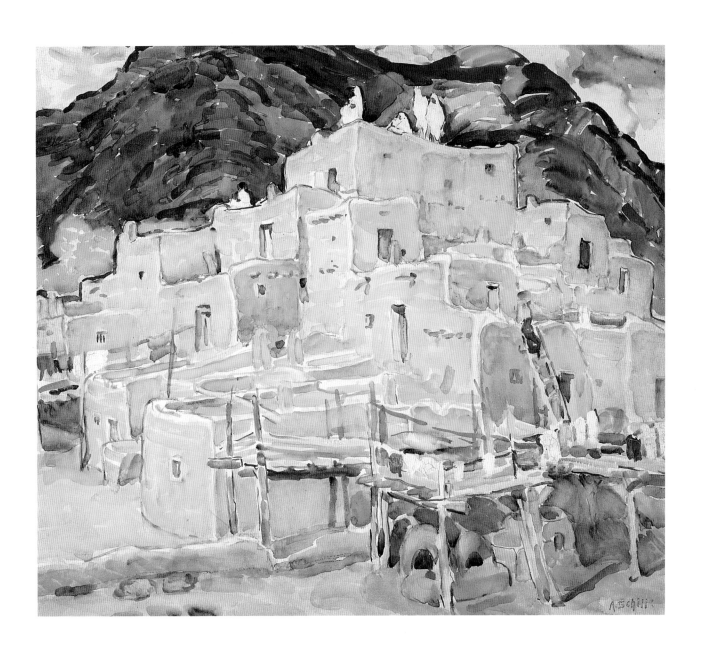

169.
Alice Schille, *Pueblo, Drying Clothes*, c. 1919–20

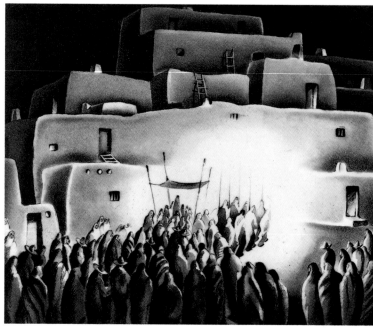

170. Gene Kloss, *The Old Taos Junction Bridge,* c. 1941

171. Gene Kloss, *Christmas Eve— Taos Pueblo,* 1934

Georgia O'Keeffe, Tonita Peña, Alice Schille, Gina Knee, and Catharine Carter Critcher, who founded her own art school in Washington, D.C., also taught.

Stereotypes have persistently marginalized women artists.[38] Only rarely have women found a central place in the art world. Georgia O'Keeffe was one of the few, recognized at the summit of a separate category for women. New Mexico before 1945 was no exception to this marginalization, despite more or less equal artistic training for men and women as well as comparable professional activity. Those whose work did receive widespread recognition were ultimately sustained, like Schille, van Pappelendam, and O'Keeffe, by their work outside the state. By contrast, those whose work was seldom seen outside New Mexico were often less successful, with the exception of Gene Kloss, Henriette Wyeth, Pablita Velarde, and Pop Chalee. Though Dorothy Morang exhibited regionally for decades, most of her time was consumed by her museum curatorial position, and even today her painting remains largely unknown.

As abstractionists Morang and Florence Miller Pierce faced the difficulties shared by most American innovators. Yet, while modernist painting has always had a small audience, the more traditional women painters in New Mexico fared little better. Like many of their male colleagues, these women often studied with the greatest teachers in America and Europe—among them Frank Duveneck, William Merritt Chase, Lucien Simon, Jean Paul Laurens, and René Menard—yet most of the women have not received the recognition they deserve. Before 1945 almost half of them had exhibited at the Museum of Fine Arts, Santa Fe, and in other highly prestigious museums and institutions in America or Europe, in either one-person or group exhibitions. At the Museum of Fine Arts, for example, Catharine Carter Critcher exhibited at least six times, Gene Kloss twenty-three, Dorothy Morang thirty-seven, Olive Rush sixty, Pablita Velarde sixteen, and Agnes Tait thirty-eight. After her return to California, however, Louise Crow, who had gained early recognition as a promising young artist, died there poor, alone, and unknown.[39] Agnes Tait, in a letter a few years before her death in Santa Fe, in 1981, wrote, "I've been so isolated by the long illness, tho happily recovered now, I find the imposed anonymity rather pleasant, tho at times there's too much of it. All the years of work, constant and so various here, seem of little effect."[40] Olive Rush, whose admiration for Chinese and Japanese painting (see plate 181) parallels O'Keeffe's, and whose achievement in easel and mural painting invites comparison with Marie Laurencin, remained largely "undiscovered" until recently. Pablita Velarde, who continues to work, is at last nationally recognized. Recent recognition has come to Gene

SANDRA D'EMILIO AND SHARYN UDALL

172.
Georgia O'Keeffe, *Red Hills with Pedernal*, 1936

173.
Rebecca Salsbury (Strand) James, *Untitled [Elk Tooth and Magnolia]*, c. 1930s

174.
Margaret Lefranc, *Self Portrait*, 1928

Henriette Wyeth, *Portrait of Witter Bynner*, 1939

176.
Florence Miller Pierce, *Blue Forms*, 1942

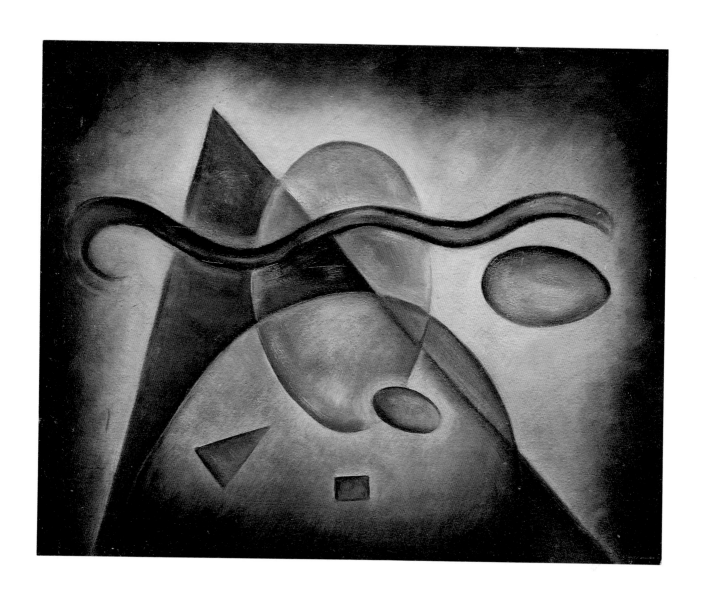

177.
Dorothy Morang, *Untitled*, 1941

Top LEFT
178. Ina Sizer Cassidy, *Olive Rush Painting Ceiling at New Mexico State University, Las Cruces, New Mexico*, May 1936

Top RIGHT
179. Joaquín Sorolla y Bastida's class at the School of the Art Institute of Chicago, 1911

BOTTOM
180. Dorothy Morang holding painting *Nightbird*, 1955

Kloss, Henriette Wyeth and Florence Miller Pierce with major exhibitions of their work, acknowledgments they well deserve.

For all these women, the experience of living and working in New Mexico provided both frustrations and rewards. Among the rewards was a positive ambience for art and artists, a milieu conducive to creativity. With the opening of the Museum of Fine Arts in 1917 and the help of women art patrons Mary Cabot Wheelwright, Florence Dibell Bartlett, and Amelia and Elizabeth White, a support system for women artists was developed. Authors Mary Austin, Willa Cather, Alice Corbin, Ina Sizer Cassidy, and especially Mabel Dodge Luhan, verbalized the responses of these women painters to the environment of New Mexico. Even though some of these artists were not commercially successful, there were other, deeper satisfactions: to act, to paint with deliberation, to attend to the inner as well as the outward experiences of life; to let the land, the sun, the native peoples work to restore the balance in lives overurbanized, overpaced, and overanalyzed. In this atmosphere of spiritual reconciliation, what became important to these women was their determination to express, record, preserve, and interpret what they saw, for themselves and for distant audiences.

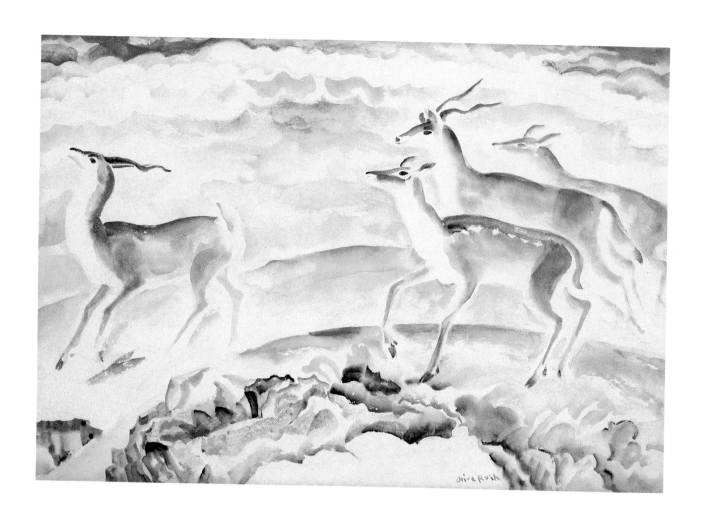

181.
Olive Rush, *Clouds and Gazelles*, n.d.

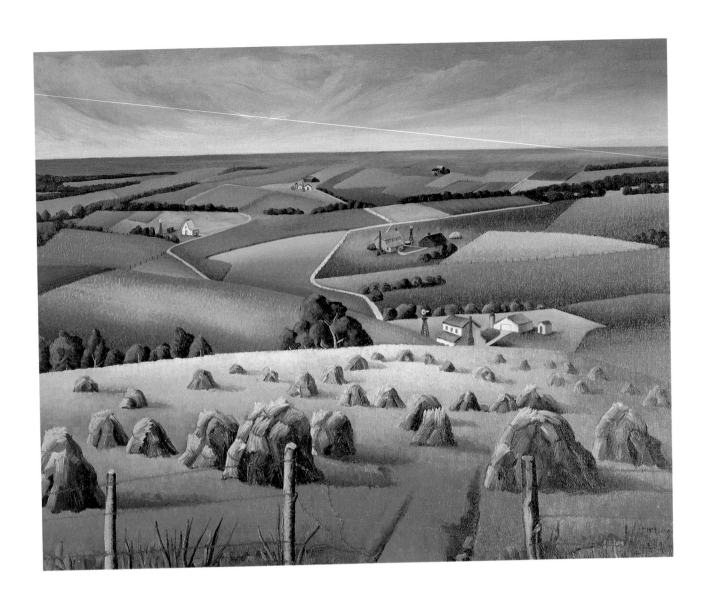

189.
Florence McClung, *Squaw Creek Valley*, 1937

VII
Lone Star Spirits

Susan Landauer with Becky Duval Reese

BY 1890 TEXAS WAS EMERGING from its frontier status. Its Indian wars were over in the 1880s, and railroads now connected the state to the rest of the nation. In 1901 the discovery of the Spindletop oil field in Southeast Texas gave new impetus to the state; for the next half century Texas steadily became wealthier, adding petroleum to its traditional economic base of cotton and cattle. Oil and the financial industries that grew from it accelerated urbanization, as Dallas and Houston gained in population and importance. By the 1920s the home-front experience of World War I, the automobile, and the radio brought Texas along with other regions of the nation into the American mainstream. Urbanization, increased ease of transportation and communication, and growing affluence had far-reaching effects on the arts in Texas. More Texans could devote time and funds to the arts, and a growing number of Texas artists were able to afford professional training, locally, nationally, and sometimes abroad. By the 1930s many Texas painters were focusing on regional subjects, concerned, like artists elsewhere in the nation, that cultural homogeneity threatened the very roots of local identity and vitality.

Although both men and women were engaged in the growth of the state's arts, most historians acknowledge a striking division of labor along gender lines as Texas developed. While men were preoccupied with building the state's economic base, women took the lead in promoting cultural causes and raising the aesthetic consciousness of Texans. From 1890 to 1945 a number of pioneering women spearheaded the formation of art associations, took art education into the public schools, founded art institutions, opened galleries, and taught art. In cities throughout the state, the Texas Federation of Women's Clubs encouraged art appreciation as early as 1897 by showing the work of members and bringing art exhibitions to their communities. Many of these clubs eventually evolved into art museums, such as the Fort Worth Library and Art Gallery, now the Modern Art Museum of Fort Worth, the oldest museum in Texas, chartered in 1892 by twenty-four women. In 1899 the Dallas Public School Art League was founded and held the first exhibition in the city devoted entirely to art. A group of Austin club women established the Texas Fine Arts Association in 1911 as a means of preserving the studio of German-born Texas sculptor Elisabet Ney. In 1924 San Antonio's Witte Museum was founded by two women, Ellen Schulz Quillin, its director from 1926 to 1960, and Eleanor Rogers Onderdonk, its curator of art from 1927 to 1958.[1]

Along with the development of art institutions, the 1936 centennial celebration was a particularly important event in the cultural history of Texas. After intense competition with other cities, Dallas won the honor of hosting the Texas Centennial Exposition, held in a huge complex of forty-five exhibition halls on the 185-acre Fair Park.[2] The exposition included a display of more than six hundred works of European and American art, with an entire section devoted to Texas artists, 60 percent of whom were women.[3] The Texas General exhibitions, jointly organized by and shown at the Dallas Museum of Art, the Museum of Fine Arts in Houston, and the Witte Museum, were initiated two years later. These shows were held through 1965, and they introduced large audiences to the quality and diversity of Texas arts. Although the exhibitions always included women artists, their names were typically left out of catalogue essays and reviews, an omission that ultimately diminished their stature in the historical record.[4]

This invisibility did not dissuade women from promoting the arts in other ways. By the 1920s art education was available at many Texas colleges. Denton's College of Industrial Arts (later Texas Woman's University), for example, offered programs that included furniture design and construction. A decade later women were on the faculties of numerous Texas colleges: May Schow taught at Sam Houston State

Teachers College (now Sam Houston State University); Edith Brisac, Marie Delleney, and Coreen Mary Spellman taught at Texas Woman's University; and Vera Wise became the art department's first chair at Texas Western College (now the University of Texas at El Paso).

Women also offered private art instruction. Vivian Aunspaugh (1869–1960), who had studied at New York's Art Students League and in Chicago, Paris, and Rome, arrived in Dallas by 1891. Her school, founded in 1902, was the only one in the Southwest to use nude models in life-drawing classes for both men and women. In 1926 Kathryne Hail Travis and her husband, Olin, founded the Dallas Art Institute, and by 1931 Blanche McVeigh and Evaline Sellors had cofounded, with a male colleague, the Fort Worth School of Fine Arts.

Whether artists or educators, most of the women discussed here received similar training. Their relative affluence gave all of them the privilege of art education. Many attended the School of the Art Institute of Chicago; others studied at the Parsons School of Design or the Pratt Institute in New York. Edith Brisac, May Schow, Marie Delleney, and Coreen Mary Spellman attended universities in Texas before enrolling at Columbia University for graduate work to prepare themselves for careers in university teaching. Ruth Pershing Uhler and Frances Johnson Skinner supported themselves by teaching art in museum schools.

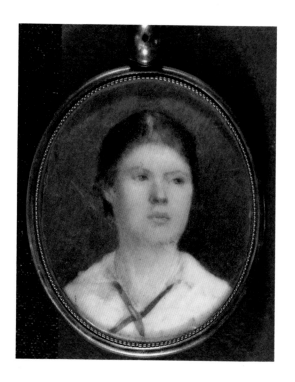

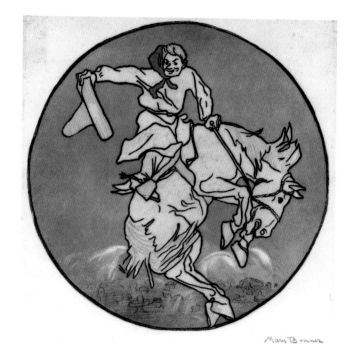

Most first-generation Texas artists, who arrived in Texas in the 1850s and settled primarily in the emigré colonies of New Braunfels and Castroville, were trained in Germany and France. Among them, Eugénie Etienette Aubanel Lavender (1817–1898) deserves special attention. Her life reads like a pulp romance set in frontier Texas. A beautiful young patrician, she had studied history painting and portraiture with several well-known Parisian artists (plate 182). While copying a painting at the Louvre, she met the dashing young Englishman Charles Lavender, who became her husband. Several years later, with their two small daughters, the Lavenders set out for Texas. Stopping first in New Orleans, they purchased a pair of wagons and headed West, settling finally in Waco. An early biographer idealized Lavender's experiences: "The vastness of the Texas prairies, the wildness of their surroundings, and the novelty of it all satisfied to a certain extent their romantic longing. The fields of bluebonnets, the patches of paintbrush and Indian blanket, the purple mountain laurel—all delighted them." But harsh reality impinged on this romance. Food and medicine were scarce, and there were frequent Indian raids, keeping the Lavenders in constant fear. The family crossed swollen rivers with their animals and wagons, dodged Indians, fought a prairie fire, and killed rattlesnakes and panthers.

With all the demands of frontier life,

Eugénie Lavender found time to paint, sometimes making her own pigments with extracts of plants and flowers. In the late 1870s, widowed and no doubt in search of a less strenuous life, she settled in Corpus Christi, where she gave art lessons and continued to paint. Her work from the 1890s consists primarily of religious subjects and imaginary landscapes. At the remarkable age of seventy-nine she won a commission to paint Saint Patrick for the Corpus Christi cathedral. This was probably her last major work; the strain of painting on such a large scale reportedly broke her health, and she died in 1898.[5]

The next generation of Texas artists found an environment much more amenable to the arts. Marie Fargeix Gentilz (1830–1898) and Louise Andrée Frétellière (1856–1940) were, respectively, wife and niece of the well-known San Antonio painter Theodore Gentilz; they were also among his best students.[6] Frétellière's choice of subjects in her paintings of early Texas life reflect the influences of her uncle (see plate 183). The Gentilz family's interest in Native Americans was shared by other immigrant artists, many of whom drew inspiration from indigenous cultures.

Another San Antonio painter born into a distinguished family of artists was Eleanor Rogers Onderdonk (1884–1964).[7] Her father, Robert Onderdonk, was a prominent painter trained under Robert Henri and William Merritt

184. Eleanor Onderdonk, *Mary*, n.d.

185. Mary Anita Bonner, *The Circular Cowboy*, 1929

186. Emma Richardson Cherry in her studio in Houston, n.d

187. Emma Richardson Cherry, *The Precious Bowl*, c. 1925

Chase at New York's Art Students League. Although Robert Onderdonk advised his children to avoid painting for a living, both became artists. His son Julian painted impressionist landscapes and created a genre of Texas art that became known as "bluebonnet painting," while Eleanor, like her father and brother, studied at the Art Students League in New York. She later became an accomplished painter of miniature portraits (see plate 184). Her most important contribution to the arts in Texas, however, was not as a painter but as curator of art at the Witte Memorial Museum, where she organized many important exhibitions and competitions. Along with founding director Ellen Schultz Quillen, she made the Witte a major repository for nineteenth- and early twentieth-century art from Texas and the surrounding region.

In concentrating on miniature portraits, Eleanor Onderdonk followed a pattern characteristic of women artists throughout America during the early part of the twentieth century. The physical exertion demanded by large-scale mural commissions and plein-air landscape painting was thought to be inappropriate for proper Victorian ladies. Portraiture, however—especially child portraiture—attracted many women artists, amateurs as well as professionals. Louisa Heuser Wueste, Penelope Thomas Crouch, Ella Moss Duval, Penelope Lingan, and Martha Simkins were among the better-known women artists in Texas who specialized in por-

traiture.[8] But even in this genre, lucrative society portrait commissions tended to go to men. One of the few exceptions to this trend was the incorrigible Marie Cronin (d. 1951), who for a time was president of the Bartlett Western Railway. As a painter Cronin won the honor of portraying not only Colonel Alonzo Steele, the last survivor of the Battle of San Jacinto, but also three Texas governors, Thomas Campbell, O. B. Colquitt, and James E. Ferguson.[9]

Another appropriately genteel subject for women artists was still life, which for the most part could be practiced safely within the home. Among the Texas women who worked in this genre in the early twentieth century were Eloise Polk McGill, Adele Laure Brunet, and Ursula Lauderdale. Nannie Huddle (1860–1951), the wife of painter William Henry Huddle, was somewhat more adventurous, making her name as a painter of wildflowers native to various parts of the state. Not surprisingly, her most popular canvases depicted the bluebonnet, Texas's colorful and ubiquitous state flower.[10]

Early twentieth-century Texas art is often associated with the folklore of the cowboy and the Wild West. Frederic Remington, who frequently traveled in Texas, probably did the most to popularize the subject, but numerous artists followed suit—notably L. Schloss and E. Martin Hennings. Among these painters, only one was a woman: Mary Anita Bonner (1887–1935). Bonner, a student of Robert

SUSAN LANDAUER WITH BECKY DUVAL REESE

188. Florence McClung in her studio at Trinity University, c. 1940

190. Florence McClung, *The Swamp (Caddo Lake)*, 1940

Onderdonk, became a celebrated chronicler of Texas cowboy life, winning numerous awards for her lively and often humorous tinted etchings (see plate 185). She was one of the few San Antonio artists who exhibited in the Paris Salons and could regularly sell her work in Europe and on the East Coast.

If successful women artists in Texas secured their reputations by specializing in marginal genres, the career of Houstonian Emma Richardson Cherry (1859–1954) stands apart (plate 186).[11] Cherry, one of the first professional artists to make Houston her home, became a driving force behind the development of art education in that city. She was remarkably versatile, working in a variety of genres that included landscape, still life, portraiture, and religious subjects. Her interest in art was recognized by her architect father when he saw her draw on the scraps of paper that fell from his drafting board. After attending the School of the Art Institute of Chicago, Cherry studied at the Art Students League in 1883 with a number of prominent artists, including William Merritt Chase, Walter Shirlaw, and Kenyon Cox.[12] She continued her studies at the Académie Julian in Paris, with André Lhote and other European artists. Married to a Texas businessman, Cherry lived briefly in Denver during the early 1890s, where she helped establish the Artists' Club of Denver in February 1893.

In 1900 Cherry and three other women organized the Houston Public School Art League, and by 1913 the Art League had expanded its mission beyond taking art education into the schools by offering lectures for adults and sponsoring exhibitions. The league also began to work toward building an art museum. Cherry often told of her hours with a tin cup outside a local department store, asking for money to buy land for an art museum. The museum was finally completed in 1924, and in 1925 E. Richardson Cherry was the first woman to have a one-person exhibition there. Among the works she exhibited was *The Precious Bowl,* about 1925 (plate 187).[13] Cherry described her model for the picture as a close friend whose personality was "detached, withdrawn from the world, as one who turned her thoughts inward, mystical, introspective."[14] Perhaps it was this emphasis on subjective experience that led the exhibition's jury to classify the canvas as "modern." The painting's style, like that of much of Cherry's work, might be described as an amalgam of Impressionism and Realism. In an era when Precisionism dominated modernist circles in New York, this work demonstrates the lag between New York's avant-garde and the Texas art world.

Not until the early 1950s would Texas artists embrace abstraction in appreciable numbers, a change in taste that was encouraged by two women collectors, Marion Koogler McNay in San Antonio and Anne Burnett Tandy in Fort

191.
Clara M. Williamson, *Get Along Little Dogies*, 1945

Worth, who developed sizable collections of European modernist art. Yet Texans had in their very midst as early as the 1910s one of America's foremost modernists. Georgia O'Keeffe, fresh from her studies at the Art Students League, came to Texas in 1912, settling first in Amarillo and then in Canyon, where she taught from 1916 to 1918 at West Texas State Normal School. O'Keeffe's stay resulted in a group of dramatic abstractions that captured the sweep and grandeur of West Texas. One art historian described them as depictions of some of the region's most spectacular sights: "a cauldron-like view of the Palo Duro Canyon, views of headlights racing across the endless Texas highways at night, lightening storms on the plains, and a series on the evening star as it appeared surrounded by a halo of red, dust-laden clouds, or sudden storms, or the fading sunlight on the plains."[15]

Landscape themes began to appear with increasing frequency in the work of women artists in Texas during the late 1920s. Few pioneering women had worked in this genre before that time—notably Mary Darter Coleman, Nannie Huddle, and Ida Weisselberg Hadra. The infusion of women resulted in part from a changing cultural climate, for the 1920s proved a liberating decade for women as they broke out of their confining Victorian roles and embraced the image of the New Woman projected by the mass media. Equally significant was the rise of American Scene Painting and its offshoot, Regionalism, both of which stressed the indigenous landscape. In the 1930s and well into the 1940s, Texas artists of both sexes embraced Regionalism and American Scene Painting with enthusiasm, finding the expression of their native roots through a celebration of the local geography and its inhabitants. Art historian Susie Kalil has written that Texas artists "captured the essence of the land with instinctive if not spiritual affirmation. Their works did not negate the historical past; neither did they wax nostalgic for its fictional moments. Texas artists, at last, were coming to grips with their own time and their own particular place."[16]

Many Texas artists were familiar with the ideas expressed in John Dewey's *Art and Experience* (1934), with its forceful argument that culture more than economics or politics would influence the nation's growth over the next decade. Dewey saw art as a social force vital to the country's well-being and believed that by

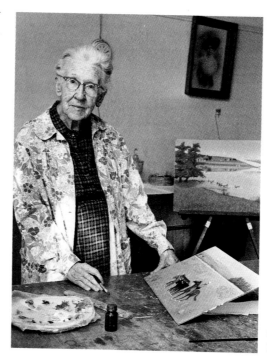

192. Clara M. Williamson in her studio at age ninety, 1965

celebrating what was local, Americans could find a basis for universal truth. Texas artists absorbed these ideas, sketching "not so much nature as the nature of their experience."[17] Dallas-based Alexandre Hogue proclaimed that "the American artist in general will come of age only when he has the stamina to blaze his own trails through the part of his country in which he lives."[18]

Texas artists acknowledged Regionalism's concepts throughout the 1930s, 1940s, and into the 1950s. Many women artists who were maturing as Regionalism was coming to the fore in American art embraced it in varying degrees as a mode of aesthetic expression. Several of them also had studied with Alexandre Hogue, Everett Spruce, Otis Dozier, and Jerry Bywaters, the primary exponents of Regionalism in Texas.

Among Texas women painters, Florence McClung (1896–1992) (plate 188) comes closest to orthodox Regionalism, the optimistic brand of boosterism espoused by Thomas Hart Benton, Grant Wood, and John Steuart Curry. McClung moved to Dallas at the age of three and lived there until her death.[19] She married Rufus A. McClung, a Dallas cotton broker, in 1917 and began to study art ten years later. Over the course of her career, she studied with Frank Reaugh, Frank Klepper, Olin Travis, Alexandre Hogue, and Thomas Stell. McClung painted for periods of time in Taos between 1928 and 1932, joining a circle that included Hogue, Mabel

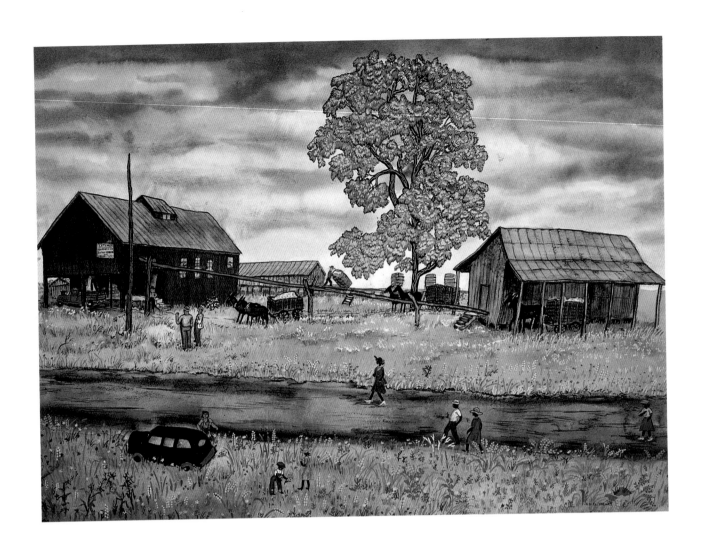

193.
Ethel Spears, *Terrell Cotton Gin with Kathleen Blackshear and J. P. Terrell*, c. 1940s

Dodge and Tony Luhan, and the Taos Society of Artists.[20] Twenty-two years after graduating from high school McClung enrolled at Southern Methodist University and received both her B.A. and B.S. degrees while she was teaching art and chairing the department at Trinity University (then in Waxahachie), a position that required her to drive forty-five miles each day. At the same time, she exhibited widely both regionally and nationally, while caring for her husband and son.

McClung's Texas landscapes brought her national attention. *Lancaster Valley* had been exhibited at the 1936 Texas Centennial and later at the New York World's Fair of 1939 before it was purchased for the Metropolitan Museum of Art. McClung's *Squaw Creek Valley*, 1937 (plate 189, page 182), is characteristic of her crisp style. It recalls the work of Grant Wood in its buoyant vision of clean, pure living in America's agrarian paradise. The perfectly manicured fields and sparkling white farmhouses resemble Wood's own verdant and abundantly fertile Iowa. McClung also liked to paint scenes that could only be found in Texas. In *The Swamp (Caddo Lake)*, 1940 (plate 190), she depicts the strange backcountry of northeastern Texas, where enormous, primordial stands of cypress trees grow in profusion out of the bogs of Caddo Lake. Her intention seems less to portray an image of gloom or despondency than to record the particulars of the landscape that she loved.

This documentary impulse is evident in a statement that summarizes her reasons for painting Texas locales: "I wanted children a hundred years from now to know how Texas looked in this day and time. . . . Everything that I've painted has been with the idea of showing people in the future what Dallas was like."[21]

The folk-art style of another Dallas woman artist stands in stark contrast to McClung's academic approach. In fall 1943, sixty-eight-year-old Clara Williamson (1875–1976) enrolled in an art class at Southern Methodist University. Her life had been extremely busy and full until the death of her husband. As she reminisced, "I grew up on the frontier where life was hard. . . . I liked the beautiful country but never had an opportunity to express myself."[22] Jerry Bywaters, director of the Dallas Museum of Fine Arts and a teacher at Southern Methodist University, had encouraged Clara to enroll in classes. When Bywaters purchased one of her paintings for the museum's collection, the news of Clara Williamson's accomplishments spread rapidly. Donald Vogel, a Dallas artist and gallery owner with his wife Margaret, took "Aunt Clara" under his wing, selling and documenting her work and encouraging her to continue her "painting from memory."[23] Williamson recalled:

> I was raised for the most part by old women. I use the words "raised" and "old" with deliberateness, for they go together. I

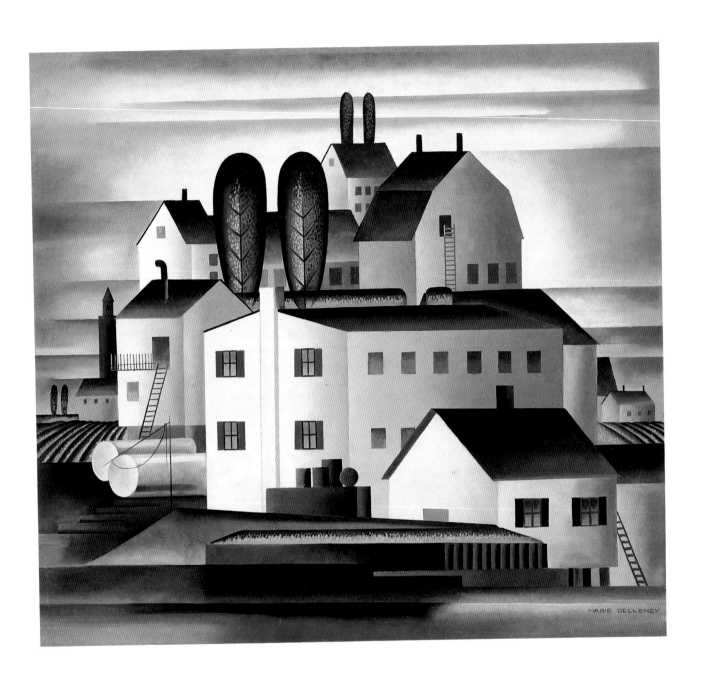

196.
Marie Delleney, *Houses, Provincetown*, c. 1939

197.
Coreen Spellman, *Railroad Signal*, 1936

198.
Coreen Spellman, *Road Signs*, c. 1936

was raised, also, by two old Texans, one a great-grandmother who had frontiered it in an Erath County dugout, had killed a panther with an ax and made her own soap almost to the day of her death. . . . I have always had a fondness for old women. . . . I [have] collect[ed] their images, the Sixties, Seventies and Eighties of the Nineteenth Century, those simpler times, particularly as they were lived in Texas and most particularly as they were lived in my own part . . . of this vast state where . . . I feel most at home.[24]

Of her memory painting *Get Along Little Dogies,* 1945 (plate 191), Williamson commented: "To prevent the little orphan calves from falling behind and getting lost from the herd the cow-boys would often gently prod them along; all the while singing and talking to them in the typical and amusing cow-boy dialect."[25] Williamson's hometown, Iredell, was a stopover on the Chisholm Trail, and she included herself in the picture standing under a tree as the cowboys guide the longhorns across the Bosque River. Clara Williamson painted until she was ninety-one and lived to be one hundred (plate 192). Sometimes described as "strong-willed," she called herself "an honest old sister."[26] "Paintings," she said, "should reflect truthfulness and beauty of the soul."[27] The art of Clara Williamson bears witness to Texas's frontier history and becomes a record of a way of life long vanished.

Another artist who chronicled Texas life in a folk-art style was Ethel Spears (1902–1974). A Chicagoan, Spears had studied with Alexander Archipenko in Woodstock, New York, and at the Art Students League. Her degrees in drawing, painting, and textile design enabled her to teach a variety of courses, and ultimately she established the departments of enameling and silk screen at the School of the Art Institute in Chicago. Spears taught there for twenty-four years. In the late 1950s, she became ill, possibly with lead poisoning from her work with enamels, and in 1961 she left Chicago with fellow Chicago artist and companion Kathleen Blackshear to settle in Navasota, Texas, Blackshear's birthplace. As an undergraduate, Spears had completed two murals for the tearoom at the Art Institute of Chicago; these established her as an accomplished painter with a sense of humor, which

199. Kathleen Blackshear, *Gallery Notes (Self-Portrait),* 1926

she demonstrates in her more than twenty-three murals in the Chicago area.[28]

In her watercolors Spears expressed an affection for the quotidian details of everyday life in rural Texas. *Terrell Gin Mill with Kathleen Blackshear and J. P. Terrell,* about 1940 (plate 193), presents a country scene in miniature, complete with mill buildings, horse-drawn carts, and doll-sized figures—two of which ostensibly portray her close friend Kathleen Blackshear and a cousin. Although this painting has none of the rib-tickling humor of her satirical cartoons, Spears's sense of playfulness is apparent in her teasing refusal to provide any information that might enable the viewer to identify the figures in the painting's title.

Spears's childlike naiveté differs greatly from the approaches of Marie Delleney (1903–1967) and Coreen Mary Spellman (1905–1978), who taught together at Texas Woman's University in Denton (plate 194). Both completed graduate degrees at Columbia University and continued to study painting in Provincetown in the summers as well as working with artists such as Charles and Fletcher Martin.[29] Unlike Spears, Delleney and Spellman focused on the industrial and man-made features of the contemporary landscape, utilizing styles that incorporated aspects of Precisionism's machine aesthetic.

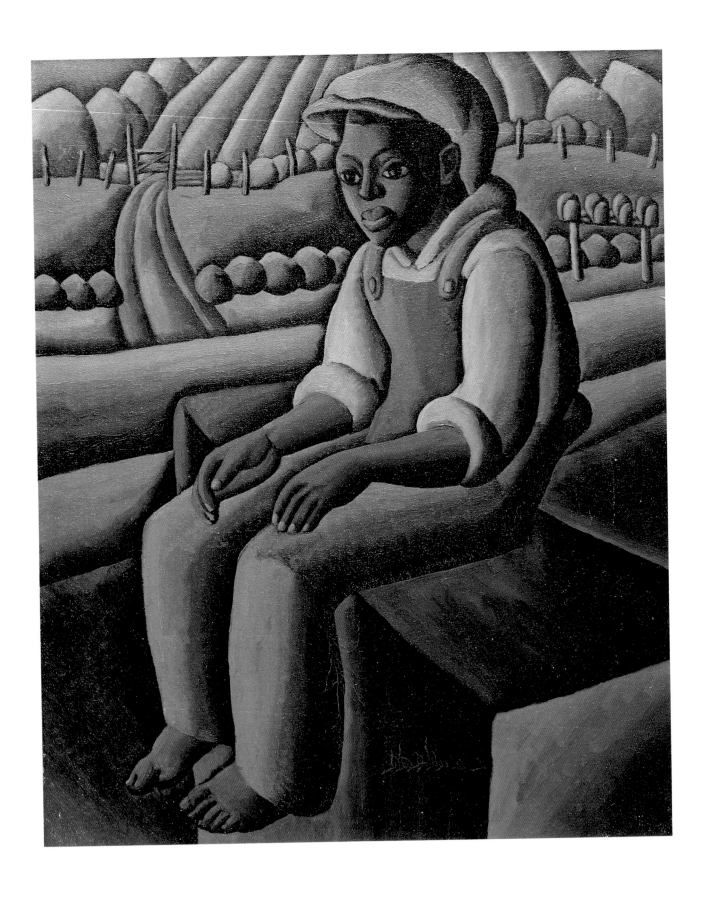

200.
Kathleen Blackshear, *A Boy Named Alligator*, 1930

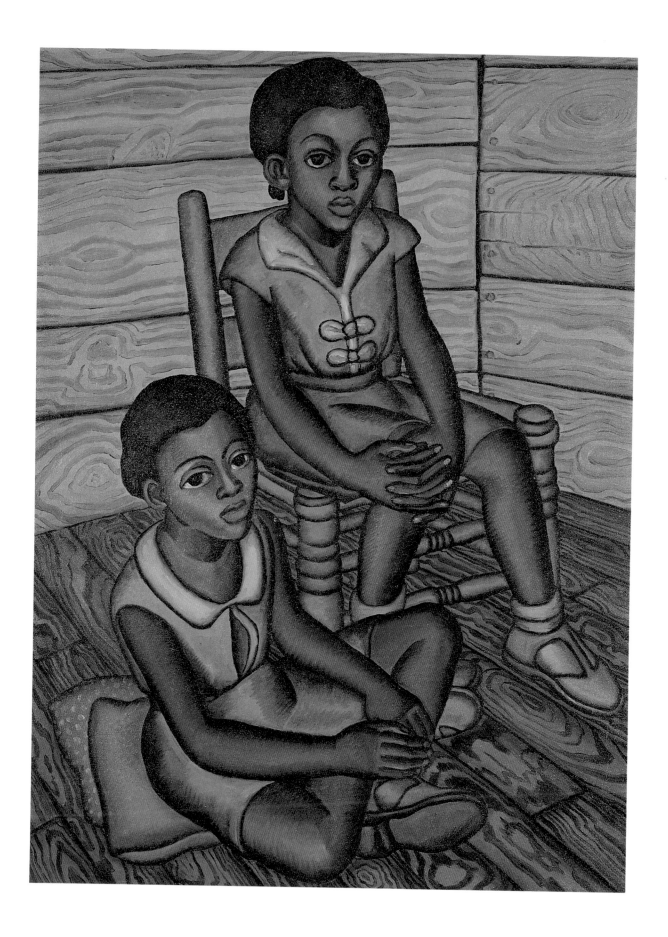

201.
Kathleen Blackshear, *Ruby Lee and Loula May Washington*, 1932

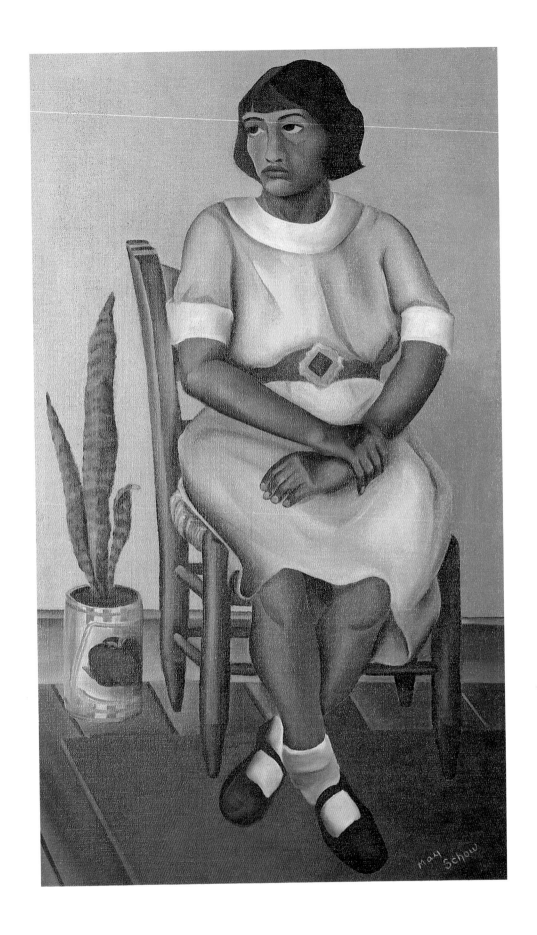

202.
May Schow, *Mexican Girl*, 1935–36

Of the two, Delleney was more modernist in sensibility. Much of her work can be classified as Cubist Realist in its clarity of line and geometric simplification of form, and *Houses, Provincetown*, about 1939 (plate 196), typifies her work of the 1930s. A cluster of buildings and tanks along the shoreline is reduced to barest essentials. Like the quintessential Precisionist, Charles Sheeler, Delleney has, to borrow art historian Abraham Davidson's words, "stripped [her] landscape of its rough edges, of its people, and all signs of activity, to create an airless world of pristine purity."[30]

Spellman also created an airless, silent industrialism held frozen in place; but rather than reduce her imagery to geometric abstraction, she rendered it in painstaking, sharply focused detail. Spellman, along with Delleney, had studied watercolor technique with Charles Martin in Provincetown, and Spellman credits Martin with a masterful understanding of composition, apparent in the work of both women. Spellman was a prolific painter who exhibited in more than forty one-person shows, and her works are included in museum collections across the country. Expansive in her teaching, she spent her life contributing to the arts of Texas (plate 195).

In *Railroad Signal*, 1936 (plate 197), and *Road Signs*, about 1936 (plate 198), Spellman paints a stark Texas landscape. The terrain is dry, harsh, and vast. In this austere environment, road markers stand as silent sentinels, often the only link for travelers on empty Texas highways. They are totems of a new industrial Texas, just as they are structures the artist chose for their powerful shapes and architectonic monumentality. Of these images Spellman wrote:

> I enjoy taking some rather obscure or unimportant subject or theme and making something fine and important out of it as you will see in "Railroad Sign" or in other paintings whose predominate [*sic*] subjects are mills and roadways and fields. . . . It always gives me great pleasure to discover something which has been passed over as being inadequate material. As a result I feel that my best work is that concerning my own environment. I am definitely of Texas and the Southwest of which I am a part. All of which is another way of saying that one must be familiar with what one is doing.[31]

This same philosophy of elevating the

203. May Schow standing before her painting of Ranchos de Taos (c. 1926)

commonplace and universalizing the familiar was shared by Kathleen Blackshear (1897–1988) (plate 199), a Navasota native who began to study art in her early teens. The first woman in her small hometown to wear pants, she bucked convention throughout her life.[32] After college, she went on to the Art Students League and traveled extensively before commencing studies at the School of the Art Institute of Chicago. There, she worked with the art historian Helen Gardner, and after finishing her studies in 1926 she joined the faculty; for the next thirty-five years she taught both studio courses and art history. Blackshear executed the analytical drawings for Gardner's revised and third editions of her well-known textbook, *Art Through the Ages*. Gardner maintained that art could be understood and appreciated cross-culturally and pan-historically, a philosophy that suited Blackshear, who emphasized the aesthetic over the historical in teaching art history.[33]

Blackshear was an important force at the Art Institute, and long before the Civil Rights movement she had earned a reputation for supporting African American students. Among these students was Margaret Burroughs, who became a national leader in art education as well as a strong force in Chicago's African American community. Dr. Burroughs said of

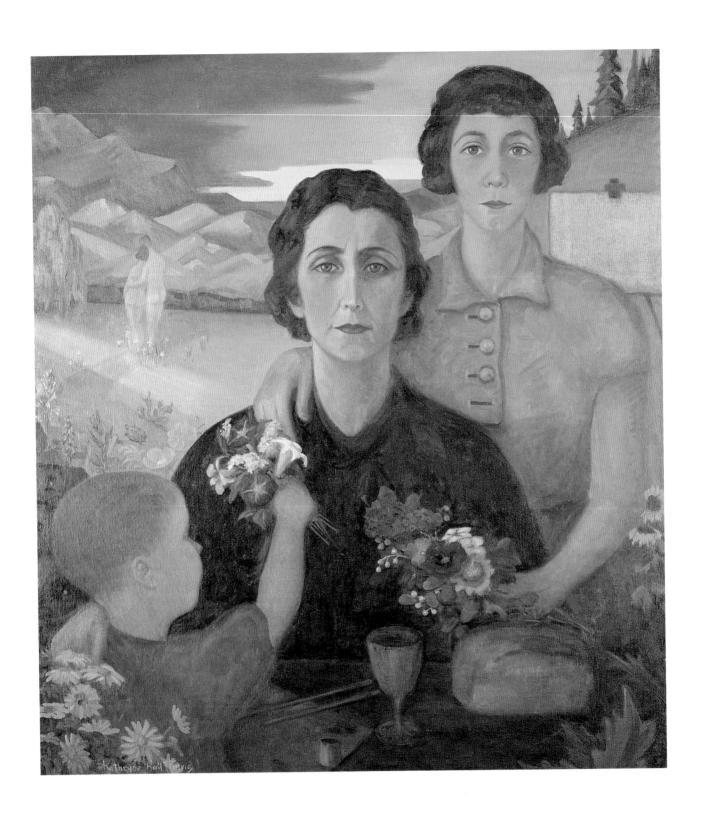

204.

Kathryne Hail Travis, *The Unfinished Picture*, c. 1935

Blackshear, "She was a kind, gentle, and sympathetic woman; she was a teacher and an artist; she was a human being. But more than all of that, Kathleen Blackshear provided crucial encouragement to a number of her African-American students at the School of the Art Institute in the 40s and 50s. I am proud to say that I was one of them."[34]

From 1924 to 1940 Blackshear returned to Navasota to visit her mother during the summer and at Christmas. During these visits, she often depicted the small-town Texas ritual of Saturday shopping. Familiarity with her subjects enhanced her sensitivity and understanding. A recent reviewer remarked that Blackshear's painting "reflects a simpler world where eloquent compassion was adequate for commenting on racial issues and clean form was remarkably effective in communicating art values."[35]

In her best works, Blackshear captures her subjects with simple grace and humanity. Sentimentality and cliché are refreshingly absent in *A Boy Named Alligator,* 1930 (plate 200). Here we find little of the anecdotal storytelling found in much Regionalism of the time. The painting's interest lies not in its narrative but in its bold, simplified forms and rhythmic patterning. Surface texture often lends cohesion to Blackshear's compositions, as in *Ruby Lee and Loula May Washington,* 1932 (plate 201), where the wood grain provides an intriguing visual backdrop for the dual portrait. Blackshear, who was familiar with non-Western art, was adept at setting up compositional tensions by means of oppositional diagonals and a tilted perspective—much like that found in Japanese prints.

Like Blackshear, May Schow (1895–1976) felt compelled to register her interpretations of the black communities in southeastern Texas.[36] From the late 1930s well into the 1950s, Schow sketched and painted African Americans at work and at play in the largely rural areas around Huntsville. She was also one of the few artists who ventured to paint members of the Hispanic community, then the ethnic group most discriminated against in Texas.

Educated at Columbia University, Schow continued her studies in summer art courses with the well-known New York artists Hans Hofmann, Millard Sheets, and Fletcher Martin. Closer to home, Schow studied with Alexandre Hogue, who influenced a number of artists in Texas and Oklahoma with his un-

205. Edith Brisac,
In the Mirror, c. 1940

derstated style of painting. He advised students to avoid "false charm, empty prettiness and sentimentality"—advice Schow clearly took to heart.[37] In *Mexican Girl,* 1936 (plate 202), modesty of conception is matched by an unaffected style. The simplicity of the setting underscores the frank honesty of the figure. Schow conveyed her humble philosophy of art to an entire generation of Texans from her position as head of the art department at Sam Houston State Teachers College in Huntsville, a post she held from 1938 to 1962 (plate 203).

Another talented and prolific portraitist, who painted landscapes and still lifes as well, was the Dallasite Kathryne Hail Travis (1894–1972).[38] Travis exhibited widely, following study with George Bellows, Randall Davey, and Robert Henri. Perhaps her best-known painting is a self-portrait chronicling an intensely personal loss. As a student at the Art Institute of Chicago, Travis had met and married Olin Travis of Dallas. In 1926 the couple founded the Dallas Art Institute, and by 1927 they had opened the Travis Ozark Summer School of Painting. In October 1933, however, the Travises' impending divorce suddenly made the news. The prominence of newspaper stories suggests that the divorce proceedings were bitter and played out in public. *The Unfinished Picture,* about 1935 (plate 204), relates to the unhappiness experienced by Travis during the year after the divorce.

CONTINUITY

I GATHERED
ANOTHER'S
FLOWERS
TODAY
IN TANGLED GRASS
NARCISSI NODDED
"WE HAVE WAITED
FOR YOU, TAKE US—"
AND I DID!

THIS LINK
PICKING FLOWERS
FROM BULBS SET
BY SOMEONE
LONG AGO
IS A SORT
OF IMMORTALITY

DON'T YOU THINK?

206. Grace Spaulding John, line drawing from John's *The Knotted Thread: Drawings and Verses*

In a show of self-portraits at the Dallas Museum of Fine Arts, the painting created something of a stir. Reproduced in the *Dallas Morning News* on January 10, 1936, it was described in a matter-of-fact manner. About a week later, however, the *Dallas Times Herald* reported that "members of the palette set" claimed to recognize the figures in the picture and that the artist "wielded a bitter brush while applying the paint."[39] Close together in the foreground of *The Unfinished Picture* Travis and her children touch supportively and offer each other small bouquets, perhaps in consolation or in observance of a private ritual. Placed before the painter are her palette and brushes, a loaf of bread, and a goblet or chalice. In the middle ground a blank canvas stands on an easel, and in the distance two nude figures embrace as they stroll toward a sky struck with sunlight and shadow. According to Travis's son, David, at the time the picture was exhibited many believed that the two nude figures in the background represented Olin and another woman.[40] The controversial figures may as easily represent innocent love lost.

While sharing Travis's reportorial style, Edith M. Brisac (1894–1974) took an entirely different approach to self-portraiture. *In the Mirror,* about 1940 (plate 205), with its theme of self-fashioning, seems an appropriate work for an independent fashion illustrator (she also taught interior design at Texas Woman's University).[41] With her broad shoulders, arched eyebrows, and firmly set mouth, Brisac presents herself as a woman of strength and self-possession. The painting has an iconic frontality and directness that seems almost confrontational. And yet the title suggests that we are viewing a private moment, as the artist composes herself in the mirror. By representing herself directly as a subject who is experiencing her own (re)presentation in a reflection, Brisac partakes of a tradition that dates back at least to the sixteenth-century work of Parmigianino. Art historian Richard Brilliant has noted that in this genre "the spectator is made to feel that in looking at this mirror image he is intruding into the apparently reciprocal relation between the artist and the mirror. . . . The intrusive eye of another is permitted access only by the painter's crafty objectification of the distinction between himself and his reflection, through his art."[42]

Another artist proficient in the genre of portraiture—as well as landscape, still life, and religious subjects—was the Houstonian Grace Spaulding John (1890–1972). A feisty iconoclast (she allegedly shocked Houston's polite society in 1920 when she suggested to a newspaper reporter that women stop wearing dresses), John was also an accomplished poet whose social orbit contained almost as many writers as painters. Some of John's portrait sitters included Thomas Mann, Edgar Lee Masters, and Rise Stevens. She also founded Houston's first professional cooperative gallery in 1930 and was an indefatigable experimenter who pioneered the technique of painting on plexiglass (she had a one-person show of such works in 1953), and was equally at ease working in oil, fresco, watercolor, pastel, conte crayon, ink, drypoint, woodblock, monotype, lithography, and linoleum block.[43]

It is difficult to summarize John's creative output because she followed so many avenues of expression (see plate 206). For her portraits, John sometimes worked in a crude expressionist style, while she chose impressionism for many of her landscapes. In the 1930s John, like so many American artists, came under the influence of the Mexican muralists. Her oil painting *Easter,* 1933 (plate 207), with its abbreviated graphic style and repetition of motifs, is strongly reminiscent of Diego Rivera's well-known *Flower Festival,*

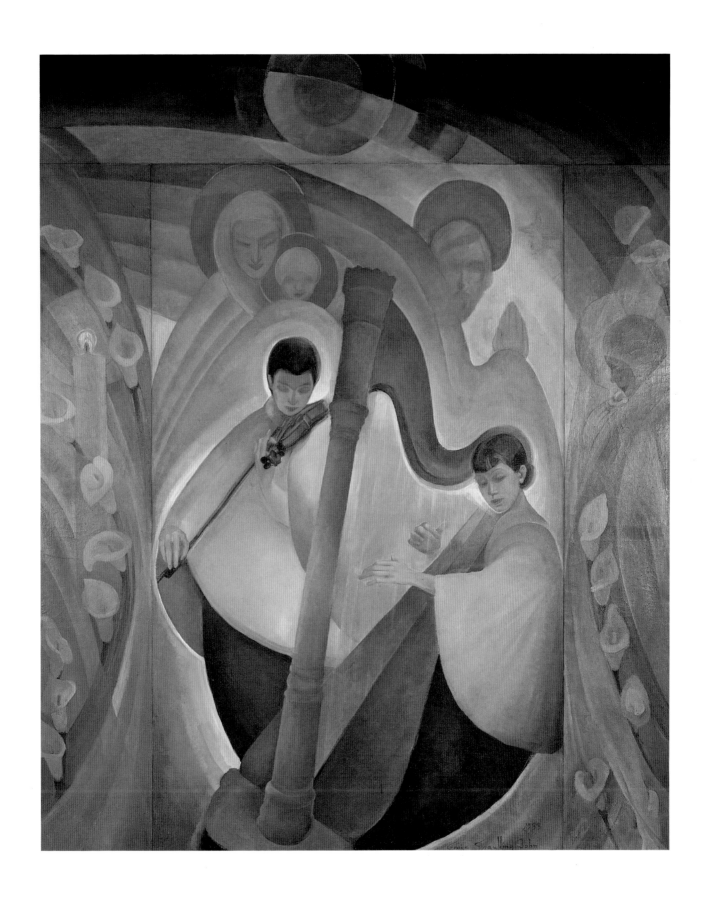

207.
Grace Spaulding John, *Easter,* 1933

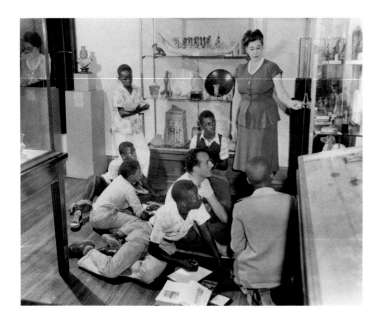

1931, which also makes emphatic use of the calla lily as a symbol of devotion.

John's close friend and colleague Ruth Pershing Uhler (1895-1967) (plate 208) collaborated with John on the murals for Houston's City Hall as well as on ceiling decorations for the Nelson Gallery in Kansas City, but Uhler is best known for her powerful abstractions of the Southwestern landscape.[44] *Decoration: Red Haw Trees, November,* about 1929–30 (plate 209), is representative of her highly charged, fantasmic visions of nature. Employing the curving forms and ornamental lines of Art Nouveau, Uhler infuses the scene with a feeling of movement, so that birds and trees "breathe" a common spiritual energy, or what Zen Buddhist landscape painters called the force of *ch'i* that animates all living things.

An avid student of non-Western art, Uhler was especially intrigued by Native American cultures. Between 1935 and 1936 Uhler lived in Santa Fe, where she studied native arts and crafts. She was also deeply inspired by the New Mexican landscape and upon her return to Houston, she completed nine paintings that express the distinctive clear light and vast horizons of the Southwest. The setting of these paintings is an Indian turquoise mine between Santa Fe and Albuquerque. Entitled *Earth Rhythms,* 1936 (see plate 210), the paintings in this series impart the essence and pulse of the land in a manner reminscent of O'Keeffe, whose work Uhler may have seen in Taos.[45]

Uhler's decision to paint abstractly placed her in a small minority of artists during the 1930s. Well into the 1940s, after much of the rest of the country was beginning to embrace European modernism, conservative taste held court in Texas. But while the trauma of World War II did not serve as an immediate catalyst for modernism in the state, it did draw Texas artists out of their provincial preoccupations. Like artists elsewhere in the country, they responded to the ferment by turning away from political reality and inward to the realm of private imagination. They found allegories for the strife in storm-ravaged seascapes, darkened woods, and deserted spits of land. Palettes generally darkened to suggest the prevailing mood of despondency. Even the staid genre of still life could provide a subtle commentary on the psychological climate of the era, as in the work of Frances Johnson Skinner (1902–1983) (plate 211). Skinner's wartime *Exercise for a Rainy Afternoon,* about 1942 (plate 212), conveys a sense of nature grown dark, brooding, and disoriented, even as it depicts a simple arrangement of fruit.

Skinner's still life spoke in its own understated way of the communal home-front experience of the war—shared by men and women alike. The painting's humble subject also has domestic connotations, although its cluttered, haphazard assemblage certainly does not match the image of the cleanly household touted in the popular media during the 1940s. But beyond this, can we say that the painting evinces an identifiable feminine aesthetic or

209.
Ruth Pershing Uhler, *Decoration: Red Haw Trees, November*, c. 1929–30

211. Frances Johnson Skinner at home in Houston, n.d.

consciousness? As in the case of the great majority of works discussed here, it would be difficult if not impossible to make such a case. Confronted with the tremendous range and variety of paintings by women artists in Texas from 1890 to 1945, it seems perhaps futile to search for a uniquely female style or sensibility.[46] There seems to be no mysterious "feminine essence" connecting Kathleen Blackshear's powerful portraits of African Americans to Clara Williamson's childlike daydreams of the Texas frontier. And certainly Florence McClung's visions of agricultural arcadia are best compared with those of other "Lone Star Regionalists," specifically her male colleagues of the Dallas Nine.[47]

Yet, as Linda Nochlin has astutely observed, "to discard obviously mystificatory, essentialist theories about women's 'natural' directions in art is by no means to affirm that the fact of being a woman is completely irrelevant to artistic creation. That would be tantamount to declaring that art exists in a vacuum instead of in the complex, social, historical, psychological, and political matrix within which it is actually produced."[48] Surveying the careers of Texas women artists, we can indeed find distinct patterns and consistencies. Among those most successful, there is a discernable typology: they either came from exceptional artistic families or they had the temperament and daring to break with societal expectations governing feminine behavior. In the early years, the ideology of separate spheres extended to the subjects women painted: floral still lifes, domestic scenes, and portraits were initially more prevalent than landscapes, and gritty genre scenes seldom appeared until the 1930s. Yet, while their productivity remained restricted to the less profitable genres, these same women took the lead in establishing art communities in Texas. As "civilizers" and crusaders for cultural enlightenment, they became educators and founders of art institutions. From their positions as curators, gallery directors, and faculty members, these artists exerted considerable influence on the art of Texas and made important contributions to the state's artistic heritage. It is against this backdrop, then, that the formidable production of women artists from 1890 to 1945 should be seen, including the probing portraits of May Schow, the icy Precisionism of Marie Delleney, and the vibrant abstractions of Ruth Pershing Uhler.

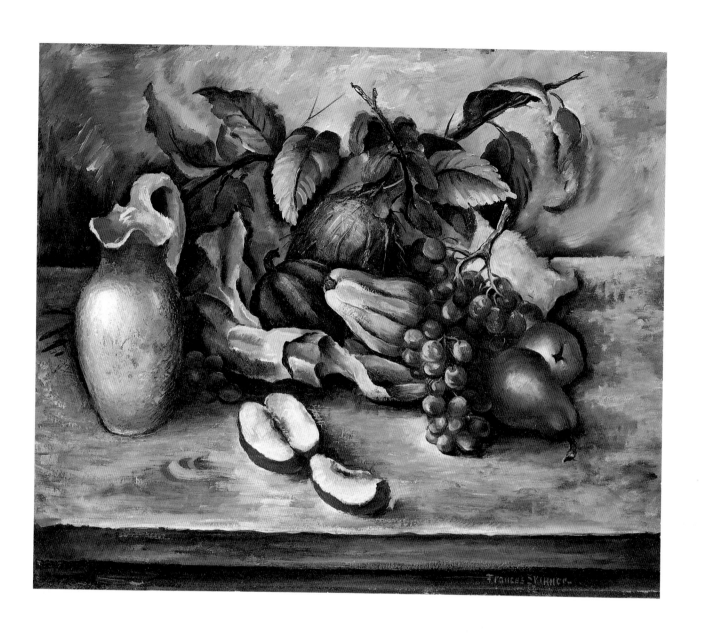

212.
Frances Johnson Skinner, *Exercise for a Rainy Afternoon*, c. 1942

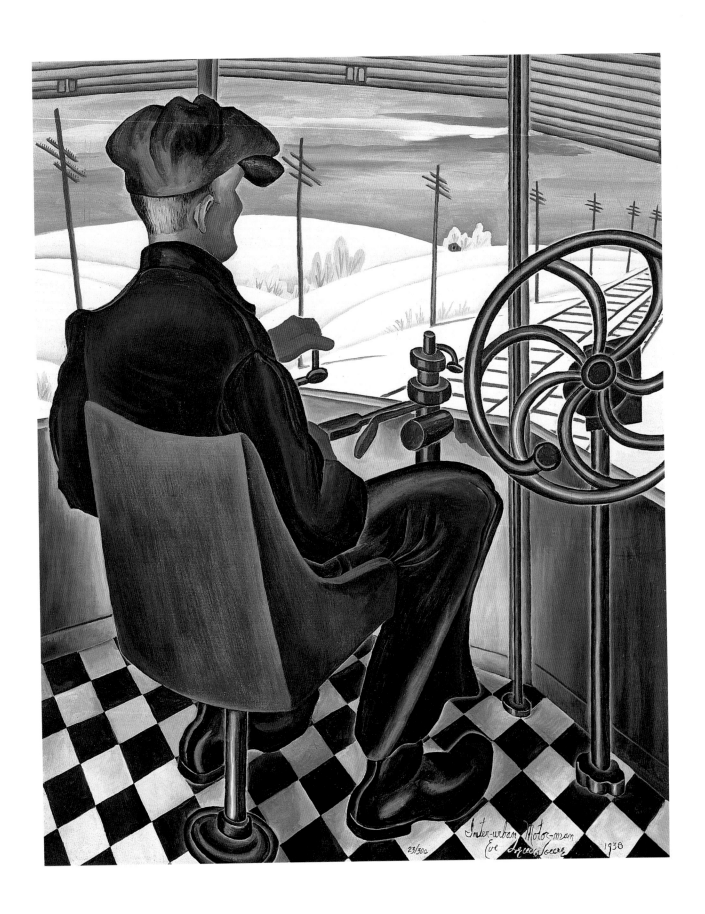

234.
Eve Drewelowe, *Inter-Urban Motor-Man*, 1938

VIII

"I *must* paint"

WOMEN ARTISTS OF THE ROCKY MOUNTAIN REGION

Erika Doss

HANDWRITING HER MEMOIRS in the late 1940s, Utah painter Minerva Kohlhepp Teichert (1888–1976) (plate 213) remembered the moment in her life when her "calling" as a Western woman artist jelled. During a critique in Robert Henri's portraiture class at the Art Students League in New York, where Teichert studied from 1915 to 1916 (plate 214), her mentor asked, "Has anyone ever told your great Mormon story?" Teichert answered, "Not to suit me," and Henri advised, "Good Heavens, girl, what a chance. You do it. You're the one." Teichert soon left New York and returned to her family's homestead in Idaho, near the Utah border. She married her "cowboy sweetheart," "helped in the hay fields," did the books for the family ranch, raised five children (naming her second son Robert Henri Teichert), and painted almost every day of her life, "usually after [the children] were tucked into bed at night." "I *must* paint," she wrote. "It's a disease."[1]

For over half a century Teichert captured "the great Mormon story" in hundreds of murals and easel paintings for churches, schools, and private patrons throughout the Rocky Mountain region. Loosely painted, large-scale pictures like *Handcart Pioneers,* 1930 (plate 215), and *Covered Wagon Pioneers, Madonna at Dawn,* 1936 (plate 216), show the breadth of her attention to the West and its landscape. Still, despite her amazing productivity, and Henri's wager—"George Bellows, John Sloan, and Minerva Kohlhepp—these are my bets. This girl from Utah you're bound to hear from"— Teichert's art remains relatively unknown.[2]

Teichert's art-world obscurity may result from her primary attention to Mormon history and theology. Her celebration of the roles and experiences of pioneer women, especially, simply did not jibe with the "how the West was won" approach assumed by most Western art-

ists when they imagined, and mythologized, the American frontier. "Our picture of the Old West," writes art historian Jules David Prown, "a West distant in time and now physically transformed—the West of cowboys and Indians, of wagon trains rolling westward and herds of buffalo grazing on vast prairies—has been colored by countless romanticizations in film and fiction and art." Not the least of these romantic images is that of the legendary Western artist bravely traversing unknown territory, capturing in oils and inks the landscapes and lore of the New World frontier. Familiar models are such artists as Albert Bierstadt, George Catlin, Frederic Remington, and Charles Russell. That this artist was male and that the central theme of Western art was "a celebration of masculine dominance of the landscape" have long been broadly accepted tenets of this mythical "picture of the Old West."[3]

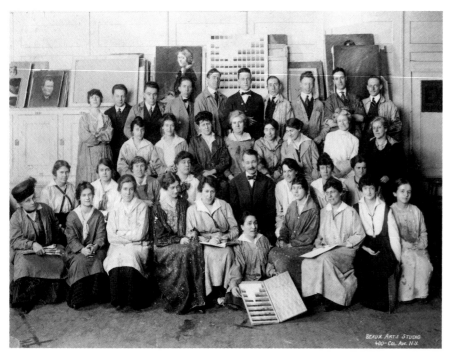

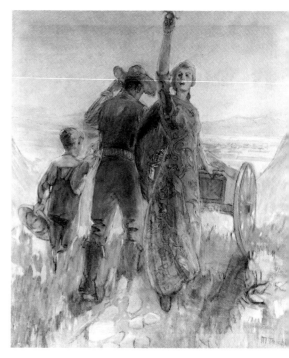

Historian Patricia Nelson Limerick cautions: "Exclude women from Western history, and unreality sets in. Restore them, and the Western drama gains a fully human cast of characters—males and females whose urges, needs, failings, and conflicts we can recognize and even share."[4] Indeed, paintings produced by Western women artists like Minerva Teichert during the later nineteenth century and the first half of the modern era suggest a deeper and more critical analysis not only of American Western art but of our own abiding mythical construction of the American West.

Nowhere, perhaps, has that myth been more resonant than in the Rocky Mountain region, in the Western states of Colorado, Idaho, Montana, Utah, and Wyoming. Awed by a dramatic landscape of snow-capped mountain ranges, big skies, and seemingly endless terrain, romanced by their own naive impressions of the region's native peoples and personalities, and, more often than not, directed by patrons with their own particular ideas about the American frontier, nineteenth-century male artists created pictures of the Rocky Mountain region that came to be broadly mythologized as icons of the whole, true West.

Albert Bierstadt's panoramic Western scenes were among the most powerful in this regard, painted in an exaggerated, romantic-realist style that persuaded audiences that his Rocky Mountain landscapes *were* the West.

Popular illustrators such as John Gast fired those assumptions with images like *American Progress*, 1872 (plate 217), where Native Americans and bison are beset by the onslaught of advancing Anglo civilization—wagon trains, railroads, prospectors, and farmers—guided overhead by a gigantic Gilded Age female clad in loosely flowing drapery and carrying a schoolbook and a rope of telegraph wire.[5] Pushed aside by the course of empire, the Rocky Mountain landscape and its indigenous population were central to the construction of the mythical American frontier but essentially disposable when it came to the business of conquering, and settling, that place.

These popular pictures, along with a host of cultural artifacts ranging from dime novels and tourist guidebooks to Wild West shows, U.S. Geological Survey photographs, and cowboy paintings, encouraged Americans to imagine the true West of the Rocky Mountains as a place of particularly masculine adventures and opportunities. "In popular culture as well as scholarship," historian Katherine Morrissey observes, "the American West is most often associated with masculine images. Cowboys and soldiers, gold miners and fur traders—the cast of characters that peoples the stereotypical West is male-dominated."[6] The occasional Anglo females included in this construction of the manly Rocky Mountain frontier were stereotyped as much as their male counterparts—

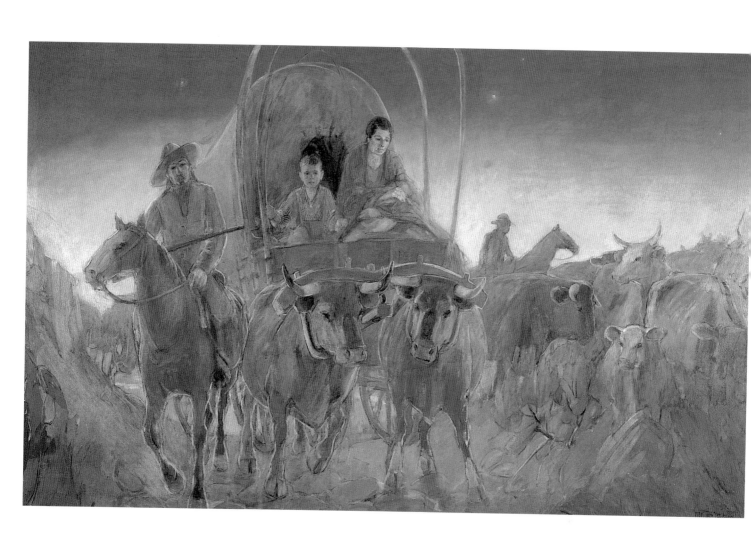

216.
Minerva Teichert, *1847 Covered Wagon Pioneers, Madonna at Dawn,* 1936

217. John Gast,
American Progress, 1872

as helpmates, prairie madonnas, schoolmarms, and prostitutes with golden hearts.[7] William T. Ranney's *Advice on the Prairie,* 1853, centers on a pioneer wife cradling her young baby and passively listening to the words of a mountain man, while William Koerner's *The Madonna of the Prairie,* 1922, captures a Clara Bowesque beauty gazing into the frontier future from her covered wagon perch (forming a halo around her bobbed hair). Both typify the consistent typecasting of white Western women as handmaidens of civilization and Christianity, the gentle and passive tamers of the Wild West.[8] Gast's allegorical figure in *American Progress* was an especially obvious manifestation of the expected functions of women in the West.

Recognizing the fallacies of these gender stereotypes and realizing their contemporary currency, as the abiding presence of the Marlboro Man attests, recent writers have begun to dismantle and expose these components of the Western frontier myth. Challenging the notion that the story of the American West is especially a masculine tale, historians have returned to the words written by Western women, in letters, diaries, and novels. Little attention has yet been given, however, to the images that Western women artists produced, even though "we now know that women, indigenous and immigrant, participated in all stages of western development, in numbers far larger and roles more varied than their appearances in catalogs and exhibitions of

western art would suggest."[9] Close scrutiny of those images, as well as the diverse histories and cultures that Western women artists lived and created, along with the words of Western women, will contribute to a fuller and more comprehensive account of the story of the American West. A new, gendered Western art history revels in the necessary questions it raises about the entire Western experience—for men and women.

One major area of inquiry should lead to accounting for the various styles and subjects selected by women artists in the Rocky Mountain region from the beginnings of Western suffrage through the advent of abstract art. Colorado and Utah, the most heavily populated of the Rocky Mountain states, produced the largest body of works by women artists in the region from 1890 to 1945. Denver, in particular, the second largest city in the West (after San Francisco), was dominant among Rocky Mountain cities for the sheer number and extraordinary talent of its artists. Important, too, was Denver's prominence not simply as a summer art colony (as were Colorado Springs and the New Mexican towns of Taos and Santa Fe) but also as a year-round community where art exhibitions and lectures, art schools, public art competitions, and art galleries were thoroughly integrated into civic life by the turn of the century. Given the constraints of the Gilded Age's Cult of True Womanhood that perceived Anglo-

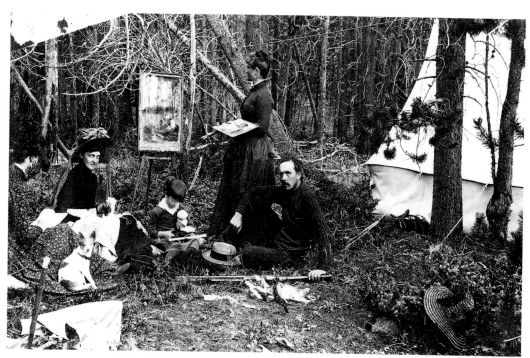

American, middle- and upper-class women as morally superior to men, Western women were seen as the Wild West's civilizing influence and assigned the task of ordering and educating its frontier denizens.[10]

It is not surprising, then, that women were largely responsible for many of Denver's elite cultural venues. Spurred by the discovery of gold in the central Rockies in the late 1850s, Denver's population and prosperity boomed. By the time Colorado was granted statehood in 1876, the city had practically shed its notorious outlaw image and had begun to "assume metropolitan airs."[11] Along with the Tabor Grand Opera House (1881) and the "Brown Palace" Hotel (1892), art clubs and associations contributed to Denver's cultural reputation. Artists had lived in the city since the 1860s; by 1884, over fifty artists were listed as Denver residents. The burgeoning artists' colony initiated several clubs—the Kit Kat Club, the Art Reading Society, the Denver Art Club—but most were short-lived because of internal bickering over leadership and failed efforts to receive more than cursory patronage from the city's wealthy mining and railroad barons.[12]

Denver landscape painter Helen Henderson Chain (1849–1892) was more successful than other artists, establishing the city's first art school in 1877 and often taking her students with her on extended sketching trips in the Rocky Mountains (see plate 218).[13] By the 1890s

other Colorado women had carved out art clubs and associations, creating spaces for female autonomy and arenas of opportunity and influence for themselves outside the domestic sphere. The first of these was the Le Brun Art Club (named after French portraitist Elisabeth Vigée-Le Brun). Modeled on Chicago's Palette Club, the group consisted of both professional and amateur women artists who met regularly to discuss and exhibit their work. Several prominent female painters, including Henrietta Bromwell (1859–1946), Emma Richardson Cherry (1859–1954), Anne Evans, and Elisabeth Spalding (1868–1954), founded the city's next art association, the Artists' Club of Denver, in 1893. The club's frequent exhibitions attracted large crowds and plentiful critical attention and Bromwell's Colorado scenes, such as *[Rocky Place and Junipers],* about 1890 (plate 219), and Cherry's still lifes, such as *[Sweet Peas],* 1894 (plate 220), were among the state's most significant paintings from the turn of the century.

Instead of contributing to a nostalgic, frontier image of the Wild West as painted by Remington and Russell, or furthering Bierstadt's vision of the Rocky Mountains as a sublime place of Manifest Destiny, Colorado's white women artists concentrated on their own experiences and interests—the local landscape, the domestic interior. They were certainly not restricted to these subjects, however. Helen Henderson Chain, for one, was consistently

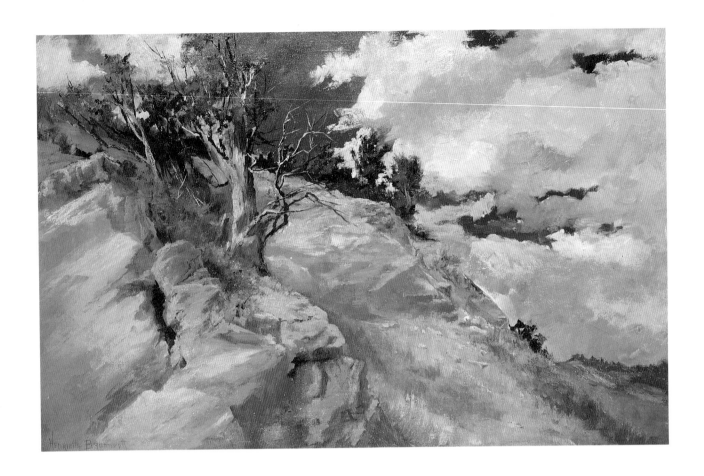

Henrietta Bromwell, *Untitled Landscape [Rocky Place and Junipers]*, c. 1890

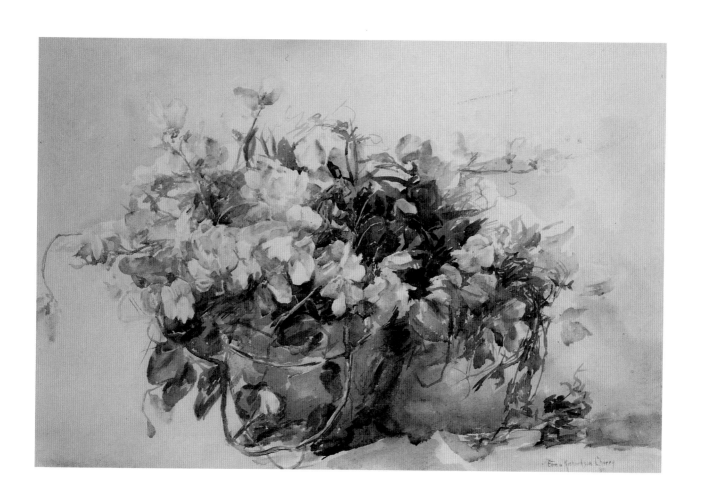

220.
Emma Richardson Cherry, *Untitled [Sweet Peas]*, 1894

attracted to the scenery of the Rockies and spent her career capturing that landscape. Intent on turning Denver into an art center on par with Omaha and Kansas City, most of the city's female artists eschewed a mythological picture of the Rocky Mountain region in favor of their own significant roles in cultivating the West. In creating their own artistic environments, they were able to direct Denver's cultural future. Eventually, spearheaded by the efforts of Cherry and Evans, the Artists' Club changed its name to the Denver Art Association, incorporated as the Denver Art Museum in 1923, where Evans's collections of Native American and Southwestern art are still prominently featured.

As a result of the cultural support structure developed by women, Denver remained a magnet for Western artists in the twentieth century. It was not alone: an active art colony emerged in Salt Lake City in the 1890s. After leading Mormon pioneers to the Great Salt Lake Valley in 1847, Brigham Young encouraged Utah painters toward proselytization. The Church of Jesus Christ of Latter-day Saints emerged as the most profound influence on Utah's artistic development, providing patronage to arts groups and artists who concentrated on the physical and spiritual character of the state in church decorations and similarly didactic works. In 1890 the church sponsored the Paris art studies of four male Mormon painters: Edwin Evans, John B. Fairbanks, John Hafen, and Lorus Pratt; in return, these "French Mission" artists promised to paint murals for the Salt Lake City Temple.[14] Utah's female artists of the era, however, including Harriet Richards Harwood, Rose Hartwell, and Mary Teasdel, were never granted such largesse by the Latter-day Saints, and they relied on family finances and prize monies to sustain their art careers. Circumscribed by a dominant theology that sanctioned the preeminent role of Mormon men, the art associations that emerged in Utah provided sustenance mostly for male artists, and thereby helped institutionalize Latter-day Saints ideology. "The West," historian Sara M. Evans writes, "provided spaces for intensified male domination as well as for female autonomy."[15]

Utah's first art dealer and historian, Alice Smith Merrill Horne (1868–1948), was clearly an independent Western woman, the second woman elected to the Utah House of Representatives. In 1899, three years after Utah was granted statehood, Horne instigated the Utah Art Bill, establishing the nation's first state-sponsored art collection. After founding the Utah Art Institute, whose holdings (called the Alice Art Collection) grew through the purchase of paintings and sculptures annually exhibited by state artists, the indefatigable Horne went on to sponsor more than thirty-five other exhibitions of Utah art, run her own galleries, raise six children, serve in innumerable Latter-day Saints relief societies, and author two books. One of these, *Devotees and Their Shrines* (1914), was the first published account of Utah's artists.[16] But Horne's aesthetic sensibility, writes art historian Will South, "was inextricably entwined with her religious beliefs," and her arts activism especially focused on identifying and promoting an art of morality and religion.[17] Unlike the autonomy that art associations provided white women artists in Colorado, Utah's art associations gave further solidity to already extant codes of patriarchal behavior.

The career of Harriet Richards Harwood (1870–1922) shows the struggles that Utah women underwent trying to juggle painting and family without the sustenance of truly autonomous female art associations. Harwood studied in Paris in the early 1890s, painted accomplished floral studies and still lifes, and participated in the Society of Utah Artists, which her husband, landscape painter and art teacher James Taylor Harwood, helped organize in 1893. *Etude,* 1892 (plate 221), her still life of a pumpkin, cauliflower, and potatoes, was the only oil painting by a woman artist to be exhibited in the Utah Pavilion at the World's Columbian Exposition in Chicago in 1893. While neither Harwood nor her husband were practicing Mormons, her intimate pictures closely followed the Latter-day Saints prescription for images of God's handiwork and Zion's bounty.[18] Despite her talents and critical success, Harriet Richards Harwood basically abandoned painting by the late 1890s, her energies spent on furthering her husband's artistic career and raising a family in the Mormon West.

Harwood herself never explained exactly why she disengaged from the art world, but Minerva Teichert's autobiography poignantly addresses the difficulties encountered by Utah's women artists, perhaps more than other women artists in the Rocky Mountain region, when they attempted to pursue professional

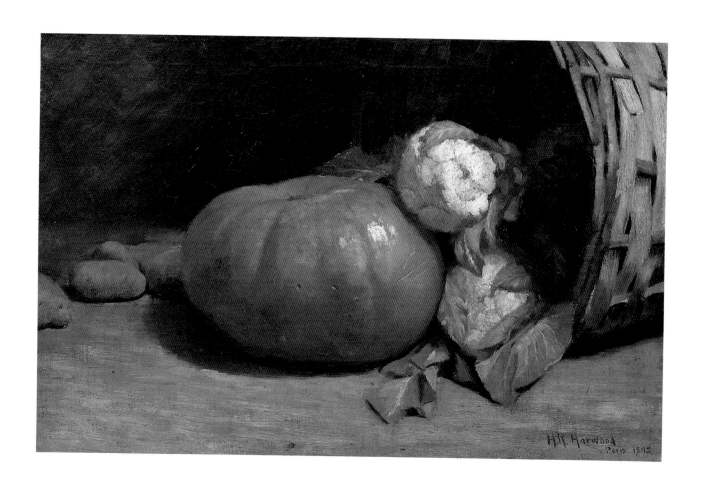

221.
Harriet Richards Harwood, *Etude,* 1892

lives. During her art studies in New York, Teichert attended a Mormon church meeting and heard a speaker acclaim, "Girls, what's a career? I have known the joy of motherhood. You go home and marry your sweethearts and have your families and you will be much happier than you will by following a career."[19] Just a few months later Teichert herself abandoned the art world and, while she never abandoned art, became Utah's most significant painter of the "great Mormon story."

Other Utah artists, such as Mary Teasdel (1863–1937) and Rose Hartwell (1861–1917), resisted the power of Mormon theology by leaving the country and either remaining single or marrying late in life. Teasdel left Salt Lake City in 1899 to study in Paris for three years with James Abbott McNeill Whistler, Benjamin Constant, and Jules Simon. Hartwell also left Utah in the late 1890s. She first studied at the Académie Julian in Paris and then traveled and painted throughout Europe until 1913, when she returned to Utah. "In Paris and Florence I am more at home than in Salt Lake City," she told Alice Merrill Horne in 1914.[20] Teasdel was the first Utah woman artist to exhibit at the Paris Salon, in 1902; the following year Hartwell made her debut at the Salon. In Paris, Hartwell befriended another American expatriate, Mary Cassatt, and like her was drawn to intimate depictions of motherhood, such as *Nursery Corner,* about 1910 (plate 222). The picture's dramatic reds and greens and its tightly controlled brushwork reflect Hartwell's interest in Dutch genre pictures and her studies with Spanish colorist Claudio Castelucho. The softer colors and painterly qualities of Teasdel's pictures, such as *Mother and Child,* about 1920 (plate 223), are stylistically closer to Cassatt's Impressionist style.

Given the subjects that both Hartwell and Teasdel chose to paint, it is interesting to speculate on the authority that may have been exerted by the Church of Latter-day Saints on their artistic production. The church's emphasis on domesticity and motherhood was strong, and Teasdel never married, while Hartwell was only married during the last three years of her life. Indeed, one author finds Hartwell's *Nursery Corner* to be "full of the maternal longing that must have been in Rose's own heart. As an unmarried woman who went into her forties with no children of her own, she seems to echo the maternal loneliness of the door that was closed to her, by repeating the reflection of the European door handle in the wall mirror."[21] Despite their studies abroad and their remove from Mormonism, as Western women artists Hartwell and Teasdel may have found their efforts at artistic self-actualization modified by Utah's peculiar spiritual and social context. Even the art of a later Utah painter like Florence Ware (1891–1971) belies that authority. Ware studied at the School of the Art Institute of Chicago and then taught for most of her professional career at the University of Utah in Salt Lake City.[22] While *Breakfast in the Garden,* 1928 (plate 224), is indicative of Ware's experiments in color and brushwork, it also romanticizes the genteel passivity of middle- and upper-class female experience. Considering the circumstances under which such paintings were created and displayed—Ware's picture was purchased for Alice Merrill Horne's state art collection—it is hard to decide whether Utah's women artists chose these subjects to give validity to their lives or because they meshed with Mormon assumptions about female behavior.

Outside the Rocky Mountain region's two largest cities, women artists in Idaho, Montana, and Wyoming struggled with their own obstacles, particularly those of geographic and cultural isolation. Fra Dana (1874–1948) (plate 225) was probably the region's best-trained painter, studying with Joseph Henry Sharp at the Cincinnati Art Academy, William Merritt Chase at the Art Students League in New York, and Alfred Maurer and Mary Cassatt in France. Sharp considered her a superb painter, once boasting "she paints like a Man!"; and Maurer "often used to invite [her] to accompany him when he painted."[23] But Fra (pronounced "Fray") Dana's professional art career was eventually undercut by her marriage to a Wyoming rancher who considered painting secondary to raising prize cattle. Born and raised in Indiana, Dana studied with Sharp in the early 1890s. She and her sister were transplanted to Wyoming in 1893, where her mother had been willed a parcel of land. Three years later she married Edwin L. Dana, although only after signing a prenuptial agreement allowing her to spend a portion of each year studying art in New York and Europe.

Dana's paintings of the next decade, like *On the Window Seat,* about 1909 (plate 226), and

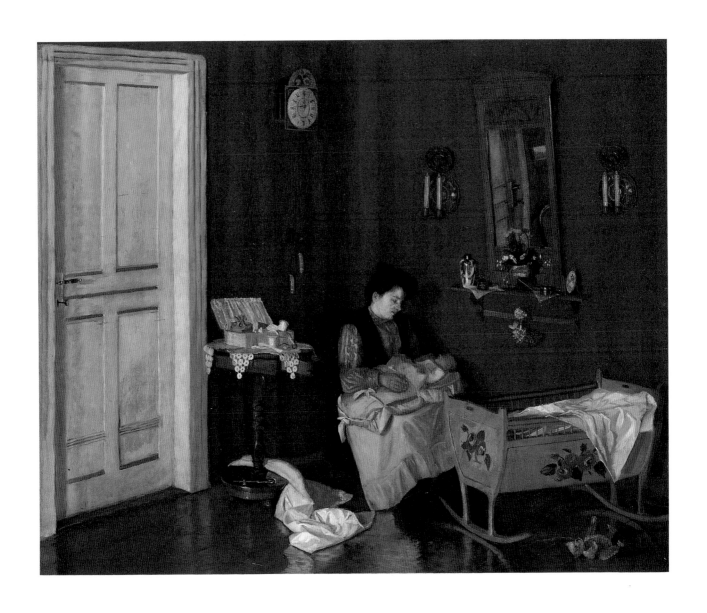

222.
Rose Hartwell, *Nursery Corner,* c. 1910

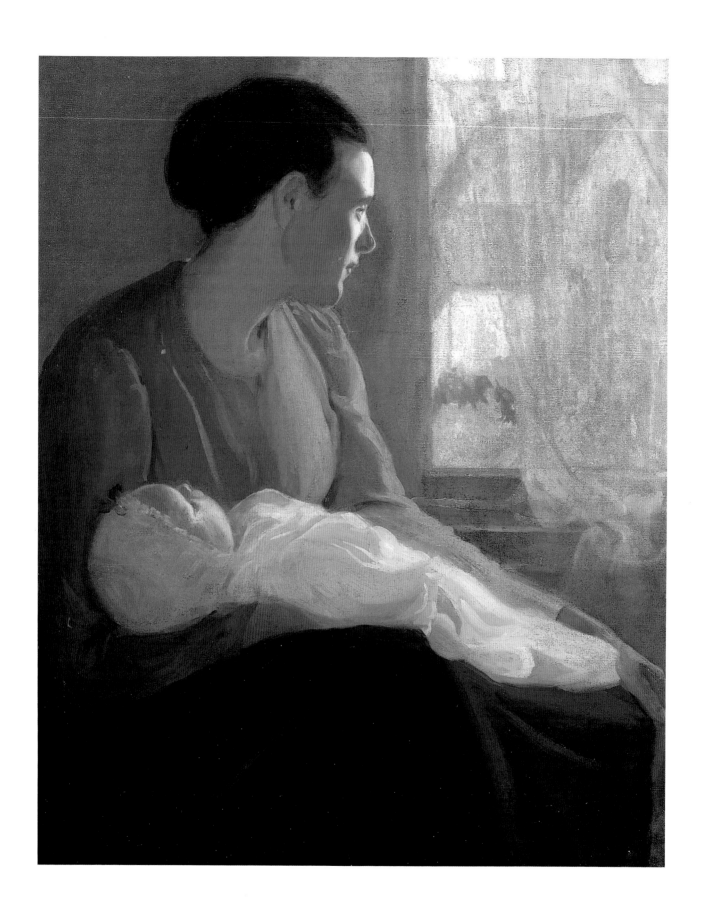

223.
Mary Teasdel, *Mother and Child*, c. 1920

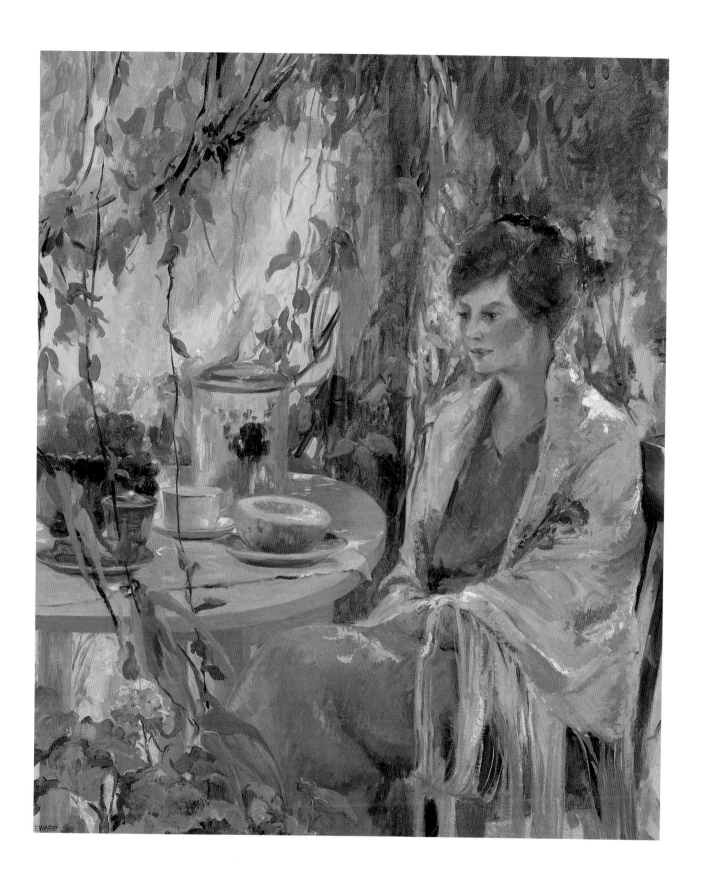

224.
Florence Ware, *Breakfast in the Garden*, 1928

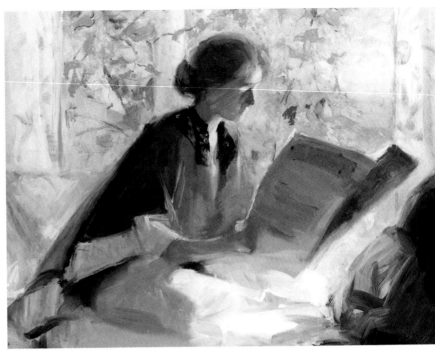

225. Fra Dana, c. 1900

226. Fra Dana, *On the Window Seat,*
c. 1909

Breakfast, about 1910 (plate 227), probably self-portraits done in Wyoming, show her efforts to claim herself as a woman of refinement—dressed in morning clothes, reading the newspaper, sipping tea. Yet in both pictures her face is hidden and her features are blurred, a revealing comment on how much Dana detested her life in the Rocky Mountain West but was incapable of completely leaving the region. Dana's paintings, and her diary accounts, such as this one from June 5, 1907, show the deeply felt tensions between her desire to be an artist and her role as a rancher's wife:

> Today is Velazquez's birthday. I always keep it in my heart. But I speak no more of my vanished dreams. We spayed sixty-eight heifers this morning. It took from six o'clock until eleven of hard work. I tallied and got hungry and sleepy—so sleepy that I fell over against the gate post of the corral. It was while I was tallying that I remembered it was Velasquez's birthday, and a strange place it was to remember. This is life and the thoughts that I used to think were dreams. Beauty of any kind is a thing held cheap out here in this land of hard realities and glaring sun and alkali. There are no nuances.[24]

Cassatt apparently advised Dana to leave Wyoming and the West, telling her that she must become "ruthless" in order to survive and succeed as a woman artist. But Dana could

never break free of her husband and their Western ranch. In a 1911 passage written in New York, she revealed her frustrations: "I could fight the world and conquer, but I cannot fight the world and Edwin, too. He will always pull against me in the life that I desire. So I shall give up. He has won. Why struggle? I will go back to the ranch and never ask to go away again and try to content myself with the flowers and books, both of which I love. But the loneliness! And how can one live without making some big effort all the time?"[25] Although Wyoming Territory first granted women the right to vote in 1869 (followed by Utah in 1870, Colorado in 1893, and Idaho in 1896), long before the country as a whole ratified the Nineteenth Amendment in 1920, political emancipation did not necessarily lead to social liberation and professional autonomy for Western women.[26] After 1912 Dana remained on her Wyoming ranch, just south of the Montana border. She painted only sporadically for the remainder of her life and died in Great Falls, Montana, in 1948. Shortly before her death she donated her paintings and her substantial collection of works by Chase, Maurer, and Sharp to the University of Montana. In a brief letter she wrote, "I do not know that there is anything to tell you about my life. My annals are short and simple. I was born, I married, I painted a little, I am ready to die."[27]

Dana was an exception. For many West-

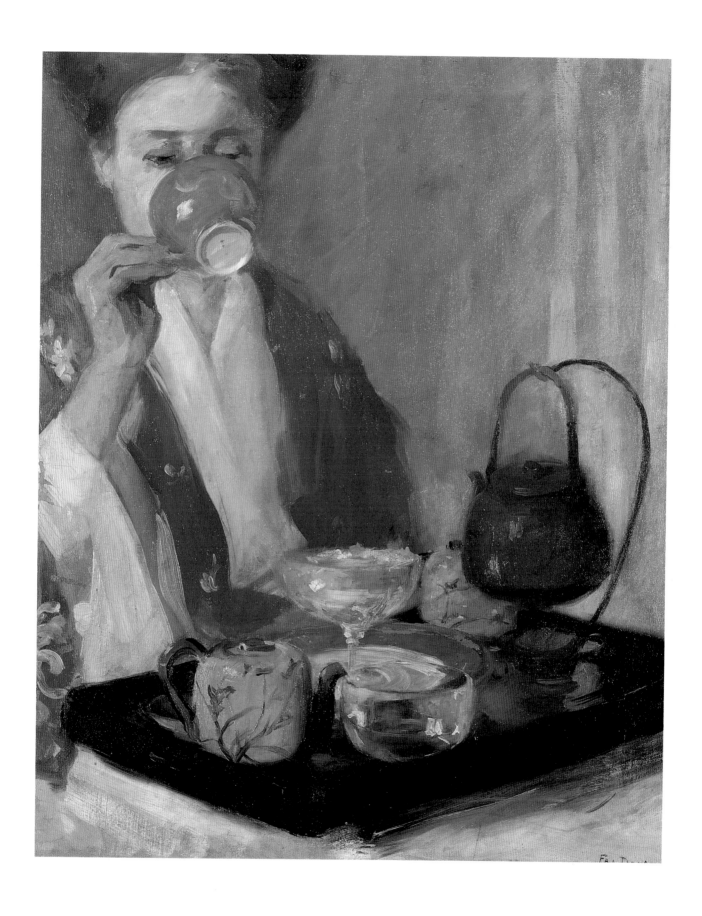

227.
Fra Dana, *Breakfast*, c. 1910

ern women artists the Rocky Mountain region was a place of overwhelming natural resources. These painters celebrated the splendor of the landscape, occasionally calling attention to its industrial utility. Mrs. M. J. Bradley (active 1891–92) chose an industrial subject in *Gem, Idaho, and Gem Mill,* an oil dated 1892 (plate 228). Her picture of a peaceful and prosperous mountain mining town only subtly hints at Gem's real history. Situated among the canyons of northern Idaho's Coeur d'Alenes, Gem was a huge source of lead and silver from the 1880s through the 1970s. It was also the site of fierce labor battles between miners and management in 1892 and 1899, when scabs were murdered and mines were firebombed. Nothing is known of this presumably self-taught artist, but it is interesting to consider how her social standing as, perhaps, the wife of a mining engineer or merchant may have influenced her decision to paint Gem as a charming place, rather than the site of Idaho's bloodiest labor conflict.

Another Idaho painter, Mary Kirkwood (1904–1995), a Moscow, Idaho, resident since the 1920s (she taught at the University of Idaho from 1930 to 1970), painted vivid, patterned local landscapes such as *Palouse Autumn,* 1939 (plate 229), capturing southeastern Idaho's pervasive sense of expansive aridity. For her and other women artists who painted in the Rocky Mountain states and often taught in regional colleges and universities, Western scenery was a source of artistic experimentation. Among these women were Mabel Frazer (1887–1982), Louise Farnsworth (1878–1969), and Florence Ware. "It was often the women artists who led the way in the very slow development of modernism in conservative Utah," one writer remarks. "Women didn't get to lead much in the traditional sense in Utah . . . and so they were used and then left pretty much alone to experiment more than their male counterparts. While the gents carefully ran the show, many women in subordinated positions worked hard and had more creative ideas in a week than some of their supervisors or directors/protectors and/or chairmen actually had in a lifetime."[28]

Frazer's powerful landscapes, such as *Sunrise, North Rim* (Grand Canyon), 1928 (plate 230), and *The Furrow,* 1929 (plate 231), display her mastery of Fauvist and Expressionist styles. These bold paintings suggest that she found aesthetic autonomy in a personal design rather than a more pragmatic approach to Western scenery. Farnsworth painted similarly forceful local landscapes, shedding "the threadbare shibboleths of realism and picturesqueness" for brightly colored and extremely tactile canvases such as *View of Salt Lake City and Hotel Utah,* 1929 (plate 232).[29] Abandoning the dictates of pictorial representation and Mormon religiosity, these artists made the Rocky Mountain landscape the subject of their own independence. Abandoning a mythologized and masculine approach to the Western landscape, they concentrated on their own, entirely subjective regional views.

This was true of their teaching as well: Frazer and Ware were longtime faculty members in the art department at the University of Utah, where they urged students to pursue a modern aesthetic far different from that condoned by Alice Merrill Horne. One of Frazer's students recalled that "she had a kind of easy, free watercolor approach, and encouraged this. . . . [She] decried anybody's compulsion to hold to rigorous detail. Frazer was a challenging teacher." Seizing the spheres of opportunity and influence that were available, Western women artists thus provided models of artistic behavior for others in how they taught and what they painted.[30] Suffrage may have liberated them politically, but their challenge to masculine authority in the classroom and their refusal to perpetuate the grand myth of the Western frontier in their pictures helped them transcend both the ideology of the Cult of True Womanhood and the dominance of a social sphere that cast them primarily as helpmates and homemakers.

The most outstanding Western woman artist in this regard was Eve Drewelowe (1899–1989) (plate 233), who lived and painted in Boulder from the mid-1920s until her death.[31] Born on an Iowa farm, Drewelowe spent her entire adult life fighting for the recognition of her artistic persona and struggling against the demands of domesticity: "Housewife! What an odious word!" she often remarked. "First! Foremost! Always! My waking thought from an embryo on was my need to be an artist!" she passionately exclaimed just before she died. As an artist she felt "an insatiable appetite and a need to create," coupled with an almost obsessive need to preserve her work and "to hang onto some infinitesimal 'something' of everything I have touched."[32] When Drewelowe's

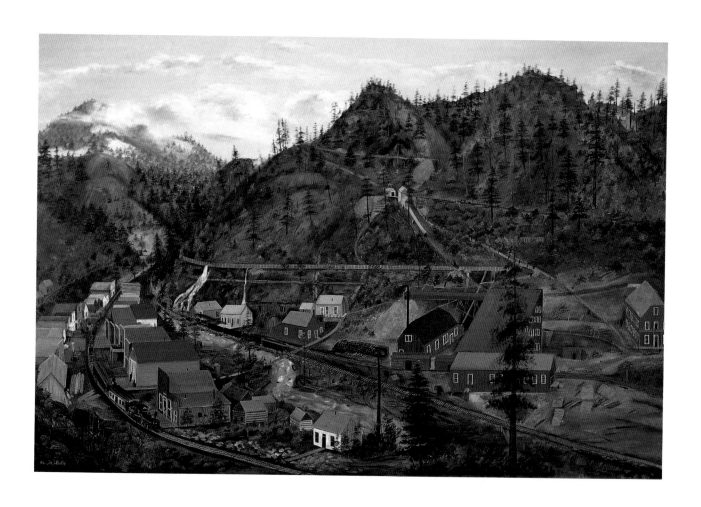

228.
Mrs. M. J. Bradley, *Gem, Idaho, and Gem Mill*, 1892

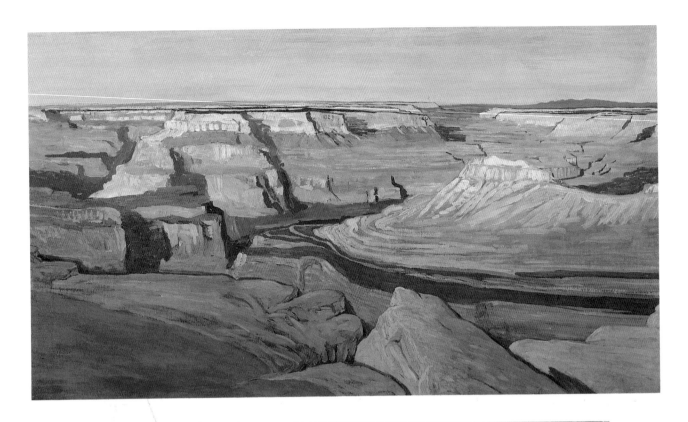

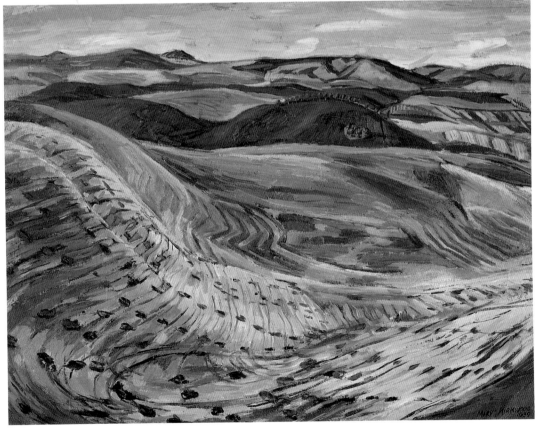

230.
Mabel Frazer, *Sunrise, North Rim*, 1928

229.
Mary Kirkwood, *Palouse Autumn*, 1939

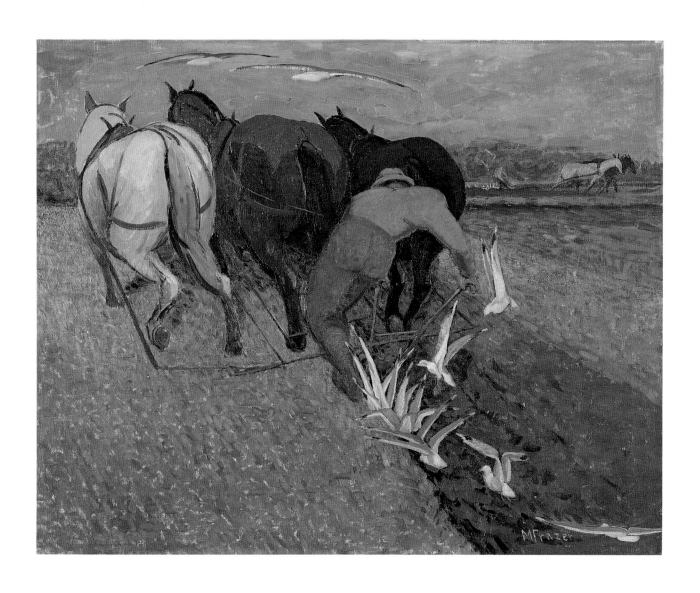

231.
Mabel Frazer, *The Furrow*, 1929

estate was brought together in the mid-1980s in preparation for a retrospective of her work at the University of Iowa, researchers found paintings and drawings, along with diaries, letters, notebooks, prescriptions, and receipts, hidden in every nook and cranny of her home—in cupboards, between mattresses, even in the stove and dishwasher (testimony to her distaste for housecleaning and cooking). More than just a pack rat, however, Drewelowe was a talented and extremely prolific painter who was determined to see her lifework as a woman artist of the West memorialized.

The first woman to receive a master of fine arts degree from the University of Iowa in 1924, Drewelowe settled in Boulder with her husband, Jacob van Ek; there he taught political science and soon became dean at the University of Colorado. Drewelowe had expected to pursue her artistic career and bridled at the hostess duties expected of a dean's spouse. "Naturally, the hospitality chores fell to me," she bitterly recalled.[33] She retreated to her studio to paint scenes sketched during the "highly euphoric thirteen months" that she and her husband spent on a trip around the world in 1928 and 1929, as well as scenes that conveyed local flavor, such as *Inter-Urban Motor-Man,* 1938 (plate 234, page 208), a depiction of the commuter train that ran between Boulder and Denver before World War II. She became one of the founding members of the Boulder Artists'

Guild (organized in 1925) and actively participated in the group's annual exhibitions. But in the late 1930s Drewelowe experienced a major physical collapse that she attributed to her "chores" as the dean's wife. A self-portrait from 1939, subtitled *Reincarnation,* showing Drewelowe confined to bed, gives some clue to her agony and alienation (plate 235). Finally, en route to New York in 1940, where paintings and sketchbooks from her global voyage were being soloed at the Argent Galleries, she fell ill and underwent emergency surgery at the Mayo Clinic. In Drewelowe's view the surgery prompted her "reincarnation" in which painting was emphasized over social obligations. She recalled that her husband and the clinic's doctors "gave their seal of approval to my artist's lifestyle." "The work that I love was the solution to my recovery. Mark it as a significant and complete change in the pattern of my lifestyle and existence."[34]

Drewelowe's work changed as well, and she began painting a series of Rocky Mountain landscapes characterized by their expressionist energy and animation. *Vertical, Vaulting, Veined,* 1943 (plate 236), in addition to demonstrating Drewelowe's love of alliterative word play, shows her delight in rich colors and spatial ambiguity. As these fluid and highly patterned Western landscape paintings came to symbolize her personal physical recovery, she became deeply anxious about environmental

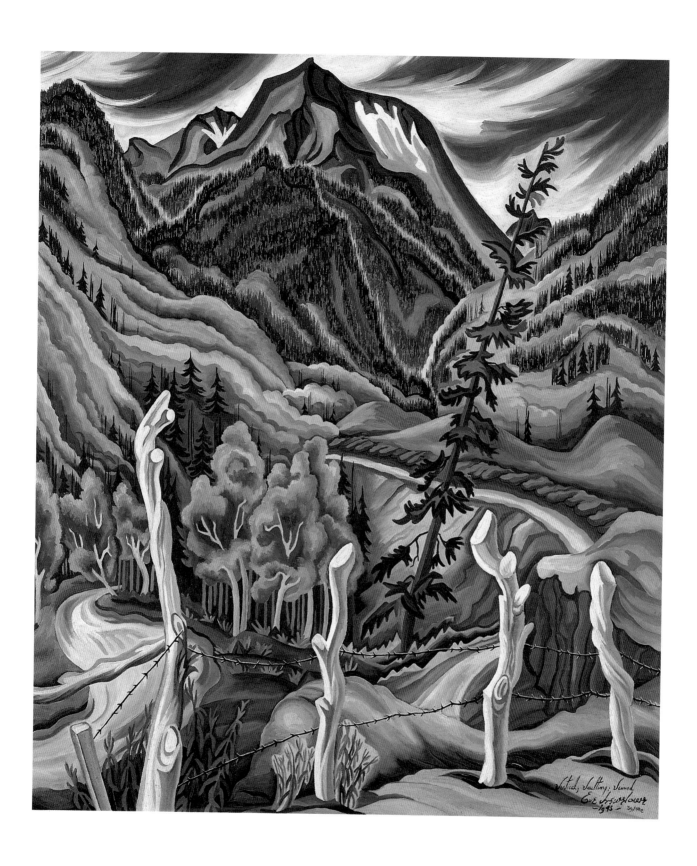

236.
Eve Drewelowe, *Vertical, Vaulting, Veined (Aspen)*, 1943

237. Ethel (seated) and Jenne Magafan in front of Ethel's 1941 mural *Horse Corral* for South Denver Post Office, 1941

from a broader, more public perspective. Both Ethel and Jenne Magafan (plate 237), twins born in 1916 (Ethel died in 1993, Jenne in 1952), received considerable government support during the New Deal. Ethel was awarded seven mural commissions for various United States post offices and other government buildings from 1937 to 1943, and Jenne was awarded five; together, they painted the mural *Mountains in Snow* for the Social Security Building in Washington, D.C., in 1941.[36] It is interesting to speculate on how the collective sense of female cultural responsibility inherent at the turn of the century was sustained in the 1930s, particularly in the narrative and easily accessible style of Regionalism that the Magafan twins adopted in their murals and paintings of the era.

The Magafans' careers took off early. After graduating from high school, they pooled their monies and went to study with Regionalist painters Frank Mechau and Boardman Robinson at the Colorado Springs Fine Arts Center (formerly the Broadmoor Art Academy).[37] Mechau soon hired them as mural assistants and encouraged them to enter the open juried competitions sponsored by the Treasury Department's Section of Fine Arts. "I was rather naive," Ethel remarked about her first try for a post office mural in Fort Scott, Kansas. "I chose to depict the Lawrence Massacre. [It was] a very bloody, tragic event in this town"[38] (plate 238). On August 21, 1863, William Quantrell's gang of some four hundred Missouri Bushrangers burned Lawrence to the ground in retaliation for the town's abolitionist activities. Ethel Magafan's sketch shows the town in flames and centers on the heroic acts of Lawrence women during the early dawn raid. Her sketchbook notes for this post office project reveal how much she was attracted to this theme: "Women were struggling with their bare hands while homes were burnt down and men were killed. Woman clinging to the bridle of a guerrilla horse while husband tries to escape, she was dragged around. Women's bravery!" Not surprisingly, while Magafan's mural proposal greatly excited the Treasury Department, it was rejected at the local level.[39]

Ethel Magafan went on to paint a contemporary agricultural scene, *Threshing,* for the Auburn, Nebraska, post office in 1938. Local citizens, or at least the ladies of Auburn's Art Class, had declared their preference for a pic-

devastation in the West and the necessity for ecological balance: "I cannot but marvel at the wondrous indefinable land of the Rockies that is Colorado, that is the West! I am dismayed, appalled at the deprivation called 'progress'. Much of the fragile terrain has been layered by acres of asphalt for the convenience of an automobile age. It is sealed against the vitalizing forces of a remedial sun and the touch of soothing rains."[35] Drewelowe spent the remainder of her career examining the transitional frontier of the Rocky Mountain West, leaving a legacy of well over a thousand paintings, drawings, sculptures, and prints.

Other regional women artists were similarly drawn to the industrial and social conditions of the modern age. If Gilded Age paintings by Bromwell and Cherry focused rather objectively on the Colorado landscape or domestic interiors, women artists working from the 1930s through the mid-1940s interpreted the era of the Great Depression and World War II

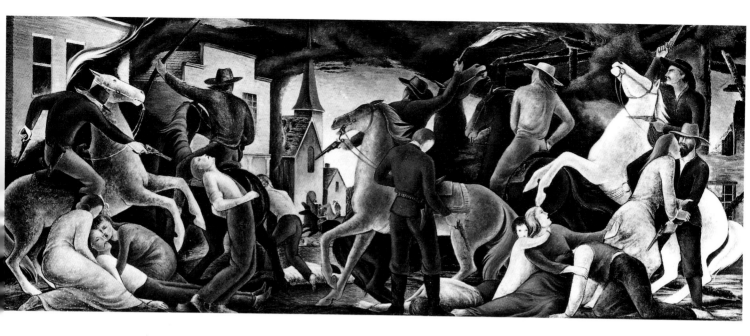

ture of "the early history of Nemaha County" but soon agreed that Magafan's mural was perfectly fine. One woman predicted that the picture "some day . . . may be as popular as the one painted by Grant Wood—*Dinner for Threshers.*" As Americans struggled with the exigencies of the Great Depression, many Western women artists and most public artists of the era aimed at providing their audiences with uplifting accounts of the nation's promise and potential. Ethel Magafan may have been naive in proposing a scene of the Lawrence Massacre in Fort Scott, but one of fertile productivity in Nebraska's fields was right on the mark in Auburn. So too was Jenne Magafan's energetic depiction of pioneer good times in *Cowboy Dance,* a post office mural painted for Anson, Texas in 1940. In the troubling times of the 1930s, art historian Karal Ann Marling writes, post office murals like those Ethel and Jenne Magafan painted came to symbolize a "collective act of faith. . . . The murals were bridges, anchored at one end in the past and vaulting over the present into the world of tomorrow."[40]

In their smaller, private paintings the Magafan twins were hardly so optimistic. Ethel's *Garden of the Gods,* 1938 (plate 239), and Jenne's *Deserted Street,* 1943 (plate 240), are more eerie than upbeat. One is a surreal landscape of small figures posed against sharp stone outcroppings, the other a disturbing portrait of her twin in an abandoned mining town; both hint at the

psychological and physical tensions of the Great Depression and World War II. Another Colorado artist concerned with the social realities of the era was Irene Fletcher (1900–1969). Fletcher captured the impact of economic uncertainty in pictures like *Laid Off,* 1938 (plate 241). Still another Coloradan, Nadine Drummond (1912–1966), frequently depicted the windswept desolation of the small-town West during the later years of the Great Depression.[41] Her *Colorado State Fair,* 1940 (plate 242), with its staked goat and foreground cesspool, gives a particularly unsettling view of an annual celebration usually portrayed with a surfeit of cotton-candy colors and happy, whooping fairgoers.

Drummond was especially attentive to the catastrophies affecting Colorado farmers in the 1930s, when prices for potatoes and wheat plummeted, plagues of grasshoppers ravaged fields, drought dried up hundreds of thousands of acres, and "black blizzards"—dust storms made from rich topsoil—forced thousands off their family farms. In 1934 Lorena Hickok, writing to Harry Hopkins, administrator of the Federal Emergency Relief Administration, reported that throughout the state, farmers did not "expect more than a five per cent crop. A Government wheat inspector reports that in one of those counties they expect to get only 300 bushels off from 2,560 acres of land!"[42] Drummond's gloomy scenes of repossession

238. Ethel Magafan, *Lawrence Massacre,* 1936

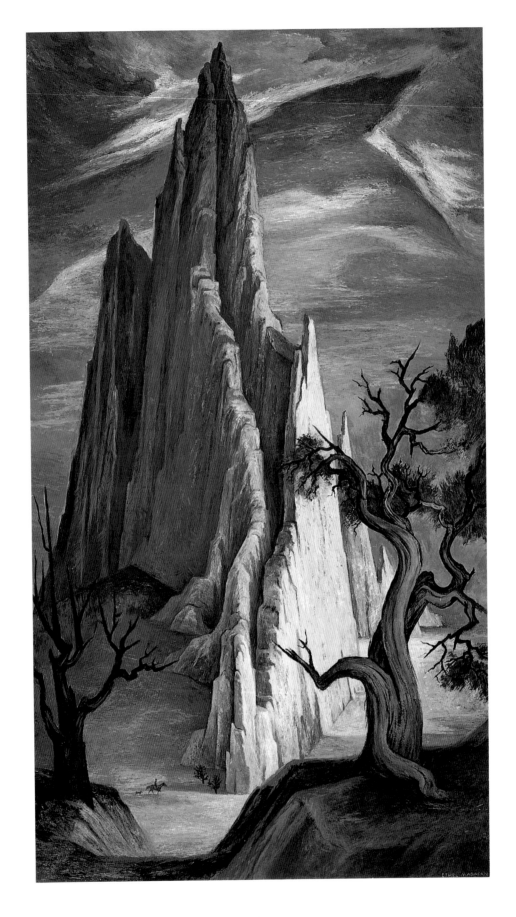

239.
Ethel Magafan, *Garden of the Gods, Colorado*, 1938

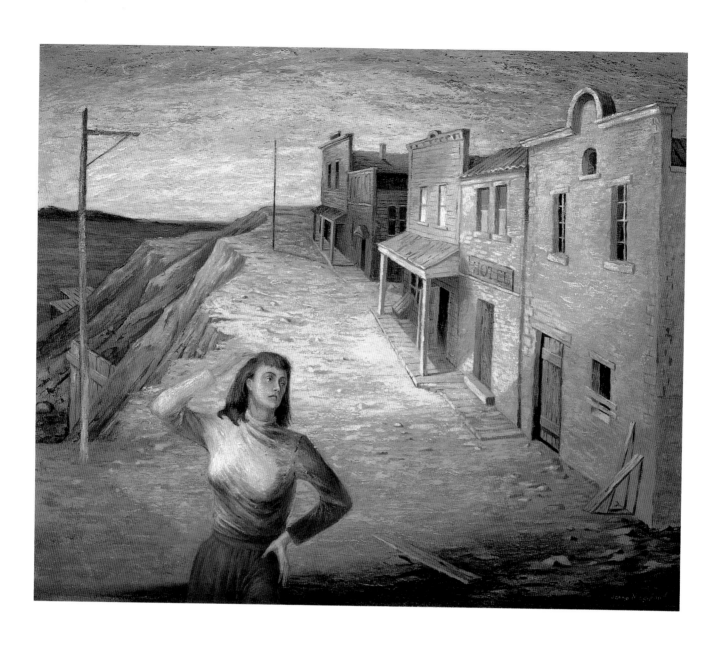

240.
Jenne Magafan, *Deserted Street,* 1943

and loss, such as *Farm Auction in Trinidad,* 1940 (plate 243), speak to the devastation of the Great Depression in Colorado and the failing economic circumstances that preceded it. Trinidad, where Drummond was born and raised in the heart of Colorado's coal fields, was crippled by an abrupt decline brought on by the end of World War I and lagging demand. Thousands of workers were left destitute by massive layoffs. One local newspaper reported that their numbers included "weary and bedraggled young girls and middle-aged and even elderly women"; another writer described the dispossessed as "tumbling off freight cars, sometimes hitchhiking, occasionally coming by car, the 'box car tourists' and 'gasoline hoboes' [who] asked for gasoline and oil and clothing and food and other things."[43] In 1928 Drummond's merchant father watched his business fail and the family was forced to leave Trinidad, personal events that certainly shaped his daughter's aesthetic empathy a decade later in gripping scenes of Great Depression dispossession.

Like the Magafan twins and Nadine Drummond, Colorado painter Louise Rönnebeck (1901–1980) (plate 244) found inspiration in the local landscape and the daily lives of regional women, from accused murderers to schoolteachers. In November 1935 seventeen-year-old Mary Elizabeth Smith shot and killed her husband in an argument over divorce proceedings. Smith and her young husband Bob ("Sonny") had met in high school, but she dropped out when she became pregnant. Baby Rodney was named, Smith said, for a "lovely boy" in one of her favorite movies, the sentimental 1932 film *Emma.* Penniless and unskilled, the newlyweds moved in with Mary Elizabeth's mother, but Sonny couldn't stand the situation, soon left, and filed for divorce. The afternoon Mary Elizabeth received the legal papers, fearing a divorce would "rob our baby of his name and protection," she walked ten blocks to Sonny's house with a .22 rifle hidden in her winter coat and took his life. The murder made the front page of the *Denver Post* and prompted one of Rönnebeck's most compelling paintings (plate 245).[44] Cast in the local press as a "girl mother" with "the wistful face of a Botticelli Madonna," Mary Elizabeth Smith pled temporary insanity to the charge and stood trial in early 1936.[45]

Rönnebeck was one of many Denverites crowding the courtroom during the four-day trial, attracted to the sensational story of a woman more child than adult, a girl who took her advice from the movies. The papers insisted on describing the murderer in artistic terms as a "pale, wistful, auburn-haired girl, who, with her big brown eyes and delicately modeled face, might have stepped from the canvas of an old master."[46] Perhaps this popularization of Rönnebeck's professional calling particularly attracted her. She had studied at the Art Students League from 1922 to 1925 with Kenneth Hayes Miller and then moved to Denver in 1926, after her husband, sculptor Arnold Rönnebeck, was appointed director of the Denver Art Museum. In the attic of their Denver home, next door to Steck Elementary School (attended by their two children, Ursula and Arnold), she painted numerous scenes of schoolchildren and family outings, such as *4-B,* 1937 (plate 246).

4-B demonstrates her fondness for group studies, showing Mrs. Daniels, Ursula's fourth-grade teacher, leading the class in a rousing winter concert. Her children were her most frequent models, and in *4-B* Ursula is seen near the blackboard, and Arnold, visiting his sister's classroom and wearing a blue sweater, is pictured in the front row. The inclusion of three African American children suggests Rönnebeck's liberal social sentiments. "There weren't more than a handful of black children in the entire school," her daughter recalls, confirming that *4-B,* with its racially mixed class singing "My Country, 'Tis of Thee" against a backdrop of United States maps, was more a picture of what her mother, like many 1930s New Dealers, wished an integrated America of the future would look like. In addition to these private paintings of family and friends, Rönnebeck painted murals for Denver's Children's Hospital, Morey Junior High School, and post offices in Worland, Wyoming, and Grand Junction, Colorado. Recently rediscovered and rehung, *Harvest* (plate 247), a 1940 mural depicting men and women harvesting peaches in southeastern Colorado, shows Rönnebeck's enthusiasm for what historian Barbara Melosh terms the "comradely ideal" of shared labor during the New Deal era.[47]

The People v. Mary Elizabeth Smith best shows Rönnebeck's storytelling sensitivity and sense of drama. Mary Elizabeth takes center stage, with prosecutor A. G. Gertz waving the

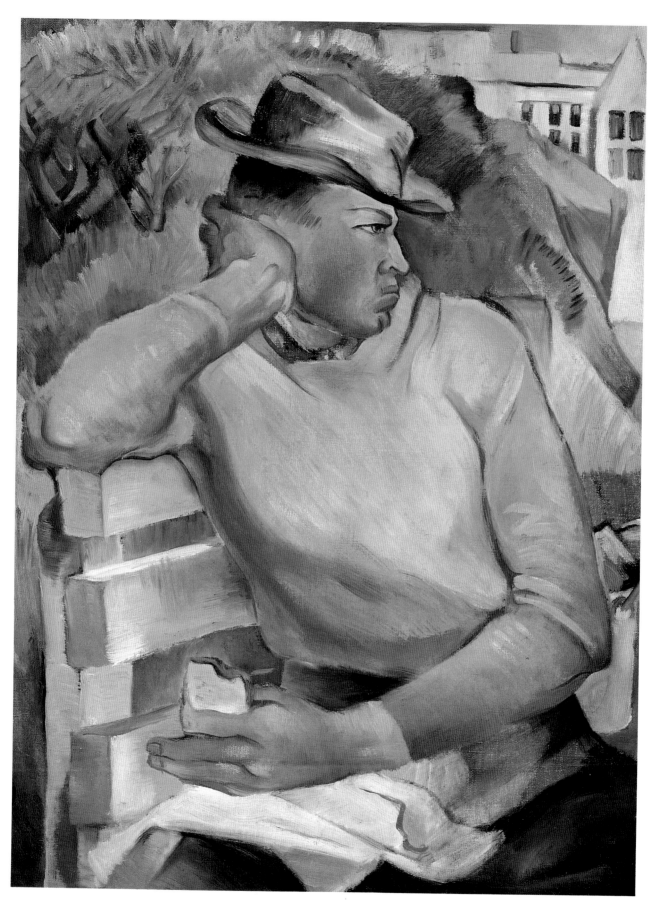

241.
Irene Fletcher, *Laid Off*, 1938

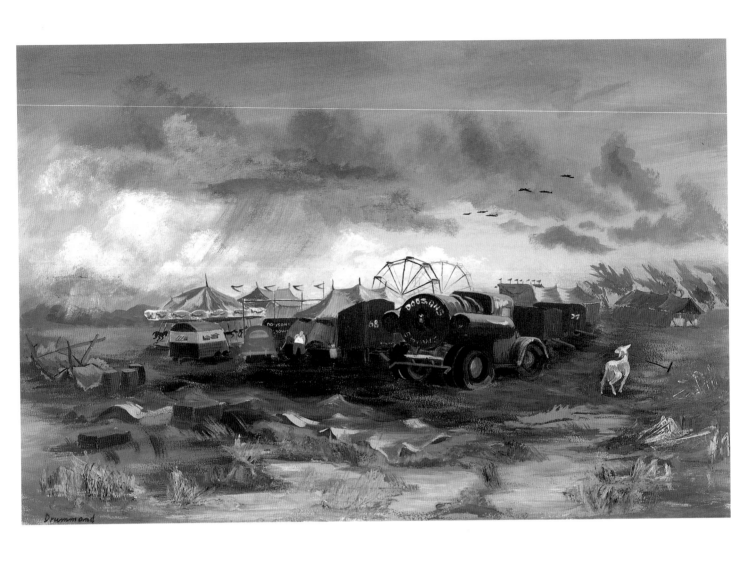

242.
Nadine Drummond, *Colorado State Fair,* 1940

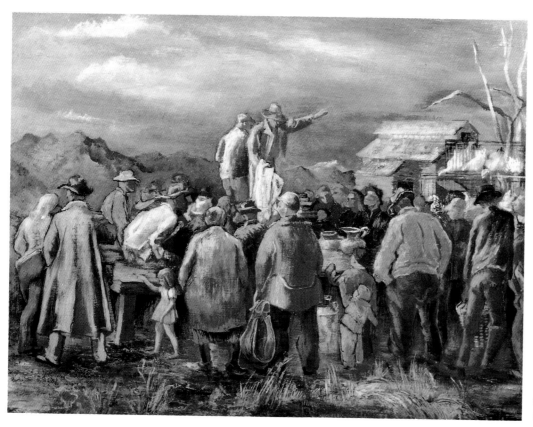

243. Nadine Drummond, *Farm Auction in Trinidad*, c. 1940

.22 in her direction and the all-male jury (ten of them were fathers, the press breathlessly intoned) pictured on the right. Rönnebeck knew most of the defense attorneys sitting at the table near the blackboard (four lawyers flocked to Smith's defense, attracted as much to her beauty as the shot at good publicity), and defense psychiatrist Leo Tapley (far left, with white curly hair) was a good friend. Rönnebeck painted herself into the picture on the left, head in hand, among a group of mostly female onlookers surveying "the fate of the young mother with a madonna face" who left the entire courtroom crying "unashamedly" after her revelations of poverty, marital abuse, and abandonment. In just a few hours the jury acquitted Mary Elizabeth Smith, who left the courtroom clutching baby Rodney and telling reporters that she just wanted to see the movie *Mutiny on the Bounty*.[48]

Although *The People v. Mary Elizabeth Smith* is a far cry from Koerner's *Madonna of the Prairie* or Gast's *American Progress*, it intimates less an effort to enlarge the canon of Western female stereotypes by including images of gun-toting "bad girls" than Rönnebeck's overall commitment to depict the social realities of the Great Depression. Minerva Teichert, by con-

trast, painting during the same decades as Rönnebeck, was openly committed to revising those codes, both pictorial and theological, that sanctioned male authority in the Rocky Mountain West. In scores of narrative paintings that convey the history of Utah's Mormon pioneers, Teichert focused on Western women, showing them tall, strong, capable, and in control, as in *Handcart Pioneers*.

Teichert's perceptions of female strength were nourished early by her formidable grandmother and namesake, Minerva Wade Hickman, who joined the Church of the Latter-day Saints in Palmyra, New York, and then followed them on foot to Nauvoo, Illinois, and the Great Salt Lake in the 1840s. She became the third wife of "Wild Bill" Hickman, a bodyguard to Brigham Young, but divorced him because she "hated polygamy" and wound up singlehandedly supporting her family as a midwife and subsistence farmer on a homestead near American Falls, Idaho.[49] Teichert's remarkable mother, Ella Hickman Kohlhepp, was another strong influence in her life. Minerva's father suffered from tuberculosis and her mother supported their nine children by selling handmade lace, and fruits and vegetables raised on the family farm. In her limited free time she also managed to

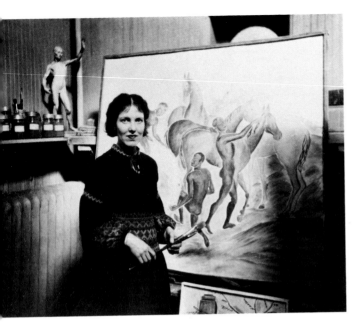

educate her children, publish several popular songs, and write suffrage pamphlets.

Born in 1888, Minerva Teichert was raised by strong and independent women who encouraged her to pursue her talents and break free of her family's grinding poverty. As a child she sketched everything she saw on the Idaho homestead; in high school she "drew Gibson girl heads on silk for pillows or wall hangings" and got a job painting china to pay for her education; during her late teens, she taught in one-room schoolhouses in rural Idaho.[50] Most of her income went to her family, but from 1909 through 1916 she was able to save enough to study painting, first at the Art Institute of Chicago and later at the Art Students League. In New York she supported herself by performing as a trick rider and Indian dancer in a Wild West troupe (plate 248). Returning to Idaho in 1916, she married Herman Adolph Teichert, ran their cattle ranch in Cokeville, Wyoming, wrote *Drowned Memories,* a collection of short stories about Idaho's Snake River, and published the novel *A Romance of Fort Hall* in 1932.[51] And always, Teichert painted portraits and landscapes that reflected her life and experiences as a Western woman. She recounted her grandmother's dramatic tales of the native peoples encountered on the great Mormon trek in paintings such as *Night Raid,* about 1935 (plate 249). She captured the endurance of her Mormon forebears, particularly the women who were her own role models, in pictures such as *Covered Wagon Pioneers, Madonna at Dawn,* and *Handcart Pioneers.* The heroic female figure in *Handcart Pioneers* wears a dress patterned with a bird-of-paradise motif that Teichert copied from a fragment of cloth owned by her grandmother.[52] Celebrating her confidence and command, Teichert testified to the almost superhuman strength and endurance of thousands of Western women.

Teichert did much the same in her plentiful illustrations of scenes from the Bible and *The Book of Mormon,* gravitating "to scripture verses that mentioned women" in paintings such as *Queen Esther,* 1939. *Joseph Smith Receives the Plates,* 1947 (plate 250), is a remarkable interpretation of Prophet Smith's receipt of the golden tablets (the basis of Mormonism) from the angel Moroni, a heavenly being who in this picture looks remarkably like Teichert herself.[53] Teichert was a devout Mormon who taught *Book of Mormon* lessons and genealogy classes throughout her long life, a woman for whom nothing was greater than the life of service to the Church of Latter-day Saints. Her religion was her guide, she explained in 1937: "As the children grow more responsible and I find more freedom I do not care for bridge or teas or clubs but the story of the building of a mountain empire and the struggles of my people drive me on and unless I can paint a little each day on the great pageant of the West I think the

ERIKA DOSS

245.
Louise Emerson Rönnebeck, *The People v. Mary Elizabeth Smith*, 1936

246.
Louise Emerson Rönnebeck, *4-B*, 1937

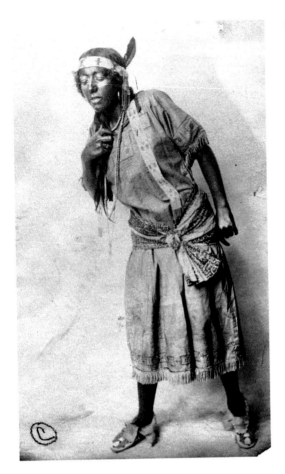

248. Minerva Teichert costumed as an Indian dancer for a Wild West troupe, New York, 1916

250. Minerva Teichert, *Joseph Smith Receives the Plates,* 1947

day is lost. It seems like a call to me that I sin if I while my time away and do not answer."⁵⁴ Yet, as her pictures reveal, Teichert's artistic efforts were especially directed toward reimagining that resoundingly patriarchal religion and challenging the overtly masculine cast of the frontier myth painted by Bierstadt and other Western artists. Consistently, the "great Mormon story" that Teichert told was that of the strength and perseverance of Mormon women, the pioneers and homesteaders who also built Utah's "mountain empire."

Few Western women artists painting in the Rocky Mountain region from 1890 to 1945 chose subjects or styles that perpetuated the nostalgic frontier image of the Wild West that still pervades our historical consciousness. Even artists who, like Minerva Teichert, chose to look backward and paint the heroic westward treks of pioneers, or to portray the native peoples who once inhabited the region, did so in order to revamp a mythic picture of the Old West that favored the action-packed exploits of mountain men and cowboys. Eschewing images of progress and the sublime, women artists of the West imagined their lives and the Western landscapes on their own terms. The diversity of their paintings reveals the diversity of Western life and experience, and it calls into question the veracity of our picture of an overwhelmingly masculine American West and its mythic stronghold.

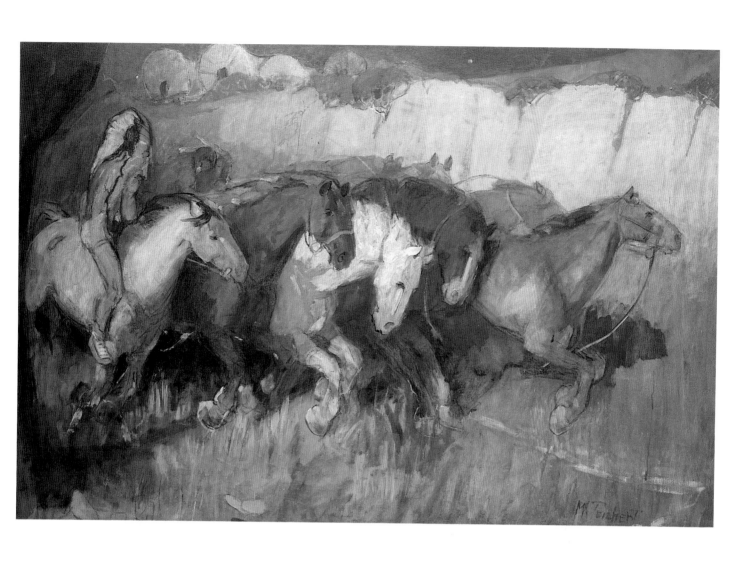

249.
Minerva Teichert, *Night Raid*, c. 1935

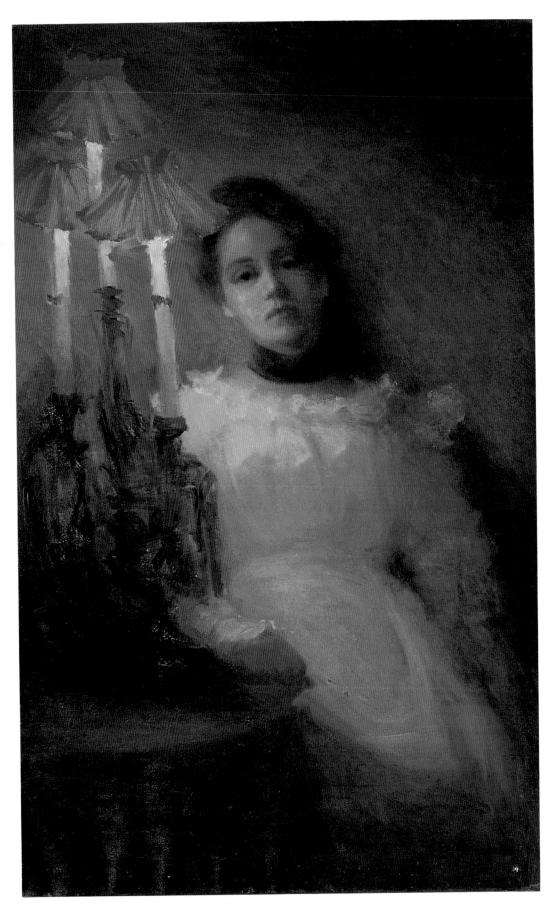

273.
Cora Parker, *Candlelight*, 1899

IX
Cultivating the Grasslands
WOMEN PAINTERS IN THE GREAT PLAINS

Joni L. Kinsey

ULTIVATING THE GREAT PLAINS was a goal of many settlers of the vast grassland region of the central United States in the second half of the nineteenth century.[1] Not only a matter of plowing, planting, and harvesting, cultivation also meant establishing a society with all of its attendant cultural and social activities and institutions.[2] Only a few urban areas, such as Omaha and Kansas City, with advantageous locations on navigable rivers and railroad lines, achieved sizable populations and early economic prosperity. Elsewhere in the region, relatively late settlement, persistently low population densities, and great distances markedly delayed the development of cultural institutions, especially in the fine arts.[3]

Even as late as 1890 the territory encompassed by the present states of North and South Dakota, Nebraska, Kansas, and Oklahoma was hardly "settled up." Only Nebraska and Kansas had been states for more than a year and Oklahoma did not achieve statehood for seventeen more.[4] Yet, despite the absence of developed urban centers and the remoteness of the East Coast art world, a surprising number of artists, many of them women, achieved local, national, and international prominence from 1890 to 1945. Although their work is little known or appreciated today, these women painters cultivated a rich social and visual environment that ranks with that of older, more established regions. At the same time, the culture of this region has a special character of its own.

Exceptionally little has been published on the contribution of women to the visual arts in the central United States beyond cursory biographies and modest regional studies, and most existing information lies in the scant files of widely dispersed local museums and libraries.[5]

Even the best-funded attempt to gather information about paintings produced in the region requires exhaustive travel over thousands of miles and diligent examination of poorly documented collections.[6]

Although the women who painted and taught art in the Dakotas, Nebraska, Kansas, and Oklahoma after 1890 were not among the earliest pioneers in the Great Plains, they were part of a frontier of a different sort—one that challenged traditional boundaries of profession, gender, and forms of visual representation. Perhaps because the culture of the region was in its infancy, these artist-pioneers were at the forefront of a developing professionalism that gender bias often denied to women elsewhere. A surprising number of them were college and art academy graduates who, early in the histories of their states, held prominent positions on university faculties, as art program directors, and as successful participants in significant juried exhibitions. During their tenures and beyond, these eminent and accomplished

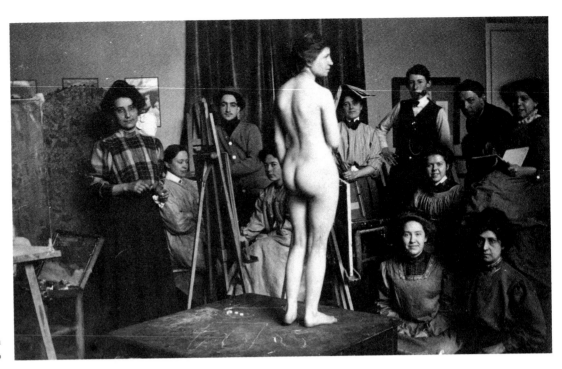

251. Nellie Shepherd (far left) with art class in Paris, c. 1910

women influenced entire generations of students (including a sizable number of other women who went on to pursue art careers). They also fostered the building of museums and art schools, encouraged public interest in the visual arts, and produced an impressive body of work that stands with that of the best of their male colleagues across the country.

Kathleen McCarthy explains in *Women's Culture: American Philanthropy and Art, 1830–1930* that although women typically were the principal founders of cultural institutions throughout the United States, as soon as schools, museums, and societies became financially viable and "professionalized," their management was taken over by men.[7] This was true in the Great Plains as well, but perhaps because institutions were slower to mature there, women had a longer and consequently greater impact on the development of the fine arts. Lack of male competition may have been another reason why women commanded positions as artists and cultural entrepreneurs in the early years, perhaps because of a gender bias *against* artistic culture that would have relegated it largely to females. At the University of Nebraska in Lincoln, for example, women made up the majority of the art faculty for the first thirty years, a statistic that was neither the regional norm nor the exception.[8]

Many of the region's women artists succeeded because of the quality of their art edu-

cation.[9] Many of them studied at prestigious academies, most often the School of the Art Institute of Chicago, the closest art school of national stature. Others attended the Pennsylvania Academy of the Fine Arts, the Art Students League in New York, and regional schools such as the Kansas City Art Institute or state universities.[10] Often their teachers were among the most notable artists of the time, including William Merritt Chase, Frank Duveneck, Edmund Tarbell, Frank Benson, Cecilia Beaux, Julien Alden Weir, and Kenyon Cox. Several studied abroad, in Vienna and in Paris at the Académie Julian, which opened its classes to women in 1873—charging them more than it did men for the same courses.[11] Armed with such experience the women were well prepared to produce paintings of sophistication, and as teachers and administrators they were equipped to pass their knowledge to their students and their communities.

Even a brief survey of women's art in the Great Plains from 1890 to 1945 reveals an astonishing array of painting styles and circumstances. Much of this work does not conform to traditional preconceptions of the "feminine" arts. Among the paintings are figure studies (including nudes; see plate 251), portraits, still lifes, landscapes, and allegorical histories, executed in academic, Impressionist, Regionalist, and modernist styles. Although these images sometimes portray women at work or leisure and include

252.
Mary Bartlett Pillsbury Weston, *The Spirit of Kansas*, 1892

such traditional "female" themes as flower arrangements or garden scenes, no overwhelming gender orientation dominates. Traditional "male" imagery such as hunting and boxing is also explored. In several instances, the work was a valued means of self-representation that could transcend boundaries of race, class, or circumstance and stand for universal ideals.

Little is known about many of the plains women beyond the work they left, but even this offers insight into the painters' aspirations to evoke something of themselves and their locale. The monumental *The Spirit of Kansas, 1892* (plate 252), was painted by Mary Bartlett Pillsbury Weston (1815–1895?) of Lawrence, Kansas. One of the earliest works in this book, and the artist's last effort (she was then seventy-two), it was exhibited in the Kansas Building at the World's Columbian Exposition in 1893. Yet neither the picture nor the artist has received much attention outside Kansas, despite the work's obvious nationalistic references and Weston's professional credentials as a New York portraitist in the 1840s.[12] Weston's allegory, in keeping with its world's fair context, symbolizes the progress of Kansas from the turmoil of the Civil War to its bright future within the Union. Riding a white horse and holding a white dove of peace overhead, a young woman bedecked in stars and stripes is crowned with rays of light. Over a rolling Kansas landscape just emerging from a smoky cloud cover into clear light, the horse bounds in galloping strides above a coiled serpent, for Weston a symbol of tyranny overcome.[13] This allegorical image, composed from her imagination and youthful memories of horses on the New York stage, has both a naive charm and a high-minded purpose, conveying Kansas's lofty aspirations and noble ideals to the fair's visitors.

Much more is known of other artists and their lives. Some, such as Narcissa Chisholm Owen (1831–1911), published memoirs of their experiences. Others, like Nan Sheets (1889–1976), were prominent art critics and museum directors who provided a rich body of published material documenting their interests and activities.[14] During the first half of the twentieth century, women artists, like women in other professions, were diverse in personality and circumstance. Some were extremely talented but had little formal training; others were better trained but less accomplished and found important careers by influencing the development of the fine arts in their communities; still others had the advantage of excellent educations, prodigious talents, and the opportunities to apply themselves to their art. Some managed to paint prolifically amid the competing responsibilities of marriage and children; some never married, dedicating themselves wholly to their work and their students. Some lived conservatively and others were eccentrics, delighting in the freedom that a career in art offered at a time when most women were neither encouraged to pursue professionalism nor to develop independent identities. In this lack of conformity to a single model, however, women artists of the region were representative of their time and place. From 1890 to 1945 the Great Plains was transformed from a largely undeveloped region that had earlier been written off as "the Great American Desert" to one of the most sought-after and productive areas of the world.[15] In those short fifty-five years the five states saw both an agricultural boom and a dustbowl, the discovery of one of the richest oil fields in the world, and one of the worst economic depressions in history. Moreover, the plains themselves are hardly the monotonous terrain they have sometimes been considered. The rich, if subtle, complexity of the subterranean ecosystems, the multitude of plant species, the ever-changing sky, and the dramatic history of the region can be seen as a metaphor for the women who lived there; the ability of the place to defy monolithic characterization fostered similarly independent spirits in the artists who sought their visions within its horizons.[16]

While young women in the region were sometimes inhibited by conservative social norms and expectations as they pursued their artistic educations or careers, even within these limitations many managed to develop their talents to a surprising degree. Sometimes a deeply conflicted life and career resulted. Nebraskan Alice Cleaver (1878–1944) (plate 253) and Oklahoman Nellie Shepherd (1877–1920) (plate 251)[17] traveled and studied widely, exhibiting in Paris and living what might be called bohemian lives in their early years; ultimately, both restricted their promising careers and returned home because of familial pressure.[18] Daughter of an insurance salesman and former homesteader in Falls City, Cleaver studied art at the University

of Nebraska with Cora Parker, at the Art Institute of Chicago with John Vanderpoel from 1900 to 1903, and then at the Pennsylvania Academy of the Fine Arts with William Merritt Chase and Cecilia Beaux. Between 1905 and 1908, while still a student in Philadelphia, she traveled to New Mexico and Arizona to paint the Pueblo people, exchanging her paintings with the Atchison, Topeka & Santa Fe Railway for rail fare and adventure. During 1913–14 she lived in Paris and exhibited her work under the direction of Lucien Simon and Louis-François Biloul. Shepherd also studied in Paris, after a stint at the Art Institute of Cincinnati. She exhibited at the Paris Salon of 1910, and like Cleaver spent time in the Southwest, painting portraits of the Pima before returning home to teach at the University of Oklahoma.[19] One of her most engaging pictures is the later portrait *Girl with a Palette,* about 1915 (plate 254).[20]

Neither Cleaver nor Shepherd married, but despite their early freedom, their later lives were restricted by family obligations. Each lived with her parents and sisters (none of whom married) after returning to her home state, and in different ways each career ended tragically. Shepherd died suddenly in her prime, leaving an unfinished portrait, *Te Ata,* 1920, of one of the most prominent Native American women of her time. Cleaver was disappointed both romantically and professionally, constrained by overly protective parents.[21] In Chicago she had met and for some years apparently maintained an intimate relationship with the poet and erstwhile art student Vachel Lindsay (1879–1931), the itinerant distributor of rhymes and preacher of the "Gospel of Beauty" throughout the Midwest and Southwest. Each made an appearance in the other's art: Cleaver portrayed Lindsay in her 1904 painting *The Cast Room,* which won a medal in the Women's Exhibition at the Louisiana Purchase Exposition of that year; and she became the inspiration for Lindsay's heroine in his story "The Lady Poverty."[22] Attempting to visit Cleaver in Falls City in 1912, Lindsay was intercepted by her disapproving father; although the couple apparently continued their friendship throughout her year in Paris, they lost contact after her return to Falls City in 1914. After the last family member died in the 1970s, a bundle of unopened correspondence from Lindsay was found in the attic of the house;

253. Alice Cleaver

Cleaver's parents had never informed her of the letters' arrival.[23]

While the elder Cleavers apparently did not completely prevent Alice from pursuing her art, they probably curtailed her career by intervening in her relationship with Lindsay. Although she continued to paint a little and to teach music and art locally, she remained close to home throughout the rest of her life. Like so many of the region's women artists, however, she remained true to Lindsay's "Gospel of Beauty," adhering to what he called "The New Localism": "They should, if led by the spirit, wander over the whole nation in search of the secret of democratic beauty with their hearts at the same time filled to overflowing with the righteousness of God. Then they should come back to their own hearth and neighborhood and gather a little circle of their own sort of workers about them and strive to make the neighborhood and home more beautiful and democratic and holy with their special art."[24] Whether they wandered in fact or simply in spirit, women artists of the Great Plains excelled

254.
Alice Cleaver, *Girl with a Palette*, c. 1915

at precisely these things. They brought to their communities and their histories a rich and unique sense of place, time, and identity.

A sense of place on the plains is perhaps best experienced through the landscape, and women artists of the region found a great variety of inspiring scenes in their surroundings.[25] Hardly a featureless expanse, the vast terrain encompassed by the states of North and South Dakota, Nebraska, Kansas, and Oklahoma ranges from hilly woodland in the eastern regions to rolling grassland punctuated by small ponds or "potholes," wide rivers, and picturesque creeks in the midlands, to rocky badlands and even mountains such as the Black Hills in the west. Although the earliest landscapes in this book date to the teens, at least two women, Sallie Cover and Imogene See, worked in this genre in Nebraska as early as the 1880s.[26] A Corn Field, about 1920 (plate 255), by Marion Canfield Smith (1873–1970), very successfully evokes the agricultural character of the region, with its vivid harvest scene of corn shocks and brilliant orange pumpkins. Such vistas would have been familiar to Smith, who studied art in the corn-growing states of Nebraska, Minnesota, and Illinois as well as at the Pennsylvania Academy before returning home to found the art department at Kearney State College in central Nebraska (today the University of Nebraska at Kearney).[27]

Like Smith in their espousal of Impressionist style were Nebraskans Elizabeth Holsman (1873–1956) and Elizabeth Dolan (1871–1948), both trained at the University of Nebraska and the Art Institute of Chicago. Their striking scenes demonstrate the variety of the plains landscape, urban and rural, and they showcase the painters' virtuosic, nuanced displays of tone, light, and color. Holsman's Still Waters, 1914 (Joslyn Museum, Omaha), a depiction of a prairie wetland, won a silver medal at the Northwestern Artists exhibition in Saint Paul in 1916. She returned to the subject in A Drowsy Day, 1915 (plate 256), an equally refreshing and in some ways even more impressive work with its striking vertical composition and shady coolness. A sculptor as well as a painter, Holsman also taught at the University of Nebraska in 1893, although her productivity as an artist was certainly curtailed by her marriage and three children.[28]

Elizabeth Dolan left her imprint on Lincoln, Nebraska more notably than perhaps any other artist, through her large-scale murals that are scattered throughout the city. By the time she began painting murals in 1927, at the age of fifty-six, she had already attended not only the University of Nebraska, Lincoln, and the Art Institute of Chicago, but also the Art Students League in New York (where she moonlighted as a portraitist and as a stained-glass window designer for Louis Comfort Tiffany) and the American School of Art in Fontainebleau, France, where she specialized in fresco painting.[29] Dolan's early ambition was to be "a famous painter," and in Lincoln she gained notoriety for self-promotion and single-minded pursuit of her work, as well as for the sizable projects she tackled.[30] Her monumental works, which are mostly figurative and tend toward the illustrative, differ markedly from her earlier, more Impressionist Hall Garden, Eleven A.M., 1913 (plate 257), which depicts the Lincoln property of one of her most important patrons.[31] Even in the later projects, however, Dolan maintained a sense of both her regional identity and her gender. The Spirit of the Prairie, 1930, which still looms over the law library in the Nebraska State Capitol, portrays a young mother, two children, and a dog looking out from a small rise over the waving grassland surmounted by puffy white clouds. Originally it was to have been called "The Pioneer Mother," but its title was changed, presumably to better represent the whole of Nebraska and its population.[32]

In the northern plains two other artists, Zoe Beiler (1884–1969) and Grace French (1858–1942), painted landscapes inconsistent with preconceptions of empty grasslands. Beiler, who had supervised art programs in Michigan and Ohio before chairing the art department at Dickinson State College for twenty-two years (1931–53), captured the drama of the western Dakotas in Badlands, 1944 (plate 258).[33] The eroded hills and outcroppings of this region interrupt the continuity of the plains, accentuating to some minds an already overwhelming desolation, but Beiler's interpretation renders these features beautiful in their subtle color and delicate texture. By contrast, Grace French, who had equal access to badland landscapes, chose more pastoral scenes like the one in Wooded Hillside, about 1915 (plate 259), which resembles an Eastern forest with its thick tangle of foliage.

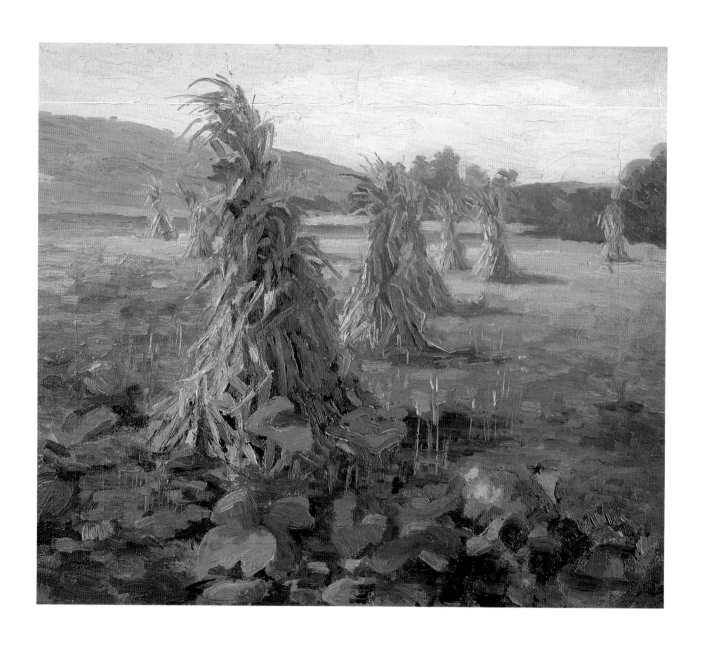

255.
Marion Canfield Smith, *A Corn Field*, c. 1920

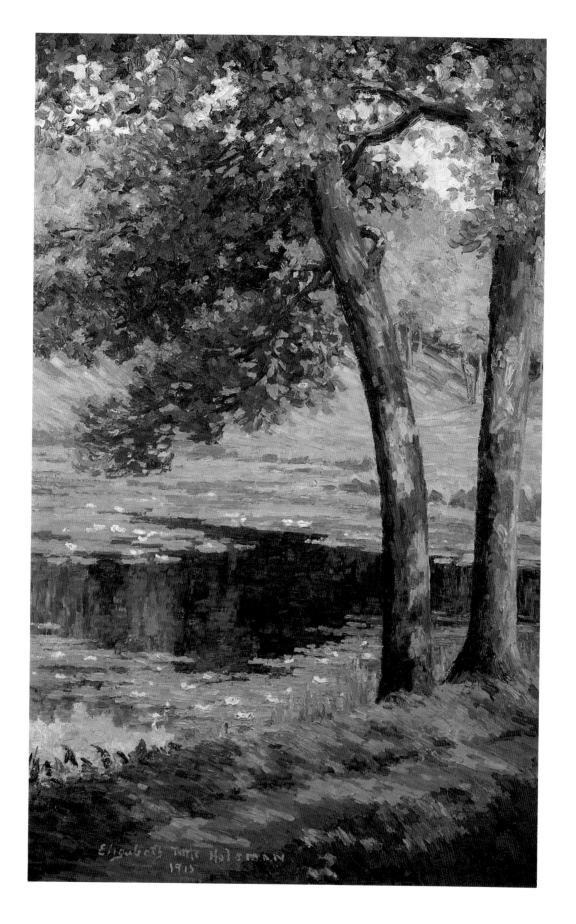

256.
Elizabeth Tuttle Holsman, *A Drowsy Day*, 1915

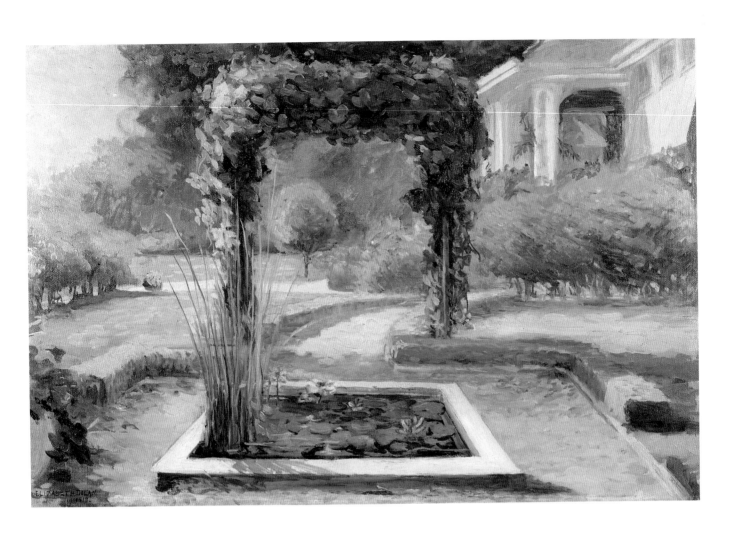

257.
Elizabeth Honor Dolan, *The Hall Garden, Eleven A.M.*, 1913

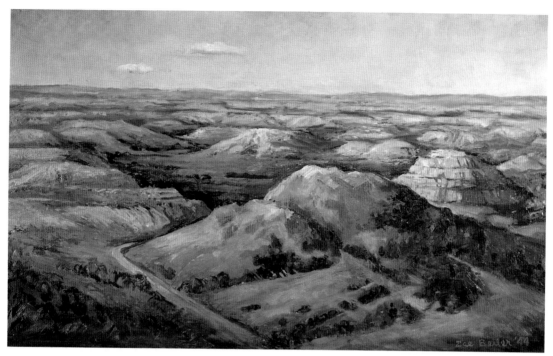

258. Zoe Beiler,
Badlands, 1944

French and her sister, Abbie A. French, also a painter, frequently sketched together in and around Rapid City, South Dakota, at the edge of the Black Hills, where their family had homesteaded in the 1880s. Their financial security came from the land—their father had invested in the Homestake gold mine—although Grace taught briefly at Black Hills College (1888–93).[34] The sisters, neither of whom married, lived together, taught painting locally, and prepared a number of students for regional and national art schools.[35]

Although most of the images in this book were selected to reflect the work of women artists within their home states, many of the Great Plains painters traveled widely, and their work often reflects an interest in subjects beyond their native region. Alice Righter Edmiston (1874–1964) in *Provincetown Church*, about 1927 (plate 260), offers a Cubist-inspired perspective of the Rhode Island cityscape, markedly different from anything in Lincoln, Nebraska.[36] Other artists in the region, such as Nan Sheets, Ina Annette, both of Oklahoma, or Topekan Helen Hodge, traveled regularly to the Southwest and the Rocky Mountains, painting landscapes quite different from those produced in their own locales. Another traveler attracted by less conventional subjects is Gladys Lux (b. 1899), a longtime professor at Nebraska Wesleyan University, whose *Inflation*, 1934 (plate 261), combines landscape with contemporary history. The work depicts

one of the first nocturnal launches of a stratospheric balloon, which Lux witnessed in South Dakota in summer 1934 when she was teaching at Spearfish (now Black Hills State College).[37] Although little of her later work was concerned with scientific innovations, Lux still regards this painting as one of her most significant pictures, and it is remarkable not only for its historic significance but also for its almost voyeuristic glimpse into a private world created and dominated by males.[38]

Another artist who entered realms that were usually the province of men was the Kansas City, Missouri, painter Ruth Bohan (1891–1981). Bohan traveled internationally with her physician husband and depicted many exotic scenes. One of the more striking is her interpretation of the 1926 Gene Tunney–Jack Dempsey boxing match, which she had attended at the Philadelphia Stadium (plate 262).[39] This sport was a frequent subject for male artists of her generation (especially George Bellows, whose works Bohan collected and copied), but for her boxing was less a confrontation of two forces than a spectator sport, a spectacle notable for its contrasting spatial relationships and garish, circuslike atmosphere. Bohan's depiction of the fight, with its distant vantage, provides a new dimension to a masculine domain. In other works Bohan was more traditional, as in her delightful portrait of the privileged child in *Billie Bellport*, 1927 (plate

259.
Grace French, *Wooded Hillside*, c. 1915

260.
Alice Edmiston, *Provincetown Church*, c. 1927

261.
Gladys Marie Lux, *Inflation*, 1934

262.
Ruth Harris Bohan, *The 1926 Tunney-Dempsey Fight in Philadelphia, 1926–27*

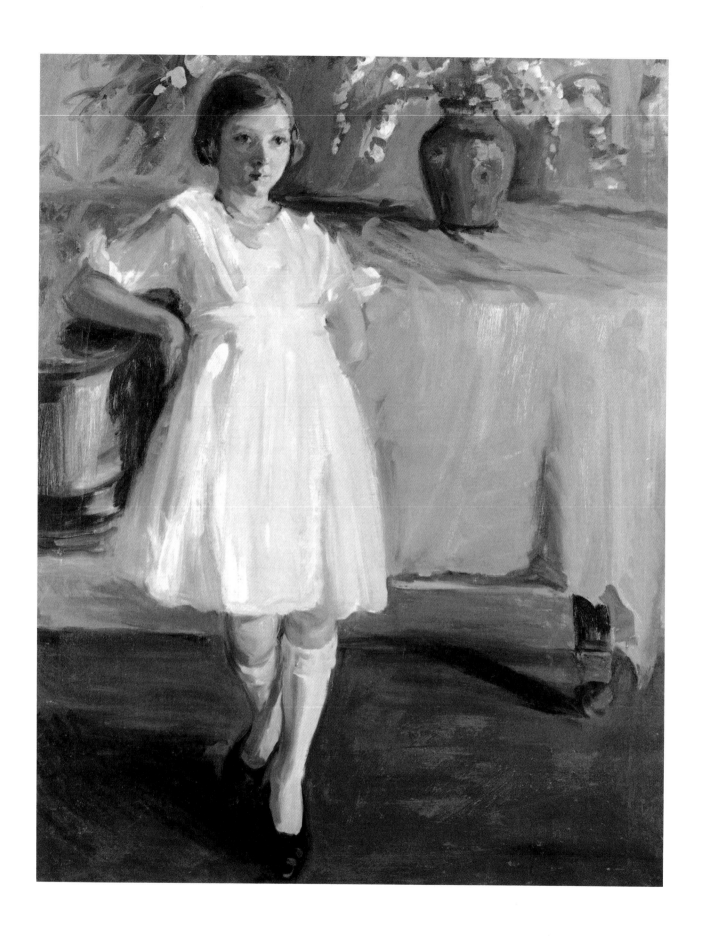

263.
Ruth Harris Bohan, *Billie Bellport*, 1927

263). Regardless of subject, however, she was clearly a perceptive and expressive portrayer of the world around her. At the Kansas City Art Institute she had studied with Randall Davey, a student of Robert Henri, and her interest in portraiture and subjects such as Asian Americans and circus performers, as well as her virtuoso handling of paint, are consistent with the dictates of the Ashcan School painters whom she admired throughout her career.[40]

Another painter who explored subjects usually treated by male artists was Myra Miller (1882–1961), a South Dakota homesteader's wife (plate 264). Unlike Bohan, whose life was filled with travel and opportunity, Miller came from a Minnesota farm family and completed only eight years of schooling. Marrying in 1907, she lived the rest of her life near Sisseton, South Dakota, on a thousand-acre farm where she spent most of her time tending the sheep and hogs, working in her garden, canning, and raising children (see plate 265). Like Abby, the Nebraska farm wife in Bess Streeter Aldrich's novel *A Lantern in Her Hand* (1928), Miller also sought other kinds of cultivation. She took art lessons from Laura and Anna Rogers in nearby Milbank, South Dakota, and found her subjects in familiar things, most notably the game birds that abounded in the midwestern flyways. Some of these birds were probably Sunday dinner fare brought home from hunting excursions by her husband Charles, but as her interest in them increased she sought out more exotic species. For one of her works, *Spoonbills* (undated), she wanted to paint the drake in the cobalt plumage of the mating season rather than in the drab he molted to in the fall when hunting was legal. Appealing to the State Fish and Game Commission, she was provided with a spring specimen.[41]

To preserve her subjects Miller stored them in a local freezer locker. She worked primarily during the winter months in an unheated room, presumably roasting the birds after the visual feast. More than just quaint anecdotes, such details reveal Miller's intimate relationship and her faithful commitment to her subjects. In the end, Miller's case offers an insight that may add substantially to our understanding of the trompe l'oeil genre, a meticulously illusionistic style of painting. Practiced from ancient times, trompe l'oeil experienced a revival in the 1880s and 1890s with the work of artists such as William

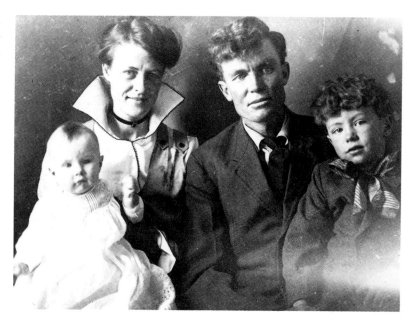

264. Charles and Myra Miller with two of their children

Harnett, John Peto, and John Haberle. Until recently, critical discussions of their paintings focused almost solely on technique, regarding the pictures as virtually devoid of conceptual intent. As the painter Marsden Hartley observed in 1939, "Harnett invested all his paintings with the reality of things, having nothing to do with interpretations. . . . Because there is no interpretation in Harnett, there is nothing to bother about, nothing to confuse . . . there are in the common sense no mind-workings—there is [instead] the myopic persistence to render every single thing, singly."[42] More recently, scholars have challenged this simplistic, formalist reading of these mysterious still lifes. The 1992 retrospective of Harnett's work, for example, prompted a new range of interpretations, from historical comparisons with seventeenth- and eighteenth-century Dutch and French vanitas pictures and sociocultural discussions of Harnett's middle- and upper-class patronage, to post-structural interpretations on the relationship of viewer and image, to speculations about the almost wholly male-oriented subject matter of so many of these works.[43]

Miller's pictures may well have been inspired by reproductions of Harnett's works or those of other male artists working in a similar vein, featured on feed-store calendars and in art magazines, for hers contain precisely the same sort of imagery. But a contemporary photograph of Miller standing next to one of her subjects demonstrates that she set up her own still lifes of real birds and guns on weathered wooden panels rather than copying from pho-

265. Myra Miller's farm at Buffalo Lake west of Sisseton, South Dakota

266. Myra Miller with still life for *Hunter's Pride*, c. 1912

tographs (plate 266).[44] Nor were Miller's pictures, unlike Harnett's, painted for a business clientele, and they never would have graced the masculine interiors of bars, smoking lounges, or private studies. Instead, they were the private delight of a solitary artist of the Great Plains who saw the fowl she rendered so painstakingly as beautiful to behold, characteristic of her world, and perhaps bounty for her table (see plate 267). Remarkably large, each of her pictures is approximately four by two feet; they are almost confrontational in their proportional analogy to the original subjects. Their authentic sincerity is impossible to misinterpret, nor can they be dismissed as mere pastiches of more famous works. More important, to regard such paintings simply as "masculine" denies both the universality of the subject matter and the versatility of the woman who painted them.

Still life, of course, was not a novel subject for women artists. In the strict hierarchy of art academies, it is one of the few genres deemed appropriate for the fair sex. But feminine still lifes more conventionally emanated from the traditional domestic sphere, featuring flower arrangements or familiar items of the table. Here, however, is the key to the significance of Myra Miller and other women artists of the region, such as Martanie Snowden of Omaha, who painted trompe l'oeil trophy pictures (plate 268).[45] Seeing these images through the eyes of the hardworking women on whose

domestic tables these subjects regularly appeared, they become neither simply *memento mori* nor the macho reminiscence of primal foraging in an increasingly industrial world, but rather the essential, if ordinary, stuff of life that one pauses to contemplate before humbly consuming, almost as if saying grace before a meal.

Such remarkable still lifes need not detract from more conventional work such as *Eggs,* 1892 (plate 269), by Clarisse Laurent (1857–1940), which conforms to the standard domestic focus of feminine art but is exemplary in its highly developed academic technique. Laurent's French training is evident in the exquisitely rendered details of the simple setting of eggs, shells, and plain pewter teapot. In the late 1880s she studied with Parisian academicians Gustave-Rodolphe Boulanger (1824–1888) and Jules-Joseph Lefebvre (1834–1911) at the Académie Julian.[46] Laurent's family had emigrated from France after her father was exiled for his participation in the uprising of 1848; they moved inland from New York to Topeka shortly after her birth. Despite this relatively remote location, the Laurent children were given every educational opportunity. Clarisse attended Bethany College and studied piano and violin at the Cincinnati Conservatory; after her time in Paris she spent several years in Oakland, California, before returning home, where she continued to paint and participated in founding the Topeka Art Guild in 1916.[47] Among the

267.
Myra Miller, *Hunter's Pride, c.* 1912

268. Studio of Martanie (Janie) Snowden, Omaha, c. 1890s

four paintings she exhibited in 1904 at the Louisiana Purchase Exposition in Saint Louis was one of raw eggs. (Whether or not that is the picture illustrated in this essay is unknown.)

Although the work of Nan Sheets (1889–1976) ranged widely, from landscapes like *Among the Hills* (undated; plate 270) to other subjects, her *Still-Life* (undated; plate 271) makes an interesting contrast to Laurent's nineteenth-century academic style. With its heightened chromatic range and abstract background reminiscent of the choreography of Isadora Duncan, Sheets's image conveys this traditional feminine subject with a new panache. Sheets was an unusual woman. Graduating from Valparaiso University in Indiana with a degree in pharmacy, she worked for a time in that profession in Salt Lake City. After her marriage, she and her physician husband moved to the new state of Oklahoma, where she became interested in painting. With Oscar Jacobsen, the influential professor of art at the University of Oklahoma, she virtually created the fine arts community in central Oklahoma. Although Sheets had little formal art training, she studied for several summers in the early 1920s at the Broadmoor Art Academy in Colorado Springs (now the Colorado Springs Fine Arts Center) and painted during her extensive travels throughout the country and abroad. By 1927 her work was included in the exhibition of the National Association of Women Artists in New York. Sheets lectured and exhibited widely throughout Oklahoma and became one of its best-known artists. As a result she was appointed supervisor of the state's WPA art program during the Great Depression, after serving as co-supervisor for a short time with Jacobsen.[48] In 1935 she founded an art gallery in Oklahoma City with federal funding; when the program was terminated in 1942, she managed to keep the gallery open as the Oklahoma Art Center, forerunner of the Oklahoma City Art Museum. In addition to directing the institution until 1965, Sheets played a very active role in fostering the arts throughout the state and wrote a regular column for the *Daily Oklahoman* and other publications. She was inducted into the Oklahoma Hall of Fame in 1953 and admitted to the Royal Society of Art in London in 1955.[49]

Sheets's entrepreneurial abilities, which enabled her to thrive in the arts even during the country's most devastating economic depression, were shared by a number of other women artists in the Great Plains. In addition to her mural work at the Nebraska State Capitol, Elizabeth Dolan, for example, painted small easel works that she sold for five dollars each from the front windows of a local Sherwin-Williams paint store.[50] Although details of their activities are sketchy, other women produced art for the PWAP (Public Works of Art Project),

269.
Clarisse Madelene Laurent, *Eggs*, 1892

or the FAP (the Federal Art Project), within the larger WPA, part of Franklin Roosevelt's New Deal.[51] Often, however, women's murals in the region, even those devoted to local subject matter, were painted by female artists from other parts of the country.[52]

Representations of Native Americans in the region were not, of course, entirely the province of non-Indian artists. Several Native American women distinguished themselves and their people through their paintings and cultural activities. Angel DeCora (1871–1919), a Winnebago, and Susette (or Yosette) LaFlesche Tibbles (1854–1903), an Omaha, were quite prominent as reformists at the turn of the century, and although little of their visual work has surfaced, each painted and wrote. DeCora was especially well educated, having attended the Hampton Indian School in Virginia, Smith College, and the School of the Museum of Fine Arts, Boston. A friend of the portraitist Cecilia Beaux, DeCora exhibited two paintings at the 1910 Paris Salon. She also worked for a time as an illustrator, and one of her teachers, the noted illustrator Howard Pyle, asked if he had ever had a student he considered a genius, is said to have replied, "Yes, once, but unfortunately she was a woman, and still more unfortunately, an American Indian."[53]

Another artist who experienced and fought against such racial stereotypes was Narcissa Chisholm Owen (1831–1911), a Cherokee from Indian Territory (now Oklahoma). The studied elegance and genteel confidence of her self-portrait, 1896 (plate 272), reveals a great deal about the woman: by her own admission she was using her art to counteract misconceptions about Native Americans. Owen was the daughter of an Irish mother and Thomas Chisholm, the last hereditary chief of a division of the Cherokee nation known as Lower Town or Western Cherokees.[54] Even as a youth Thomas Chisholm was of sufficient stature to have been received by President Thomas Jefferson and given a presidential peace medal like those Lewis and Clark carried as they explored the Louisiana Purchase. The medal became a family heirloom and one of Narcissa's proudest possessions.[55] Her high regard for Thomas Jefferson is expressed in two group portraits of six generations of the Jefferson family. These unique composite portraits, painted from photographs and other paintings, were awarded medals when they were displayed in the Indian Territory Building at the 1904 Louisiana Purchase Exposition in Saint Louis.[56]

Owen was born in Indian Territory in 1831, shortly after her family arrived there from their ancestral homeland in Georgia and Alabama. Raised in a well-to-do home and tended by slaves, she was educated in Indiana and Arkansas. After her marriage to Colonel Robert Owen, president of the Virginia and Tennessee Railroad, she lived in Lynchburg, Virginia, until her husband's death in 1873. Returning to Indian Territory, she taught music and art at the Cherokee Female Seminary from 1880 to 1884 and assisted her son Robert, the United States Indian agent for the Five Civilized Tribes. In a house she had built for herself, ceremoniously named Monticello after the Virginia home of Thomas Jefferson, she reigned as the belle of local society. After Oklahoma statehood in 1907, Robert was elected one of the first United States senators of the new state, and in her later years Narcissa Owen divided her time between her beloved Monticello on the plains and Washington, D.C.[57]

Owen's only art training was as a schoolgirl, and she did not begin to paint seriously until after her return to Indian Territory in the 1880s. Her criticism of a Saint Louis reporter who ignored the sophistication of the 1904 Indian Territory exhibition, commenting primarily on the tomahawks, reveals a great deal about her belief in the power of art to transform preconceptions. Scoffing at his surprise at the quality of her paintings, which he called the work of an "old Indian woman," she wrote, "The facts are [that] the Indians of Indian Territory are civilized, educated Christian people . . . my painting was not done in a tepee, but on Pennyslvania Avenue, in the Corcoran Building, opposite the Treasury, in Washington City. Among my studio friends, I was known as the 'lightning artist,' because of my rapid work."[58]

Owen's self-portrait, presumably painted from a photograph, indeed displays a verve more commonly associated with the subjects of contemporaneous portraitists John Singer Sargent and Cecilia Beaux. Owen's black bombazine dress, with its delicate lace collar, is in the height of fashion; she wears a diamond necklace and holds her eyeglasses with a casual elegance. These details and the graceful curve of her arm over the wicker chair against

the deep crimson of the curtain backdrop convey a polished self-possession and a striking awareness of presentation. This self-conscious formation of identity is at odds with our preconceptions of both women and Native Americans in the 1890s, especially in the Great Plains. There, the experimental mission schools, where Owen had received her primary education, often produced individuals who were neither self-possessed in their Indianness nor comfortable in white culture. In her striking portrait Owen positions herself not as the haughty daughter of a chief, but rather as she hoped to be seen, an example of the melding of two worlds, a model of her aspiration, not only for herself but for any who associated her with the Cherokee people.

Owen's determined efforts at composing a sophisticated demeanor that would challenge stereotypes was, in a larger sense, paralleled by the efforts of women throughout the region to develop societies, clubs, and art galleries. These and other organizations would help them overcome the distances from major cultural centers and at the same time lead to cultivated communities. The establishment of these institutions coincided with a boom in this kind of activity throughout the United States. From the end of the Civil War until the Great Depression, more schools, libraries, museums, and amateur associations connected with the arts were formed than ever before. These were especially significant in the Great Plains, because they were often the only such organizations in a large area. Much more than the philanthropic dabbling of leisure-class women, cultural institutions in the West were, like churches and schools, highly influential in fostering positive human interaction and in providing constructive alternatives to the difficult work of daily life. Alan Trachtenberg has observed that culture during this period was viewed less as an idle pastime than as a "hopeful social and political force" to help elevate people from the mundane and redeem them from the dehumanizing influences of unrelenting labor.[59] Equally significant, this important part of life was increasingly dominated by women.[60]

Although each state in the Great Plains can claim similar developments in the period from 1890 to 1945, Nebraska women established themselves as cultural enthusiasts relatively early. The principal centers for their activities were Omaha and Lincoln. Omaha was a siz-

able city by 1890 because of its position as the eastern terminus and headquarters of the Union Pacific Railroad, and Lincoln was the state capital and home of the state university. Courses in art were offered at the University of Nebraska beginning in 1877, two years before the Art Institute of Chicago and its school were officially opened, and its faculty was dominated by women for the next thirty years.[61] The first three women instructors, Emma Richardson (later Cherry), Ada Seaman, and A. Davis (who taught sequentially from 1879 to 1884), received studio space in lieu of salary. Although a School of Fine Arts had been envisioned in the university's original constitution, for many years the art program remained in the Agriculture Division of the Industrial College.[62] Sarah Wool Moore, a Vienna-trained artist who directed the program from 1884 to 1891, sought to rectify this. Moore wrote detailed and passionate letters to the board of regents and the university chancellor, reporting on the current program and its budget in comparison to those of other art schools, from Ivy League colleges to Midwestern institutions, such as Washington University in Saint Louis. Her commentary on the purposes of art quotes extensively from other sources whose sentiments she clearly shared, and it offers unique insight into the struggles as well as the pleasures of early women artists in the Great Plains. Her report not only referred to "Art" as a means of "developing the feelings for the True, the Good, and the Beautiful," but also to the encouragement of "creative growth . . . from the practical, hard-headed standpoint of dollars and cents."[63] In short, the new college would be a financial asset to the students, the university, and therefore to the state of Nebraska. Although Moore's petition to establish a full-fledged school of art was unsuccessful at the time (it was not approved fully until 1912), the program nevertheless continued and became one of the most important art departments in the plains states.[64] And Moore went on to initiate the establishment of the Haydon Art Club in 1888 (later the Nebraska Art Association), whose goals were typical of similar fledgling art societies of the time: "To study and prepare papers on art, to form a collection, to acquire a suitable art museum, to encourage young artists, to interest public school children and to attract industry and keep abreast of a growing city."[65]

Among the other members of the early

270.
Nan Jane Sheets, *Among the Hills*, n.d.

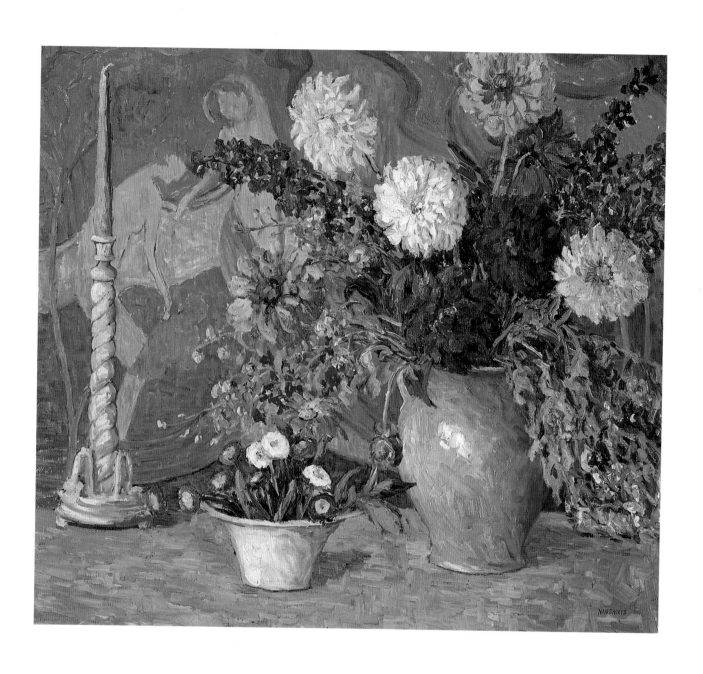

271.
Nan Jane Sheets, *Still-Life*, n.d.

272.
Narcissa Chisholm Owen, *Self Portrait*, 1896

274.
Sara Shewell Hayden, *Girl in Green*, 1899

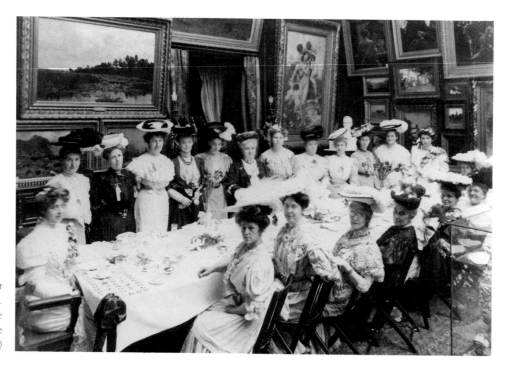

University of Nebraska, Lincoln faculty were Cora Parker (1859–1944), Sara Shewell Hayden (1862–1932), and Alice Righter Edmiston (1874–1964), a student of Sarah Moore's in 1886 and a founding member of the Haydon Art Club. Parker succeeded Moore as director of the college's art program in 1893, after study at the Cincinnati Art Academy, the Académie Julian in Paris, and with William Merritt Chase in New York. Her *Candlelight,* 1899 (plate 273, page 242), has something of Cincinnati artist Frank Duveneck's "dark manner," with its thick application of deep tones, and the sitter's pensive manner is in keeping with many contemporary works that depict languid women in varying states of repose or ennui. Similar in its thoughtful effect is Hayden's *Girl in Green* , 1899 (plate 274). A sensitive rendition of a young woman reading, it is a study in color more than value, a strikingly beautiful work with rich nuances that art historian William Gerdts has compared to the work of Hayden's contemporary John White Alexander.[66] Hayden, who had attended the School of the Art Institute of Chicago and traveled widely through Europe, spent sixteen years in Lincoln, influencing many students before returning to her native Chicago.[67]

Not far east of Lincoln, in Omaha, equally impressive development in the arts was under way. At the turn of the century much of it focused on the Lininger Gallery, a private mu-

seum opened to the public in 1888 by George Lininger, an Omaha merchant, politician, and collector. The gallery was specially constructed in a Beaux-Arts style, to exhibit his approximately three hundred paintings (as well as many decorative objects), including a sensuous nude, *Return of the Spring,* 1886, by William Bouguereau.[68] Lininger financed several other ventures that shaped Omaha's art scene: the founding of the Western Art Association (1889); the hiring of J. Laurie Wallace, a pupil of Thomas Eakins and a former professor of art at both the Pennsylvania Academy of the Fine Arts and the Art Institute of Chicago; and the establishment of the Omaha Academy of Fine Arts, which Wallace directed.[69] Although these endeavors were initiated, financed, and managed by men, women in Omaha made full use of the opportunities they afforded (see plates 275 and 276). This burgeoning interest and involvement in art gave Omaha a strong community of dedicated individuals who, in 1931, established the Joslyn Art Museum, one of the region's major institutions.

Elsewhere in the Great Plains, at slightly different rates, women sought to establish similar organizations that offered societal outlets and opportunities for educational and cultural advancement. Their efforts did not necessarily require large urban centers. The Leavenworth (Kansas) Art League, for example, already in existence for some time, founded the Leavenworth

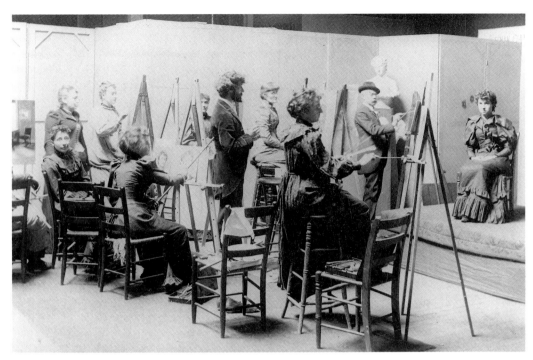

276. J. Laurie Wallace instructing an early class in painting, Omaha, c. 1890s

Art School in 1891, complete with a regular publication, *The Art League Chronicle*.[70] The Kansas State Art Association (KSAA), initiated in the state capital of Topeka in 1883, may have been inspired by the enthusiasm generated by Washburn College, which began offering art courses in 1865 under the direction of Minnie V. Otis.[71] Topeka's contribution to the arts has been continuous; the KSAA not only established an art school but also a museum in the public library, and although many of the original objects (such as the large group of casts of Greek sculpture) have been lost, the city's library still maintains a sizable art collection that includes works by some of its early residents.[72]

Among the most innovative of Topeka's artists was Mary Huntoon (1896–1970). After earning an art degree from Washburn College in 1920 and studying at the Art Students League with Robert Henri and Joseph Pennell, she traveled to Paris, where she reputedly introduced Stanley Hayter to printmaking techniques. Despite these notable connections, her gender seemed a detriment. Under an assumed name, Huntoon's husband, a former reporter, mocked a reviewer's praise of Huntoon's work in a letter to the editor of a Paris newspaper: "No women [sic] has distinguished herself in 5,000 years and it is a little too late to begin to hope." Public outcry at this apparent misogyny prompted record crowds at the exhibition, exactly the intended effect.[73] Returning to Topeka

in 1934, Huntoon taught at Washburn College and worked as state supervisor for the Federal Art Project. In later years she directed the art programs at the Menninger Sanitarium and the Winter Veterans Hospital and became a pioneer in art therapy.[74]

Equally remarkable was Olinka Hrdy (1902–1987) of Oklahoma, the only truly abstract painter among the women discussed here. Daughter of Bohemian immigrants who homesteaded near Prague, Oklahoma, Hrdy attended the University of Oklahoma in the 1920s, studying with Edith Mahier and Oscar Jacobsen. Her reputation as an eccentric derived from her inability to contend with roommates and an almost fanatical dedication to her art. On her own initiative she produced twenty large painted panels, depicting a fanciful medieval banquet hall, for the dining room of the women's dormitory. Their success earned her a commission to produce murals for a local restaurant. Although this mural series has been destroyed, it artfully satirized college life, including the bobbing of women's hair and the shortening of their skirts, both of which were features of Hrdy herself. After graduation Hrdy worked as a muralist in Oklahoma City and in Tulsa for the visionary architect Bruce Goff. She became increasingly interested in modernism, not only in the visual arts but also in music, theater, and architecture. Fascinated with machinery, especially that of the booming petro-

277.
Olinka Hrdy, *Games,* 1936

leum industry, she produced murals for the prestigious Tulsa Club based on photographs of oil fields.[75] In addition to its machine-like qualities, her 1936 oil *Games* (plate 277) reveals her interest in dynamic symmetry, a compositional theory she studied in New York after leaving Tulsa in the early 1930s.[76] The painting's strongly defined linearity and geometric emphasis bear a strong resemblance to the contemporaneous work of the Abstract American Artists group. Similar paintings by Neo-Constructivists such as Charles Shaw and Rolph Scarlett were not produced until the late 1930s and early 1940s, making Hrdy a true member of the avant-garde.[77]

In the early 1930s Hrdy managed Taliesin East, the studio and estate of architect Frank Lloyd Wright, who admired her work. Later, as chief designer for the state of California, she directed exhibitions for various state industries and produced industrial designs and packag-ing.[78] For her innovation, independent spirit, and visionary abilities, Hrdy deserves more attention than she has received.

Many other women artists of the Great Plains who made important contributions to the development of the fine arts in their states are not included here because their work is either unavailable or in poor condition. And less research has been done on those who are included than on their male counterparts. Yet even the paintings and histories of relatively few demonstrate that women artists in the Dakotas, Nebraska, Kansas, and Oklahoma made the most of their opportunities in a time and place that did not encourage women's independence. Their work compares favorably not only with that of other women in the country but with that of men as well. Their legacy is in their work, in their cultivation of arts institutions and programs, in their students, and most important, in their example of perseverance and ingenuity.

Notes

Preface

NOTES

1. See Phil Kovinick, *The Woman Artist in the American West, 1860–1960* (Fullerton, Calif.: Muckenthaler Cultural Center, 1976). This exhibition catalogue is the only publication, other than lexicons, that deals exclusively with women artists in the trans-Mississippi West. It provides a series of biographies of the women whose paintings were restricted to Western subjects in the exhibition.

2. Discriminatory gender attitudes from an earlier age lingered on well into the last quarter of the nineteenth century. These attitudes held that the "great endeavor of painting" was reserved primarily for the male sex, that a woman was incapable, both mentally and physically, of creating great works of art. Very few women were encouraged to follow the profession by their parents, husbands, or society. Many of those who followed their natural desires encountered additional barriers simply because they were women. Those who strove for equal education, greater independence from the constraints and gender assumptions of society, and a share in the rewards of professional recognition contributed greatly to the profound changes that took place at the turn of the century. Cultural changes proved beneficial to women artists in their progress toward equality in education and professional status. This topic has been fully discussed recently in a number of fine publications and need not be elaborated here.

3. The trans-Mississippi West includes seventeen states but this study covers only sixteen, excluding Nevada because of its transient state and undeveloped art community before 1945. Nevada historian Jim McCormick writes that not until after World War II did Nevada begin to grow and even minimally nurture its artists. A limited number of women seem to have been able to maintain a consistent level of artistic production (McCormick to author, April 29, 1994). In the introduction to the *Nevada Historical Society Quarterly* 33 (summer 1990): 72–73, devoted to Nevada's painters from 1860 to 1960, McCormick states that "from the days of the earliest settlements, artists in Nevada faced a number of problems that did not confront their counterparts in more populous regions. Unstable economic conditions, inherent in the boom-or-bust nature of the mining industry, did not encourage the establishment of galleries or museums. The Nevada Art Gallery in Reno, founded in the 1930s, was the first public art facility in the state." This volume includes only two women artists, one of whose work dates prior to 1960; only two of her paintings are extant today. I am grateful to Jim McCormick, guest editor of the quarterly cited above, for bringing this information to my attention.

4. See *Impressionism: Art, Leisure, and Parisian Society* (New Haven: Yale University Press, 1988), xiii. I am indebted to Susan Landauer for her scholarly assistance.

5. In the preface to *Trail Toward a New Western History* (Lawrence: University Press of Kansas, 1991, x), editor Patricia Limerick states that Western history is receiving "its full share of the constructive tension of dissent, disagreement, and ferment. Scholars are subjecting the old and familiar to new assessments and exploring new and different horizons in all directions. As some scholars reevaluate the eighteenth- and nineteenth-century western experience, others lay the foundations for understanding the twentieth-century West."

6. Discussing "The Problem of Invisibility," Joan Wallach Scott states, "It is clearly not the absence of information about women, but the sense that such information was not relevant to the concerns of 'history' that led to the invisibility of women in the formal accounts of the past" (in S. Jay Kleinberg, ed., *Retrieving Women's History* [Providence, RI, and Paris, France: Berg Publishers, Inc., and Unesco Press, 1988], 10). Limerick observes that "the explosion of work in western women's history, which began in the late 1970s and gained momentum in the 1980s, can be linked to feminism's insistence since the late 1960s that women be recognized as active players in all facets of society. . . . Women have [now] become an essential part of the western story, as have ethnic and racial groups. Viewing the past from their perspectives, we find cultural and social complexity in place of archetypal white male simplicity" (Patricia Nelson Limerick, Clyde A. Milner II, and Charles E. Rankin, eds., *Trails: Toward a New Western History* [Lawrence: University Press of Kansas, 1991], x–xi).

SCHARFF *Introduction*

ACKNOWLEDGMENTS: I would like to thank Michael Anne Sullivan and Pablo Mitchell for assistance with research for this essay, Patricia Trenton for editorial direction and advice, and Martha Scharff for support and good ideas.

NOTES

1. My thinking on the contingency of women's lives has been influenced by Mary Catherine Bateson, *Composing a Life* (New York: Plume, 1990). Many thanks to Martha Scharff for sending me the book.

2. Frederick Jackson Turner, "The Significance of the Frontier in American History," *Proceedings of the Forty-First Annual Meeting of the State Historical Society of Wisconsin* (Madison: State Historical Society of Wisconsin, 1894), 79–112. On empire and frontier, see Patricia Nelson Limerick, *The Legacy of Conquest: The Unbroken Past of the American West* (New York: Norton, 1987).

3. Joan M. Jensen, *One Foot on the Rockies: Women and Creativity in the Modern American West* (Albuquerque: University of New Mexico Press, 1995).

4. I am indebted to Raphael Cristy, a doctoral candidate at the University of New Mexico currently working on a dissertation on Russell, for identifying Bower in this painting.

5. This question has been most importantly explored in Virginia Woolf, *A Room of One's Own* (New York: Harcourt Brace, 1929).

6. Deena J. González, "La Tules of Image and Reality: Euro-American Attitudes and Legend Formation on a Spanish-Mexican Frontier," in Adela de la Torre and Beatríz M. Pesquera, eds., *Building with Our Hands: New*

Directions in Chicana Studies (Berkeley: University of California Press, 1993), 75–90.

7. Western women won the franchise in Wyoming, 1869; Utah, 1870; Colorado, 1893; Idaho, 1896; Washington, 1910; California, 1911; Arizona, 1912; Kansas, 1912; Oregon, 1912; Montana, 1914; and Nevada, 1914. See Richard White, *"It's Your Misfortune and None of My Own": A New History of the American West* (Norman: University of Oklahoma Press, 1991), 355–56.

8. For an overview of women's political history in this period see Nancy F. Cott, *The Grounding of Modern Feminism* (New Haven: Yale University Press, 1987). On specific women see Blanche Wiesen Cook, *Eleanor Roosevelt* (New York: Viking, 1992); Susan Ware, *Partner and I: Molly Dewson, Feminism, and New Deal Politics* (New Haven, Conn.: Yale University Press, 1987); Elisabeth Israels Perry, *Belle Moskowitz: Feminine Politics and the Exercise of Power in the Age of Alfred E. Smith* (New York: Routledge, 1992); Hannah Josephson, *Jeanette Rankin: First Lady in Congress* (Indianapolis: Bobbs-Merrill, 1974); Sandra Haarsager, *Bertha Knight Landes of Seattle: Big City Mayor* (Norman: University of Oklahoma Press, 1994); Virginia Scharff, "Feminism and Politics in the Equality State: The Defeat of Nellie Tayloe Ross," paper presented to the Western History Association, Wichita, Kansas, October 1988.

9. Wendy Holliday, a doctoral candidate at New York University, is writing a dissertation about women screenwriters in Hollywood, "Hollywood's Modern Women: Work, Culture, and Politics, 1915–1940."

10. Karen Anderson, "Western Women: The Twentieth-Century Experience," in Gerald D. Nash and Richard W. Etulain, eds., *The Twentieth-Century West: Historical Interpretations* (Albuquerque: University of New Mexico Press, 1989); Susan Armitage and Elizabeth Jameson, eds., *The Women's West* (Norman: University of Oklahoma Press, 1987); Lillian Schlissell, Janice Monk, and Vicki Ruiz, eds., *Western Women: Their Land, Their Lives* (Albuquerque: University of New Mexico Press, 1988); Karen Anderson, *Wartime Women: Sex Roles, Family Relations, and the Status of Women during World War II* (Westport, Conn.: Greenwood Press, 1981); Sherna Berger Gluck, *Rosie the Riveter Revisited: Women, the War, and Social Change* (Boston: Twayne, 1987).

11. Virginia Scharff, "The Independent and Feminine Life: Grace Raymond Hebard, 1861–1936," in Geraldine J. Clifford, ed., *Lone Voyagers: Academic Women in Coeducational Universities, 1870–1937* (New York: The Feminist Press, 1989), 125–46; Deborah Hardy, *Wyoming University: The First One Hundred Years, 1886–1986* (Laramie: University of Wyoming, 1986).

12. Phil Kovinick, *The Woman Artist in the American West, 1860–1960* (Fullerton, Calif.: Muckenthaler Cultural Center, 1976), 32; see also Jensen, *One Foot on the Rockies*.

13. Polingaysi Quoyawayma (Elizabeth White), *No Turning Back* (Albuquerque: University of New Mexico Press, 1979).

14. Pamela Hronek and Mary Logan Rothschild, *Doing What the Day Brought: Lives of Arizona Women* (Tucson: University of Arizona Press, 1992).

15. Hisako Hibi, "Mothers Bathing Children in Laundry Room (Topaz 1943)," in Deborah Gesensway and Mindy Roseman, *Beyond Words: Images from America's Concentration Camps* (Ithaca and London: Cornell University Press, 1987), 110.

16. Doris Ostrander Dawdy, *Artists of the American West: A Biographical Dictionary* (Athens: Ohio University Press, 1981), 2:325.

17. Ibid., 3:344; Patricia J. Broder, *The American West: The Modern Vision* (Boston: Little, Brown, 1984), 249, 254.

18. Mabel Dodge Luhan, *Movers and Shakers* (Albuquerque: University of New Mexico Press, 1985).

19. James R. Mellow, *Charmed Circle: Gertrude Stein and Company* (New York: Avon Books, 1974), plate insert between pages 384 and 385.

20. Terry R. Reynolds, "Women, Pottery and Economics at Acoma Pueblo," in Joan M. Jensen and Darlis A. Miller, eds., *New Mexico Women: Intercultural Perspectives* (Albuquerque: University of New Mexico Press, 1986), 279–300.

21. Miné Okubo, *Citizen 13660* (Seattle: University of Washington Press, 1983).

22. Virginia Scharff, "Else Surely We Shall All Hang Separately: The Politics of Western Women's History," *Pacific Historical Review* 61, no. 4 (November 1992): 535–56.

23. Kovinick, *The Woman Artist*, 51.

24. Broder, *The American West*, 164.

25. Ibid., 163.

26. Anderson, *Wartime Women*; Gluck, *Rosie the Riveter*.

27. Anderson, *Wartime Women*; Elaine Tyler May, *Homeward Bound: American Families in the Cold War Era* (New York: Basic Books, 1988).

28. Michael Schaller, Virginia Scharff, and Robert Schulzinger, *Present Tense: The United States Since 1945* (Boston: Houghton Mifflin, 1992), 36.

29. Ibid.; White, *No Turning Back*, 510–13.

30. Gesensway and Roseman, *Beyond Words*, 159.

31. Ibid., 59.

I. LANDAUER *Searching for Selfhood*

ACKNOWLEDGMENTS: I would like to thank numerous individuals who gave generously of their time and expertise to this project. Scholarly research on the period's art and criticism was facilitated by the staffs of several museums, galleries, archives, and libraries: Harvey Jones, Arthur Monroe, Janice Capecci, and Drew Johnson of The Oakland Museum; Marc Simpson and Jane Glover of the M. H. de Young Memorial Museum; Margaret Lee of the San Francisco Museum of Modern Art; Mary Murray of the Monterey Peninsula Museum of Art; Katherine Crum, Tim Mosman, and Leah Goldberg of the Mills College Art Gallery; Alfred C. Harrison and Jessie Dunn-Gilbert of the North Point Gallery; Jan Holloway of Jan Holloway Fine Art; Paula and Terry Trotter of Trotter Galleries; John Garzoli of Garzoli Gallery; Tobey C. Moss of Tobey C. Moss Gallery; Mark Hoffman of Maxwell Galleries, Ltd.; Lynn Curtis and Virginia Dorn of San Francisco Women Artists; Jeff Gunderson of the San Francisco Art Institute; Victor H. Bausch of the Monterey Public Library; and Robert L. Haynes of the Northern California Center for Afro-American History and Life. Other individuals who aided in research include Miriam Matthews, Edan Hughes, Penny Perlmutter, Walter A. Nelson-Rees, James L. Coran, David Howard, David and Jeanne Carlson, Mrs. Alice Virginia Larribeau, John and Lorna Meyer, Mrs. Christine Allen, Don Crocker, and Nan and Roy Farrington Jones.

NOTES

1. See Whitney Chadwick and Isabelle de Courtivron, eds., *Significant Others: Creativity and Intimate Partnership* (London: Thames and Hudson, 1993).

2. See the Mathews scrapbooks, Archives of California Art, The Oakland Museum.

3. This is with the exception of the one- and two-line newspaper reports on her silver medal for watercolors at the Panama-Pacific International Exposition; see, for example, "The Exposition Awards: California Artists," *San Francisco Chronicle*, July 25, 1915.

4. While some of these artists were not local, they did visit the Mathewses when they came to San Francisco; see Mathews scrapbooks, Archives of California Art.

5. Harvey Jones was the first art historian to place Lucia on a par with Arthur, in his book *Mathews: Masterpieces of the Decorative Style* (Layton, Utah: Gibbs M. Smith, Peregrine Smith Books, in association with The Oakland Museum, 1985). Although Jones spent little time discussing Lucia's work, he did state that "her best efforts, although fewer in number and smaller in scale, attest to the notion that she was at least his equal in most respects" (p. 79). More recent critics have often preferred Lucia's work to her husband's. In 1985, for example, a critic for the *San Jose Mercury* opined that "as a painter, Arthur was less successful than his wife . . . he never found his own style or subject." Dorothy Burkhart, "The Turn of the Century Returns: More than Decoration," *San Jose Mercury News,* February 22, 1985.

6. Although Lucia and Arthur Mathews worked together on designs for furniture at their Furniture Shop, Arthur maintained the position of "master designer" and supervisor. Similarly, when they founded the magazine *Philopolis* (1906–1920), Arthur did the lion's share of writing and illustration, while Lucia designed the magazine's vignettes and decorative borders.

7. "Ruskin's Advice to Young Women," *San Francisco Call*, March 4, 1896. Ruskin's compilation of lectures, *Sesame and Lillies* (1865), is one of the clearest statements of the Victorian ideal of separate spheres and was required reading in girls' schools through the early twentieth century.

8. Quoted in Susan Waller, *Women Artists in the Modern Era: A Documentary History* (Metuchen, N.J.: The Scarecrow Press, 1991), 261.

9. In California, many colleges and universities were coeducational by charter. This includes Stanford University, founded in 1885. Stanford had a precedent in the University of California at Berkeley, which, in 1869, just one year after opening, amended its prospec-

tus to state explicitly that women were eligible for enrollment, given the proper high-school requirements.

10. "Fair Bread Winners: The Successful Women of the West Unbosom Themselves for the Benefit of Struggling Sisters," *San Francisco Examiner*, 1890, Alice Chittenden papers, roll 919, frame 346, Archives of American Art, Smithsonian Institution, Washington, D.C.

11. Raymond L. Wilson, "The First Art School in the West: The San Francisco Art Association's California School of Design," *American Art Journal* (winter 1982): 47.

12. See Kate Montague Hall, "The Mark Hopkins Institute of Art: A Department of the University of California," *Overland Monthly* 30 (December 1897): 539.

13. Raymond L. Wilson, "Introductory Essay," *A Woman's Vision: Painting into the 20th Century* (San Francisco: Maxwell Galleries Ltd., 1983), 5.

14. Ibid., 5–6.

15. See the *Daily Alta*, December 16, 1885; *San Francisco Chronicle*, December 20, 1885; and *San Francisco Examiner*, December 16, 1885. The exhibition included eighty artists, including Alice Chittenden and Mary Curtis Richardson. The report on the event in the *Argonaut* is typical of the commentary: "The rooms looked cheerful and attractive, being handsomely decorated with flowers, foliage, clusters of fruit, screens, drapery, all arranged with artistic effect. The exhibition was to many a most pleasant surprise, as but few had any idea of the degree of enthusiasm that the ladies had concentrated on the exhibition." "The Ladies' Art Exhibition," *Argonaut* 17 (December 19, 1885): 10.

16. Justus, "The Lady Artists," *San Francisco News Letter*, January 2, 1886.

17. Raymond L. Wilson, "Towards Impressionism in Northern California," in Ruth Lilly Westphal, ed., *Plein Air Painters of California: The North* (Irvine, Calif.: Westphal Publishing, 1986), 8. See also *Final Report of the California World's Fair Commission, Including a Description of all Exhibits from the State of California, Collected and Maintained under Legislative Enactments at the World's Columbian Exposition, Chicago, 1893* (Sacramento: California State Office, 1894), 53–55.

18. Far less important, but nonetheless of historical significance, was the Oakland Sketch Club, founded by Mary DeNeale Morgan in the 1890s. Its initial aim was apparently to provide live models. (Jack London, then a student at Oakland High School, was one of the models.)

19. For more on the early history of the Sketch Club see Eleanor Warren, "The Sketch Club," *San Francisco Chronicle*, July 23, 1893; and N. L. Murtha, "The Sketch Club: 'Art for Art's Sake,'" *Overland Monthly* 29 (June 1897): 577–90.

20. See *The Sketch Club: Ninth Semi-Annual Exhibition, 1897* (San Francisco: The Sketch Club, 1897). In 1925 the Sketch Club changed its name to the San Francisco Society of Women Artists. An offshoot of the organization still exists under the name San Francisco Women Artists, with offices and a gallery on Hayes Street in San Francisco.

21. Ruth Armer, one of the Sketch Club's members, recalled that the club had started as an alternative to the Bohemian Club, which she described as "a terrible thorn in the side of the ladies," since it was the "only . . . group exhibition that anybody could get into. Of course, anybody but women had a chance." Interview with Paul J. Karlstrom, August 14, 1974, Archives of American Art, roll 3196, frame 198.

22. See the Pauline Powell papers in the Archives of California Art.

23. See Nicole Atkinson, "Pauline Powell: Artist and Musician," *From the Archives* (a publication of the Northern California Center for Afro-American History and Life, Oakland) 1 (fall 1990): 11.

24. This is not to say that there were not male interpreters of the floral still life, such as William Hubacek, Edwin Deakin, and Ferdinand Richardt, but the proportion of women floral painters remained large.

25. Wilson, "Introductory Essay," 7. See also "Ladies Day at the Bohemian Club Winter Picture Show, *San Francisco Chronicle*, October 14, 1898.

26. One reviewer declared that "Keith and other good judges say that she has few equals in this line of work in the whole country." Quoted in Janice T. Driesbach, *Bountiful Harvest: Nineteenth-century Still Life Painting* (Sacramento: Crocker Art Museum, 1991), 67.

27. Charles Keeler, *San Francisco and Thereabout* (San Francisco: The California Promotion Committee, 1906), 48.

28. "San Francisco Women Who Have Achieved Success," *Overland Monthly* 44 (November 1904): 517.

29. Searles R. Boynton, *The Painter Lady: Grace Carpenter Hudson* (Eureka, Calif.: Interface California, 1978), 84.

30. Ninetta Eames, "The California Indian on Canvas," *Popular Monthly* 43 (April 1897): 380.

31. Quoted in Christine Shuken, "A Passion for Preservation: The Sun House and Grace Hudson Museum," 106, undated clipping in the Hudson papers, Archives of California Art.

32. The painting also became known as *Quail Baby* when it was so captioned in an article Hudson authored in the *Overland Monthly*; see Boynton, *The Painter Lady*, 29.

33. Eames, "The California Indian on Canvas," 384. Hudson made her national debut with *The Interrupted Bath*, exhibited in 1893 at the World's Columbian Exposition in Chicago to general acclaim. Originally, the child was unclothed, but at some later date, probably in the 1900s, prudish Victorian sensibility dictated that a fig leaf (since removed) be painted over the baby's genitals.

34. Anne Higonnet, "Images—Appearances, Leisure, and Subsistence," in Genevieve Fraisse and Michelle Perrot, eds., *A History of Women in the West*, vol. 4, *Emerging Feminism from Revolution to World War* (Cambridge: Harvard University Press, 1993), 260.

35. Gene Hailey, ed., "Evelyn Almond Withrow, 1858–1928: Biography and Works," in *California Art Research* 5 (San Francisco: WPA Federal Art Project, 1937): 4. See also Millie Robbins, "Gifted Hostess for the Artistic Elite," *San Francisco Chronicle*, July 15, 1969.

36. There seem to be at least two versions of this painting, one reproduced in George Wharton James, "Evelyn Almond Withrow: Painter of the Spirit," *National Magazine* (August 1916): 3–15; the other in the collection of John Garzoli, San Rafael.

37. Even the de Young was not solely a museum of art but also housed a collection of historical and ethnographic objects. The next museum to open in San Francisco was the San Francisco Museum of Art in 1916, initially located in the Palace of Fine Arts. This museum, however, had no collection of its own other than ninety-eight prints. The California Palace of the Legion of Honor did not open until 1924, with a collection that emphasized the French masters.

38. Robert E. Brennan, "Effie: The Landscape Painter," *Colors and Impressions: The Early Work of E. Charlton Fortune* (Monterey: Monterey Peninsula Museum of Art, 1990), 15.

39. Anna Cora Winchell, "The Exposition Awards: California Artists," *San Francisco Chronicle*, July 25, 1915.

40. J. Nilsen Laurvik, quoted in Janet B. Dominik, "E. Charlton Fortune (1885–1969)," in Westphal, *Plein Air Painters of California*, 69.

41. At least one critic assumed that she was a man; in a review of California landscape painting for the *Overland Monthly* in 1915, the author devoted three paragraphs to *Mr.* Fortune's work. Catherine A. Johnson, "A Time of Change: Northern California Women Artists, 1895–1920," *Viewpoints* 15 (June–August, 1991), The Fine Arts Museums of San Francisco, M. H. de Young Memorial Museum.

42. Brennan, *Colors and Impressions*, 12.

43. Typescript autobiography in E. Charlton Fortune scrapbook, n.d., Archives of California Art; Brennan, *Colors and Impressions*, 13–14.

44. Ibid., 14.

45. Josephine Mildred Blanch, "The 'Barbizon' of California: Some Interesting Studios of Old Monterey," *Overland Monthly* 50 (July 1907): 63–68.

46. Harold and Ann Gilliam, *Creating Carmel: The Enduring Vision* (Salt Lake City: Peregrine Smith Books, 1992), 146–47.

47. Although Chase has never been considered a member of the Ashcan School, Fortune remembers that for him "any unpaintable material was considered suitable to break through the academic jam, and his students were in the vanguard of California. For the most part the 'Queers' [as he called them] were limited in subject matter to old brooms, telegraph poles, sinks and garbage cans, some the most ambitious going so far as to add dead cats and chickens to their compositions—and always using tones and planes of bluish gray and umber." Typescript autobiography in E. Charlton Fortune scrapbook, Archives of California Art.

48. Helen Dwyer Donovan, "California Artists and Their Work," *Overland Monthly* 51 (January 1908): 25–33.

49. Irene Alexander, "Last Link with Bohemian Past Broken: Evelyn McCormick, Friend of George Sterling, Joaquin Miller, Dies in Monterey," *Monterey Peninsula Herald*, May 7, 1948.

50. Until 1924 Morgan used strictly oleo tempera, a kind of tempera emulsified with oleoresin. Later, she also worked in oil. Janet B. Dominik, "Mary DeNeale Morgan," in Westphal, *Plein Air Painters of California*, 122.

51. For a fascinating history of the Montgomery Block, see Idwal Jones, *Ark of Empire: San Francisco's Montgomery Block* (New York: Doubleday Books, 1951). Some of the women who had studios there were Dorr Bothwell, Helen Forbes, and Helen Bruton.

52. See Laura Bride Powers, "Women's Art Show Proves that Personality, Not Sex, Dominates Art," *San Francisco Call*, February 18, 1906, Archives of The North Point Gallery, San Francisco.

53. Westphal, *Plein Air Painters of California*, 2.

54. Porter Garnett, "New Notes of the Artist Folk," *San Francisco Call*, September 15, 1912.

55. Dorr Bothwell, interview with author, September 25, 1993.

56. Whitney Chadwick, *Women, Art, and Society* (London: Thames and Hudson, 1990), 265.

57. Ruth Pielkovo, "Bremer's Exhibit of Paintings," *San Francisco Journal*, April 2, 1922.

58. Waller, *Women Artists in the Modern Era*, 308.

59. Quoted in Conrad Aikin, "California and New York: 1913–1927," in Conrad Aikin and Richard Lorenz, *Henrietta Shore: A Retrospective Exhibition: 1900–1963* (Monterey, Calif.: The Monterey Peninsula Museum of Art), 19.

60. Shore was quoted as saying she did not believe in "isms of any kind, life is too big for that," in Rose Miele, "Henrietta Shore," *Carmel Gossip*, 1952, clipping in Shore papers, Archives of California Art.

61. Jean Charlot included a chapter on Shore in his book *Art From the Mayans to Walt Disney* (New York: Sheed and Ward, 1939).

62. Charlotte Streifer Rubenstein, *American Women Artists from Earliest Times to the Present* (Boston: G. K. Hall and Co., 1982), 262.

63. Nancy Acord, "The Women of the WPA Art Projects: California Murals, 1933–1943," in Silvia Moore, ed., *Yesterday and Tomorrow: California Women Artists* (New York: Midmarch Arts Press, 1989), 21.

64. Margaret, Helen, and Esther Bruton were especially remarkable for their design, execution, and installation of one of the most ambitious murals of the 1939–40 Golden Gate International Exposition on Treasure Island—the monumental *Peace Makers* mural, dominating the Court of the Pacifica. According to Beatrice Judd Ryan, then state director of WPA exhibitions, this project alone required a warehouse that extended half a city block. Ryan, "The Bridge Between Then and Now," manuscript, Bancroft Library, University of California, Berkeley, n.d., 97.

65. See Karal A. Marling and Helen Harrison, *Seven American Women: The Depression Decade* (Poughkeepsie, N.Y.: Vassar College Art Gallery, 1976), 14; see also Linda Nochlin, "The Twentieth Century: Issues, Problems, Controversies," in Ann Sutherland Harris and Linda Nochlin, *Women Artists: 1500–1950* (New York: Alfred A. Knopf, 1976), 64.

66. Acord, "The Women of the WPA Art Projects," 3.

67. "Ideology of largesse" is Linda Nochlin's term; see Nochlin, "The Twentieth Century," 64.

68. Barbara Melosh, *Engendering Culture: Manhood and Womanhood in New Deal Public Art and Theater* (Washington, D.C.: Smithsonian Institution Press, 1991), 1.

69. Ibid.

70. Melosh, *Engendering Culture*, 215–16.

71. Acord, "The Women of the WPA Art Projects," 9.

72. The phrase "Berkeley School" was first used by the critic Alfred Frankenstein in a review in 1937; see *San Francisco Chronicle*, November 7, 1937. The Berkeley artists, who generally combined Cubism, Post-Impressionism, and contemporary watercolor practices were part of a broad trend known as the California Watercolor School, lasting from the late 1920s to the mid-1940s.

73. See Deborah Gesensway and Mindy Roseman, *Beyond Words: Images from America's Concentration Camps* (Ithaca and London: Cornell University Press, 1987); Karin Higa et al., *The View from Within: Japanese American Art from the Internment Camps, 1942–1945* (Los Angeles: Japanese American National Museum, UCLA Wight Art Gallery, UCLA Asian American Studies Center, 1992). It is not known if Miki was interned.

74. Dorr Bothwell, interview with author, September 25, 1993. My analysis of this painting stems from this interview.

75. Gwen Raaberg, "The Problematics of Women and Surrealism," in Mary Ann Caws, Rudolf E. Kuenzli, and Gwen Raaberg, eds., *Surrealism and Women* (Cambridge: MIT Press, 1991), 8.

76. Chadwick, *Women, Art, and Society*, 9.

II. TRENTON *Islands on the Land*
NOTES

1. Quoted in Franklin Walker, *Chronicles of California: A Literary History of Southern California* (Berkeley and Los Angeles: University of California Press, 1950), 5.

2. Mark Daniels, "Where Beauty and Pleasure Join Hands," *California Arts & Architecture*, December 1935, 15.

3. Many of these terms are from Carey McWilliams, *Southern California: An Island on the Land* (Santa Barbara and Salt Lake City: Peregrine Smith, 1973), 97; Scott O'Dell, *Country of the Sun* (New York: Thomas Y. Crowell, 1975), 221; and other sources.

4. McWilliams, *Southern California*, 231, 238.

5. Ibid., 181.

6. First used by Helen Hunt Jackson, the term is quoted in McWilliams, 7.

7. U.S. Census Reports on Population Growth:

	1880	1890	1900	1920
Los Angeles	11,183	50,395	102,479	576,673
Pasadena	39	4,882	9,117	45,354
Santa Barbara	3,460	5,864	6,587	19,441
San Diego	2,637	16,159	17,700	74,683

8. The author has made an extended inquiry into the presence of conservative women painters active in Southern California between 1890 and 1945. Before World War II there were few recognized women painters among some racial and ethnic groups. While there are certain exceptions, such as the African American painters Lula Adams and Alice Taylor Gafford (Gafford played a major role in the establishment of the Los Angeles Negro Art Association about 1935), their work did not receive widespread recognition in the art community. For a brief biography of Gafford, see Samella Lewis and Ruth G. Waddy, *Black Artists on Art* (Los Angeles: Contemporary Crafts, 1971). For Adams, see n. 72. Both cultural and economic factors seem to have prevented women's involvement in painting as a profession in the Native American, African American, Hispanic, or Asian American populations, although to date only a modicum of research has been done on painters among any of these racial and ethnic groups in Southern California. (The term Hispanic is used here to refer to Spanish-speaking residents of the United States or to their descendants.) The author is indebted to the following Los Angeles historians who provided informative response to her inquiries: Suellen Cheng, Curator, El Pueblo; Ramón Favela, Ph.D., Associate Professor in the History of Art and Architecture, Associate Professor in Chicana Studies, University of California, Santa Barbara; Karin Higa, Curator, Japanese American National Museum; Miriam Matthews, former librarian of the Los Angeles Public Library; Gloria Miranda, Ph.D., Professor of Sociology, El Camino College; Rick Moss, History Program Director, California Afro-American Museum; Charles Choy Wong, Ph.D., Education Consultant.

9. "Cecilia Beaux, Artist, Her Home, Work and Ideals," *Boston Herald*, September 23, 1910, Archives of American Art, Smithsonian Institution, Washington, D.C., roll 3658.

10. Linda Nochlin in Thomas B. Hess and Elizabeth C. Baker, eds., *Art & Sexual Politics* (New York: Collier Books, 1973), 31.

11. Gail Levin, "The Changing Status of American Women Artists, 1900–1930," in Eleanor Tufts, *American Women Artists, 1830–1930* (Washington, D.C.: National Museum of Women in the Arts, 1987), 13.

12. *Boston Herald*, September 23, 1910.

13. White's *Memories*, dictated late in her life, refers only to an "Academy" as the exhibition venue for this picture, although listings of exhibition entries for the National Academy of Design in 1892 and 1893 do not include works by White.

14. Information on her life and career from White's *Memories* (Privately printed, 1936), 5–23.

15. Gerald J. Miller, Administrator of San Juan Capistrano Mission, to author, September 23, 1994: "Following our conversation on . . . Duvall's [erroneously titled] 'Confirmation' painting . . . I examined the picture together with Monsignor Paul Martin, Pastor of this Mission. It would appear from the apparent ages of the girls and the mode of dress that the event pictured is in fact a First Communion (Communion Class) rather than a Confirmation Class. The class is pictured entering the temporary chapel (now Gift Shop), which was used at that time because the old Serra Chapel (c. 1776) had been closed (1895 to about 1920) for repairs."

16. Katherine Tingley, *Theosophy and Some of the Vital Problems of the Day* (Point Loma, Calif.: Woman's International Theosophical League, 1915), 6. Emphasis added.

17. The Pasadena Theosophical Society "Register, 1897," lists Edith and her mother, Mary Stanton White, as new members. The author is indebted to Kirby Van Mater, Secretary General and Chief Archivist of the Pasadena Theosophical Society, for his many courtesies and able assistance.

18. See Emmett Alwyn Greenwalt's doctoral dissertation, "The Point Loma Community in California, 1897–1942," University of California, Los Angeles, June 1949. The Theosophical community of 500 acres (at its peak) was a unique complex called Lomaland, consisting of some forty exotic buildings, and was considered a city within itself. Among the many structures was the Homestead building (known later as the Raja-Yoga), which included a rotunda 300 feet in circumference and 85 feet in height (equivalent to an eight-story building).

19. White, *Memories*, 22.

20. Printed in the *Los Angeles Times* on December 10, 1911, and October 19, 1913.

21. For the history of early art in Southern California, see Nancy Dustin Wall Moure, *Loners, Mavericks & Dreamers: Art in Los Angeles before 1900* (Laguna Beach, Calif.: Laguna Art Museum, 1993).

Biographical information on Duvall's life and career is from the following sources: local newspaper clippings; Moure, *Loners*; and Iona M. Chelette, *California Grandeur and Genre: From the Collection of James L. Coran and Walter A. Nelson-Rees* (Palm Springs, Calif.: Palm Springs Desert Museum, 1991). The last source lists Duvall's birth date as 1859, based on her death certificate; most reference books cite 1861. To verify the date of birth, the author is researching the artist's birth certificate and baptismal record.

22. *Saturday Night*, July 31, 1926.

23. *Saturday Night*, November 10, 1934.

24. A copy of the will was provided the author by Deborah Solon, researcher for this book.

25. J. M. Guinn, *Historical and Biographical Record of Southern California* (Chicago: Chapman Publishing, 1902), 935. Dorothy Henderson to author, October 17, 1994.

26. Three years after the death of her husband, she moved to Boston, where she established a studio (letter from B. Wood to Mrs. Henderson [Farr's great-granddaughter], September 8, 1986).

27. The move to Pasadena was probably prompted by C. H. Merrill, who was the general manager of the resort-destination Raymond Hotel and former manager of the Crawford House in the White Mountains, New Hampshire (letters from Farr's great-granddaughter Dorothy Henderson to author, 1993). The author is most grateful to Farr's relatives for their willingness to share family memorabilia and photographs of the artist. For additional information on Farr's residence in Pasadena, the author wishes to express her gratitude to Carolyn L. Garner, Librarian, Pasadena Public Library.

28. D. Appleton and Company, New York (1893), 64, 66.

29. Focus on husband-and-wife and artist teams was arrived at independently, without the knowledge of other publications devoted to this subject. Later, Susan Landauer brought to my attention a book of collected essays on writer and artist teams: Whitney Chadwick and Isabelle de Courtivron, eds., *Significant Others* (London: Thames and Hudson, 1993).

30. The author extends thanks to Nancy Moure, who provided background information on the McCloskeys. Alberta's date of birth was taken from the U.S. Census Report of 1860, provided by research associate Roberta Gittens, who assisted the author in gathering some of the research material for this essay.

On November 23, 1884, the *Los Angeles Times* announced the arrival of the McCloskeys, "who in 1884 opened a studio in Child's Grand Opera House. [William] McCloskey was a graduate of the Philadelphia [*sic*] Academy of the Fine Arts and his wife a pupil [?] of William Merritt Chase of New York City. Portraits were their specialty and their attractive studio was open to the public on Wednesdays of each week." Chase's biographer, art historian Ronald Pisano, did not locate Alberta's name on the lists of the artist's students. When Alberta met her husband in Denver in 1882, she was an established artist. Some historians believe that Alberta was self-trained. In the author's opinion, Alberta's work reflects some knowledge of the principles of design, color, and composition; she probably obtained some formal training either at a local seminary or in private lessons with a professional artist in her hometown.

31. William H. Gerdts and Russell Burke in *American Still-Life Painting* (New York, Washington, and London: Praeger Publishers, 1971), 166–67, suggest that William McCloskey may have known of Lemuel Everett Wilmarth's still life with oranges wrapped in tissues, painted in 1889. The authors do not imply that Wilmarth was a source for the McCloskey pictures, and they point out that the older, more renowned New York artist painted in a "lighter tonality" and "more broadly" than McCloskey; they state, too, that the subject was most unusual and did not appear until after California fruits were readily available on the East Coast, several years after the second transcontinental railroad was completed in 1881. At the time the authors did not know of Alberta's painting of the same subject, dated 1889. Perhaps the McCloskeys were aware of the Wilmarth picture since they were living in New York at the time.

32. *Los Angeles Herald*, January 26, 1895. The letter is in the collection of Tim Mason (Moure to author).

33. *Los Angeles Herald*, January 26, 1895.

34. See *Los Angeles Herald*, February 16, 1895.

35. In 1993 Nancy Moure interviewed the McCloskeys' grandson, who communicated this to her. The author is grateful to Moure for sharing this information. In many of the McCloskeys' pictures luxury items are included: rich textiles, objets d'art, and period furnishings. The sumptuous settings for their genre and still-life paintings probably reflect their luxurious lifestyle.

36. Reprinted in the *Los Angeles Herald*, January 26, 1895.

37. Vysekal was the author of a *Los Angeles Times* column titled "Counterfeit Present-ments," a series of character sketches of unidentified artists.

38. Printed by Carl A. Bundy Quill & Press, Los Angeles, 1930.

39. Interview with the author, July 13, 1994. I am indebted to George Stern of George Stern Fine Arts for arranging the contact with Marion's family.

40. Arthur Millier, "Our Artists in Person: Marion Kavanagh Wachtel," *Los Angeles Times*, November 8, 1931.

41. Everett C. Maxwell, *South Coast News* (Laguna Beach), n.d., in the Ferdinand Perret Papers, Archives of American Art, roll nos. 3864–65.

42. According to Paul Benesik, Curator of the Santa Fe Railway Art Collection, Marion Kavanaugh (later Wachtel) traveled on the Santa Fe Railway to Southern California sometime in 1903 or 1904. To reach San Francisco would have required switching to a branch line at San Bernardino. In the author's opinion, Marion went to Los Angeles and met Elmer through mutual friends; she never studied with Keith, who, according to Alfred Harrison, was not teaching at the time (author's communication with Harrison, Keith authority and director of North Point Gallery, San Francisco). The confusion may lie in the fact that Elmer studied with William Keith in San Francisco sometime between 1892 and 1893 (see *Los Angeles Herald*, November 18, 1894).

Marion Wachtel's maiden name was spelled "Kavanaugh," but she later changed the spelling to Kavanagh. For the original spelling, see "Artist Biographical Files," deposited in the California State Library, Sacramento. She enrolled in three life classes at the School of the Art Institute of Chicago, from February to April 1895 (Wachtel's SAIC transcript from the Registrar/Archivist Richard Lynch).

43. Dudley Crafts Watson, "Beauty at the Art Institute," n.d., newspaper clipping, Ferdinand Perret Papers, Archives of American Art, roll nos. 3864–65.

44. Published November 10, 1912, and November 2, 1924 respectively.

45. *Pasadena Star-News*, April 18, 1940; Pasadena Community Book, 1943, in "California (Pasadena) Biography," Pasadena Public Library; and *Pasadena Star-News*, March 29, 1944.

46. *California Southland*, April/May 1919. Among the other artists in the club were R. Clarkson Colman, president, Maurice Braun, Benjamin Brown, Edgar Payne, Guy Rose, Hanson Puthuff, Jack Wilkinson Smith, Elmer Wachtel, William Wendt, and John F. Kanst, secretary and treasurer. Exhibitions were held at the Kanst Art Galleries in Los Angeles.

47. *Palo Alto Times*, November 6, 1935. A beautiful print of her watercolor *The Oaks* is in the family's collection.

48. "The Herter Memorial," *The American Magazine of Art*, 18 (June 1927): 299.

49. 45:189.

50. *California Arts & Architecture*, December 1929, n.p. Unfortunately, El Mirasol was razed in the 1960s and the murals were purportedly stolen after being removed from the walls. Another rumor is that the murals were

removed and given to the I. Magnin store in Santa Barbara. The author has not substantiated either report.

51. *Santa Barbara News-Press,* September 17, 1971.

52. Pages 510–12. The exact date of the murals is unknown, since the house has had a number of owners.

53. *The Western Woman,* March 1931: 11–12.

54. *Memorial Exhibit of the Paintings of Albert and Adele Herter,* assembled by their late daughter's companion, Miss Ingeborg Praetorius. Catalogue courtesy of Michael Redmon, librarian, Santa Barbara Historical Society.

55. Ernest Watson, *Twenty Painters,* 11, quoted in Patricia Trenton and Deborah Epstein Solon, *Birds, Boughs, & Blossoms: Jessie Arms Botke (1883–1971)* (Los Angeles and Carmel: Karges Fine Art, 1995). All information on the Botkes comes from this source.

56. Rena Neumann Coen, *The Paynes, Edgar & Elsie: American Artists* (Minneapolis: Payne Studios, 1988), 72. As young married couples, the Botkes and Paynes had been friends in Chicago during their early careers, a friendship that endured throughout the years. Coen's research is based on the family's archival records, with the assistance of the Paynes' daughter, Evelyn, and her husband, Dr. John B. Hatcher.

57. Coen, *The Paynes,* 71.

58. Ibid., 76.

59. Arthur Millier, "Our Artists in Person: Kathryn W. Leighton," *Los Angeles Times,* January 5, 1936.

60. On an "artist index card" dated June 1925 and deposited in the California State Library in Sacramento, Leighton lists the titles of her principal works: *Grinnell Glacier* (purchased by the president of Great Northern Railroad); *Desert Bloom; Spring in the Coachella Valley; Lake George;* and *Mount Rainier.* This indicates that Leighton had not yet begun to paint Native American portraits.

61. The author wishes to express her gratitude to Ginger Renner, who checked the Ginger and Frederic Renner Archives on Russell for this information. While at Bull Head Lodge, Kathryn painted two landscapes (one of them signed and dated) on a muslin divider that separated the beds of Russell's guests. The Leightons are listed on the Bull Head Lodge guest register as well.

62. The author is grateful to Brian W. Dippie, Professor of History, University of Victoria, Canada, for this information. Dippie states Russell had exhibited at the Biltmore Salon from March 26 to April 9, 1924, and the Russells probably met the Leightons again when Russell came to Los Angeles for a short visit in November 1924. Kathryn Leighton became a member of Painters of the West in May 1925, and Edward Leighton was secretary of the member-owned Biltmore Salon. Dippie mentioned that the Leightons had rented a cabin at Apgar on Lake McDonald for the summer of 1925. He believes it is "doubtful" that Kathryn got to the Blackfeet reservation that summer, which validates the author's own opinion. Russell's letter to Los Angeles artist Carl Oscar Borg, August 29, 1925, mentions the Leightons' presence at Bull

Head Lodge (see Dippie, *Charles M. Russell, Word Painter: Letters 1887–1926* [Fort Worth, Tex.: Amon Carter Museum, 1993], 379–80). When Russell died in October 1926, Edward Leighton sent a letter of condolence on his law firm's stationery to Nancy Russell (Kathryn was ill at the time).

63. Before this time Leighton's exhibition records and the media reports mentioned only her landscapes and portraits of non-Indian subjects (see Nancy Moure, *Dictionary of Southern California Artists*).

64. *Los Angeles Evening Express,* October 1, 1926.

65. Since the merger of the Great Northern and the Burlington Railroads in 1970, the Great Northern art collection has been dispersed and many of its paintings lost (author's conversation with the railway archivist). *Grinnell Glacier,* painted in 1923, is recorded on the Great Northern's inventory sheet in November 1925, which confirms Leighton's contact with the railroad and its then president Ralph Budd (Dennis Meissner, Manuscripts Processing supervisor, Minnesota Historical Society, Saint Paul, found this record in the president's file).

66. Leighton quoted in *Indians, Flowers and Landscapes of Glacier National Park by Kathryn W. Leighton,* January 30 to February 11, 1928, Robert C. Vose Galleries, Boston.

67. *Portraits of North American Indians/Exhibition of Paintings/by Kathryn W. Leighton,* The Abbey Gallery, London, July 1929. Nine portraits of Indians painted in Glacier National Park, Montana, on exhibit at M. Knoedler and Company Galleries, Paris, in January 1930; reviewed in *Paris Montparnasse,* January 15, 1930. The author is grateful to Robert C. Vose, Jr., for his assistance in obtaining copies of these catalogues.

68. There are several versions of *Chief Standing Bear,* one of the chief standing full figure with a buffalo robe wrapped around him toga-fashion. In a letter to Bill Ehrheart, dated October 13, 1993, archivist Marcella Cash of the Sinte Gleska College, Rosebud Sioux Reservation, South Dakota, writes that Luther was "probably of mixed Oglala-Brule background" based on early Rosebud census lists. Luther's birth date comes from this source and his death date from the *Los Angeles Times,* February 24, 1939.

69. Boston and New York: Houghton Mifflin, 1928.

70. "Notebooks on California Artists," Ferdinand Perret papers, Archives of American Art, roll no. 3859.

71. Ferdinand Perret papers, Archives of American Art, roll no. 3859.

72. The author contacted Miriam Matthews, retired Los Angeles librarian and collector of African American archival material; Rick Moss, Program Manager for History, California Afro-American Museum, Los Angeles; and Professor Emeritus Samella S. Lewis, author of recent publications on African American artists, as well as other scholars, but none was able to shed light on Lula Josephine Adams (Mrs. Daniel Adams). Little is known about Adams except that she is recorded in the *Negro Year Books* from 1918 to 1938 as "a promising artist." In the 1932 issue of *California Arts & Architecture* she is listed among Los

Angeles's professional artists with a Venice address. She was not a member of the Los Angeles Negro Art Association or the Allied League of Art, both established in the mid-1930s, according to Miriam Matthews, a former member of both associations. It is likely that Adams sold her work to friends and patrons by means of personal contact, while working in obscurity. After residing in Southern California for almost sixty-five years, Lula Adams died in Los Angeles in 1952, leaving an unmarried daughter, Elizabeth Adams, as her informant.

Rick Moss said that "it is safe to assume that any African American artist in Los Angeles prior to the 1930s would have produced their art in relative obscurity. This would be especially true for Black female artists. Arriving in Southern California around 1890, Lula Adams would have been part of the first major wave of African American migrants to come to the southern part of the region. Uncharacteristic of subsequent migrations, this early group of African Americans did venture west to escape racism of the southern states. Traditional forms of racism were prevalent in California as elsewhere, but the numbers of African Americans arriving in the 1880s and 1890s were relatively small (fewer than 2,000 in a total population of 50,000). While African Americans at that time could settle in various locations, including what is now West Los Angeles, the kinds of 'acceptable occupations' in which they could earn a living were proscribed."

73. Anderson quoted in Harold Smithson, "Nell Walker Warner," *How Nell Walker Warner Paints in Oils* (Tustin, Calif.: Walter T. Foster, c. 1950s).

74. An instruction book published by Walter T. Foster, *How Nell Walker Warner Paints in Oils* (c. 1950s), illustrates the techniques she utilized in constructing her Hawaiian floral compositions.

75. "Inspiration in the Desert," *The Western Woman,* January 1938, 54.

76. "The plants pictured are probably Echeverias. Echeveria is a genus of plants that mainly comes from Mexico. . . . It is possible that one or two of the plants may have been Hybrids as Echeveria were quite popular at that time [1930s]" (Joe Clements, Curator of the Desert Garden, The Huntington Botanical Gardens, San Marino, letter to author, August 11, 1994).

This painting may be *Blooming Echeverias,* about 1933, which was exhibited at The Friday Morning Club, Los Angeles, from January 1 to 31, 1933, #17.

77. "By 1889 the encampment [Laguna] already had a reputation as a place of beauty" (see Moure, *Loners,* 110).

78. Hills attributed her early inspiration to the Barbizon school of painting, which she eventually broke away from with her high chromatic range of color ("Art and Artists," *The Graphic,* April 22, 1916).

79. In 1901–2 she studied at the Art Institute (Hills's transcript record, courtesy of Richard Lynch, Registrar/Archivist at SAIC).

80. From Hills's obituary (Arthur Millier, *Los Angeles Times,* July 7, 1931 and the Laguna Art Museum archives, courtesy of Bolton Colburn, Collections Manager).

81. See Patricia Trenton and Roberta Gittens, "Donna Norine Schuster (1883–1953): Afloat on the Currents of Change," *Southwest Art*, 22 (February 1993): 68–74, 132.

82. *Los Angeles Times*, August 13, 1922.

83. According to the Payne's daughter Evelyn Payne Hatcher, in 1940 when the society formed Elsie was more liberal in her thinking and leaned toward the modern movement. In 1943, however, she had a change of heart and began exhibiting with the group.

84. Edgar Payne quoted in "The Los Angeles Branch of the Society for Sanity in Art, Inc./ 1940/Directory and Catalog/First Exhibition of Paintings/Sculpture and Miniatures/State Building, Exposition Park/Los Angeles, April 1st to May 1st" (courtesy of Los Angeles County Museum of Art library). Emphasis added.

III. FORT *The Adventuresome, the Eccentrics, and the Dreamers*

ACKNOWLEDGMENTS: My research was greatly facilitated by the artists themselves, their families, friends, and dealers, as well as by colleagues. Heartfelt thanks to Dorr Bothwell and Beatrice Wood for allowing me to interview them; both conversations were quite enjoyable. Glenn Bassett (friend of Mabel Alvarez), Robert Cressey (son of Meta Cressey), Dorothy Miedecke (niece of Annita Delano), and Mr. and Mrs. William F. Thomas (nephew of Adele Watson) kindly shared personal reminiscences. The art dealers Lee Clark, Whitney Ganz, Mike Kelley, Tobey Moss, and Steve Turner, all of whom have realized the significance of these various modernists, were also generous with their time. The assistance of Susan Anderson, Bruce Kamerling, Nancy Moure, Katherine Noble, Martin E. Petersen, Allan Russack, Naomi Sawelson-Gorse, and Stephanie Strass must also be acknowledged.

NOTES

1. Stanton Macdonald-Wright, "Art Stuff," *Rob Wagner's Script* 27 (November 21, 1942): 14. I would like to thank Will South, who is preparing a monograph on Macdonald-Wright, for bringing this article to my attention.

2. Nancy Moure, "Long Beach Art Association History," unpublished typescript, pt. 2, n.p.

3. Everett Gee Jackson expressed typical male chauvinism when he explained that the Contemporary Artists of San Diego, founded about 1929, included no women because there were no competent female artists in the city. Everett Gee Jackson, interview with Bruce Kamerling, 1985, Oral History Collection, San Diego Historical Society.

4. Antony Anderson, "A Fly in the Ointment," *Los Angeles Times*, August 31, 1919, sec. 3, 2.

5. The *Los Angeles Times*, the most conservative newspaper in the city, was the only daily or weekly publication in the area with an art column written by a man, first Antony Anderson and later Arthur Millier.

6. *Aspects of California Modernism, 1920–1950* (Washington, D.C.: Federal Reserve Board Gallery, 1986), essay by Diane Moran; and

Paul J. Karlstrom and Susan Ehrlich, *Turning the Tide: Early Los Angeles Modernists, 1920–1956* (Santa Barbara, Calif.: Santa Barbara Museum of Art, 1990).

7. Southern Californians were merely reflecting a national trend that started, according to Judy K. Collischan Van Wagner, in the 1930s. *Women Shaping Art: Profiles of Power* (New York: Praeger, 1984), 2, 5.

8. "Society," *Toledo Daily Blade*, October 17, 1912, clipping in (Fanny) Adele Watson papers, private collection.

9. Adele Watson to Katherine Watson, January 14, 1904 and January 27, 1917, Watson papers.

10. Agnes Pelton to Raymond Jonson, September 4, 1933, Raymond Jonson archival collection, Jonson Gallery, University of New Mexico, Albuquerque (Archives of American Art, Smithsonian Institution, Washington, D.C., roll RJ 4, frame 2562).

11. In her letters to Edward Weston written in 1927 from Mexico, Shore refers to a misunderstanding that she had with Helena Dunlap, her studio-mate in Los Angeles, in terms that imply a close and caring relationship. Roger Aitkin in his article "Henrietta Shore and Edward Weston," *American Art* 6 (winter 1992): 55–60, discusses at length and conjectures on Shore's sexuality and the issue of sexual metaphor in her art, noting that in the opinion of Weston's son Brett, Shore was attracted to women. Bruce Kamerling suggests that Baranceanu might have been a lesbian, despite her love affair with her teacher, Anthony Argola; to support this assumption he cites an incident at the Art Institute of Chicago and her preference for wearing pants (Kamerling, "Belle Baranceanu biography," forthcoming catalogue on three San Diego women modernists).

12. Dorothy Miedecke (Delano's niece), interview with author, December 18, 1993.

13. Margaret Stainer, "Agnes Pelton," in Jan Rindfleisch, ed., *Staying Visible: The Importance of Archives* (Cupertino, Calif.: De Anza College, 1981), 8.

14. Adele Watson to Katherine Watson, December 29, [?], Watson papers.

15. Henrietta Shore to Edward Weston, September 3, 1927, Edward Weston Archives, Center for Creative Photography, Tucson; quoted with consent of Shore's heirs, Nicholas André and the late Anthony Hollinrake.

16. Dorr Bothwell interview with Bruce Kamerling, February 3, 1980, Oral History Program, San Diego Historical Society; and Dorr Bothwell interview with author, November 6, 1994.

17. James Oles, *South of the Border: Mexico in the American Imagination, 1914–1947* (Washington, D.C.: Smithsonian Institution Press, 1993), 3, 5, 55, 87.

18. Alvarez Diary, May 3, 1930 and June 30, 1934 entries, Mabel Alvarez papers, Archives of American Art; Glenn Bassett, interview with Patricia Trenton and author, March 21, 1993; and Bram Dijkstra, "Belle Baranceanu and Linear Expressionism," in *Belle Baranceanu—A Retrospective* (La Jolla: Mandeville Gallery, University of California, San Diego, 1985), 23–24.

19. Judy Rocle to Bruce Kamerling, October

1, 1985, curatorial file, San Diego Historical Society.

20. Carey McWilliams, *Southern California: An Island on the Land* (Santa Barbara and Salt Lake City: Peregrine Smith, 1973), vii. Originally published as *Southern California Country: An Island on the Land* (New York: Duell, Sloan, and Pearce, 1946).

21. Bruce Kamerling suggested the fondness of San Diego women for less popular subjects as one reason they have suffered from historical obscurity. "Painting Ladies," *Journal of San Diego History* 32 (summer 1986): 148.

22. "Pictures of Places," *Los Angeles Times*, October 22, 1911, sec. 3, 21.

23. Fleischer Museum Collection, Scottsdale, Arizona.

24. Martin E. Petersen ("Alice Klauber: San Diego's First Lady of the Arts," unpublished paper, 1984, n.p.) theorizes that Barney might have been responsible for suggesting that Klauber join the Henri class. Although Barney attended school and painted in Northern California before her New York training, it is not known whether she visited San Diego before settling there in 1921 with her new husband.

25. Esther Stevens Barney quoted in Hazel Boyer Braun, "Art Comment," *San Diego Tribune*, July 20, 1929, clipping in Scrapbook, Library, San Diego Museum of Art.

26. Kamerling, "Painting Ladies," 158.

27. The author is strongly indebted to McWilliams's discussion of cults in *Southern California*, 249-72; and in his autobiography *The Education of Carey McWilliams* (New York: Simon and Schuster, 1978), 46–47.

28. Nancy Moure, "Laguna Beach Art Association History," typescript, pt. 2, n.p.

29. McWilliams, *The Education of Carey McWilliams*, 47; and Everett Carter, "Hamlin Garland," in *Dictionary of American Biography*, 11:219.

30. Claude Bragdon, "Delphic Woman," originally published in *The Forum*, reprinted in Bragdon's *Delphic Woman: Twelve Essays* (New York: Alfred A. Knopf, 1936, 1945), 3–11.

31. Bothwell to Sally [?], March 26, 1973, Dorr Bothwell papers, Archives of American Art; and "Profile," *Mendocino Art Center Arts and Entertainment Magazine*, September 1978, 8–9.

32. Alvarez Diary, October 28, 1917.

33. Ibid., June 8, 1919.

34. Ibid., March 17, 1919.

35. *Dreams, Visions and Imagination* (Montecito, California: Maureen Murphy Fine Art Gallery, 1990), n.p.

36. For example, Alvarez Diary, November 7, 1919 and January 11, 1921.

37. Alvarez might have known of Kandinsky's writing through her friend Shore, but she also could have learned about color theory in Macdonald-Wright's class. On January 12, 1920, Alvarez wrote, "W.L.C. [Comfort] talk brot [sic] just what I needed. Interesting things in color, line, and form opening up at same time through Macdonald Wright class."

38. Annie Besant and C. W. Leadbeater, *Thought-Forms* (1901; reprint, Wheaton, Ill.: Theosophical Publishing House, 1969), 22–24; and Wassily Kandinsky, *Concerning the Spiritual in Art, and Painting in Particular* (1912;

English trans. reprint, Documents of Modern Art series, no. 5, New York: George Wittenborn, 1972), 43–66.

39. Watson may have met Davies through Gibran, who admired and knew Davies and whose romantic drawings also reflected Davies's influence.

40. Watson to Katherine Watson, July 30, 1899, Watson papers.

41. Arthur Millier quoted in *Adele Watson* (New York: Studio Guild, n.d.), n.p.

42. Agnes Pelton, in *Imaginative Paintings by Thirty Young Artists of New York City* (New York: Knoedler Galleries, 1917), n.p.

43. Agnes Pelton, "Abstract Paintings," n.d., typescript, Agnes Pelton papers, Archives of American Art, roll 3427, frame 180; and "Abstractions in Color," in *Abstractions by Agnes Pelton* (New York: Montross Gallery, 1929), n.p.

44. She had painted a portrait of Comfort's daughter Jane in 1929 when she visited Taos.

45. Pelton Diary, August 16, 1932, Pelton papers, roll 3426, frame 659.

46. Pelton quoted in "Agnes Pelton Tells About Modern Art in the Abstract," *The Desert Sun*, February 16, 1934, clipping in Pelton papers, roll 3427, frame 595.

47. Maurice Tuchman, "Hidden Meanings in Abstract Art," in *The Spiritual in Art: Abstract Painting, 1890–1985* (Los Angeles and New York: Los Angeles County Museum of Art and Abbeville Press, 1986), 43.

48. Pelton Diary, January 1, 1937, Pelton papers, roll 3426, frame 785.

49. Pelton, *The Desert Sun*, February 16, 1934, Pelton papers, roll 3427, frame 595.

50. Besant and Leadbeater, *Thought-Forms*, 15–17.

51. Dane Rudhyar, "An Experience in Light," in *Agnes Pelton Paintings* (Santa Barbara: Santa Barbara Museum of Art, 1943), n.p.

52. Dane Rudhyar, *Transcendental Painting Group* (Santa Fe: Transcendental Painting Group, [1938]), n.p.

53. Beatrice Wood, *I Shock Myself: The Autobiography of Beatrice Wood*, ed. Lindsay Smith (Ojai: Dillingham Press, 1985), 59–60, 78–79, 96–97, 113–14. Wood recounted her trip to Holland in the amusing *The Angel Who Wore Black Tights* (Ojai: Rogue Press, 1982).

54. Grace Clements, "Pluto, Uranus and Modern Art: The Armory Show, 1913," paper presented at the AFA Convention, Washington, D.C., 1966, typescript, 7, David Forsberg papers, Archives of American Art, roll 4048, frame 166.

55. Sanford Gifford, "The American Reception of Psychoanalysis, 1908–1922," in Adele Heller and Lois Rudnick, eds., *1915: The Cultural Moment* (New Brunswick, N.J.: Rutgers University Press), 128–40.

56. Annita Delano, interview with James V. Mink, 1971, Oral History Program, University of California, Los Angeles, 1: 81–82, 158, 160.

57. Barney was supposedly greatly interested in Surrealism, as evidenced by *The Conquest of Time* and *The Conquest of Space*, two lost works mentioned by Harold Kerr, "Art Biographies," *San Diego Evening Tribune*, February 18, 1939, sec. A4, 6.

58. Although Whitney Chadwick focuses on artists who first encountered the avant-garde aesthetic in Europe, much of what she says applies equally to the Southern California modernists. My generalizations about women Surrealists are therefore indebted to Chadwick's *Women Artists and the Surrealist Movement* (New York: Thames and Hudson, 1991).

59. Weston quoted in "Henrietta Shore and Destiny," *Monterey Peninsula Herald*, November 1, 1946, 4.

60. The Buck Collection.

61. Joe Solman, "The Post Surrealists of California," *Art Front* 2 (June 1936): 12.

62. Sheldon Memorial Art Gallery, University of Nebraska, Lincoln.

63. The brochure has been reprinted in *80th, a Birthday Salute to Helen Lundeberg* (Los Angeles: Los Angeles County Museum of Art, American Art Council, 1988), 4.

64. Grace Clements, "New Content—New Form," *Art Front* 2 (March 1936): 8–9. According to Lundeberg and Clements, Post-Surrealists aimed to create "an art which achieves classical unity through multiple perception, visual, psychological and philosophical."

65. "Los Angeles Museum's Third Group Show," *Arts and Architecture* 61 (October 1944): 21.

66. Bothwell, interview with author.

67. Chadwick, *Women Artists and the Surrealist Movement*, 39, 65–66.

68. Stendahl Art Galleries in Los Angeles occasionally demonstrated an openness to such avant-garde art with exhibitions in the 1930s on Cubism, Synchromism, the Blue Four (Lyonel Feininger, Alexei Jawlensky, Kandinsky, and Paul Klee), and Picasso's *Guernica*.

69. Naomi Sawelson-Gorse, "Hollywood Conversations: Duchamp and the Arensbergs," in Bonnie Clearwater, ed., *West Coast Duchamp* (Miami, Fla. and Santa Monica, Calif.: Grassfield Press with Shoshana Wayne Gallery, 1991), 25–29.

70. Delano, interview, 1: 90, 113–14, 159; and Marianne Lorenz, "Kandinsky and Regional America," in Gail Levin and Marianne Lorenz, *Theme and Improvisation: Kandinsky and the American Avant-Garde, 1912–1950* (Dayton, Ohio, and Boston: Dayton Art Institute and Little, Brown, 1992), 156–59.

71. Milton W. Brown, *American Painting from the Armory Show to the Depression* (Princeton, N.J.: Princeton University Press, 1955), 160.

72. Alvarez Diary, May 2 and 11, 1925, Alvarez papers.

73. Frederick Schwankovsky, *The Use and Power of Color* (Los Angeles: Duncan, Vail Co., 1931), copy in Schwankovsky file, Perret papers, Archives of American Art, roll 3863, frames 674–696.

74. Frederick Schwankovsky, "Talking Shop: Dynamic Symmetry," *California Art Club Bulletin* 5 (December 1930): 4, reprinted (slightly edited) as "Dynamic Symmetry," *Art Digest* 5 (January 1, 1931): 29–30.

75. Virginia Osgood, "Elanor Colburn," typescript, Colburn file, Archives, Laguna Art Museum.

76. Elanor Colburn, quoted in *Memorial Exhibition: The Paintings of Elanor Colburn* (San Diego: Fine Arts Gallery of San Diego, 1939), n.p.

77. Louis Danz, quoted in *Exhibition of Abstracts by Ruth Peabody* (San Diego: Fine Arts Gallery of San Diego, 1939), n.p., reprinted from Danz's *The Psychologist Looks at Art* (London: Longmans, Green, 1937), 216.

78. Peabody quoted in Marg Loring, "Exhibit of Ruth Peabody's Abstract Paintings Shown at Fine Arts Gallery," *San Diego Sun*, February 19, 1939, clipping in Scrapbook, p. 13, Library, San Diego Museum.

79. In the 1930s Elise and Shore were the only two modernists to whom monographs were devoted.

80. *Freeway*, 1936 (Bryce Bannatyne Gallery, Santa Monica, Calif.).

81. Robert C. Hay, "Dane Rudhyar and the Transcendental Painting Group of New Mexico," master's thesis, Michigan State University, 1981, 43; and Lorenz, *Theme and Improvisation*, 1992, 124, 127.

82. Elise had ample exposure to Kandinsky and the other artists of the Blue Four not only because of her husband but also through her friends in the Arensberg and Scheyer circles.

83. Mike Davis, *City of Quartz: Excavating the Future in Los Angeles* (New York: Vintage Books, 1992), 32–33.

84. For example, Watson to Katherine Watson, April 7, 1931, Watson papers; and Alvarez Diary, October 28, 1934, Alvarez papers.

85. Helen Lundeberg, interview with Jan Butterfield, 1980, California Oral History Project, Archives of American Art, roll 3198, frame 572.

86. Clements, "New Content—New Form," 9.

87. Information culled from the Still Pictures Division of the National Archives as well as from Steven M. Gelber, "Guide to New Deal Art in California," in *New Deal Art: California* (Santa Clara, Calif.: de Saisset Art Gallery and Museum, University of Santa Clara, 1976).

88. Susan M. Anderson, "Dream and Perspective: American Scene Painting in Southern California," in Ruth Lilly Westphal and Janet Blake Dominik, eds., *American Scene Painting: California, 1930s and 1940s* (Irvine, Calif.: Westphal Publishing, 1991), 18–19.

IV. HALPER *Northwestern Exposure*

ACKNOWLEDGMENTS: The research assistance of Ann Wagner, Seattle, Washington and Catherine Johnson, Eugene, Oregon was crucial to the writing of my essay. I am grateful for their intelligence, enthusiasm, persistence, and good humor.

Surviving artists, their families, and friends supplied essential information. I am particularly indebted to Ward Beecher, grandson of Harriet Foster Beecher; Leslie Brockelbank, grandniece of Maude I. Kerns; Doris Jensen Carmin, daughter of Dorothy Dolph Jensen; Katie Dolan, niece of artist Kathleen Houlahan; Robert Engard, friend of

Z. Vanessa Helder; Miro FitzGerald, daughter of Margaret Tomkins; Peggy Frazier, grandniece of Helen Loggie; Wright Helder, brother of Z. Vanessa Helder; Yvonne Humber, artist; and Joan Wahlman, niece of Viola Patterson.

Professionals in the art world freely shared their knowledge and enlarged my horizons. Among them are: Lynn Anderson, Washington State Historical Society, Tacoma; Len Braarud, Braarud Fine Art, La Conner, Washington; Jan Budden, historian and collector; Laura Brunsman, art historian; Jack Cleaver, Oregon Historical Society; Ronald Fields, University of Puget Sound; David Foster, University of Oregon emeritus; Martha Fulton, Museum of History and Industry, Seattle; Tommy Griffen, University of Oregon Museum of Art; Robert Joki, Sovereign Gallery, Portland; Glenn Mason, Eastern Washington Historical Society; David Martin, Martin-Zambito Fine Art, Seattle; Keith Richard, University of Oregon; Prudence Roberts, Portland Art Museum; Evearad Stelfox, Lane County Historical Museum, Oregon; Derrik Valley, State Capitol Museum, Washington; and Fran Yates, Arkansas State University.

Drafts of this essay were read by Chiyo Ishakawa, Seattle Art Museum; Barbara Johns, Tacoma Art Museum; Martha Kingsbury, University of Washington; Suzanne Kotz, editor; David Martin, Martin-Zambito Fine Art, Seattle; and Ann Wagner, research assistant. I thank them for their helpful comments and take full responsibility for errors I failed to correct. Susan McKinney prepared the final manuscript for publication.

NOTES

1. Nellie Centennial Cornish, *Miss Aunt Nellie: The Autobiography of Nellie C. Cornish* (Seattle: University of Washington Press, 1964), 67.

2. Ibid., 119.

3. Glen Mason personal files (Western Washington Historical Society, Spokane).

4. Jack Cleaver to author, May 17, 1994.

5. A few galleries and collectors currently specialize in regional art prior to World War II, although the bulk of their holdings postdate 1930. Particularly notable are David Martin, Martin-Zambito Fine Art, Seattle; Robert Joki, Sovereign Gallery, Portland, Oregon; Jan Budden, Camano Island, Washington; and Braarud Fine Art, La Conner, Washington.

6. Agnes Barchus, *Eliza R. Barchus, The Oregon Artist* (Portland: Bindord & Mort, 1974).

7. Beecher quoted in J. Kingston Pierce, "Strokes of Genius," *Washington Magazine,* December 1987, 62.

8. Ronald Fields, ed., "Abby: Notes from the Wilderness, 1895–1906" (unpublished transcripts with commentary), October 15 and 21, 1902.

9. Ibid., November 27, 1906.

10. It is clear from Hill's journals that she was rarely a lone adult and was often besieged by tourists while in the wilderness. Biographer Ronald Fields believes that it was not isolation but the "special rank and authority" accorded to Hill in the wilderness that made it so attractive. In his manuscript, Fields states his belief that Hill's "overriding concern is an idealized self image" (ibid., 7–8).

11. *Tacoma Times,* December 6, 1948.

12. *No. 2,* 1912; Philadelphia Museum of Art.

13. Portland collector and museum backer Sarah H. Lewis was instrumental in bringing this work to Oregon, according to her obituary in the *Eugene Register Guard,* January 6, 1964.

14. Cornish, *Miss Aunt Nellie,* 136. The influence and seriousness of women's groups has generally been underrated. Nellie Cornish notes in her autobiography that fund-raising by a coalition of women's clubs saved the Seattle Symphony from certain demise in the early 1920s. The role of these clubs in the lives of women and in the community deserves further study.

15. There is no record of strong friendships or artistic influence among the women discussed in this essay, although Helder certainly had social contacts with Margaret Camfferman and other members of the Women Painters of Washington and knew Hilda Morris and Margaret Tomkins from their days together at the Spokane Art Center. In Eugene, Oregon, Maude Kerns and Anne McCosh were distant acquaintances.

16. "Walk a Little Faster," *Seattle Times,* December 20, 1936.

17. William Cumming, *Sketchbook: A Memoir of the 1930s and the Northwest School* (Seattle: University of Washington Press, 1984).

18. Other women fared less well with their artist-husbands. Imogen Cunningham and Roi Partridge were divorced in 1934 over Cunningham's independence (Richard Lorenz, *Imogen Cunningham: Ideas Without End* [San Francisco: Chronicle Books, 1993], 35) and University of Washington professor Walter Isaacs remarked to his wife after her sole attempt to paint after their marriage, "Mildred, in any family there is only room for one artist" (Cumming, *Sketchbook,* 177).

19. *New York Times,* February 21, 1938.

20. Helder's meticulous scrapbook was generously lent to the author by the artist's brother, Wright Helder.

21. 1937; Reina Sofia, Madrid.

22. Margaret Tomkins, interview with Bruce Guenther, Northwest Oral History Project No. 14, Archives of American Art, Smithsonian Institution, Washington, D.C.

23. The Northwest School of painting was defined by critics in the late 1940s and the 1950s and centered on Mark Tobey, Morris Graves, Guy Anderson, and Kenneth Callahan. It was characterized in part by muted colors and Eastern mysticism—a satisfying linking of murky local climate and Pacific Rim geography to a regional style of painting. Callahan, the Seattle Art Museum's curator until 1953 and an important art critic as well, was instrumental in defining the school and shaping the museum's regional painting collection to reflect his interests.

24. A wetly brushed, soft, naturalistic watercolor by Tomkins, *Wooded House,* is illustrated in the catalogue of the 1939 New York World's Fair exhibition: *American Art* (New York: New York World's Fair, 1939). Given the importance of the exhibition, the artist probably submitted her best and most representative work.

25. Ibid., 10.

26. Cumming, *Sketchbook,* 136.

27. Tomkins, interview, 31.

28. Yvonne Humber, interview with author, Seattle, June 28, 1993

29. Ibid.

30. Hilda Morris always wished to return to the East Coast, but her husband found he was unable to paint while living there.

31. Nancy Ross, *Farthest Reach: Oregon and Washington* (New York: Knopf, 1941), 187.

32. Martha Kingsbury and Rachael Griffen, "Portland and Its Environs," *Art of the Pacific Northwest: From the 1930s to the Present* (Washington, D.C.: Smithsonian Institution Press, 1974), 5.

33. *The Oregonian,* January 10, 1926, mentions a painting of "children around a fountain" that appeared in Stephens's exhibition at the Portland Art Museum of that year. Stephens, however, painted many pictures of children, and Robert Joki of Portland's Sovereign Gallery suggests a date of about 1935 for *Park Blocks* based on stylistic evidence. Additional documentation or firmly dated paintings by Stephens are needed before this one can be assigned a date.

34. Anne McCosh, interview with author, Seattle, June 27, 1993.

35. Anne McCosh, interview with Lotte Streisinger (University of Oregon Museum of Art files).

36. Marion S. Goldman, "Anne McCosh, Painting Possibilities," *CSWS Review,* Center for the Study of Women in Society, University of Oregon, 1989.

37. Linda P. Di Biase, *Culture at "the End of the Line": The Arts in Seattle, 1914–1983* (master's thesis, California State University, Los Angeles, 1984).

38. Frances Yates, *Remembering Artist and Educator Maude I. Kerns: An Historical Study Using Oral History Techniques and a Contextual Approach* (Ph.D. diss., University of Oregon, Department of Art Education, 1993), 10.

39. Louise Rickabaugh Smith letter about Maude Kerns, January 21, 1988, Lane County Historical Museum MS242. A significant number of important male and female artists active at the time also remained single, including Mark Tobey, Morris Graves, Guy Anderson, C.S. Price, Charles Heaney, Clara Jane Stephens, Ruth Penington, Helen Loggie, and Anna Gellenbeck. There are many reasons for remaining single, including homosexual orientation, and one should not assume that every professional woman was forced to choose between marriage and a teaching career.

40. Mimi Bell et al., *Maude Irvine Kerns, 1876–1965* (Eugene, Ore.: Kerns Art Center, 1988).

41. In 1944, Kerns wrote a lengthy letter to the art critic of the *Christian Science Monitor* comparing Kandinsky's teachings with excerpts from Mary Baker Eddy's *Science and Health.* See Maude Kerns papers, Lane County Historical Museum MS242.

42. Ibid.

43. Ibid.

44. *Seattle Times,* May 26, 1946.

45. "Time Present—Time Past," Kerns papers.

46. See Paul J. Karlstrom, "Observations on the Concept of Regionalism," in Barbara

Johns, *Modern Art from the Pacific Northwest* (Seattle: Seattle Art Museum, 1990) and Patricia Failing, "Temporary Indulgences: Exotic Cuisine and Regional Art," *Reflex,* May 1989.

V. MOORE *No Woman's Land*

ACKNOWLEDGMENTS: This essay has benefited enormously from the advice and assistance of many colleagues, librarians, scholars, collectors, and archivists. It is a pleasure to acknowledge them here with gratitude. Among those who have significantly aided my research, I thank Jessie Benton Evans Gray, Lucy Jane Jackson, Randi Lynn Kent, Virginia Couse Leavitt, René Verdugo, Edwin Wade, and Barton Wright. Thanks also to James Ballinger, Peter Bermingham, Paul Benisec, Carol Burke, Freda M. Chambers, Katherin Chase, Jeanne D'Andrea, Susan Deaver, Daphne Deeds, Michael DiMarco, Krista Elrick, William H. Gerdts, Don Gray, Mr. and Mrs. Michael Hard, Abe Hays, Ann Lane Hedlund, Jules Heller, Deb Hill, Bruce Hilpert, Karen Hodges, Ken Howell, Clayton Kirking, Lyman A. Manser, Beverly Miller, Jeffrey Mitchell, Dianne Nielson, Richard Pearce-Moses, Paul Piazza, Pat Ryans, Deborah Shelton, Ro Sipek, Deborah Solon, Joanne Stuhr, Norm Tessman, Mary Jane Williams, Sue Willoughby, Mr. and Mrs. Richard Wilson, Nancy Wright, Larry Yanez, and Robert Yassin. Finally, a warm thank-you to Patricia Trenton, without whose vision and perseverance this essay would not have been possible.

NOTES

1. May Noble, "Arizona Artists," *The Arizona Teacher and Home Journal,* February 1923, 7, 9.

2. Nancy J. Parezo, "Conclusion: The Beginning of the Quest," in Nancy J. Parezo, ed., *Hidden Scholars: Women Anthropologists and the Native American Southwest* (Albuquerque: University of New Mexico Press, 1993), 341.

3. Barbara A. Babcock, "By Way of Introduction," *Journal of the Southwest* 32 (winter 1990): 384. The entire issue of the journal is devoted to the theme "Inventing the Southwest."

4. Annette Kolodny, *Land Before Her* (Chapel Hill: University of North Carolina Press, 1984), xiv. This essay is limited to a discussion of European American women in Arizona, whose art added to the already well-established traditions of Native American, Mexican American, and Hispanic women.

5. Joan Scott, *Gender and the Politics of History* (New York, 1988), 29. See also introduction to Karen Offen, Ruth Roach, and Jane Rendal, eds., *Writing Women's History: International Perspectives* (Bloomington: Indiana University Press, 1991), xix–xli.

6. Territorial senator Ben Wade quoted in Sharlot M. Hall, "Arizona," *Out West* 24 (February 1906): 71.

7. Joan A. Jensen and Darlis A. Miller, "The Gentle Tamer Revisited: New Approaches to the History of Women in the American West," *Pacific Historical Review* 49 (May 1980): 175.

8. Kate T. Cory, "Life and Its Living in Hopiland: Good-Bye to the Steam-Cars," *The Border* 1 (May 1909): 1.

9. Ibid., 10. For information on Akin, see William H. Gerdts, *Art Across America: Regional Painting in America, 1710–1920,* vol. 3 (New York: Abbeville Press, 1990), 171; and Bruce E. Babbitt, *Color and Light: The Southwest Canvases of Louis Akin* (Flagstaff, Ariz.: Northland Press, 1973).

10. Charles Franklin Parker, "Sojourn in Hopiland," *Arizona Highways,* May 1943, 11.

11. Cory, "Good-Bye to Steam-Cars," 4.

12. "All the water used, except what can be caught from melting snow in winter and from rains during the two rainy months in the summer in a few small holes on the mesa tops, must be carried up the mesa on the back of the women in jugs holding about three gallons. This is the hardest thing in the life of a Hopi woman." J. G. Owens, *Natal Ceremonies of the Hopi Indians* (1892), in Barton Wright, Marnie Gaede, and Marc Gaede, *The Hopi Photographs: Kate Cory: 1905–1912* (La Cañada, Calif.: Chaco Press, 1986), opposite photograph number 2. For a review of this book see Peter M. Whiteley, "Book Reviews," *American Indian Quarterly* 14 (summer 1990): 325–26.

13. Parker, "Sojourn," 41.

14. Marnie Gaede notes that Curtis was active at the Hopi Reservation between 1904–6 and 1913, Vroman between 1895 and 1902, and Mora between 1903 and 1912 (*Hopi Photographs,* 3). For information on Curtis see Barbara A. Davis, *Edward S. Curtis, The Life and Times of a Shadow Catcher* (San Francisco: Chronicle Books, 1985). For information on Vroman see *Adam Clark Vroman: Photographs from the 1901 Museum-Gates Expedition* (Los Angeles: Southwest Museum, 1988). There is a book in press on Mora by Stephen Mitchell.

15. Such a sensitivity to the vernacular rather than the heroic has been noted in the work of other women photographers of the Southwest, including Laura Gilpin (1891–1979) and Nancy Newhall (1908–1974). See Martha A. Sandweiss, "Laura Gilpin and the Tradition of American Landscape Photography," and Malin Wilson, "Walking on the Desert in the Sky: Nancy Newhall, Words and Images," in Janice Monk and Vera Norwood, eds., *The Desert Is No Lady: Southwestern Landscape in Women's Writing and Art* (New Haven: Yale University Press, 1987), 62–73, 249–51, and 47–61, 248–49 respectively.

16. The author's observations on Hopi ceremonies and rituals, in particular those depicted in Cory's photographs and paintings, are indebted to Barton Wright, who shared his expertise and knowledge with the author in an interview, Phoenix, April 1, 1994. The titles appearing in brackets (plates 127, 128, 129) are attributed by Wright. Cory maintained scrapbooks of some of her photographs, which often included unspecific titles such as "Dance" or "Hopi Girl." Scrapbooks of her photographs are in the collections of the Smoki Museum, Prescott, and the Museum of Northern Arizona, Flagstaff.

17. The Kachina season begins with the winter solstice (December 21); Kachinas appear at Soyalangwu, the first ceremony of the year, which marks the return of the sun to its "winter house," and preparations begin for the planting season to come. The central focus of Cory's pueblo scene (plate 130) is the Hemis Kachinas, to the left, who pass four times around the kiva at dawn. The central figure in white, Eototo, is chief of the Kachina village and oversees all major ceremonies; the two figures to his left are the kiva chief and his assistant. Emerging from the kiva are the Hemis Manas, who will join the Hemis Kachinas in their march around the kiva. Behind the kiva stand four men holding prayer meal bags in front of them, from which they sprinkle the meal on the Kachinas as they pass; each is a chief who has participated in the Niman rite. At the Niman ceremony, which ends the Kachina season, the Kachinas return to their spiritual home in the sky, thus beginning the cycle anew. Outside the Kachina season, many women's societies perform ceremonies for health and prosperity, and to celebrate the harvest. Literature on Hopi religion and ceremonies is rather extensive; however, the author has found the following works to be the most informative: David W. Laird, *Hopi Bibliography: Comprehensive and Annotated* (Tucson: University of Arizona Press, 1975); Edmund Nequatewa, *Truth of the Hopi* (Flagstaff: Library of the Museum of Northern Arizona, 1936); Walter C. O'Kane, *The Hopis: Portrait of a Desert People* (Norman: University of Oklahoma Press, 1953); and Barton Wright, *Kachinas: A Hopi Artist's Documentary* (Flagstaff, Ariz.: Northland Press, 1973).

18. Unpublished text by Kate Cory at Smoki Museum, Prescott. Cory's text suggests that she returned to this painting after leaving the reservation in 1912 and completed it for the newly opened Smoki Museum in 1935. The dictionary and journal are in the Smoki Museum, Prescott. Facsimile editions are in the Museum of Northern Arizona, Flagstaff. For a list of Cory's articles, see Laird, *Hopi Bibliography,* 114–16.

19. Cory's painting was catalogue number 122 in the New York exhibition; number 75 in the Chicago exhibition. For general information on the Armory Show and a list of all works exhibited, see Milton W. Brown, *The Story of the Armory Show* (New York: Abbeville Press, 1988). Cory's painting is listed on p. 257.

20. Peter Whiteley discusses the Smoki enterprise as offensive to the Hopi and as a "process of cultural hegemony, a politics of representation wherein a dominant group appropriates and refigures a subaltern's cultural symbols as its own" in "The End of Anthropology (at Hopi)?," *Journal of the Southwest* 35 (summer 1993): 132. For a related discussion see also Linda Alcoff, "The Problem of Speaking for Others," *Cultural Critique* (winter 1991): 5–32. Additional information on the Smoki Museum and its history was provided by Ken Howell, Chairman of the Board of the Smoki Museum, during an interview with the author, Prescott, September 30, 1993.

21. Although no records have been found, it is reasonable to assume that Cory did not find the Smoki enterprise offensive. Between 1921 and 1935, during the time Cory was actively involved with the Smoki organization, she not only produced several large-scale paintings but published three articles on the Hopi Snake Dance that relate to her large narrative panel of the same subject. After this period Cory's production dropped off pre-

cipitously. See "The Snake Dance and Its Origins," *Arizona* 13 (August 1923): 4–5, 12; "A Realistic Story of the Great Hopi Indians," *Yavapai Magazine* 13 (May 1925): 7–12; and "A Weird Hopi Snake Dance is One of Reverence and Awe," *American Indian* 3 (December 1928): 6–7, 16.

22. For a discussion of women's roles in the early years of natural-history and anthropology museums and their relationship to the emerging discipline of anthropology, see Susan Brown McGreevy, "Daughters of Affluence: Wealth, Collectors, and Western Institutions," in Parezo, *Hidden Scholars*, 76–100; see 94–96 for information on Mary-Russell Ferrell Colton.

23. For a brief discussion of the first annual Arizona Artists Arts and Crafts Exhibition, see "1929 at the Museum," *Museum Notes* 2 (January 2, 1930): 3. Although these exhibitions were open to all residents of Arizona, one can reasonably assume that participants were largely from northern Arizona. Unfortunately, detailed exhibition records have not been located. In addition to the exhibitions of Arizona artists, Colton brought in contemporary and historical exhibitions under the auspices of the American Federation of Arts.

24. For information on Colton's early years and art training, see *American Art Annual* (Washington, D.C.: American Federation of Arts, 1929), 26:251–52; "Mary-Russell Ferrell Colton, 1889–1971," *Plateau* 44 (fall 1971): 38–40; *Mary-Russell Ferrell Colton* (Flagstaff and Phoenix: Museum of Northern Arizona and the Arizona Bank Galleria, 1982); Katherin L. Chase, *Brushstrokes on the Plateau* (Flagstaff: Museum of Northern Arizona, 1984), 22–23. See also "Mary-Russell Ferrell Colton," in Eleanor Tufts et al., *American Women Artists 1830–1930* (Washington, D.C.: National Museum of Women in the Arts, 1987) 176–77.

25. Mary-Russell F. Colton, "Wanted—a Market for Indian Art," *Southern California Business* 9 (October 1930): 24.

26. Circa 1930, Museum of Northern Arizona, Flagstaff.

27. Although primarily a landscapist, Colton painted other portraits of Hopi craftspeople with both aesthetic and ethnographic value. See for example *Sequoptewa, Hopi Weaver Spinning,* 1931 (Museum of Northern Arizona).

28. For information on the traveling exhibitions see "1931 at the Museum," *Museum Notes* 4 (February 1932): 1–2. Included among Colton's numerous publications on Hopi art and culture are: "Art for the Schools of the Southwest: An Outline for the Public and Indian Schools," *Museum of Northern Arizona Bulletin* 6 (February 1934): 1–34; "The Arts and Crafts of the Hopi Indians," *Museum Notes* 11 (July 1938): 3–24; "The Four Periods of a Hopi Woman's Life," *Indian at Work* 3 (December 1935): 26–28; "The Hopi Craftsman," *Museum Notes* 3 (July 1930): 1–4; and "The Hopi Indians: Craftsmen of the Southwest," *School Arts Magazine* 38 (October 1938): 39–44. A bibliography of Colton's writings appears in Colton's nomination form to the Arizona Women's Hall of Fame, November 25, 1980, prepared by Dorothy A. House, Librarian, Museum of Northern Arizona. Colton was among the first six inductees to the Arizona Women's Hall of Fame in 1981. See "Mary Colton Among 6 Women Named to State Hall

of Fame," *Flagstaff Daily Sun,* March 9, 1981. See also Laird, *Hopi Bibliography*, 106–9.

29. Colton and Nequatewa coauthored "Hopi Courtship and Marriage: Second Mesa," *Museum Notes* 5 (March 1933): 41–54; and "Hopi Hopiwime: The Hopi Ceremonial Calendar," *Museum Notes* 3 (March 1931): 1–4. Moreover, Edmund Nequatewa's *Truth of the Hopi* was originally edited by Colton and published in *Museum of Northern Arizona Bulletin* 8 (1936). For information on Nequatewa, see P. David Seaman, ed., *Born a Chief: The Nineteenth-Century Hopi Boyhood of Edmund Nequatewa* (Tucson: University of Arizona Press, 1993).

30. See Mary-Russell F. Colton and Edmund Nequatewa, "Hopi Legends of the Sunset Crater Region," *Museum Notes* 5 (October 1932): 17–23.

31. Harold Colton, "The Museum Is Ten Years Old," *Museum Notes* 10 (May 1938): 34, 36.

32. For biographical information on Smith's art training and early trips to Arizona, see Henry M. Norton, "Lillian Wilhelm Smith—Southwestern Artist," *Progressive Arizona* 12 (December 1932): 6, 16; Pauline Cooper Bates, "Arizona Women Worth Knowing: Former New Yorker Wins Recognition as Artist, Illustrator, Designer and Rancher," *Arizona Republic,* July 28, 1940; Mary Comfort, "Lillian Smith—She Remembers Western Author Zane Grey Well," *Prescott Courier,* March 3, 1965, 8; and Catherine M. Manley, "Lillian Wilhelm Smith," unpublished manuscript, Lillian Wilhelm Smith files, Sharlot Hall Museum Archive, Prescott. See also Chase, *Brushstrokes on the Plateau,* 20–21.

33. See Zane Grey, *The Rainbow Trail* (New York: Grosset and Dunlap, 1915). Smith illustrated at least one other book by Grey, *The Border Legion* (New York: Harper and Brothers, 1916).

34. Smith, in Comfort, "Lillian Smith," 8.

35. "Lillian Wilhelm Smith," February 9, 1936, unidentified newspaper clipping in Lillian Wilhelm Smith files, Sharlot Hall Museum Archive, Prescott.

36. "Exhibits Art," *Arizona Republic,* December 26, 1954.

37. Quoted in Chase, *Brushstrokes on the Plateau,* 20.

38. The first exhibition of any size in the territory was the Arizona Industrial Exposition in Phoenix in 1884. After a fourteen-year hiatus, the Arizona Territorial Fair Association incorporated in 1905, purchased eighty acres in Phoenix, and constructed two race tracks and a wooden grandstand. The site and its buildings were later expanded, and with Arizona's statehood in 1912 the name was changed to the Arizona State Fair. For a history of the fair, see C. S. Scott, "The First State Fair," *Arizona, the New State Magazine* 2 (October 1912): 4–5, 12; Al Wein, "The Arizona State Fair," *Progressive Arizona* 3 (October 1926): 15–16, and Lynn Adair, "Hi, Ho! Come to the Fair!," *Arizona Highways* 65 (October 1989): 4–9.

39. See Adair, "Hi, Ho! Come to the Fair!," 5. Dr. Jonas's demonstrations were noted in Wein, "State Fair," 16.

40. Scott, "First State Fair," 5.

41. Tracking the fate of the paintings purchased from the annual art exhibits at the

Arizona State Fair is difficult, as records are very scarce. It is reasonable to assume, however, that at least some of the paintings became part of the Phoenix Art Center collection, organized with federal funds in the late 1930s, and that they formed the nucleus of what ultimately became the Phoenix Art Museum.

42. For a history of the Temple of Music and Art see Bernice Cosulich, "The New Temple of Music and Art in Tucson," *Progressive Arizona* 5 (December 1927): 21–23. The activities of the Tucson Fine Arts Association were widely reported in the local press. For a history of the association, see Stella M. Roca, "Tucson's Fine Arts Association," *Tucson,* January 1933, 7, 11. Roca (1881?–1954) had studied at the School of the Art Institute of Chicago before coming to Tucson in 1915. A charter member of the Tucson Fine Arts Association, she was the association's self-styled historian, collecting clippings and ephemera related to art activities in Tucson. Her scrapbooks are in the collection of the Arizona Historical Society, Tucson.

43. "Exhibition by State Artists Opens in Society's Gallery," *Arizona Daily Star,* December 2, 1928; Cosulich, "The New Temple," 23.

44. For a discussion of the role of government support of the arts in Arizona in the 1930s, see Daniel A. Hall, "Federal Patronage of Art in Arizona From 1933–1943" (master's thesis, Arizona State University, 1974). Numerous clippings related to the founding and evolution of the Phoenix Federal Art Center are gathered in the Philip C. Curtis Archives, Arizona Room, Hayden Library, Arizona State University, Tempe. The role of women's clubs in the development of art in Arizona may also be considered within the broader history of women's organizations, which in the late nineteenth and early twentieth centuries provided not only fellowship, community, and autonomy for women but served as vehicles of entry into the public sphere. Recent studies chronicling the emergence of women's clubs at the turn of the century refer to these early organizations as manifestations of "social" or "domestic" feminism. See Karen J. Blair, *The Clubwoman as Feminist: True Womanhood Redefined, 1868–1914* (New York: Holmes and Meier, 1980), and Estelle Freedman, "Separatism as Strategy: Female Institution Building and American Feminism, 1870–1930," *Feminist Studies* 5 (fall 1979): 512–29.

45. See for example Société des Artistes Français, *Le Salon* (1911), 60; and *Salon de 1912,* 136. In both salons, she exhibited works painted in Italy.

46. Florence Seville Berryman, "An Artist of the Salt River Valley," *American Magazine of Art* 20 (August 1929): 450. For biographical information on Evans, see also Dee Dvoino, "Arizona's Own Noted Painters," *Arizona, the State Magazine* 12 (October 1922); and "Jessie Benton Evans," in *Arizona Women's Hall of Fame* (Phoenix: Arizona Historical Society, 1989), 8–10.

47. Evans, in Berryman, "An Artist," 452. Similar comparisons between Arizona and the so-called Old World were made by Harriet Monroe, "Arizona," *Atlantic Monthly* 89 (June 1902): 782, where she noted: "The sublimity of the Pyramids is endurable, but

at the rim of the Grand Canyon we felt out-done."

48. "Artists of Desert Tell Story of Southwest in Paintings Approved by Local Committee," *Arizona Republic,* June 24, 1934. See also "Project Brings Art Renaissance to Arizona," *Arizona Republic,* June 24, 1934; "Many Contributions by Arizona Artists Made in Public Works of Art Project," *Arizona Daily Star,* July 1, 1934; "Beauty of Arizona Is Stressed by Director of National Project," *Arizona Republic,* March 12, 1937, 2; and Alice B. Hewins, "Arizona Painters," unpublished field report, c. 1940, in collection of Arizona State Archives, Arizona Department of Library, Archives and Public Records, Phoenix.

49. For the most thorough account of federal support for the arts in Arizona in the 1930s, see Peter Bermingham, *A New Deal for the Southwest* (Tucson: University of Arizona Museum of Art, [1980]).

50. For biographical information on Thomas, see Mary Bach, "$1.25 an Acre in Mule-Powered Past," *Arizona Republic,* January 22, 1969, 7. See also Marjorie Thomas, unpublished letter, October 14, 1968, Arizona Archives, Arizona Department of Library, Archives and Public Records, Phoenix.

51. The author is indebted to Lucy Jane Jackson, daughter of Lucy Drake Marlow, who has kept extensive records on the career of her mother. See also "Lucy Drake Marlow Exhibits Work at Studio This Week," *Arizona Daily Star,* January 12, 1941, 5; and "The Staying Power of an Artistic Pioneer: the Work of Lucy Drake Marlow, Arizona Artist, Adventurer and Feminist," *Prescott Courier,* August 4, 1991, 3. Frederick Sommer had studied and practiced architecture in Rio de Janeiro and had a master's degree in landscape architecture before coming to Tucson in the early 1930s. At that time, he was interested in watercolor painting, which he taught at the school he founded with Marlow. Sommer went on to distinguish himself as one of the foremost photographers working in the United States.

52. "Artists of Desert Tell Story of Southwest in Paintings Approved by Local Committee," *Arizona Republic,* June 24, 1934. See also "Moeur Given Work of Art," *Phoenix Gazette,* May 21, 1934, 7.

53. Marlow painted portraits of Dr. Leroy Shantz, president of the university and founder of the school of music, and Dean Byron Cummings, anthropologist and director of Arizona State Museum.

54. Private collection.

55. University of Arizona Museum of Art, Tucson.

56. Barbara A. Babcock, "Bearers of Value, Vessels of Desire: The Reproduction of Pueblo Culture," *Museum Anthropology* 17 (October 1993): 43–57. This article elaborates on some of the ideas Babcock raised in *Pueblo Mothers and Children: Essays by Elsie Clews Parsons, 1915–1924* (Santa Fe: Ancient City Press, 1991). For a related discussion, see Trinh T. Minh-ha, *Woman, Native, Other: Writing Postcoloniality and Feminism* (Bloomington: Indiana University Press, 1989).

57. For biographical information on Hamlin see Donald J. Hagerty, "Edith Hamlin: A California Artist," unpublished interview, Univer-

sity of California, Davis, American Studies Program, 1981. See also Edith Hamlin, "Maynard Dixon: Painter of the West," *American West* 19 (November/December 1982): 50–58. The bibliography on Maynard Dixon is extensive; the most recent and authoritative biography of the artist is Donald J. Hagerty, *Desert Dreams: The Art and Life of Maynard Dixon* (Layton, Utah: Gibbs-Smith, 1993).

58. See James K. Ballinger, *Visitors to Arizona, 1846 to 1980* (Phoenix, Ariz.: Phoenix Art Museum, 1980), 150.

59. Dorothea Tanning, *Birthday* (Santa Monica: Lapis Press, 1986), 86.

60. Ibid., 81.

61. 1944, private collection.

62. For a discussion of Tanning's work within the purview of women and Surrealism, see Whitney Chadwick, *Women Artists and the Surrealist Movement* (New York: Thames and Hudson, 1985), especially 135–40. For biographical information on Tanning and a general discussion of Surrealism, see Jeffrey Wechsler, *Surrealism and American Art, 1931–1947* (New Brunswick, N.J.: Rutgers University Art Gallery, 1977).

63. Tanning, *Birthday,* 82.

64. C. Gregory Crampton, ed., *Sharlot Hall on the Arizona Strip: A Diary of a Journey Through Northern Arizona* (Flagstaff, Ariz.: Northwood Press, 1975), 4–5. For information on Sharlot Hall see Margaret F. Maxwell, *A Passion for Freedom: The Life of Sharlot Hall* (Tucson: University of Arizona Press, 1982); Parezo, *Hidden Scholars,* 80–82; and Nancy Kirkpatrick Wright, ed., *Sharlot Herself: Selected Writings of Sharlot Hall* (Prescott, Ariz.: Sharlot Hall Museum Press, 1992).

65. Sharlot M. Hall, "Women Who Broke Trails for Us," *Arizona, the New State Magazine* 2 (February 1912): 4.

VI. D'EMILIO AND UDALL *Inner Voices, Outward Forms*

ACKNOWLEDGMENTS: For research assistance we are grateful to Mariella Lange, Rose and George Kaplan, Zoe Starling, Ruth LaNore, and Emilie Goeser. For contributing curatorial expertise we thank Luba Rhodes, Suzan Campbell, Lydia Pena, and Phil and Marian Yoshiki Kovinick. Archival material and/or library assistance were received from Fenn Gallery; Gerald P. Peters Gallery; Phyllis Cohen, Chief Librarian, Museum of Fine Arts, Museum of New Mexico; Kathey Swan, Denver Public Library; Edna van McCleod; Gene Kloss; John C. Emmett and Dorothy Morang; Florence Miller Pierce; Theresa Curry, Director, The Hurd–La Rinconada Gallery; Wheelwright Museum of the American Indian; Eiteljorg Museum; Skip Miller, Curator/Associate Director, Kit Carson Historic Museums; Elizabeth Cunningham, Independent Curator, and former Curator, The Anschutz Collection; Sandra McKenzie; Margaret Lefranc; Gary Roybal, Museum Specialist, and James R. Marmon, former Archaeological Laboratory Curator, Bandelier National Monument; Martin Krause, Curator of Prints, Drawings, and Photographs, Indianapolis Museum of Art; James Moore, Director, and

Ellen Landis, Curator of Art, The Albuquerque Museum; Joan Tafoya, Curator of Collections and Registrar, Museum of Fine Arts, Museum of New Mexico; David Witt, Curator, Harwood Foundation Museum; The O'Keeffe Foundation; James Keny, Keny Galleries; Museum of Northern Arizona; David Martin, Martin-Zambito Fine Art; Geoffrey and Helen Cline, Cline Gallery; Richard Lampert and Mark Zaplin, Zaplin-Lampert Gallery; Nat Owings, Owings-Dewey Fine Art; Teresa Ebie, Registrar, Roswell Museum and Art Center; Arthur Olivas, Photo Archives, Museum of New Mexico; Paul Saavedra, Archivist, New Mexico State Records Center and Archives; Carol Stodgel, Historic Santa Fe Foundation; Gary M. and Brenda Ruttenberg; John Meigs, *The Seattle Times*; Leonor and Ernesto Mayans, Mayans Galleries; Eric Knee; Richard H. Engeman, Photographs and Maps Librarian, University of Washington Libraries; Jonathan C. Mintzer, The Hearst Corporation. Finally, we acknowledge the conservation expertise of Chiara Carcano-Carl, Conservation Services; and Claire Munzenrider, Director of Conservation, Museum of New Mexico.

NOTES

1. Mary Austin, *Taos Pueblo* (San Francisco: Grabhorn Press, 1930), 6, 7.

2. Marta Weigle and Kyle Fiore, *Santa Fe and Taos: The Writer's Era 1916–1941* (Santa Fe: Ancient City Press, 1982), 11.

3. Rita Simmons, "Ila McAfee," *Southwestern Art* 20 (September 1990): 100.

4. T. J. Jackson Lears, *No Place of Grace: Antimodernism and the Transformation of American Culture, 1880–1920* (New York: Pantheon, 1981), 49.

5. Kathleen D. McCarthy, *Women's Culture: American Philanthropy and Art, 1830–1930* (Chicago and London: University of Chicago Press, 1991), 150.

6. "The Passing of the Devil," *Scribner's Magazine* 25 (April 1899): 508.

7. See S. Weir Mitchell, "Rest," in Mitchell, *Fat and Blood: And How to Make Them* (Philadelphia: J. B. Lippincott, 1877), 37–44.

8. Charlotte Perkins Gilman's autobiographical short story "The Yellow Wall Paper" (1892) exemplifies this prescription. In Gilman's story a patient slips into madness, shredding the patterned wallpaper where she imagines other tormented women creep. Seen this way, the claustrophobic parlors and bedrooms of late-nineteenth-century culture symbolize the restrictions placed on women and their aspirations. Blamed on one hand for society's "enervating feminization," they felt, paradoxically, the lingering powerlessness of the patient in Gilman's story.

9. Griselda Pollock, "Modernity and the Spaces of Femininity," in Norma Broude and Mary D. Garrard, eds., *The Expanding Discourse: Feminism and Art History* (New York: HarperCollins, 1992), 245–68.

10. Alice Corbin, *The Sun Turns West* (Santa Fe: Rydal Press, 1933), 46.

11. Barbara Brennan, "Catharine Carter Critcher" (master's thesis, Indiana University, 1983), 23.

12. Henriette Wyeth, interview with Sandra D'Emilio, San Patricio, New Mexico, May 1988.

13. Ina Sizer Cassidy, "Art and Artists of New Mexico: Louise Crow," *New Mexico Magazine* 17 (December 1939): 23.

14. Sandra D'Emilio, "Laura van Pappelendam: A Lively and Generous Spirit," *Antiques and Fine Art* 8 (March/April 1991): 113–14.

15. Alice Corbin, Untitled, *Red Earth: Poems of New Mexico* (Chicago: Ralph Seymour, 1920), 3.

16. Annette Kolodny, *The Land Before Her: Fantasy and Experience of the American Frontiers, 1630–1860* (Chapel Hill: University of North Carolina Press, 1984), xiii.

17. John Collier, Jr., foreword to *Edge of Taos Desert: An Escape to Reality* by Mabel Dodge Luhan (Albuquerque: University of New Mexico Press, 1987), xxv.

18. Georgia O'Keeffe to Ettie Stettheimer, August 24, 1929, in Jack Cowart et al., *Georgia O'Keeffe: Art and Letters* (Washington: National Gallery of Art, 1987), 195.

19. Wyeth, interview.

20. Sherry Clayton Taggett and Ted Schwarz, *Paintbrushes and Pistols: How the Taos Artists Sold the West* (Santa Fe: John Muir Publications, 1990), 141.

21. Dorothy Brett, in *Contemporary American Painting and Sculpture* (Urbana: University of Illinois College of Fine Arts, 1953), 169.

22. Lois Palken Rudnick, introduction to *Edge of Taos Desert*, xvi.

23. Mary Austin, *Earth Horizon* (New York: Literary Guild, 1932), 336.

24. In later years women painters often worked to preserve and promote traditional arts: Rebecca Salsbury James championed the art of *colcha*; Olive Rush worked with Native American painting students.

25. Sally Hyer, "*Woman's Work": The Art of Pablita Velarde* (Santa Fe: The Wheelwright Museum of the American Indian, 1993), 9.

26. Ina Sizer Cassidy in Samuel L. Gray, *Tonita Peña: Quah Ah, 1893–1949* (Albuquerque: Avanyu Publishing, 1990), 21.

27. Hyer, "Woman's Work," 1.

28. Sally Hyer, "Pablita Velarde," *Art Journal* 53 (spring 1994): 63.

29. Ibid.

30. Mabel changed the spelling of the family name from Lujan to Luhan so that her East Coast friends would pronounce the name properly. Sally Eauclaire, "Go Like Heck!," *Southwest Profile* 14 (November/December/January 1991/1992): 47.

31. Ina Sizer Cassidy, "Art and Artists of New Mexico: Indian Artists," *New Mexico Magazine* 16 (November 1938): 22.

32. Arguably, this phenomenon is not unique to New Mexico; it has been widely noted that the landscape remains a powerful presence in painting from other Western states as well.

33. See, for example, Stephen Daniels, *Fields of Vision: Landscape Imagery and National Identity in England and the United States* (Princeton, N.J.: Princeton University Press, 1993).

34. Bill and Gail Bishop, "Gene Kloss: Fifty Years in Taos," *Southwest Art* 4 (March 1975): 56.

35. Mary Austin, *Lost Borders* (New York: Harper and Brothers, 1909), 10.

36. Linda Nochlin, "Some Women Realists," in Nochlin, *Women, Art, and Power and Other Essays* (New York: Harper & Row, 1988), 99.

37. *Rising Red*, 1942. Private collection.

38. See, for example, Whitney Chadwick, *Women, Art and Society* (London: Thames and Hudson, 1990), 265–66.

39. David Martin, letter to Sandra D'Emilio, June 16, 1993, private collection.

40. Lydia M. Pena, S.L., *The Life and Times of Agnes Tait* (Arvada, Colorado: Arvada Center for the Arts and Humanities, 1984), 23–24.

VII. LANDAUER WITH REESE
Lone Star Spirits

ACKNOWLEDGMENTS: All researchers of the history of Texas art are indebted to the late Jerry Bywaters, who saw early on the need for an archive of Texas art history. Our thanks to all those who assisted with information on the artists in this essay: on Frétellière and Onderdonk, Cecilia Steinfeldt; on Blackshear and Spears, Mr. and Mrs. William Terrell and research assistant Stephanie A. Strass; on Schow, Darryl Patrick, Joan Spieler, and Dr. George Larson; on John, Patricia John Keightley, the artist's daughter, and Lise Darst of the Rosenberg Library in Galveston; on Uhler, Allan Key, Lowell Collins, and Rosemary Uhler Rowland, the artist's niece; on Skinner, Joe Wilson, Jr.; on Brisac, Kim Grover-Haskin and Professor Betty Copeland of Texas Woman's University; on Lavender, Evans R. Woodhouse, Lavender's great-grandson, and Sister Mary Philomena, Incarnate Word Convent, Corpus Christi, for materials originally collected by Sister M. Borromeo, Lavender's granddaughter; on Cherry, Kathleen Robinson and Steven Johns, Archives, Museum of Fine Arts, Houston, and the Harris County Historical Society; on Williamson, Mrs. P. M. Williamson, daughter-in-law, and Kevin Vogel; on McClung, the McClung brothers and Fred R. Kline; on Spellman, Mick Spellman, Sandra Kirk, and Paul Harris; on Travis, David Hail Travis, her son. We also wish to recognize Patricia Hendricks for her exhibition on the work of Texas women artists in 1974 and Michael Grauer for his 1993 exhibition. All of us working in this area are indebted to William H. Goetzmann, who turned his attention to the history of Texas in the early 1980s and continues to write perceptively on the subject. Our thanks, too, for research assistance to Jeanette Dixon, librarian, Museum of Fine Arts, Houston; Eleanor Jones Harvey, curator of American art, Dallas Museum of Art; and Sam Ratcliffe, director, and Ellen Niewyk, curator, Jerry Bywaters Special Collections Wing, the Jake and Nancy Hamon Arts Library, Southern Methodist University. A special thanks to research assistant Sam Blain, Jr. Our gratitude to A. C. Cook, who advised and facilitated much of the Texas project and introduced us to Mary and Bill Cheek, Earl Weed, Bob Brousseau, David Dike, and Edward Denari, supporters of early Texas painting.

NOTES

1. This summary of women's art activities was compiled from Frances Battaile Fisk, *A History of Texas Artists and Sculptors* (Abilene, Tex., 1928); Michael Grauer, *Women Artists of Texas: 1850–1950* (Canyon, Tex.: Panhandle-Plains Historical Museum, 1993); and Patricia D. Hendricks, *20th Century Women Artists in Texas* (Austin: Laguna Gloria Art Museum, 1974).

2. Kenneth B. Ragsdale, *The Year America Discovered Texas: Centennial '36* (College Station: Texas A & M University Press, 1987), 176, 180.

3. Grauer, *Women Artists of Texas*, n.p.

4. Ibid.

5. Sister M. Borromeo, *Biography of Mrs. Charles Lavender by Her Granddaughter* (Galveston, Tex.: Sacred Heart Academy, n.d.), n.p. Eugenie Lavender's story is also recounted in "Grandma Lavender is the Pride of Corpus Christi," *The Republic*, Saint Louis, Missouri, February 28, 1897, and in "Collection of Paintings Brought to Texas in 1851 Is Displayed at Academy," *Houston Chronicle*, January 6, 1929. Copies of these articles were provided by Lavender's great-grandson, Evans R. Woodhouse.

6. Cecilia Steinfeldt with introduction by William H. Goetzmann, *Art for History's Sake: Texas Collection of the Witte Museum* (Austin: Texas State Historical Association, 1994), 78–79, 80–91, 104.

7. For the Onderdonk family, see Steinfeldt, *Art for History's Sake*, 174–75, 200–2, 211.

8. See Esse Forrester-O'Brien, *Art and Artists of Texas* (Dallas: Tardy Publishing Company, 1935). For his research assistance, the authors are indebted to Michael R. Grauer, Curator of Art, Panhandle-Plains Historical Museum, Canyon, Texas.

9. Ibid., 79–80.

10. Fisk, *A History of Texas Artists and Sculptors*, 12–13.

11. For a biographical sketch of Cherry's life and career, see Fisk, *A History of Texas Artists and Sculptors*, 38–40; Forrester-O'Brien, *Art and Artists of Texas*, 69–70, and Steinfeldt, *Art for History's Sake*, 32–33.

12. Information provided by Lawrence Campbell, registrar at the Art Students League, to researcher Deborah Solon, 1994.

13. According to Steven Johns, archivist, Museum of Fine Arts, Houston, E. R. Cherry's painting *The Precious Bowl* was exhibited only at her 1925 solo exhibition; see *Oil Paintings by E. Richardson Cherry, Museum of Fine Arts, Houston, Texas, 1925,* "Modernist Group," #31.

14. "February Will Be Important Month in Annals of Museum," *Houston Chronicle*, February 1, 1925, n.p.

15. William H. Goetzmann, "Images of Texas," in Goetzmann and Becky Duval Reese, *Texas Images and Visions* (Austin: Archer M. Huntington Art Gallery, College of Fine Arts, University of Texas at Austin, 1993), 33.

16. Susie Kalil, *The Texas Landscape, 1900–1986* (Houston: The Museum of Fine Arts, 1986), 27.

17. Rick Stewart, *Lone Star Regionalism: The Dallas Nine and Their Circle, 1928–1945* (Austin: Texas Monthly Press, 1985), 147.

18. Ibid., 24.

19. For biographical information on McClung, see Florence McClung papers, the Jerry Bywaters Special Collections Wing, the Jake and Nancy Hamon Arts Library, Southern

Methodist University; and Fred R. Kline, "Florence McClung," manuscript, December 1993, courtesy of the author, whose information was provided by the McClung family.

20. Fred R. Kline, "Florence McClung," 1.

21. "Interview of Florence McClung by Sam Ratcliffe," Jake and Nancy Hamon Arts Library.

22. Kathleen Ayres, "Art Keeps Mrs. Williamson Busy," press release prepared for USIS, courtesy of the Jake and Nancy Hamon Arts Library. See also Frank Muth, "Golden Years Art," *Dallas Times Herald Sunday Magazine,* March 15, 1964.

23. See Donald and Margaret Vogel, *Aunt Clara: The Paintings of Clara McDonald Williamson* (Austin and London: University of Texas Press, published for the Amon Carter Museum of Western Art, 1966).

24. A. C. Greene, "The Printed Page: They Call Her a Primitive," *Dallas Times Herald,* January 8, 1967.

25. Williamson papers, August 21, 1945, Archives, Dallas Museum of Art.

26. Janet Kutner, "Her Memory Hues Bright," *Dallas Morning News,* November 29, 1974.

27. Williamson papers, Archives, Dallas Museum of Art.

28. Biographical information from Ethel Spears–Kathleen Blackshear papers, Archives of American Art, Smithsonian Institution, Washington, D.C. (unmicrofilmed).

29. Biographical information on Delleney was provided by archivist Kathleen Robinson, Archives, the Museum of Fine Arts, Houston. See also Patricia Peck, "Marie Delleney in Solo Show at Art Museum," *Dallas Morning News,* January 24, 1943.

Biographical information on Spellman was taken from Mick Spellman and Sandra Kirk, "Coreen Mary Spellman, 1905–1978," unpublished biographical compilation, 1993.

30. Abraham A. Davidson, *Early American Modernist Painting, 1910–1935* (New York: Harper and Row, 1981), 185.

31. Coreen Mary Spellman to artist Nan Sheets, director of Oklahoma City Art Center, letter, November 6, 1953, Mick Spellman Collection, courtesy of Paul Harris, Ph.D.

32. Carole Tormollan, *A Tribute to Kathleen Blackshear* (Chicago: The School of the Art Institute of Chicago, 1990), 12.

33. Biographical information from the Blackshear-Spears papers, Archives of American Art (unmicrofilmed), courtesy of research assistant Stephanie Strass.

34. Burroughs quoted in Tormollan, *A Tribute,* 8.

35. Andy Argyropoulos, "A Tribute to Kathleen Blackshear," *New Art Examiner,* March 1991, 35–36.

36. Biographical information on Schow provided by Professor Darryl Patrick, Art Department, Sam Houston State University, Huntsville, Texas. "A Commentary on May Schow: Her Life, Times & Art," an unpublished four-page brochure accompanying an exhibition of her works in Clifton, Texas, was compiled and written by Joan Spieler and Dr. George Larson in 1983.

37. Hogue quoted in Rick Stewart, *Lone Star Regionalism,* 62.

38. "Kathryne Hail Travis, 1894–1972," an unpublished biographical sketch of the artist, was compiled and written by her son David Hail Travis.

39. "Reviewing the Crowd" by Jimmy Lovell, published on January 19, 1936.

40. Interview with David Hail Travis by Becky Duval Reese, El Paso, Texas, spring 1994.

41. See Forrester-O'Brien, *Art and Artists of Texas,* 343–44; and "Artists Files," Special Collections, Blaggy-Huey Library, Texas Woman's University.

42. Richard Brilliant, *Portraiture* (Cambridge, Mass.: Harvard University Press, 1991), 157.

43. See Patricia John Keightley, *Grace Spaulding John: Artist, 1890–1972,* 2 vols. (Houston: Pantile Press, 1993) and M. Hal Sussmann, "Grace Spaulding John," *Southwest Art,* June 1988, 74–75.

44. Information about Ruth Pershing Uhler's life and career comes from an interview of Uhler conducted by Sylvia Loomis on May 11, 1965, for the Archives of American Art.

In 1934 the Museum of Fine Arts, Houston, director, James Chillman, offered Uhler a mural commission for the Houston Public Library, under the auspices of the Public Works of Art Project. Uhler chose to depict the committee that raised money for Houston's first library. Although women were not allowed membership when the library was first established, she included the figure of the daughter of one of the founders.

By the mid-1940s Ruth Uhler had decided to devote the remainder of her career to museum work; until a few months before her death she worked as curator of education at the Museum of Fine Arts in Houston, from 1937 to 1967.

45. O'Keeffe began spending summers in Taos in 1929, so it is possible that Uhler saw her work while in New Mexico.

46. Linda Nochlin makes a similar point for the whole sweep of twentieth-century women's art in Ann Sutherland Harris and Linda Nochlin, *Women Artists: 1550–1950* (New York: Los Angeles County Museum of Art and Alfred A. Knopf, 1976), 58.

47. See Rick Stewart, *Lone Star Regionalism: The Dallas Nine and Their Circle* (Dallas: Texas Monthly Press and Dallas Museum of Art, 1985).

48. Harris and Nochlin, *Women Artists,* 58.

VIII. Doss "I must *paint*"

ACKNOWLEDGMENTS: I would especially like to thank my research assistant, Billie C. Gutgsell, for helping with this project; the artistic and biographical jewels that she unearthed about Western women artists from the Rocky Mountain region have added immensely to this essay. I also thank the students who participated in my spring 1994 seminar on Women Artists of the West at the University of Colorado: Monique Derouin, Amy Doering, Carrie Fox, Michelle Goren, Mathes Jones, Urszula Mayo, Stacy Meiser, Rebecca Briggs Moore, Liesel Nolan, Pamela Rader, Sandra Cooper Walsh, and Anna White. Their good ideas and suggestions have significantly shaped much of what is written here.

Thanks, too, to the following people who shared their wealth of information about various Western women artists: Jannelle Lupin, Stanley Cuba, Sandy Harthorn, Elizabeth McKay, Elizabeth Schlosser, Dennis D. Kern, Robert Davis, Glen Leonard, Beth L. Barrett, Linda Jones Gibbs, Carma Rose de Jong Anderson, Vern Swanson, Julia K. Lippert, Will South, Bruce Currie, Steve Savageau, Ursula Ronnebeck Works, Arnold Ronnebeck, Linda Parsons, Dick and Jenny Kent, Kent and Taydie Drummond, Alice Moreland, Madoline Des Jardins, Georgiana Contiguglia, and Suzanne Foster. I am further indebted for help with this project to staff at the National Museum of American Art, the Archives of American Art, Midtown Galleries, the Boulder Historical Society, the Denver Public Library Western History Department, the Denver Art Museum, the Church of Jesus Christ of Latter-day Saints Museum of Church History and Art, the Utah State Fine Arts Collection, Springville Museum, Brigham Young University Museum of Art, the University of Utah Museum of Fine Arts, and the Colorado Springs Fine Arts Center.

NOTES

1. Minerva K. Teichert, handwritten manuscript, 1947, quoted in Robert O. Davis, "I *Must* Paint," in *Rich in Story, Great in Faith: The Art of Minerva Kohlhepp Teichert* (Salt Lake City: Church of Jesus Christ of Latter-day Saints, 1988), 12, 39.

2. Ibid., 38.

3. Jules David Prown, introduction to *Discovered Lands, Invented Pasts: Transforming Visions of the American West* (New Haven, Conn.: Yale University Press, 1992), xi; Vera Norwood and Janice Monk, eds., *The Desert Is No Lady: Southwestern Landscapes in Women's Writing and Art* (New Haven, Conn.: Yale University Press, 1987), 5.

4. Patricia Nelson Limerick, *The Legacy of Conquest: The Unbroken Past of the American West* (New York: Norton, 1987), 52.

5. John G. Cawelti, "The Frontier and the Native American," in Joshua C. Taylor, *America as Art* (New York: Harper and Row, 1976), 145.

6. Katherine G. Morrissey, "Engendering the West," in William Cronon, George Miles, and Jay Gitlin, eds., *Under an Open Sky: Rethinking America's Western Past* (New York: Norton, 1992), 133.

7. Native American women were stereotyped as well, especially as Indian princesses. See Patricia C. Albers and William R. James, "Illusion and Illumination: Visual Images of American Indian Women in the West," in Susan Armitage and Elizabeth Jameson, *The Women's West* (Norman: University of Oklahoma Press, 1987), 35–50, and Susan Prendergast Schoelwer, "The Absent Other: Women in the Land and Art of Mountain Men," in Prown, *Discovered Lands,* 134–65, 203–7.

8. William T. Ranney's *Advice on the Prairie,* 1853, oil on canvas, 40 x 54 in., is owned by Mr. and Mrs. J. Maxwell Moran, Paoli, Pennsylvania; William H. D. Koerner's *Madonna of the Prairie,* 1922, oil on canvas, 37 x 28¾ in., is owned by the Buffalo Bill Historical Center, Cody, Wyoming.

9. Schoelwer, "The Absent Other," 135. For recent works on Western women's writings and oral histories see, for example, Emily French's *Emily, The Diary of a Hard-Worked Woman,* edited by Janet Lecompte (Lincoln: University of Nebraska Press, 1987), and Julie Jones-Eddy, *Homesteading Women: An Oral History of Colorado, 1890–1950* (New York: Twayne, 1992); for recent studies of Western women's imagery see, for example, Norwood and Monk, *The Desert Is No Lady.*

10. For a good analysis of the impact of the Cult of True Womanhood on Western women see Elizabeth Jameson, "Women as Workers, Workers as Civilizers: True Womanhood in the American West," in Armitage and Jameson, *The Women's West,* 145–64.

11. Carl Abbott, et al., *Colorado, A History of the Centennial State* (Niwot: University Press of Colorado, 1982), 67.

12. For an overview of these Colorado arts clubs see Mary Lou Martorano, "Artists and Art Organizations in Colorado," unpublished master's thesis, University of Denver, 1962. See also Stanley L. Cuba, *Colorado Women Artists, 1859–1950* (Arvada, Colo.: Arvada Art Center, 1989).

13. For more on Chain, see Patricia Trenton and Peter H. Hassrick, *The Rocky Mountains: A Vision for Artists in the Nineteenth Century* (Norman: University of Oklahoma, 1983), 311. See also the Chain Files at the Western History Department, Denver Public Library.

14. See Linda Jones Gibbs, *Harvesting the Light: The Paris Art Mission and Beginnings of Utah Impressionism* (Salt Lake City: Church of Jesus Christ of Latter-day Saints, 1987).

15. Sara M. Evans, *Born for Liberty: A History of Women in America* (New York: Free Press, 1989), 107.

16. Alice Merrill Horne, *Devotees and Their Shrines* (Salt Lake City: The Desert News, 1914); see also Harriet Horne Arrington, "Alice Merrill Horne, Art Promoter and Early Utah Legislator," *Utah Historical Quarterly* 58, no. 3 (summer 1990): 261–76.

17. Will South, *James Taylor Harwood, 1860–1940* (Salt Lake City: Utah Museum of Fine Arts, University of Utah, 1987), 38.

18. Gibbs, *Harvesting the Light,* 29.

19. Minerva K. Teichert autobiography, 1937, quoted in Davis, "I Must Paint," 34.

20. Horne, *Devotees and Their Shrines,* 71.

21. Carma Rose de Jong Anderson, "Nina Rosabel Hartwell Whiteley, 1861–1917," undated and unpublished manuscript, Hartwell Files, Brigham Young University Museum of Art.

22. For further information on Ware see Carma Rose de Jong Anderson, "Florence Ellen Ware, 1891–1972," unpublished essay among the Ware Files, Springville Museum of Art, Utah.

23. Dennis Kern, "Fra Dana, Artist and Collector," exhibition brochure, University of Montana Museum of Fine Arts, 1994.

24. Dana quoted in Kern, "Fra Dana," n.p. Several of Dana's journal entries were transcribed by author Mildred Walker, who befriended Dana in the 1940s. The original journals have not been located.

25. Mildred Walker said this of Cassatt in "An Interview with Mildred Walker Schemm," by Dennis Kern and Bryan Spellman, University of Montana Instructional Materials Services, Mansfield Library, catalogue #1996; Dana quoted in Kern, "Fra Dana," n.p., and in Richard Ecke, "Art of Fra Dana On Display at Russell," *Casper Star Tribune,* April 10, 1994, E-4.

26. Richard White, *"It's Your Misfortune and None of My Own": A History of the American West* (Norman: University of Oklahoma Press, 1991), 355. On the issue of suffrage's significance for Western women see Jameson, "Women as Workers, Women as Civilizers," 147.

27. Dana quoted in Kern, "Fra Dana," n.p.

28. Robert S. Olpin, "Tradition and the Lure of the Modern: 1900–1950," in Vern G. Swanson, Robert S. Olpin, and William C. Seifrit, *Utah Art* (Layton, Utah: Peregrine Smith, 1991), 119.

29. Edward Alden Jewell, "Art Review," *New York Times,* March 18, 1934, 9.

30. Frazer's student George Dibble is quoted in Olpin, "Tradition and the Lure of the Modern," 120. See also Howard R. Lamar, "Looking Backward, Looking Forward: Selected Themes in Western Art Since 1900," in Prown, *Discovered Lands,* 171–73, for a discussion of women artists and teachers in Nebraska.

31. Drewelowe's voluminous archives are documented in *An Inventory of the Papers of Eve Drewelowe, Artist and Sculptor,* processed by Marcia Kehl and Janelle Luppen for the library of the Colorado Historical Society in Denver (Collection #1410) and the Iowa Women's Archives, University of Iowa, Iowa City.

32. Drewelowe quoted in "Biographical Diary," by Jan Carnes, Drewelowe Collection, File #4-15, a 42-page handwritten illustrated text dated 1978, based on personal interviews with the artist, and "'I'—The Entity," in *Eve Drewelowe, A Catalogue Raisonne* (Iowa City: University of Iowa School of Art and Art History, 1988), xiv.

33. Drewelowe, "A Misdeal," *Eve Drewelowe,* x.

34. Drewelowe quoted in "Voyages, Vessels, Vistas" and "No. 950,562," in *Eve Drewelowe,* viii, xii.

35. Drewelowe quoted in "Facts and Findings: The Past in the Present," a 10-page manuscript dated February 16, 1983, Drewelowe Collection, File #5-1, giving a synopsis of landscapes she painted under the auspices of a grant from the Boulder Art Commission in 1981.

36. Eleanor Tufts, *American Women Artists 1830–1930* (Washington, D.C.: National Museum of Women in the Arts, 1987), catalogue entry number 61. *Mountains in Snow* is now located in the offices of the Department of Health and Human Services, Washington, D.C.

37. Bruce Currie, husband of Ethel Magafan, interview with author, Woodstock, New York, March 18, 1994.

38. Ethel Magafan, interview with Joseph Travato, Woodstock, New York, November 5, 1964, Archives of American Art, Smithsonian Institution, Oral History Collection.

39. Ethel Magafan quoted in 1937 sketchbook among the Ethel Magafan Files, Denver Art Museum. Section Superintendent Edward Rowan explained that "the people of the locale are trying to forget" the massacre and the Section "did not feel justified in overriding" them. Rowan is quoted from an April 23, 1937, letter also in this file. For more on the Lawrence Massacre see Thomas Goodrich, *Bloody Dawn: The Story of the Lawrence Massacre* (Kent, Ohio: Kent State University Press, 1961).

40. Karal Ann Marling, *Wall-to-Wall America: A Cultural History of Post-Office Murals in the Great Depression* (Minneapolis: University of Minnesota Press, 1982), 207–10. *Threshing* is still on view in Auburn, and *Cowboy Dance* is now in the collection of the National Museum of American Art, Smithsonian Institution, Washington, D.C.

41. Elizabeth Schlosser, *Modern Art in Denver (1919–1960): Eleven Denver Artists* (Denver: Ocean View Books, 1993), 57–59.

42. Richard Lowitt and Maurine Beasley, eds., *One Third of a Nation: Lorena Hickok Reports on the Great Depression* (Urbana: University of Illinois Press, 1981), 281. See also Stephen J. Leonard, *Trials and Triumphs: A Colorado Portrait of the Great Depression with FSA Photographs* (Niwot: University Press of Colorado, 1993).

43. Leonard, *Trials and Triumphs,* 20, quoting the Trinidad *Chronicle News,* January 14, 1929.

44. "A Tragic Death," *Denver Post,* November 24, 1935, 1. For information on Rönnebeck see Schlosser, *Modern Art in Denver,* 49–51.

45. Frances Wayne, "Young Wife Who Killed Husband Was Trying to Save Baby's Name," *Denver Post,* November 25, 1935, 1, 3; Frances Wayne, "Girl Mother Tells Why She Killed," *Denver Post,* January 31, 1936, 1, 3.

46. Francis Wayne, "Girl Mother Insane, Says Expert, Spanking By Husband Also Contributed to Madness, Jury Told," *Denver Post,* February 1, 1936, 1, 4.

47. Barbara Melosh, *Engendering Culture: Manhood and Womanhood in New Deal Public Art and Theater* (Washington, D.C.: Smithsonian Institution Press, 1991), 60. Lost for almost two decades, the mural was recently rehung in Grand Junction, Colorado.

48. Leo Zuckerman, "Tears Flowed Freely at Mary Smith's Trial," *Rocky Mountain News,* September 9, 1957, 30.

49. Laurie Teichert Eastwood, oral interview with Robert Davis, March 26, 1987, from "Statements and Writings About Minerva Kohlhepp Teichert," Teichert Files, Museum of Church History and Art, Salt Lake City.

50. Ibid.

51. Minerva Teichert, *Drowned Memories* (Pocatello, Idaho, 1926), and *A Romance of Old Fort Hall* (Portland, Ore.: Metropolitan Press, 1932).

52. The dress was made by Teichert's great-grandmother, Sara Bundy Wade, who died in 1846 at Winter Quarters (near Council Bluffs, Iowa) during the Mormon trek.

53. Davis, "I Must Paint," 9. *Queen Esther,* 1939, oil on canvas, 55 x 35 in., is owned by Betty Curtis Stokes and William Lee Stokes, Utah.

54. Teichert autobiography, 1937, quoted in Davis, "I Must Paint," 31.

IX. KINSEY *Cultivating the Grasslands*

ACKNOWLEDGMENTS: Research on women artists in the Great Plains required extensive travel and the assistance of many individuals. In addition to the staffs of many institutions, most notably the libraries and archives of the state historical societies in North and South Dakota, Nebraska, Kansas, and Oklahoma, the following who gave generously of their time, resources, and expertise are gratefully acknowledged: Sheila Agee, Civic Fine Arts Center, Sioux Falls, South Dakota; Gail Anderson, Fred Jones Jr. Museum of Art, Norman, Oklahoma; Claudia Berg, State Historical Society of North Dakota, Bismarck; Ruth Brennan, Dahl Fine Art Center, Rapid City, South Dakota; Arthur Breton, Archives of American Art, Washington, D.C.; Jeffrey Briley, Oklahoma Historical Society, Oklahoma City; Katrina Callahan, Dickinson State University, Dickinson, North Dakota; Elizabeth Campanile, Campanile Galleries, Chicago; Marie Childers, Shepherd Manor Home, Oklahoma City; Andrew Connor, National Museum of American Art, Washington, D.C.; Daphne Anderson Deeds, Sheldon Memorial Art Gallery, Lincoln, Nebraska; James Diaton, Fred Jones Jr. Museum of Art, Norman, Oklahoma; Janet Dreiling, Spencer Museum of Art, Lawrence, Kansas; Carol Emert, Mulvane Art Museum, Washburn University, Topeka, Kansas; Norman Geske, Professor Emeritus, University of Nebraska, Lincoln; Rodger G. Harris, Oklahoma Historical Society, Oklahoma City; David Hunt, Joslyn Art Museum, Omaha; Willard Johnson, Colonial Art Gallery & Co., Oklahoma City; Kristine Kallenberger, Philbrook Art Museum, Tulsa, Oklahoma; Sherry Cromwell Lacy, Kansas City Art Institute, Kansas City, Missouri; Vern Lenzen, Western Heritage Museum, Omaha; Richard Love, R. H. Love Galleries, Chicago; Francine Marcel, South Dakota Art Museum, Brookings; Ann M. Marvin, Kansas Museum of History, Topeka; Joe Masek, Western Heritage Museum, Omaha; Thomas McCormick, Chicago; Virginia Mecklenberg, National Museum of American Art, Washington, D.C.; Larry Mensching, Joslyn Art Museum, Omaha; Anne Morand, Thomas Gilcrease Institute of American History and Art, Tulsa, Oklahoma; George W. Neubert, Sheldon Memorial Art Gallery, Lincoln, Nebraska; Richard Norton, Robert Henry Adams Fine Art, Chicago; Larry Peters, Topeka Public Library, Topeka, Kansas; Robert Powers, Tulsa Historical Society, Tulsa, Oklahoma; Laurie Redfern-Hardin, Museum of Nebraska Art, Kearney, Nebraska; Laurel J. Reuter, North Dakota Museum of Art, Grand Forks; George Riser, University of Virginia, Charlottesville; LaVera Rose, South Dakota State Archives, Pierre; Novelene Ross, Wichita Art Museum, Wichita, Kansas; Laura Scher, *Minneapolis Star Tribune*, Minneapolis; Hope Schwang, Lydia Bruun Woods Library, Falls City, Nebraska; Frank Sidles, Provident Federal Savings Bank, Lincoln, Nebraska; Penelope Smith, Joslyn Art Museum, Omaha; Alyson B. Stanfield, Oklahoma City Art Museum; Suzy Taraba, University of Chicago; Warren Taylor, Topeka Public Library, Topeka, Kansas; Rijn Templeton, University of Iowa Art Library, Iowa City; Sarah J. Wood-Clark, Kansas Museum of History, Topeka; Tom Young, Philbrook Art Museum, Tulsa, Oklahoma; Jim Zimmer, Sioux City Art Center, Sioux City, Iowa.

NOTES

1. Although the terms "prairie" and "plains" were virtual synonyms in the nineteenth century and often are still used as such in colloquial speech today, it is generally accepted that "plains" refers specifically to the region encompassed by the states of North and South Dakota, Nebraska, Kansas, Oklahoma, and much of Texas, with some extension into their western neighbors, especially in Colorado, Wyoming, and Montana. The "prairies" are more correctly identified, botanically and geographically, with the tallgrass areas that are now mostly agricultural in Minnesota, Iowa, Illinois, and parts of Indiana and Ohio, although eastern sections of the plains states are also included in this designation. Increasingly, the two terms are conjoined, as in "the prairie/plains region," to refer to that central North American region that is, or at least was, primarily grassland. Complicating the semantic problem is the too-often ambiguous usage of "Midwest" and "Middle West" for the same general areas. For more on the distinctions see John Madson, *Tallgrass Prairie* (Helena, Montana: Falcon Press, 1993); the classic by Walter Prescott Webb, *The Great Plains* (Boston: Ginn and Co., 1931; Lincoln: University of Nebraska Press, 1981); and James Shortridge, "The Emergence of 'Middle West' as an American Regional Label," *Annals of the Association of American Geographers* 74 (1984): 209–20.

2. Glenda Riley, *Female Frontier: A Comparative View of Women on the Prairie and the Plains* (Lawrence: University Press of Kansas, 1988), 173–93; and Elizabeth Jameson, "Women as Workers, Women as Civilizers: True Womanhood in the American West," in Susan Armitage and Elizabeth Jameson, eds., *The Women's West* (Norman: University of Oklahoma Press, 1987), 35–50.

3. For comparison to other areas of the country see Jean Gordon, "Early American Women Artists and the Social Context in Which They Lived," *American Quarterly* 30 (spring 1978): 54–69. For the impact of distances on social development in the Great Plains see Mary W. M. Hargreaves, "Space: Its Institutional Impact in the Development of the Great Plains," in Brian W. Blouet and Frederick C. Luebke, eds., *The Great Plains: Environment and Culture* (Lincoln: University of Nebraska Press, 1979), 205–23.

4. Statehood was granted to Kansas in 1861, Nebraska in 1867, North and South Dakota in 1889, and Oklahoma in 1907.

5. Although there have been a number of recent studies of women artists, few have included Midwestern and Western women. Notable exceptions include Phil Kovinick, *The Woman Artist in the American West* (Fullerton, Calif.: Muckenthaler Cultural Center, 1976); and William Gerdts, *Art Across America: Three Centuries of Regional Painting, 1710–1920*, vols. 2 and 3 (New York: Abbeville Press, 1990).

6. Because of these difficulties, objects from the Great Plains in the Independent Spirits exhibition were borrowed primarily from public collections. Condition was a criterion of selection as well as the prominence and talent of the artist. Many artists who played important roles in the cultural development of the region were not included because their work could not be located or it was unsuitable for the exhibition because of medium, size, or condition. Future research will no doubt uncover many more women artists and their work.

7. Kathleen McCarthy, *Women's Culture: American Philanthropy and Art, 1830–1930* (Chicago and London: University of Chicago Press, 1991), 77–78.

8. See Norman Geske, *Art and Artists in Nebraska* (Lincoln: Sheldon Memorial Art Gallery in association with the Center for Great Plains Studies, University of Nebraska, 1983); and Clarissa Bucklin, ed., *Nebraska Art and Artists* (Lincoln: University of Nebraska, 1932). In Topeka, Kansas, Baker University in Baldwin was the first to offer art courses (1858), followed closely by Washburn College in Topeka (1865) where Minnie V. Otis served as instructor. Edna Reinbach, "Kansas Art and Artists," *Collections of the Kansas State Historical Society* 17 (1926–28): 571–85.

9. Regarding the contemporary perceptions of women's training in the arts see Candace Wheeler, "Art Education for Women," *Outlook* 55 (January 2, 1897): 81, 86.

10. For more on women's attendance at these schools see Christine Jones Huber, *The Pennsylvania Academy and Its Women* (Philadelphia: Pennsylvania Academy of the Fine Arts, 1974).

11. H. Barbara Weinberg, *The Lure of Paris: Nineteenth-Century American Painters and Their French Teachers* (New York: Abbeville Press, 1991), 226.

12. Weston's husband, a gallery dealer, was significantly older, and after his death (date unknown) she moved with her two daughters to Kansas, where two of her brothers had homesteaded. Letter from Laura Carpenter Marshall, granddaughter of Mary Weston, to Joan Foth, June 26, 1954, curatorial files, Kansas Museum of History, Topeka.

13. Letter from Elizabeth Marshall Horton, great-granddaughter of Mary Weston, curatorial files, Kansas Museum of History. See also Ann Marvin, "The Spirit of Kansas," *Kansas Heritage* 1 (summer 1993): 18–22.

14. Narcissa (Chisholm) Owen, *The Memoirs of Narcissa Owen, 1831–1907* (Washington, D.C.: privately printed, c. 1907). The Oklahoma City Art Museum, the institution Sheets helped found, has considerable information about her, as does the Oklahoma Historical Society.

15. The literature on this subject is vast. For a concise summary of the issues and historiography see John L. Allen, "The Garden-Desert Continuum: Competing Views of the Great Plains in the Nineteenth Century," *Great Plains Quarterly* 5 (fall 1985): 207–20. The interpretation of the plains as a desert dates to 1810 (Zebulon Pike) and 1819 (Stephen Long), and was most pervasive as an idea before the Civil War; but as late as 1866 General John Pope reported to Congress that the plains were "beyond the reach of agriculture, and must always remain a great

uninhabited desert." General John Pope, "Report on the Department of the Missouri, February 25, 1866," 39th Cong., 1st Sess., House Exec. Doc. No. 76 (Serial No. 1263), 1866, p. 2. Cited in David Dary, "The Selling of the Great American Desert," chap. 11 of *Entrepreneurs of the Old West* (New York: Alfred A. Knopf, 1986), 226–48.

16. For a consideration of the impact of the Great Plains landscape on women, although not on professional women artists, see Julie Roy Jeffrey, "'There is Some Splendid Scenery': Women's Responses to the Great Plains Landscape," *Great Plains Quarterly* 8 (spring 1988), 69–78. Similiar issues are discussed in a more specifically visual context, although not as related to gender, in John Milton, "Plains Landscapes and Changing Visions," *Great Plains Quarterly* 2 (winter 1982), 55–62; and in Howard Lamar, "Seeing More than Earth and Sky: The Rise of a Great Plains Aesthetic," *Great Plains Quarterly* 9 (spring 1989): 69–77.

17. An oil painting of a nude by Nellie Shepherd, which may be from the model in the photograph, is in the collection of the Oklahoma Art Museum, no. 1948.002. Shepherd is also listed as Ellen in some biographical dictionaries.

18. The Falls City Public Library in Falls City, Nebraska, has a sizable file on Cleaver, as does the Museum of Nebraska Art, from which much of this information was gathered. See also Geske, *Art and Artists in Nebraska*, 34; and Bucklin, *Nebraska Art and Artists*, 31. The information on Shepherd was gleaned from the files of Shepherd Manor Retirement Home in Oklahoma City, established by Shepherd's surviving sisters with a proviso for the care of some sixty of Nellie Shepherd's paintings.

19. O. B. Jacobsen and Jeanne Ucel, "Art in Oklahoma," *Chronicles of Oklahoma* 32, no. 3 (1954): 268. The work she exhibited, a portrait of her sister Lottie, is in the collection of Shepherd Manor Retirement Home, Oklahoma City. The Oklahoma Art Center, Oklahoma City, also owns several of Shepherd's paintings.

20. The Santa Fe Railway amassed a sizable art collection by exchanging paintings for rail fare, enabling many artists to travel and paint subjects unavailable to them otherwise. Cleaver apparently painted seven canvases of the Pueblo, one of them still owned by the Santa Fe Railway. Her *Girl with a Palette* is stylistically similar to these. See Sandra D'Emilio and Suzan Campbell, *Visions and Visionaries: The Art and Artists of the Santa Fe Railway* (Salt Lake City: Peregrine Smith Books, 1991), 52.

21. Te Ata (also known as Mary Frances Thompson, b. 1895) was well known for her performances of Indian dances and stories in the United States and Europe. In 1994 she was still living in Oklahoma City.

22. (Nicholas) Vachel Lindsay, "The Lady Poverty," *The Outlook*, November 25, 1911, 734–42. According to a letter in the files of the Museum of Nebraska Art, Cleaver's *The Cast Room* was owned for many years by the city of Falls City, but it disappeared sometime in the 1980s. Gary Zaruba, Professor of Art, Kearney State College, Kearney, Nebraska, to Robert Haller, Department of English, University of Nebraska, Lincoln, April 11, 1986.

23. Letter from Zaruba to Haller, Cleaver file, Museum of Nebraska Art. Zaruba reports that the letters were unfortunately thrown away by the owners of the house sometime in the early 1980s. Verification of the continued link between Cleaver and Lindsay, however, is provided by a 1903 photograph of her that remains with his papers today in the Alderman Library, University of Virginia, Charlottesville, box 49, no. 6259.

24. Vachel Lindsay, *The Prose of Vachel Lindsay*, vol. 1, ed. Dennis Camp (Peoria, Ill.: Spoon River Poetry Press, 1988), 157–58.

25. Especially with the current interest in gender in landscape studies, the response of women to the Great Plains deserves further attention. In regard to one state see Peg Wherry, "At Home on the Range: Reactions of Pioneer Women to Kansas Plains Landscape," *Kansas Quarterly* 18 (1986): 79–91, as well as Jeffrey, "'There is Some Splendid Scenery.'"

26. Each of these women is known only by a few paintings; for example, See's *Nebraska Farmstead*, c. 1880s, Joslyn Museum, Omaha, and Cover's *The Homestead of Ellsworth Ball*, c. 1880s, Nebraska State Historical Society. For more on Cover see William Truettner, ed., *The West As America: Reinterpreting Images of the Frontier* (Washington and London: Smithsonian Institution Press, 1991), 227–28, 351.

27. Smith taught at Kearney State College from 1905 to 1943. She spent summers traveling extensively to paint landscapes in places as distant as Santiago, Chile, and in the early years of the century had spent time painting on the Rosebud and Pine Ridge Indian Reservations in South Dakota. Curatorial files, Museum of Nebraska Art, Kearney. See also Margaret Nielsen Stines, "The Arts in Early Kearney," *Buffalo Tales* 8 (September 1985): 1–6; and Gerdts, *Art Across America*, 3:76.

28. Curatorial files, Joslyn Art Museum, Omaha. See also Gerdts, *Art Across America*, 2:310.

29. Connie L. Stevens, "Elizabeth Honor Dolan," *Perspectives: Women in Nebraska History* (Lincoln: Nebraska Department of Education and the Nebraska State Council for Social Studies, 1984), 174–82.

30. Dolan, for example, was adamant about not being observed while she worked, and she threw virtual tantrums when her privacy was violated. Some of her most notable murals include a series of natural history scenes for Morrill Hall at the University of Nebraska, another series for the Age of Man Hall at the American Museum of Natural History in New York (no longer extant), ten scenes depicting "Historical Nebraska" for the Miller and Paine department store in Lincoln (no longer extant), and a mural for the Unitarian Church, Lincoln. Stevens, "Elizabeth Honor Dolan," 176–81.

31. Frank M. Hall was a prominent member of the Lincoln community. During his career he had been a bank director, head of a law firm, president of the Nebraska Bar Association, president of the board of education, and from 1900 to 1928 a twelve-term president of the Nebraska Art Association. He and his wife were avid collectors and at their deaths willed much of their collection, including the Dolan painting of their garden, to the University of Nebraska. The collection is now housed at the Sheldon Memorial Art Gallery there. Fred N. Wells, *The Nebraska Art Association* (Lincoln: n.d.), unpaginated booklet in the vertical files of the National Museum of American Art Library.

32. *The Spirit of the Prairie* is reproduced in Stevens, "Elizabeth Honor Dolan," 177, and in *The American Magazine of Art* 30 (November 1930): 660.

33. Paul E. Barr, *North Dakota Artists* (Grand Forks: University of North Dakota, 1954), 14; and Kovinick, *The Woman Artist in the American West*, 8.

34. This Black Hills College closed in 1893. The present Black Hills State College in Spearfish was founded in 1883 as the Dakota Territory Normal School, called the Spearfish Normal School after 1898, Black Hills Teachers College after 1941, and finally Black Hills State College after 1964. Alice Songe, *American Universities and Colleges: A Dictionary of Name Changes* (Metuchen, N.J.: Scarecrow Press, 1978).

35. James E. Cessna, "Grace A. French: A Rosebud Among the Prairie Grasses," pamphlet, curatorial files, Dahl Fine Art Center, Rapid City, South Dakota.

36. Provincetown had become a thriving artists' colony by the turn of the century. For more on its appeal for artists see Michael Jacobs, *The Good and Simple Life: Artist Colonies in Europe and America* (Oxford: Phaidon Press, 1985), especially chap. 9, "Victorians in the Modern World: Provincetown," 167–78.

37. This early experiment, called Explorer I, was part of a series of launches in the Black Hills that was ultimately instrumental in facilitating space exploration. For more on this and related launches see *National Geographic*, April 1934, 528–30; July 1934, 107–10; October 1934, 347–434; and February 1935, 265–72. Lux later recounted that she made a quick sketch of the scene on the back of a checkbook and later composed the painting in her studio. Typescript interview with Gladys Lux, 1980s, Sheldon Memorial Art Gallery files, University of Nebraska. For the name changes of Black Hills State College see n. 34.

38. Typescript interview with Gladys Lux, 1980s. It has been speculated that this is the only painting of the launch of the historic stratospheric balloon. James R. Palmer, State College of Pennsylvania, to George Neubert, Director, Sheldon Memorial Art Gallery, April 22, 1992, Sheldon Gallery curatorial files.

39. Bohan bequeathed her oeuvre of over 200 paintings and drawings to the Spencer Museum of Art at the University of Kansas. The Spencer maintains a sizable file on Bohan from which much of this information was gathered.

40. Although Bohan certainly had the ability to be a prominent artist, she did not pursue this aspect of her career. She exhibited little (although when she did it was notable, as with her prize-winning submission to the Pennsylvania Academy of the Fine Arts in 1934) and she rarely sold her work. See *The Paintings and Drawings of Ruth H. Bohan, 1891–1981*, pamphlet (Lawrence: The Spencer Museum of Art, 1983).

41. The South Dakota Art Museum, Brookings, owns a number of Myra Miller's paintings. Much of the information on Miller here is derived from miscellaneous clippings in the curatorial files there. See also Joseph Stuart, *The Art of South Dakota* (Brookings: South Dakota State University, 1974), 34, 42.

42. Marsden Hartley, *On Art by Marsden Hartley*, edited by Gail R. Scott (New York: Horizon Press, 1982), 178–79. Cited in Doreen Bolger, Marc Simpson, and John Wilmerding, eds., *William M. Harnett* (Fort Worth and New York: Amon Carter Museum and the Metropolitan Museum of Art in association with Harry N. Abrams, Inc., 1992), xv.

43. Bolger, et al., *William M. Harnett*. See especially Henry Adams, "A Study in Contrasts: The Work of Harnett and La Farge," pp. 60–71.

44. The actual sources of Miller's awareness of the genre of hunt pictures are undetermined, but reproductions, not only of those by Harnett, were readily available to a wide public. For example, the popular chromolithography firm of Louis Prang & Co. included "game pieces" in its illustrated catalogue for 1876. Bolger, et al., *William M. Harnett*, 215. William Gerdts notes the similarity of Miller's *Hunter's Pride* to *Theodore Roosevelt's Cabin Door* (n.d.), which Richard La Barre Goodwin produced after seeing the North Dakota exhibit at the Louisiana Purchase Exposition, and while this observation is astute, it is equally undeniable that Miller set up her own still lifes instead of simply copying images by better-known artists. Gerdts, *Art Across America*, 3:83–84, 195.

45. Helen Martanie Snowden, also known as Janie, was the daughter of two of Omaha's founders. She studied art at the Art Institute of Chicago and at the Cooper Union in New York. In 1890 she returned to Omaha, established a studio, and taught painting at Bellevue College. Letter from Paul W. Emerson (Snowden's nephew) to Mildred Goosman, Joslyn Art Museum, June 11, 1955, Joslyn Museum files, Omaha. Snowden's studio was at 608-9 Paxton Building in Omaha at about the turn of the century, and included, as the photograph reveals, two trophy bird paintings similar to Miller's. The center painting on the far right depicts *Grapes*, presently in the collection of the Joslyn Art Museum, no. 1955.207.

46. No Parisian art school admitted women until the 1860s; in desperation Elizabeth Jane Gardner had masqueraded in men's clothing in order to attend, and finally she and three other women persuaded William Bouguereau (whom Gardner later married) to open the Académie Julian to women. Even so, in the 1880s serious study of art for women in Paris was still unusual. McCarthy, *Women's Culture*, 89. Boulanger and Lefebvre taught as a team and maintained separate studios for men's and women's classes. Boulanger was especially popular, probably because, as one student remarked, "[he] often comes in during the week to see how his young ladies are getting on." Marie Adelaide Beloc, "Lady Artists in Paris," *Murray's Magazine* 8 (September 1890): 371–84, cited in Weinberg, *The Lure of Paris*, 223.

47. Handwritten history by Anita Laurent (niece), 1963, curatorial files, Mulvane Art Museum, Topeka.

48. Sheets was first named co-supervisor of the WPA program (with Oscar Jacobsen) and received the job on her own after successfully handling the WPA art center. "Nan Sheets is Chosen Director of Works Project Art Setup," unidentified clipping (probably from the *Daily Oklahoman*), curatorial files, Oklahoma City Art Museum. See also Kathleen Grisham Rogers, "Incidence of New Deal Art in Oklahoma" (master's thesis, University of Oklahoma, 1974), 40–48. The taped interview with Nan Sheets in the Oklahoma Historical Society also contains many interesting anecdotes about this part of her career.

49. Information on Sheets's career is available in the substantial files at the Oklahoma City Art Museum and the Oklahoma Historical Society, and in several master's theses and articles. See for example Bess England, "Artists in Oklahoma: A Handbook," (master's thesis, University of Oklahoma, c. 1960), 23, 125; Willie Joran Misner, "An Evaluation of Art Activity in Oklahoma During Its First Thirty Years of Statehood" (master's thesis, University of Oklahoma, 1940), 143–45; Rex Harlow, "Oklahoma's Nationally Famous Artist," *Harlow's Weekly*, March 21, 1951, 4–6. The voluminous papers and scrapbooks of Oscar Jacobsen at the Oklahoma Historical Society also contain much information on Sheets.

50. Stevens, "Elizabeth Honor Dolan," 180.

51. There is a sizable literature on the WPA art programs. See for example Edward Bruce and Forbes Watson, *Art in Federal Buildings: An Illustrated Record of the Treasury Department's New Program in Painting and Sculpture* (Washington, D.C.: Art in Federal Buildings, Inc., 1936); Francis V. O'Connor, ed., *Art for the Millions: Essays From the 1930s by Artists and Administrators of the WPA Federal Art Project* (Boston: New York Graphic Society, 1973); Marlene Park and Gerald E. Markowitz, *Democratic Vistas: Post Offices and Public Art in the New Deal* (Philadelphia: Temple University Press, 1984); Karal Ann Marling, *Wall to Wall America: A Cultural History of Post Office Murals in the Great Depression* (Minneapolis: University of Minnesota, 1982). While these sources include information on women artists in the WPA programs, only one has made a serious study of gender itself and its impact on the project: Barbara Melosh, *Engendering Culture: Manhood and Womanhood in New Deal Public Art and Theater* (Washington and London: Smithsonian Institution Press, 1991).

52. Examples include post office murals such as *The Scene Changes* (Cordell, Okla.) and *Presettlement Days* (Edmond, Okla.) by Ila Turner McAfee (New Mexico); *Wheat Threshing* (Auburn, Neb.) and *Prairie Fire* (Madill, Okla.) by Ethel Magafan (Colorado); *Winter in Nebraska* (Albion, Neb.) by Jenne Magafan (Colorado); *Wheat Threshing* (Hoisington, Kans.) by Dorothea Tomlinson (Iowa); and *Osage Treaties* (Pahuska, Okla.) by Olive Rush (New Mexico). Photographs of these may be found in the National Archives, Still Pictures Division, RG 121-CMS. Ethel Magafan was also scheduled to paint *The Lawrence Massacre* for the post office in Fort Scott, Kansas, but the project was canceled because local citizens were uncomfortable with the subject's

focus on racial tensions before the Civil War. See Charlotte Rubinstein, *American Women Artists: From Early Indian Times to the Present* (Boston: G. K. Hall, 1982), 235. The egg tempera study for the mural (1936) is in the collection of the Denver Art Museum. Another work, Joan Cunningham's *Cotton*, for Poteau, Oklahoma, was executed, but it offended local residents because it was full of inaccuracies and had been painted by a New Yorker. Murals by women from the Great Plains region include Edith Mahier's *Roman Nose Canyon* (Watonga, Okla.) and Kady Faulkner's *End of the Line* (Valentine, Neb.). Even when the artist was a local resident, however, the works were not always well received; Mahier's depiction of Cheyenne history prompted picketing of the post office by Cheyenne Chief Red Bird and other members of his tribe for what they perceived as an inaccurate and insulting representation of their forebears. See Oliver G. Meeks, "The Federal Art Program in Oklahoma 1934–1940" (master's thesis, University of Oklahoma, 1941), 2–3; Rogers, "Incidence of New Deal Art in Oklahoma," 12–13; and Nicolas Calcagno, *New Deal Murals in Oklahoma* (Miami, Okla., 1977).

53. For more on these intriguing artists see Sarah McAnulty Quilter, "Angel DeCora Dietz: The Art Career of a Winnebago Woman," and Ann Diffendal, "The LaFlesche Sisters: Susette, Rosalie, Marguerite, Lucy, Susan," in *Perspectives: Women in Nebraska History*, 97–112, 215–25. Susette's Indian name, In-stha-the-am-ba, translates to "Bright Eyes," and Angel DeCora's Hinook-Mahi-wi-kilinake means "Woman Coming on the Clouds in Glory." Bucklin, *Nebraska Art and Artists*, 15–16, 18. The Nebraska State Historical Society also has photographs and files on these artists.

54. For more on Owen and her family, see Narcissa Owen, *Memoirs*; and George H. Shirk, "Notes and Documents: Tribute to Senator Robert L. Owen," *Chronicles of Oklahoma* 49 (winter 1971–72): 504–10.

55. This medal is in the collection of the Oklahoma Historical Society, but it was lost for a time during Narcissa Owen's life. For more on its curious history see Owen, *Memoirs*, 50–51; and Ora Eddleman Reed, "The Story of a War Chief's Medal," unidentified clipping, c. 1905, Narcissa Owen vertical file, Oklahoma Historical Society Library.

56. Photography had not been invented, of course, in Jefferson's time, but photographic portraits of some of his descendants were available to Owen. Several other works by Owen also received medals. Owen, *Memoirs*, 102–3.

57. Ibid., 102–3.

58. Ibid., 103.

59. Alan Trachtenberg, *The Incorporation of America: Culture and Society in the Gilded Age* (New York: Hill and Wang, 1982), 143–53.

60. For contemporary commentary on this see Earl Barnes, "The Feminizing of Culture," *Atlantic Monthly* 109 (June 1912): 771; and "Does Masculine Predominance Injure Our Fine Arts?" *Current Literature* 50 (May 1891): 548–50.

61. For a complete listing of these women and related information see Bucklin, *Art and Artists in Nebraska*, 23–24.

62. The University of Nebraska was founded

in 1871. During the first years tuition was thirty dollars per year, or one dollar per week. Fred Meeks, *The Nebraska Art Association*, 5–6; Bucklin, *Art and Artists in Nebraska*, 23.

63. Sarah Wool Moore to the chancellor and faculty of the University of Nebraska, fall 1886, box 6, folder 56, University of Nebraska Archives. As she noted at the beginning of the passage, she was quoting from a report from the Missouri Agricultural College and University.

64. The official administrative designation of the University of Nebraska art program went through a number of different characterizations before finally receiving full university status in 1912. For more see Wells, *The Nebraska Art Association*, 5–15.

65. Ibid., 1.

66. Gerdts, *Art Across America*, 3:76.

67. In 1905, when William Merritt Chase asked Hayden—"unsolicited," she said—to join a class in Spain, she petitioned the university for a sabbatical. Sara Hayden to the chancellor and board of regents of the University of Nebraska, series 1/1/1, box 18, folder 139, UNL Archives.

68. In 1901, in a crowded gallery, a man named Carey J. Warbington, disturbed by the work's display of nudity, threw a chair through the painting. He was arrested, tried, judged insane, and acquitted; he later committed suicide. The damaged painting and the chair were exhibited in several cities before the canvas was restored. Lininger Gallery catalogue, 1911, cited in *The Lininger Era* (Omaha: Joslyn Museum, 1972), 7.

69. Lininger also sponsored the European study of J. Gutzon Borglum of Mount Rushmore fame. Michael J. Harkins, "George Washington Lininger: Pioneer Merchant and Art Patron," *Nebraska History* 52 (winter 1971): 347–57.

70. Reinbach, "Kansas Art and Artists," 572.

71. Ibid., 571. In Lawrence, the University of Kansas offered art courses shortly afterward, in 1870, although it is unclear whether the instructor, E. P. Leonard, was male or female. Washburn College was renamed Washburn University of Topeka in 1952.

72. I am grateful to Larry Peters of the Topeka and Shawnee County Public Library for showing me this collection.

73. Peggy Greene, "Topeka Artist's Paintings On Exhibition at Library," unidentified clipping, Topeka and Shawnee County Public Library, artist files. In regard to Huntoon's work with Hayter see Dorothea Pellett, "Topekan Teaches Renowned Artist," *Topeka Capital Journal*, April 29, 1962, 16A.

74. Bernard O. Stone, "A Historical Review: Mary Huntoon's Far Reaching Influence on the Field of Art Psychotherapy" (unpublished manuscript, Topeka and Shawnee County Public Library files). Huntoon, who used her maiden name professionally, was married four times; her full name would have been Mary Huntoon Atkinson Hoyt Hull Entarfer.

75. Jeanne d'Ucel, "Olinka Hrdy: Her Genius Wins Applause in the Art World Through Modern Masterpieces, *The Sooner Magazine*, July 1929, 344–45, 368, 370.

76. Interview with Olinka Hrdy, 1965, Archives of American Art, Smithsonian Institution, Washington, D.C.

77. For the development of abstract painting in the 1930s see John R. Lane and Susan C. Larsen, *Abstract Painting and Sculpture in America, 1927–1944* (Pittsburgh: Carnegie Institute, 1983). Lane notes that the Guggenheim Museum, originally called Art of Tomorrow, the Museum of Non-Objective Painting, was not opened until 1939. This was three years after Hrdy produced *Games*.

78. Much of Olinka Hrdy's career is documented in her papers at the Archives of American Art, LA 7 (frames 911–1121), and LA 8 (frames 192–232). Included in the archives is a letter of July 27, 1933, from Wright, commenting on her work (LA 7, frame 1121). Hrdy remarks tantalizingly and briefly on her short stay at Taliesin in the recorded interview at the Archives of American Art.

Plates

Works in the *Independent Spirits* exhibition are denoted by an asterisk (*). Plates are indexed by page numbers in parentheses; the page on which a plate appears in the text is given in italics.

1. Charles M. Russell
 Cowboy and Lady Artist, 1906
 Watercolor on paper, 14¾ x 11½ in.
 Bradford Brinton Memorial, Bighorn,
 Wyoming (*2, 5*)

2. Estelle Ishigo
 Children Flying a Kite (Heart Mountain 1944),
 1944
 Watercolor on paper, 18 x 22 in.
 Department of Special Collections,
 University Research Library, University of
 California, Los Angeles (*6, 7*)

*3. Lucia Mathews
 Woman Sketching, n.d.
 Pastel on paper, 13½ x 9½ in.
 The Oakland Museum, Gift of the Art Guild
 (*8, 9*)

4. Women's life-drawing class, California
 School of Design, San Francisco,
 c. early 1890s
 Lucia Mathews memorabilia, The Paul
 Chadbourne Mills Archives of California Art,
 The Oakland Museum (*xiv–xv, 10*)

5. The Sketch Club at work on the beach at
 Pacific Grove, California, c. 1890
 Photograph courtesy of San Francisco
 Women Artists (*11*)

6. Evelyn McCormick
 Still Life with Spider Mums, c. 1890s
 Oil on canvas, 26 x 39½ in.
 Terry and Paula Trotter (*12*)

7. William White Dames
 Untitled (portrait of Pauline Powell), c. 1890s
 Cabinet photograph
 The Paul Chadbourne Mills Archives of
 California Art, The Oakland Museum (*13*)

8. Pauline Powell
 Champagne and Oysters, c. 1890
 Oil on canvas, 21 x 23 in.
 Oscar and Trudy Lemer (*12, 13*)

*9. Alice Chittenden
 Chrysanthemums, 1892
 Oil on canvas, 36 x 64 in.
 Redfern Gallery, Laguna Beach, California
 (*12, 14*)

*10. Mary Curtis Richardson
 Portrait of Joseph M. Bransten as a Child, n.d.
 Oil on canvas, 22 x 18 in.
 The Oakland Museum, Gift of Mr. Joseph M.
 Bransten and Mrs. Charles McDougall (*13, 15*)

*11. Mary Curtis Richardson
 The Sleeping Child, 1911
 Oil on canvas, 50 x 30 in.
 The Fine Arts Museums of San Francisco,
 Gift of Albert M. Bender and a group of
 friends to the California Palace of the
 Legion of Honor (*13, 16*)

*12. Grace Carpenter Hudson
 Quail Baby or *The Interrupted Bath*, 1892
 Oil on canvas, 38½ x 23 in.
 The Monterey Peninsula Museum of Art
 (*13, 17*)

13. Evelyn Almond Withrow
 The Spirit of Creation, n.d.
 Oil on canvas, 26¼ x 26¼ in.
 Garzoli Gallery, San Rafael, California (*18*)

*14. E. Charlton Fortune
 Monterey Bay, 1916
 Oil on canvas, 30 x 40 in.
 The Oakland Museum, Museum Donors
 Acquisition Fund (*19, 20*)

*15. Gertrude Partington Albright
 Below Twin Peaks (San Francisco), 1925
 Oil on canvas, 24 x 29½ in.
 George Stern Fine Arts, Los Angeles (*19, 21*)

*16. Margaret Bruton
 Barns on Cass Street, 1925
 Oil on canvas, 34½ x 40½ in.
 The Monterey Peninsula Museum of Art (*19, 22*)

*17. Evelyn McCormick
 The Robert Louis Stevenson House, c. 1933
 Oil on canvas, 36 x 48½ in.
 The Monterey Peninsula Museum of Art (*23, 24*)

18. Mary DeNeale Morgan
 Cypress Trees—17 Mile Drive, n.d.
 Oil on canvas, 20 x 16 in.
 Private collection
 Photograph courtesy of Trotter Galleries,
 Carmel (*23, 25*)

*19. Anne Bremer
 The Highlands, n.d.
 Oil on canvas, 30¼ x 36 in.
 San Francisco Museum of Modern Art,
 Albert M. Bender Collection,
 Gift of Albert M. Bender (*23, 26*)

20. Claire Falkenstein
 Self-portrait, 1930
 Oil on canvas, 28½ x 24 in.
 Collection of the artist (*25, 28*)

*21. Henrietta Shore
 Untitled [Cypress Trees, Point Lobos], c. 1930
 Oil on canvas, 30¼ x 26¼ in.
 Steve Turner, Steve Turner Gallery,
 Los Angeles (*27, 29*)

*22. Helen Forbes
 Manley's Beacon, Death Valley, c. 1930s
 Oil on canvas, 24 x 40 in.
 The National Museum of Women in the Arts,
 Gift of Richard York (*27, 30*)

23. Diego Rivera and Emmy Lou Packard at work
 on mural for the Golden Gate International
 Exposition on Treasure Island, 1940
 Photograph courtesy of San Francisco
 Art Institute (*28*)

*24. Jane Berlandina
 The Feast, n.d.
 Oil on canvas, 32 x 39¼ in.
 The Fine Arts Museums of San Francisco,
 Gift of Albert M. Bender (*28, 31*)

*25. Margaret Peterson
 Three Women, 1938
 Egg tempera on board, 59¼ x 46¾ in.
 The Oakland Museum, Gift of Friends of
 the Artist (*32, 33*)

*26. Miné Okubo
 Berkeley Family Backyard, 1937
 Gouache and watercolor, 16½ x 22 in.
 The Michael D. Brown Collection (*32, 34*)

*27. Miki Hayakawa
 From My Window: View of Coit Tower, c. 1937
 Oil on canvas, 28 x 28 in.
 Bram and Sandra Dijkstra (*32, 35*)

71. Robert Henri's 1912 summer school class
in Spain
Klauber Family, photograph courtesy of
Martin Petersen (*77*, 84)

*72. Meta Cressey
Under the Pepper Tree, c. 1926
Oil on canvas, 36 x 40 in.
Joan Irvine Smith Fine Arts, Inc. (*78*, 84, 86)

*73. Henrietta Shore
Floripondes, c. 1925
Oil on canvas, 24 x 20½ in.
The Buck Collection (*79*, 86)

74. Dorr Bothwell
The Devout Vegetarian, c. 1933
Oil on canvas, dimensions unknown
Location unknown
Photograph, PWAP, National Archives,
Washington, D.C. (*80*, 86)

75. Anni Baldaugh
Murial, c. 1926
Oil on board, 21 x 23 in.
San Diego Historical Society, Anonymous gift
(*80*, 86)

*76. Mabel Alvarez
Self-Portrait, 1923
Oil on canvas, 23⅜ x 19½ in.
Janet L. Alvarez (*81*, 86, 89)

*77. Belle Baranceanu
The Johnson Girl, c. 1930
Oil on canvas, 34 x 28 in.
The Buck Collection (*83*, 89)

78. Margaret (Margot) Rocle
Eileen, c. 1939
Oil on canvas, 30 x 24 in.
San Diego Historical Society, Gift of Everett
and Eileen Jackson (*84*, 89)

79. Rex Slinkard
Ring Idols, c. 1915–16
Oil on canvas, 29½ x 33½ in.
Stanford University Museum of Art,
Estate of Florence Williams (*84*, 90)

*80. Mabel Alvarez
Dream of Youth, 1925
Oil on canvas, 58 x 50¼ in.
Adamson-Duvannes Galleries, Los Angeles
(*85*, 90, 99)

81. Adele Watson
Murmurs of the Air, 1916
Oil on canvas, 17¼ x 27 in.
Collection of Mr. and Mrs. Whitney Ganz, Jr.
(*86*, 90)

*82. Adele Watson
The Winged Rock, 1931
Oil on canvas, 40 x 30 in.
Michael Kelley (*87*, 90, 93)

*83. Agnes Pelton
Memory, 1937
Oil on canvas, 36¼ x 22 in.
The Buck Collection (*88*, 94)

84. Agnes Pelton
Drawing from her diary, January 1, 1937
Agnes Pelton Diary, Pelton papers, Archives
of American Art, Smithsonian Institution,
Washington, D.C. (*89*, 94)

*85. Agnes Pelton
Alchemy or *Pluto*, 1937–39
Oil on canvas, 36¼ x 26 in.
The Buck Collection (*91*, 94)

*86. Helen Lundeberg
The Mountain, c. 1933
Oil on Celotex, 54 x 48 in.
Redfern Gallery, Laguna Beach, California
(*92*, 96)

*87. Helen Lundeberg
Microcosm and Macrocosm, 1937
Oil on Masonite, 28¼ x 14 in.
Private collection
Photograph courtesy of Tobey C. Moss
(*74*, 96)

88. Helen Lundeberg
Plant and Animal Analogies, 1933–34
Oil on Celotex, 24 x 30 in.
The Buck Collection (*93*, 98)

89. Grace Clements
Pilgrimage of the Psyche, 1934–43
Oil on canvas, 24 x 30 in.
Location unknown
Photograph, WPA Federal Art Project,
National Archives, Washington, D.C. (*93*, 98)

*90. Dorr Bothwell
Hollywood Success, 1940
Oil on canvas, 36 x 30 in.
The Fine Arts Museums of San Francisco,
Museum Collection (*95*, 98)

91. Elanor Colburn or Ruth Peabody
Diagrammatic drawing based on dynamic
symmetry, n.d.
Drawing on paper, dimensions unknown
Location unknown
Photograph courtesy of Laguna Art Museum,
Laguna Beach, California (*96*, 100)

*92. Elanor Colburn
New Earth, 1933
Oil on Masonite, 32¼ x 40½ in.
The Buck Collection (*97*, 100)

93. Ruth Peabody
Untitled [Abstractions], c. 1935
Oil on canvas, 12 x 16 in.
Laguna Art Museum, Laguna Beach,
California, Gift of John E. Bostic (*98*, 100)

94. Ruth Peabody
Untitled, c. 1938
Oil on board, 12 x 14 in.
Laguna Art Museum, Laguna Beach,
California, Gift of John E. Bostic (*99*, 100)

95. Elise
Untitled [Succulents], c. 1934
Lithograph, 9¹¹⁄₁₆ x 12¹⁵⁄₁₆ in.
Arensberg Archives, Francis Bacon Library,
Claremont, California (100, *101*)

96. Elise
The Spinning Top, c. 1935–42
Oil on canvas, 40 x 50 in.
WPA Art on permanent loan from
the federal government, Los Angeles County
Museum of Art (100, *102*)

97. Elise
Descent, 1935
Lithograph, 10 x 8½ in.
Steve Turner, Steve Turner Gallery,
Los Angeles (101, *102*)

*98. Elise
Out of Space, 1938
Oil on canvas, 22 x 32 in.
The Buck Collection (101, *103*)

*99. Belle Baranceanu
The Brick Factory—Elysian Park, Los Angeles,
1927
Oil on canvas, 22 x 24 in.
Bram and Sandra Dijkstra (101, *104*)

*100. Grace Clements
Winter, 1932, 1933
Oil on canvas, 42⅜ x 34 in.
The Fine Arts Museums of San Francisco,
Museum Collection (101, *105*)

101. Myra Wiggins
Edge of the Cliff, c. 1902
Silver print, 8 x 6 in.
Photograph courtesy of Martin-Zambito
Fine Art, Seattle (*108*)

102. Imogen Cunningham
On Mt. Rainier 6, 1915 ©1978, 1994
Gelatin silver print, 8¾ x 7 in.
Seattle Art Museum, Funds provided by
John H. Hauberg (*108*)

103. Helen Loggie
Drawing for "The Twisted Cedar," 1930
Graphite on paper, 10 x 8 in.
Len and Jo Braarud, Promised gift to the
Seattle Art Museum (*109*)

104. Harriet Foster Beecher in Port Townsend,
before 1915
Photograph courtesy of Ward Beecher (*109*)

*105. Harriet Foster Beecher
A Camp on the Tide Flats, 1897
Watercolor on paper, 13½ x 27 in.
Museum of History and Industry, Seattle,
Gift of Mrs. Katherine M. Glenn (109, *110*)

106. Abby Williams Hill in Montana, 1905
Photograph courtesy of Ronald Fields,
University of Puget Sound, Tacoma (*111*)

*107. Abby Williams Hill
Niguel Canyon: Wild Mustard, 1919
Oil on canvas, 16 x 22 in.
University of Puget Sound, Tacoma
(111, *112*, 113)

*108. Anna Gellenbeck
Richardson Highway, Alaska, 1944
Oil on canvas, 37⅝ x 35¹¹⁄₁₆ in.
Washington State Historical Society, Tacoma
(113, *114*)

*109. Margaret Camfferman
View from Old Homestead Ranch, 1936
Oil on board, 25¼ x 29¼ in.
Seattle Art Museum, Eugene Fuller
Memorial Collection (113, *115*)

110. Members of Women Painters of
Washington with Peter Camfferman at
Langley, Whidbey Island, Washington, c. 1936
Photograph courtesy of Doris Jensen Carmin
and Martin-Zambito Fine Art, Seattle (*116*)

111. Dorothy Dolph Jensen
The Graduate, c. 1933
Oil on canvas, 26 x 20 in.
Collection of Doris Jensen Carmin
Photograph courtesy of Martin-Zambito
Fine Art, Seattle (116, *117*)

*112. Hilda Morris
Landscape, c. 1939
Tempera on paper, 17 x 21 in.
Seattle Art Museum, Eugene Fuller
Memorial Collection (117, *118*, 120)

*113. Z. Vanessa Helder
Coulee Dam Looking West, c. 1940
Watercolor on paper, 18 x 21⅞ in.
Cheney Cowles Museum, Spokane (*119*, 120)

*114. Z. Vanessa Helder
Rocks and Concrete, c. 1940
Watercolor on paper, 19 x 15⅞ in.
Cheney Cowles Museum, Spokane (*106*, 120)

115. Z. Vanessa Helder, 1941
Photograph courtesy of R. Wright Helder, Sr. (*120*)

116. Margaret Tomkins and James FitzGerald in
their Seattle studio, c. 1945
Photograph courtesy of Miro FitzGerald (*121*)

*117. Margaret Tomkins
Metamorphosis, 1943
Egg tempera on Masonite, 25 x 30 in.
Seattle Art Museum, Eugene Fuller
Memorial Collection (121, *122*)

*118. Margaret Tomkins
Anamorphosis, 1944
Egg tempera and ink on board, 17½ x 21½ in.
Seattle Art Museum, Eugene Fuller
Memorial Collection (121, *122*)

119. Yvonne Twining Humber at her Seattle Art
Museum exhibition, 1946
Collection of Yvonne Twining Humber
Photograph courtesy of Martin-Zambito
Fine Art, Seattle (*123*)

*120. Yvonne Twining Humber
Public Market, c. 1944–45
Oil on canvas, 20 x 26 in.
Dr. Richard A. Smith (123, *124*)

*121. Clara Jane Stephens
Park Blocks, n.d.
Oil on canvas, 42¼ x 60½ in.
Oregon Historical Society, Portland (*124*, 125)

122. Anne Kutka McCosh in New Mexico, 1934
Photograph courtesy of the Anne Kutka
McCosh Trust and Martin-Zambito Fine Art,
Seattle (*126*)

*123. Anne Kutka McCosh
Leaving the Lecture: The Faculty Wives, 1936
Oil on canvas, 25 x 31 in.
Center for the Study of Women in Society
University of Oregon, Eugene (125, *127*)

124. Imogen Cunningham
Portrait of Maude Kerns, c. 1915
Photograph courtesy of Leslie Brockelbank
(*126*)

*125. Maude I. Kerns
Composition #27, 1944
Oil on canvas, 36 x 24 in.
Seattle Art Museum, Eugene Fuller
Memorial Collection (128, *129*)

126. Katherine Kitt in Tucson, Arizona, c. 1898
Photograph, AHS neg. 57813
Arizona Historical Society, Tucson (*132*)

127. Kate T. Cory
The Buffalo Dancer [Komanci Mana], 1919
Oil on canvas, 84¼ x 43¼ in.
Smoki Museum, Prescott, Arizona (*133*, 135)

128. Kate T. Cory
*Untitled [Palhik'Mamantu/Dance of the Water
Drinking Girls]*, c. 1905–12
Photograph from nitrate negative
Smoki Museum, Prescott, Arizona (*134*, 135)

129. Kate T. Cory
Untitled [Comanche Dance], c. 1905–12
Photograph from nitrate negative
Smoki Museum, Prescott, Arizona (*135*)

*130. Kate T. Cory
Return of the Kachinas, c. 1912?–1935
Oil on canvas, 40 x 99 in.
Smoki Museum, Prescott, Arizona
(135, *136–137*)

131. Hopi Craftsman Show, 1930
Photograph, MNA neg. 12254
Museum of Northern Arizona, Flagstaff
(*138*, 141)

132. Mary-Russell Ferrell Colton
Edmund Nequatewa, 1942
Oil on canvas, 42 x 32 in.
Museum of Northern Arizona, Flagstaff
(*138*, 141–142)

*133. Mary-Russell Ferrell Colton
Sunset Crater, 1930
Oil on canvas, 33 x 37 in.
Mr. and Mrs. Richard Wilson (*139*, 142)

*134. Lillian Wilhelm Smith
Blue Beauty of the Bradshaws, c. 1936
Oil on canvas, 36 x 60 in.
Bank One, Phoenix, Arizona (*140*, 144)

135. Temple of Music and Art, Tucson, Arizona,
c. 1928
Photograph, AHS neg. 10387
Arizona Historical Society, Tucson
(*141*, 144, 146)

136. Jessie Benton Evans's studio, Phoenix,
c. 1930
Photograph courtesy of
Jessie Benton Evans Gray (*142*, 146)

*137. Jessie Benton Evans
Desert Picnic, Arizona, c. 1930
Oil and tempera on canvas, 50 x 58 in.
University Art Museum, Arizona State
University, Tempe, Gift of Robert Evans
(*143*, 146)

*138. Marjorie Thomas
Four White Mules, c. 1930
Oil on canvas, 22 x 28 in.
Bank One, Phoenix, Arizona (*145*, 148, 150)

139. Lucy Drake Marlow
Study in Gray, 1933
Oil on Masonite, 28 x 23 in.
The Lucy Drake Marlow Art Collection Trust
(*146*, 150)

*140. Lucy Drake Marlow
[Indian] Madonna, 1940
Oil on canvas, 46½ x 41¾ in.
The Lucy Drake Marlow Art Collection Trust
(*147*, 150)

141. Maynard Dixon and Edith Hamlin on a
sketching trip among the giant saguaro
cactus in Arizona, c. 1943
Maynard Dixon Family Collection
Photograph courtesy of John Dixon (*148*, 150)

*142. Edith Hamlin
Canyon of Flame and Storm, 1940
Oil on canvas, 41 x 48 in.
Mr. and Mrs. Michael Hard (*149*, 150)

*143. Dorothea Tanning
Guardian Angel, 1946
Oil on canvas, 48 x 36 in.
New Orleans Museum of Art, Museum
Purchase, Kate P. Jourdan Fund (*130*, 151)

144. Catharine Carter Critcher, Taos,
New Mexico
Museum of New Mexico, neg. #20452 (*154*)

145. Henriette Wyeth, c. 1928
Photograph courtesy of The Hurd–
La Rinconada Gallery, San Patricio,
New Mexico (*155*)

146. Louise Crow studying a portrait she painted
of her mother, 1928
Seattle Times photograph
Special Collections Division, University of
Washington Libraries, neg. #UW 15174 (*155*)

147. Mabel Dodge Luhan and Tony Luhan
Photograph
Kit Carson Historic Museums, Taos,
the Wallace Cheetham Collection (*156*)

148. Cady Wells
*Mabel Dodge Luhan, Frieda Lawrence, and
Dorothy Brett at Kiowa Ranch*, 1940s
Photograph
Harwood Foundation Museum, Taos (*156*)

149. Georgia O'Keeffe near "The Pink House,"
Taos, New Mexico, 1929
Museum of New Mexico, neg. #9763 (*157*)

150. Horace T. Pierce
Florence Miller Pierce in Taos, New Mexico,
February or March 1938
Photograph courtesy of
Florence Miller Pierce (*157*)

151. Mary Greene Blumenschein,
Taos, New Mexico, 1920
Museum of New Mexico, neg. #40372 (*158*)

152. T. Harmon Parkhurst
Tonita Peña, San Ildefonso, c. 1935
Photograph
Museum of New Mexico, neg. #46988 (*159*)

153. Emmett P. Hadden
Pablita Velarde, Santa Clara Pueblo, n.d.
Photograph
Museum of New Mexico, neg. #151998 (*159*)

154. Pop Chalee, Taos Pueblo, c. 1939
Photograph
Museum of New Mexico, neg. #132447 (*159*)

155. Peter Stackpole
Rebecca Salsbury (Strand), 1937
Photograph
Kit Carson Historic Museums, Taos,
Rebecca Salsbury (Strand) James
Scrapbook Collection (*160*)

*156. Mary Greene Blumenschein
Acoma Legend, 1932
Oil on canvas, 50⅛ x 45 in.
The Albuquerque Museum, Gift of the
Lovelace Medical Foundation (159, *161*)

*157. Louise Crow
Eagle Dance at San Ildefonso, 1919
Oil on canvas, 71½ x 95½ in.
Martin-Zambito Fine Art, Seattle (159, *162–163*)

*158. Catharine C. Critcher
Pueblo Family, 1928
Oil on canvas, 30 x 30¼ in.
Eiteljorg Museum of American Indians and
Western Art, Indianapolis (*152*, 159)

159. Will Connell
Mary Austin, Santa Fe, New Mexico, 1932
Museum of New Mexico, neg. #16754 (*164*)

*160. Tonita Peña
Cochiti Pueblo Indian Buffalo Dance,
c. 1920
Gouache and watercolor on paper,
17¼ x 25¼ in.
Collection of Nathaniel O. and Page
Randolph Allen Owings (163, *165*)

*161. Pablita Velarde
Life Inside a Pueblo Home (Santa Clara
Pueblo), 1939–40
Watercolor on Masonite, 26¾ x 55⅞ in.
Permanent collection of Bandelier
National Monument, National
Park Service (164, *166*)

*162. Pop Chalee
Three Leaping Deer, c. 1942
Watercolor on brown paper, 8⅞ x 11¾ in.
Museum of Northern Arizona, Flagstaff
(164, *166*)

*163. Barbara Latham
Tourist Town, Taos, c. 1940s
Egg tempera on Masonite, 25 x 35¾ in.
Roswell Museum and Art Center, Gift of
Barbara Latham (164, *167*)

*164. Gina Knee
Near Cordova, N.M., 1943
Watercolor on paper, 19 x 23 in.
The Anschutz Collection (164, *168*)

165. Georgia O'Keeffe
Black Cross with Red Sky, 1929
Oil on canvas, 40 x 32 in.
Mr. and Mrs. Gerald P. Peters,
Sante Fe, New Mexico (164, *169*)

*166. Dorothy Brett
San Geronimo Day, Taos, 1924–65
Oil on canvas, 48 x 54 in.
Glenna Goodacre (164, *170*)

167. Agnes Tait
Lane in Santa Fe, 1945
Watercolor on paper, 14¾ x 18 in.
Dr. John and Jane Bagwell (164, *171*)

*168. Laura van Pappelendam
The Stone Wall, 1925
Oil on canvas, 36 x 30 in.
Edna van McLeod (164, *172*)

*169. Alice Schille
Pueblo, Drying Clothes, c. 1919–20
Watercolor on paper, 17⅞ x 20⅞ in.
Photograph courtesy of Keny Galleries,
Columbus, Ohio
Private collection (164, *173*)

*170. Gene Kloss
The Old Taos Junction Bridge, c. 1941
Oil on canvas, 24 x 26 in.
Museum of Fine Arts, Museum of New
Mexico, Federal Art Project (169, *174*)

171. Gene Kloss
Christmas Eve–Taos Pueblo, 1934
Drypoint and aquatint, 11 x 14 in.
Museum of Fine Arts, Museum of New
Mexico, Federal Art Project (169, *174*)

*172. Georgia O'Keeffe
Red Hills with Pedernal, 1936
Oil on canvas, 19¾ x 29¾ in.
Museum of Fine Arts, Museum of New Mexico,
Bequest of Helen Miller Jones (169, *175*)

*173. Rebecca Salsbury (Strand) James
Untitled [Elk Tooth and Magnolia], c. 1930s
Reverse oil on glass, 10 x 8 in.
Mr. Robert A. Ewing (169, *175*)

*174. Margaret Lefranc
Self Portrait, 1928
Oil on canvas, 21½ x 18 in.
Margaret Lefranc (*176*)

*175. Henriette Wyeth
Portrait of Witter Bynner, 1939
Oil on canvas, 37 x 50 in.
Roswell Museum and Art Center, Gift of
Witter Bynner (171, *177*)

*176. Florence Miller Pierce
Blue Forms, 1942
Oil on canvas, 29¾ x 34 in.
Georgia Riley de Havenon (171, *178*)

*177. Dorothy Morang
Untitled, 1941
Oil on board, 16 x 20 in.
Dr. and Mrs. Harry H. Orenstein
Photograph courtesy of Zaplin-Lampert
Gallery, Santa Fe, New Mexico (171, *179*)

178. Ina Sizer Cassidy
*Olive Rush Painting Ceiling at New Mexico State
University, Las Cruces, New Mexico*, May 1936
Photograph
Museum of New Mexico, neg. #19271
(171, *180*)

179. Joaquín Sorolla y Bastida's class at the School
of the Art Institute of Chicago, 1911
Photograph
Art Institute of Chicago,
Edna van McLeod Collection (*180*)

180. Dorothy Morang holding painting *Nightbird*,
1955
Photograph courtesy of John C. Emmett (*180*)

*181. Olive Rush
Clouds and Gazelles, n.d.
Watercolor on paper, 14¼ x 20½ in.
©1994 Indianapolis Museum of Art,
Mary B. Milliken Fund (*181*)

182. Eugénie Etienette Aubanel Lavender in Paris,
c. 1845
Photograph courtesy of
Mr. and Mrs. Evans R. Woodhouse (*184*)

183. Louise Andrée Frétellière
Water Cart, n.d.
Oil on canvas board, 9 x 12 in.
The Witte Museum, San Antonio, Texas,
Gift of the artist (*184*, 185)

184. Eleanor Onderdonk
Mary, n.d.
Watercolor on ivory, 2 x 1⅝ in.
The Witte Museum, San Antonio, Texas,
Gift of Miss Eleanor Onderdonk (*185*, 186)

185. Mary Anita Bonner
The Circular Cowboy, 1929
Etching and aquatint on toned paper,
16½ x 16½ in.
The Witte Museum, San Antonio, Texas
(*185*, 187)

186. Emma Richardson Cherry in her studio in
Houston, n.d.
Photograph
Harris County Heritage Society (*186*)

187. Emma Richardson Cherry
The Precious Bowl, c. 1925
Oil on canvas, 36 x 26⅛ in.
The Museum of Fine Arts, Houston, Gift of
Mrs. Willian Chilton Maverick (*186*, 187)

188. Florence McClung in her studio at Trinity
University, c. 1940
Reproduced from *Trinity University Bulletin*,
36 (June 1940), n.p.
Photograph courtesy of
McClung Brothers Collection (*187*)

*189. Florence McClung
Squaw Creek Valley, 1937
Oil on canvas, 24⅛ x 30⅛ in.
Dallas Museum of Art, Gift of
Florence E. McClung
© 1995 Dallas Museum of Art (*182*, 191)

190. Florence McClung
The Swamp (Caddo Lake), 1940
Oil on canvas, 24 x 30 in.
The McClung Collection (*187*, 191)

*191. Clara M. Williamson
Get Along Little Dogies, 1945
Oil on canvas, 26¾ x 39¾ in.
Dallas Museum of Art, Ted Dealey Purchase
Prize, Seventeenth Annual Dallas Allied Arts
Exhibition, 1946
© 1995 Dallas Museum of Art (*188*, 195)

192. Clara M. Williamson in her studio
at age ninety, 1965
Photograph courtesy of
Dr. and Mrs. Pierce M. Williamson (*189*, 195)

*193. Ethel Spears
*Terrell Cotton Gin with Kathleen Blackshear and
J. P. Terrell*, c. 1940s
Watercolor on paper, 22⅛ x 31½ in.
Mr. and Mrs. William J. Terrell, Sr. (*190*, 195)

194. Texas State College for Women,
Denton, art department faculty photograph
from the *Daedalian* (yearbook), 1944
Photograph courtesy of Special Collections,
Blaggy-Huey Library, Texas Woman's
University, Denton (*191*, 195)

195. Coreen Spellman in her studio, c. 1940s
Mick Spellman Collection
Photograph courtesy of Paul Harris, Ph.D. (*191*)

*196. Marie Delleney
Houses, Provincetown, c. 1939
Oil on canvas, 23¼ x 25⅛ in.
The Museum of Fine Arts, Houston, Gift of
the New York World's Fair Corporation
(*192*, 199)

*197. Coreen Spellman
Railroad Signal, 1936
Oil on beaverboard, 20 x 16 in.
Mr. and Mrs. Bill Cheek (*193*, 199)

*198. Coreen Spellman
Road Signs, c. 1936
Oil on canvas, 28 x 36 in.
Dallas Museum of Art,
Gift of Helen, Mick, and Thomas Spellman
© 1995 Dallas Museum of Art (*194, 199*)

199. Kathleen Blackshear
Gallery Notes (Self-Portrait), 1926
Pen and ink on paper, 8½ x 5⅜ in.
Mr. and Mrs. William J. Terrell, Sr. (*195, 199*)

*200. Kathleen Blackshear
A Boy Named Alligator, 1930
Oil on canvas, 22⅛ x 18⅛ in.
The Art Institute of Chicago, Gift of
Mr. and Mrs. William J. Terrell, Sr.
Photograph © 1994, The Art Institute
of Chicago. All Rights Reserved. (*196, 201*)

*201. Kathleen Blackshear
Ruby Lee and Loula May Washington, 1932
Oil on canvas, 40 x 30 in.
Mr. A. C. Cook (*197, 201*)

*202. May Schow
Mexican Girl, 1935–36
Oil on canvas, 34 x 20 in.
Mr. A. C. Cook (*198, 201*)

203. May Schow standing before her painting
of Ranchos de Taos (c. 1926)
Reproduced from *Post News Service,*
May 23, 1965
Art Department, Sam Houston State
University, Huntsville, Texas
Photograph courtesy of Professor
Darryl Patrick (*199*)

*204. Kathryne Hail Travis
The Unfinished Picture, c. 1935
Oil on canvas, 39¾ x 35½ in.
Mr. David Hail Travis (*200, 201*)

205. Edith Brisac
In the Mirror, c. 1940
Oil on canvas, 23½ x 17½ in.
Special Collections, Blaggy-Huey
Library, Texas Woman's University, Denton
(*201, 202*)

206. Grace Spaulding John
Line drawing from John's *The Knotted
Thread: Drawings and Verses*
(New York: Pantile Press, 1971), 3
Mrs. Patricia John Keightley (*202*)

207. Grace Spaulding John
Easter, 1933
Oil on canvas, 84 x 68 in. (4-panel mural)
Mrs. Patricia John Keightley (*202, 203*)

208. Ruth Pershing Uhler instructing a class at the
Museum of Fine Arts, Houston, c. 1946
The Museum of Fine Arts, Houston,
Archives Collection (*204*)

*209. Ruth Pershing Uhler
Decoration: Red Haw Trees, November,
c. 1929–30
Oil on canvas, 40 x 52 in.
Mr. A. C. Cook (*204, 205*)

210. Ruth Pershing Uhler
Earth Rhythms, No. 3, 1936
Oil on canvas, 25¼ x 30⅜ in.
The Museum of Fine Arts, Houston, Twelfth
Annual Houston Artists Exhibition, Museum
Purchase Prize, 1936 (*204*)

211. Frances Johnson Skinner at home in
Houston, n.d.
Photograph courtesy of Joe Wilson, Jr. (*206*)

*212. Frances Johnson Skinner
Exercise for a Rainy Afternoon, c. 1942
Oil on Masonite, 20 x 23¹⁵/₁₆ in.
The Museum of Fine Arts, Houston,
Eighteenth Annual Houston Artists
Exhibition, Museum Purchase Prize, 1943
(*204, 207*)

213. Minerva Teichert, c. 1947
Photograph
Museum of Church History and Art,
Salt Lake City (*210*)

214. Minerva Teichert in Robert Henri's painting
class at the Art Students League, New York,
c. 1916
Photograph courtesy of Marian Wardle
(*209, 210*)

215. Minerva Teichert
Handcart Pioneers, 1930
Oil on canvas, 68 x 51 in.
Museum of Church History and Art,
Salt Lake City (*209, 210, 237, 238*)

*216. Minerva Teichert
*1847 Covered Wagon Pioneers,
Madonna at Dawn,* 1936
Oil on canvas, 72 x 132 in.
Museum of Church History and Art,
Salt Lake City (*209, 211, 238*)

217. John Gast
American Progress, 1872
Oil on canvas, 17¾ x 21½ in.
Autry Museum of Western Heritage,
Los Angeles (*210, 212*)

218. Joseph Collier (?)
Helen Chain Painting in the Rocky Mountains,
c. 1882
Photograph
Denver Public Library, Western History
Department, Robert Collier Collection (*213*)

*219. Henrietta Bromwell
Untitled Landscape [Rocky Place and Junipers],
c. 1890
Oil on canvas, 24 x 36 in.
Colorado Historical Society (*213, 214*)

*220. Emma Richardson Cherry
Untitled [Sweet Peas], 1894
Watercolor on paper, 24 x 31 in.
Colorado Historical Society (*213, 215*)

*221. Harriet Richards Harwood
Etude, 1892
Oil on canvas, 21 x 32¼ in.
Utah Museum of Fine Arts,
University of Utah (*216, 217*)

*222. Rose Hartwell
Nursery Corner, c. 1910
Oil on canvas, 23¾ x 28¾ in.
Museum of Art, Brigham Young University
(*218, 219*)

*223. Mary Teasdel
Mother and Child, c. 1920
Oil on canvas, 30½ x 24½ in.
Utah State Fine Arts Collection,
Salt Lake City (*218, 220*)

*224. Florence Ware
Breakfast in the Garden, 1928
Oil on canvas, 36¼ x 30 in.
Utah State Fine Arts Collection,
Salt Lake City (*218, 221*)

225. Fra Dana, c. 1900
Photograph courtesy of Marvene Fousek
(*222*)

226. Fra Dana
On the Window Seat, c. 1909
Oil on canvas, 16 x 19¾ in.
Museum of Fine Arts, School of Fine Arts,
University of Montana, Missoula (*218, 222*)

*227. Fra Dana
Breakfast, c. 1910
Oil on canvas, 24 x 20 in.
Museum of Fine Arts, School of Fine Arts,
University of Montana, Missoula (*222, 223*)

*228. Mrs. M. J. Bradley
Gem, Idaho, and Gem Mill, 1892
Oil on canvas, 30¾ x 45⅞ in.
Cheney Cowles Museum, Spokane (*224, 225*)

*229. Mary Kirkwood
Palouse Autumn, 1939
Oil on canvas, 29 x 36 in.
Ms. Elizabeth McKay (*224, 226*)

*230. Mabel Frazer
Sunrise, North Rim, 1928
Oil on canvas, 33 x 57¾ in.
Springville Museum of Art, Utah (*224, 226*)

*231. Mabel Frazer
The Furrow, 1929
Oil on canvas, 24 x 30 in.
Museum of Church History and Art,
Salt Lake City (*224, 227*)

232. Louise Farnsworth
View of Salt Lake City and Hotel Utah, 1929
Oil on canvas, 22 x 20 in.
Museum of Church History and Art,
Salt Lake City (*224, 228*)

233. Eve Drewelowe, c. 1924
Collection of the School of Art and Art
History, University of Iowa
Photograph courtesy of Janelle Lupin (*228*)

*234. Eve Drewelowe
Inter-Urban Motor-Man, 1938
Oil on canvas, 27 x 22 in.
Mr. and Mrs. Bruce Lueck (*208, 228*)

235. Eve Drewelowe
Self-Portrait—Reincarnation, 1939
Watercolor on paper, 28¼ x 21¼ in.
Collection of the School of Art and Art
History, University of Iowa (*228*)

*236. Eve Drewelowe
Vertical, Vaulting, Veined (Aspen), 1943
Oil on linen, 40 x 34 in.
Mr. and Mrs. Michael Loren Aronson (*228, 229*)

237. Ethel and Jenne Magafan in front of Ethel's
1941 mural *Horse Corral* for South Denver
Post Office, 1941
Photograph courtesy of Bruce Currie (*230*)

238. Ethel Magafan
Lawrence Massacre, 1936
Egg tempera on panel, 15⅝ x 40³/₁₆ in.
Denver Art Museum (*230, 231*)

*239. Ethel Magafan
Garden of the Gods, Colorado, 1938
Oil on board, 37½ x 21½ in.
Schoen Collection (231, *232*)

*240. Jenne Magafan
Deserted Street, 1943
Oil on canvas, 24 x 30 in.
Steve Turner, Steve Turner Gallery,
Los Angeles (231, *233*)

*241. Irene Fletcher
Laid Off, 1938
Oil on board, 24 x 18 in.
Springville Museum of Art, Utah (231, *235*)

*242. Nadine Drummond
Colorado State Fair, 1940
Gouache on paper, 20 x 30 in.
Elizabeth Schlosser Fine Art, Denver
(231, *236*)

243. Nadine Drummond
Farm Auction in Trinidad, c. 1940
Oil on canvas, 20 x 24 in.
Western History Department,
Denver Public Library (231, 234, *237*)

244. Louise Emerson Rönnebeck in attic studio in
Denver home, c. 1935
Photograph courtesy of
Ursula Rönnebeck Works (*238*)

*245. Louise Emerson Rönnebeck
The People v. Mary Elizabeth Smith, 1936
Oil on Masonite, 34 x 50 in.
Estate of the artist (234, 237, *239*)

*246. Louise Emerson Rönnebeck
4-B, 1937
Oil on Masonite, 34 x 50 in.
Estate of the artist (234, *239*)

247. Louise Emerson Rönnebeck
Harvest, 1940 (mural for Grand Junction,
Colorado Post Office, now rehung in
the Wayne N. Aspinall Federal Building,
Grand Junction)
Oil on canvas, 72 x 108 in.
U.S. General Services Administration
Federal Art & Art-in-Architecture Programs
Photograph courtesy of Janelle Lupin
(234, *238*)

248. Minerva Teichert costumed as an Indian
dancer for a Wild West troupe, New York,
1916
Photograph courtesy of the Museum of
Church History and Art, Salt Lake City
(238, *240*)

*249. Minerva Teichert
Night Raid, c. 1935
Oil on canvas, 45¹⁵/₁₆ x 67⅞ in.
Museum of Art, Brigham Young University
(238, *241*)

250. Minerva Teichert
Joseph Smith Receives the Plates, 1947
Oil on canvas, 60 x 48 in.
Randolph, Utah Tabernacle, Museum of
Church History and Art, Church of Jesus
Christ of Latter-day Saints (238, *240*)

251. Nellie Shepherd with art class in Paris,
c. 1910
Photograph
Oklahoma City Art Museum (*244*, 246)

*252. Mary Bartlett Pillsbury Weston
The Spirit of Kansas, 1892
Oil on canvas, 62½ x 70½ in.
Kansas State Historical Society, Topeka
(*245*, 246)

253. Alice Cleaver
Photograph courtesy of the Lydia Bruun
Woods Memorial Library, Falls City,
Nebraska (246, *247*)

*254. Alice Cleaver
Girl with a Palette, c. 1915
Oil on canvas, 21¾ x 15½ in.
University of Nebraska at Kearney, Museum
of Nebraska Art, Nebraska Art Collection
(247, *248*)

*255. Marion Canfield Smith
A Corn Field, c. 1920
Oil on canvas, 14 x 17 in.
University of Nebraska at Kearney, Museum
of Nebraska Art, Nebraska Art Collection
(249, *250*)

*256. Elizabeth Tuttle Holsman
A Drowsy Day, 1915
Oil on canvas, 43½ x 29½ in.
University of Nebraska at Kearney, Museum
of Nebraska Art, Nebraska Art Collection,
Gift of the Class of 1915, Kearney State
College (249, *251*)

*257. Elizabeth Honor Dolan
The Hall Garden, Eleven A.M., 1913
Oil on canvas, 20 x 30 in.
Sheldon Memorial Art Gallery,
University of Nebraska, Lincoln,
Bequest of Mr. and Mrs. F. M. Hall (249, *252*)

*258. Zoe Beiler
Badlands, 1944
Oil on canvas, 17⁵/₁₆ x 28¾ in.
Dickinson State University, Dickinson,
North Dakota (249, *253*)

*259. Grace French
Wooded Hillside, c. 1915
Oil on canvas, 30 x 30 in.
Dahl Fine Arts Center, Rapid City,
South Dakota (249, 253, *254*)

*260. Alice Edmiston
Provincetown Church, c. 1927
Oil on canvas, 38⅛ x 37¾ in.
Mr. and Mrs. Frank C. Sidles,
Lincoln, Nebraska (253, *255*)

*261. Gladys Marie Lux
Inflation, 1934
Oil on canvas, 28¼ x 36 in.
Sheldon Memorial Art Gallery, University of
Nebraska, Lincoln, Olga N. Sheldon
Acquisition Trust (253, *256*)

*262. Ruth Harris Bohan
*The 1926 Tunney-Dempsey Fight in
Philadelphia,* 1926–27
Oil on canvas, 31 x 39 in.
Spencer Museum of Art, University of
Kansas, Gift of Ruth H. Bohan (253, *257*)

*263. Ruth Harris Bohan
Billie Bellport, 1927
Oil on canvas, 40 x 32 in.
Spencer Museum of Art, University of Kansas,
Estate of Ruth H. Bohan (253, *258*, 259)

264. Charles and Myra Miller with
two of their children
Photograph
South Dakota Art Museum archives,
Brookings (*259*)

265. Myra Miller's farm at Buffalo Lake west of
Sisseton, South Dakota
South Dakota Art Museum archives,
Brookings (259, *260*)

266. Myra Miller with still life for *Hunter's Pride,*
c. 1912
Photograph courtesy of South Dakota
Art Museum archives, Brookings (259, *260*)

*267. Myra Miller
Hunter's Pride, c. 1912
Oil on canvas, 48⁵/₁₆ x 23⅞ in.
South Dakota Art Museum, Brookings
(260, *261*)

268. Studio of Martanie (Janie) Snowden, Omaha,
c. 1890s
Photograph
Joslyn Art Museum, Omaha (260, *262*)

*269. Clarisse Madelene Laurent
Eggs, 1892
Oil on canvas, 15½ x 21½ in.
Mulvane Art Museum, Washburn University,
Topeka (260, *263*)

*270. Nan Jane Sheets
Among the Hills, n.d.
Oil on canvas, 27 x 30 in.
The Philbrook Museum of Art, Tulsa (262, *266*)

*271. Nan Jane Sheets
Still-Life, n.d.
Oil on canvas, 27 x 30 in.
Oklahoma City Art Museum (262, *267*)

*272. Narcissa Chisholm Owen
Self Portrait, 1896
Oil on canvas, 54 x 42 in.
Oklahoma Historical Society, Oklahoma City
(264, *268*)

*273. Cora Parker
Candlelight, 1899
Oil on canvas, 38 x 24 in.
Sheldon Memorial Art Gallery,
University of Nebraska, Lincoln,
Bequest of Mr. and Mrs. F. M. Hall (*242*, 270)

*274. Sara Shewell Hayden
Girl in Green, 1899
Oil on canvas, 35 x 26 in.
Sheldon Memorial Art Gallery, University
of Nebraska, Lincoln, Nebraska Art
Association Collection (269, *270*)

275. Ladies Luncheon, Lininger Gallery, Omaha,
c. 1890s
Photograph
From the Bostwick-Frohardt Collection
owned by KMTV and on permanent loan to
the Western Heritage Museum, Omaha (*270*)

276. J. Laurie Wallace instructing an early class in
painting, Omaha, c. 1890s
Photograph
Joslyn Art Museum, Omaha (270, *271*)

*277. Olinka Hrdy
Games, 1936
Oil on panel, 24 x 36 in.
Fred Jones Jr. Museum of Art, University of
Oklahoma, Norman, Gift of the artist
(*272*, 273)

Index

Italic page numbers indicate illustrations, and bold numbers reference photographs. Numbers preceded by n or nn refer to notes.

Idaho women artists, 224

Impressionism and women painters, 19, 68, 71, 82, 84, 249

instructors, art. *See* art education for women; faculty, women

internment camps, Japanese-American, 6, 7, 32

invisibility of women artists, 2, 5, 9, 37, 174, 184

Isaacs, Mildred, 282 n18

Ishigo, Estelle, *6*, 7

Jackson, Everett Gee, 280 n3

Jacobsen, Oscar, 262, 271

James, Rebecca Salsbury (Strand), 157, 158, **160**, 169, *175*, 286 n24

Japanese Americans, 5, *6*, 7, 32

Jensen, Dorothy Dolf, **116**, *117*

John, Grace Spaulding, *202*, *203*, 204

Johnson, Raymond, 94

Kandinsky, Wassily, 90, 100–101, 128, 171, 281 n82, 282 n41

Kansas artists, 246, 270–271

Kansas State Art Association (KSAA), 271

Kavanaugh (Wachtel), Marion, 4, 50–51, *54*, *55*, 154, 278 nn42, 46

Kent, Adaline, 37

Kerns, Maude I., **126**, 128, *129*, 282 n41

Kirkwood, Mary, 224, *226*

Kitt, Katherine, 131, **132**

Klauber, Alice, **77**, 84, 280 n24

Kloss, Gene, 169, 171, 174, *174*, 180

Knee, Gina, 157, 164, *168*, 174

LaFlesche, Susette (Yosette), 264, 291 n52

Laguna Beach, California, 66, 68, 75, 99–100

Lange, Dorothea, 4

language and gender, 19, 44, 58, 76, 133

Latham, Barbara, 159, 164, *167*

Latina Americans, 160, 274 n6, 277 n8

Laurent, Clarisse Madelene, 260, *263*

Laurvik, J. Nilsen, 19

Lavender, Eugénie Etienette Aubanel, **184**, 185

Lawrence, D. H., 157, 158

Lawrence, Frieda, **156**, 157

Lawrence Massacre mural, 230, 288 n39, 291 n52

Leadbeater, C. W., 90, 94

Leavenworth Art League, 270

Le Brun Art Club, 213

Lefebvre, Jules-Joseph, 260, 291 n46

Lefranc, Margaret, 157, 158, 169, *176*

Leighton, Kathryn Woodman and Edward L., 57–58, 62, *64*, *65*, 279 nn60–68

Lindsay, Vachel, 247, 290 nn22–23

Lininger Gallery, Omaha, 270

Loggie, Helen, 108, *109*, 282 n39

Los Angeles, 27, 41–42, 44, 48, 84

Los Angeles Modern Art Society, 27, 84

Louisiana Purchase Exposition, Saint Louis (1904), 111, 247, 264

Luhan, Mabel Dodge, 5, 6, 153, **156**–157, 180, 191, 286 n30

Luhan, Tony, 6, **156**, 191

Lujan, Merina (Pop Chalee), 5, 157, **159**, 160, 164, *166*, 171

Lundeberg, Helen, *74*, 80, *92*, *93*, 96, 98, 102

Lux, Gladys Marie, 253, *256*, 290 nn37–38

Macdonald-Wright, Stanton, 75, 99, 280 n37

Magafan, Ethel, 6, **230**, *231*, *232*, 288 n39, 291 n52

Magafan, Jenne, **230**, 231, *233*, 291 n52

Mahier, Edith, 271, 291 n52

male chauvinism, 158, 240, 280 n3

Marlow, Lucy Drake, 144, *146*, *147*, 148, 150, 285 nn51, 53

marriage. *See* companions and teams, artist; single women artists

Mathews, Arthur, 9, 11

Mathews, Lucia, *8*, 9–10, 275 nn3–6

McAfee, Ila Turner, 154, 291 n52

McCloskey, Alberta and William, 48–49, *52*, **52**, *53*, 278 nn30, 31, 35

McClung, Florence, *182*, 187, **187**, 189, 191

McCormick, Evelyn, 12, 19, 23, *24*

McCosh, Anne Kutka, 125, **126**, *127*

McNay, Marion Koogler, 187

Mexican artists, *28*, 32, 82

Mexico, women artists in, 27, 82

Miller, Myra, **259**–260, *261*, 291 nn41, 44

modernism, and women artists, 23, 25, 27, 32, 71–72, 82, 113, 171, 174, 204, 224, 271, 273; and regionalism, 102, 128; in Southern California, 74–105

Monterey Peninsula, **11**, 19, 23

Moore, Sarah Wool, 265

Morang, Dorothy, 171, 174, *179*, **180**

Morgan, Mary DeNeale, 23, 25, 276 n18, 277 n50

Morisot, Berthe, 9, 155

Morley, Grace McCann, 25

Mormon women and art, 216, 237–238, 240

Morris, Carl, 117

Morris, Hilda, 117, *118*, 120, 282 n30

murals. *See* federal art patronage

Museum of Fine Arts, Santa Fe, 174, 180

Museum of Northern Arizona, 132, **138**, 141

museums: the Paris Salons, 158, 159, 247; women's exhibition records in, 11, 76, 174, 180, 276 n15; women's roles in, 25, 68, 107, 132, 138, 183, 184, 186, 187, 244, 246, 262, 284 n22. *See also specific museum names*

National Academy of Design, New York, 42, 123, 142

National Association of Women Artists, 262

National Association of Women Painters and Sculptors, 51

Native Americans, 3, 134–135, 141–142, 160, 283 n17; as art subjects, 13, 62, 64, 159, 247, 264, 291 n52; images of, *133*, *134*, *135*, *136*–*137*, *138*, *147*, *152*, **154**, *161*, *162*–*163*, *165*, *166*, *170*; portraits of, 58, *65*, *68*; traditional arts of, 2, **138**, 141, 160, 286 n24

Native American women, *133*, *134*, *135*, *147*;

painters, 159, 160, 163–164, 264–265, 277 n8; stereotypes of, 5, 150, 264, 287 n7; traditional artisans, 2, 109, 141, 160, 286 n24

Nebraska Art Association, 265

Nebraska artists, 246–247, 249, 253, 265, 270

Nequatewa, Edmund, *138*, 141–142, 284 n29

Nevada artists, 274 n3

New Deal art. *See* federal art patronage

New Localism, The, 247

New Mexico artists, 152–181, 204

New Woman, the, 18, 156, 189

New York School, 37, 72

New York Society of Women Artists, 27

New York, training in, 19, 42, 44, 113, 123, 125, 184. *See also specific school names*

New York World's Fair (1939), 282 n24

Ney, Elisabet, 183

Nimmo, Louise Everett, 52, *56*, 64, 66, **68**, *69*

Nimmo, Ray, 66

Noble, May, 132, 144, 148

Nochlin, Linda, 42, 206

North Dakota artists, 249

Northwest School, 116–117, 121, 123, 128, 282 n23

Oakland Sketch Club, 276 n18

O'Keeffe, Georgia, 5, 6, 25, **157**, 164, *169*, 174, *175*, 189

Oklahoma artists, 247, 253, 262, 264, 271, 273

Okubo, Miné, 5, 32, *34*

Onderdonk, Eleanor Rogers, 183, *185*, 186

Oregon artists, 107–109, 123, 125–126, 128

organizations. *See* women artists associations; women's clubs

Otis Art Institute, **68**

Otis, Minnie V., 271, 289 n8

Owen, Narcissa Chisholm, 246, 264–265, *268*, 291 n55

Packard, Emmy Lou, **28**

painting. *See* women artists at work

Panama Pacific International Exposition, San Francisco (1915), 18–19, 71, 84, 109

Pappelendam, Laura van, 156, 164, 171, *172*

Paris Salons, women artists exhibiting in, 158, 159, 247

Parker, Cora, *242*, 270

Parkhurst, T. Harmon, **159**

Pasadena, 47, 50

patronage, government. *See* federal art patronage

patrons, women, 25, 76–77, 180, 187, 189, 216

Payne, Elsie Palmer and Edgar, 56–57, *62*, **62**, *63*, 72, 279 n56, 280 n83

Peabody, Ruth, *96*, 98, 99, 100

Pelton, Agnes, 77, 80, 82, *88*, *89*, *91*, 93–94, 100–101

Peña, Tonita (Quah Ah), 5, 157, **159**, 160, 163, *165*, 174

Pennington, Ruth, 108–109, 282 n39

Pennsylvania Academy of the Fine Arts, 244, 247, 249, 290 n40

Peterson, Margaret, 32, *33*

photographers, women, 108, **108**, **126**, 134, 283 n15